MAGICIANS *of* LIGHT

MAGICIANS *of* LIGHT

PHOTOGRAPHS *from the* COLLECTION *of the* NATIONAL GALLERY *of* CANADA

JAMES BORCOMAN

NATIONAL GALLERY OF CANADA

OTTAWA, 1993

Published in conjunction with the exhibition *Magicians of Light: Photographs from the Collection of the National Gallery of Canada*, organized by the National Gallery of Canada, and presented in Ottawa from 4 June to 6 September 1993.

Produced by the Publications Division of the National Gallery of Canada, Ottawa.
Chief of Publications: Serge Thériault
English Editor: Susan McMaster
French Editor: Jacques Pichette
Picture Editor: Colleen Evans
Assistant Picture Editor: Andréa Fajrajsl
Production Manager: Jean-Guy Bergeron

Designed by Associés libres, Montreal.
Printed on Warren Lustro Dull 200M paper by Groupe Litho Graphique Inc., Ville Saint-Laurent.
Typeset in Perpetua by Associés libres, Montreal.
Film by Chromascan, Ottawa.

Cover: Edward Steichen, *Nocturne – Orangery Staircase, Versailles* 1908 (page 132)

Back Cover: Marcel Mariën, *Stairs* 1949 (page 208)

Photograph Credits

Canadian Cataloguing in Publication Data

National Gallery of Canada.
Magicians of light: photographs from the Collection of the National Gallery of Canada.
ISBN 0-88884-627-4

Exhibition catalogue.
Issued also in French under title: Magiciens de la lumière.
1. Photography, Artistic–Exhibitions. 2. National Gallery of Canada–Exhibitions. I. Borcoman, James. II. Title.
TR650 N37 1993 779'.074'71384
 CIP 93-099104-4

Available from your local bookseller or from:
The Bookstore
National Gallery of Canada
380 Sussex Drive, P.O. Box 427, Station A
Ottawa, Ontario K1N 9N4

PRINTED IN CANADA

CONTENTS

FOREWORD

*M*agicians of Light: Photographs from the Collection of the National Gallery of Canada *offers the public a delightful and fascinating range of images, selected with care from our permanent holdings to represent the depth and breadth of our Photographs Collection. It is the most recent addition to a long history of photography exhibitions organized by the Gallery, beginning as early as the first annual* Canadian International Salon of Photographic Art *in 1934. Jean Sutherland Boggs, however, was the first director to recognize the importance of establishing a permanent collection of photography at the Gallery, at a time when photographs were accepted as collectible objects by less than a handful of art museums. In 1967, she appointed James Borcoman to establish the Collection, first as an additional responsibility, then in 1971 as its full-time curator. It is especially fitting that, as the person whose foresight and commitment have led us to this point, a quarter of a century later, he is the organizer of this major review, and author of the beautiful book that accompanies it.*

Since 1967, the Gallery has built an international Collection that illustrates the history of photography as an art form. Charles Nègre, 1976, *the first major exhibition and catalogue to be drawn from the new Photographs Collection, was also the first such extensive treatment of a nineteenth-century European photographer in North America, or elsewhere for that matter. Over the years, the Collection acquired a professional staff to research, catalogue, and care for the works. With the move into our new building in 1988, these became housed in an environment with entirely up-to-date temperature and humidity controls. The assignment of permanent exhibition space ensures a continuing display of photographs at the National Gallery.*

With the support of many generous donors, and through wise and timely acquisitions by curatorial staff, the Gallery and the nation have achieved a worldwide reputation for the Photographs Collection. In 1969 Dorothy Meigs Eidlitz made the first donation of photographs to the Collection, followed by Dave Heath in 1973. Phyllis Lambert established the first trust fund, followed by gifts of major collections of work by Walker Evans in 1982, and German daguerreotypists in 1988. The Lisette Model Estate, through Joseph Blum, established the first research fellowship in photography in 1990 and donated the Model Archives to the Gallery. The Prospero Foundation began to provide substantial funds for acquisitions in 1990. These are only some of the many patrons who have helped to make our Collection what it is today — one of which we, as Canadians and art lovers, can be justly proud. We remain deeply grateful for their commitment to our national culture. A complete list of donors follows.

The exhibition is, for the first time at the Gallery, accompanied by an interactive, electronic-imaging data base that offers the public access to some 1200 additional photographs from the Collection. Designed especially for our use as a means of making works more accessible, we are pleased with and excited by this, our first endeavour at adapting computer technology for such ends.

As a permanent record, the book Magicians of Light will bring the many facets of the Collection to the broadest possible audience and for a life far beyond the exhibition, as well as acting as a reference to our entire holdings. But it has another purpose as well. Although photographs have been with us since 1839, their very popularity often seduces us into accepting them at face value, simply as personal souvenirs of intimate moments, or as surrogates for reality. The essays which accompany each image in the book offer pertinent information, but they also suggest ways in which a photograph may be "read," ways of delving beneath its surface. Sensitive viewers will also bring their own associations to the viewing experience. As Nadar, the nineteenth-century French photographer, said, "Photography is a marvellous discovery, a science that occupies the highest intelligence, an art that sharpens the wisest minds."

Dr Shirley L. Thomson
Director
National Gallery of Canada

DONORS TO THE PHOTOGRAPHS COLLECTION OF THE
NATIONAL GALLERY OF CANADA

Without the support and generosity of private citizens, the National Gallery's Photographs Collection would not have achieved its present richness and variety. It is through the foresight of passionate private collectors that museums are able to build public collections that are exciting and vital. These are the individuals who understand how necessary art, and the ideas that lie within art, are to life itself. For, as Francis Henry Taylor wrote in 1948, "These are the things that distinguish the adolescence of one nation from the intellectual maturity of another."

Bluma Appel

Art Gallery of Ontario

Lewis Auerbach

William Baker

Murray F. Ball

Lila and Jean Bell

Joseph Beuys

Margaret Bishop

M. J. Boote

Robert Bourdeau

F. Maud Brown

Tom Burnside

Edward Burtynsky

Canadian Centre for Architecture

Gary Carroll

Helen Chisholm

Helen Clark

Ian Christie Clark

Ghislain Clermont

Miriam Grossman Cohen

Van Deren Coke

M. Cook

John Coplans

Evelyn Coutellier

Robert W. Crook

Georges De Niverville

Jennifer Dickson

Mary Dooker

Cynthia Eberts, through Charles Hill

Edward Steichen Bequest, through Joanna T. Steichen

Dorothy Meigs Eidlitz

Larry and Anstace Esmonde-White

Estate of Frank C. Lynch

Estate of Lisette Model, through Joseph G. Blum

Leonard J. Fowler

Fraenkel Gallery

Donald Fraser

Monica Fraser

Karen Gabbett-Mulhallen

Mayo Graham

Benjamin Greenberg

Ralph Greenhill

Rodney and Cozette de Charmoy Grey

Dave Heath

Joseph L. Hennessey

Herzig Somerville Ltd

Charles Hill

William Hingston

K. M. Holper

Robert H. Hubbard

International Museum of Photography at George Eastman House

André and Marie-Thérèse Jammes

Joseph E. Seagram & Sons Inc.

Yousuf Karsh

Albert Kerenyi

Phyllis Lambert

Andrew M. Lugg

Harry H. Lunn

Brian and Lynda MacIsaac

Arnaud Maggs

Marnie Marriott

Joanna Marsden

McCord Museum

Harry O. McCurry

David Miller

Zavie Miller

G. H. Stanley Mills

Virginia P. Moore

Vera Mortimer-Lamb

W. G. Nash

Joseph Nègre

New Orleans Museum of Art

Ottawa Camera Club

Richard Pare

Marguerite Parenteau

Photography Collectors Group

Ward C. Pitfield

Charles Pollowin

Paul Price

Prospero Foundation

Provincial Archives of Alberta

John Przybytek

Herb Quick

Carol and Morton H. Rapp

Irwin Reichstein

George R. Rinhart

Judith Joy Ross with the James Danziger Gallery

Gerd Sander

Michael Schreier

Max Serlin

Albert A. Shipton

Joel Sternfeld

Sam Tata

Charles Taylor

Irving Taylor

Teleglobe Employees' Art Committee Fund

Pierre Théberge

Donald C. Thom

Ann W. Thomas

Rosemarie Tovell

Cécile and Suzanne Valin

J. Van Rooy

Vancouver Public Library

Visual Studies Workshop

Walter Phillips Gallery

Falkland Warren

Karin Weiss

William Welling

Michael Wesselink

Mrs Wilder

R. F. Wodehouse

Peter Zegers

ACKNOWLEDGMENTS

Building a collection from nothing, and devoting a quarter of a century to doing so, has been a challenge, an adventure, and a privilege. Any success I may have gained in this enterprise, however, could not have been achieved without the support of a succession of directors of the National Gallery, beginning with Jean Sutherland Boggs in 1967 through to the current director, Shirley Thomson, and from my colleagues over the years, notably Ann Thomas, Associate Curator of Photographs, and Brydon Smith, Assistant Director, Collections and Research. A special debt is owed to four individuals who, at the start of the Collection, provided the National Gallery and myself with their advice and encouragement – Beaumont Newhall, formerly director of the George Eastman House, Rochester, New York, André Jammes, private collector, Paris, Nathan Lyons, Director, Visual Studies Workshop, Rochester, and John Szarkowski, formerly Director, Photographs Department, The Museum of Modern Art, New York. Space does not permit the listing of all those who came to the Collection's support in the early years, but the prescient generosity of Phyllis Lambert, Dave Heath, Ralph Greenhill, and Rodney Grey must be noted.

Magicians of Light is the tip of the iceberg that encompasses twenty-five years of growth of the National Gallery's Photographs Collection. This book, the exhibition, and the interactive electronic-imaging data base that accompanies them would not have been possible without the enthusiastic support of a dedicated group of professionals at the Gallery. I owe a debt of gratitude to the Photographs Collection's secretary, Barbara Boutin, who has kept me on track for many years and uncomplainingly typed and retyped my manuscript for the book. I wish to express my indebtedness to Hazel Mackenzie, Art Documentation and Storage Officer, Photographs, and to Lori Pauli, Curatorial Assistant, for their tireless effort and meticulous attention to detail in compiling the information for the Synoptic Catalogue and for their valuable assistance in organizing the exhibition and preparing material for the electronic-imaging data base. For the time they gave so generously to answering our queries during these processes I would like to thank Melissa Rombout, National Archives of Canada; Paolo Costantini, Venice; Gill Thompson and Pamela Roberts, The Royal Photographic Society; Stanley G. Triggs, Notman Photographic Archives; Sara F. Stevenson, Scottish National Portrait Gallery; Dominic Cutajar, Museum of Fine Arts, Malta; Michel Auer, Geneva; Ludo Bekkers, Museum voor Fotografie, Antwerp; Bernard Marbot, Bibliothèque Nationale; Jennifer Bunting, Lennox and Addington County Museum; Malcolm Daniel, Metropolitan Museum of Art; and Carrie A. Gaskell, Rhode Island School of Design.

Dan Richards, Chief of the Gallery's Audio Visual Services, deserves special praise for his creative inventiveness and dedication in developing the interactive

electronic-imaging data project, supported so sympathetically through its birth pangs by Daniel Amadei, Assistant Director, Exhibitions and Installations. Dan was aided by Dolores Coulombe, who painstakingly retrieved over 1200 works from the Collection and made the thousands of 35 mm slides required for digital scanning by the computer. I have been impressed over the years by the genuine interest, commitment, and superior professionalism that such people have shown in their association with the Collection.

Conservation treatment for the works in the exhibition and the entire Collection continues to be ably performed by John McElhone, Conservator of Photographs, with a sympathetic and thoughtful understanding of the problems involved. I am grateful to him for sharing his specialized knowledge through the Glossary he has prepared for this book. Karen Lisa Oxorn's cheerful patience and quick footwork as coordinator of the complexity of services required for the exhibition has ensured that it was completed on time and with a minimum of fuss. To Ellen Treciokas, Designer, goes my particular thanks for her creative talent and gentle but firm guidance in providing a handsome setting for the works in the exhibition; I am also indebted to Guy Gratton, Graphics Production Technician, and to Tracy Pritchard, Designer, for the three-dimensional elements of the design. To the many dedicated and always obliging members of Technical Services goes my appreciation for the professionalism with which they carried out their tasks of installing the exhibition, among whom are Roland Bernard, Calvin Franklin, and Sat Palta, Framing; and Michel Amyot, Marcel Duguay, Claude Saumure, François Hamel, Luc Jerome, Louis Poulin, and Roger West of the installation crew: all under the capable supervision of their Chief, Jacques Naud, and Laurier Marion, Art Installation Supervisor.

I extend my grateful recognition to Clive Cretney, who brought his high professional standards to the making of the copy photographs for the book, and to Colleen Evans, Picture Editor, and her assistant, Andréa Fajrajsl, for their expert attention to the details of the design and quality of the reproductions and to the processing of reproduction rights. To the book editors goes my special gratitude for their sympathetic response to my manuscript. Susan McMaster, the English Editor, was a tireless and patient collaborator whose critical comments were a positive contribution throughout the editing process. Jacques Pichette, as French Editor, deserves special praise for the patience he displayed in wrestling with the translation of my oblique prose. Many thanks to the book designers, Associés libres, for their elegant and approachable design. Finally, I am indebted to both Serge Thériault, Chief of Publications, and Jean-Guy Bergeron, Production Manager, for the grace and enthusiasm with which they saw the book through the publication process.

James Borcoman
Curator, Photographs Collection
National Gallery of Canada

INTRODUCTION

*T*hrough our images we know our dreams and aspirations. Since the invention of photography in 1839 men and women have had at their disposal a machine for making images in more profusion than was ever possible. As a result, the nineteenth century brought a revolution in visual perception and recording more far-reaching than any other in the history of humankind. Its influence is vast and its impact little understood. The photograph as a source of discovery and its potential to record the unseen and the unforeseen; its peculiar association with reality and its remarkable ability to transfer information: these distinguishing features of photography remain mysterious even today. Attempts to define the photographic image, in relation to our perceptual and psychological responses to it, have been too often limited by prejudices more concerned with what a photograph *ought* to look like than with the many and varied forms it has actually taken. For this reason, definitions of photography have been more exclusive than inclusive.

The fact that the tool used to make the photograph is a more complex machine than the pencil, the brush, or the burin has, in the past, persuaded us to divorce photography completely from the handcrafted arts and all that we expect of them. Initially, this prejudice was further reinforced by the nineteenth-century conceit of seeing the photograph as "Nature drawing her own portrait," without aid of the human hand. From the beginning there were those, however, who recognized photography's close links with long-established pictorial conventions, ones that pre-dated the birth of the new technology. They saw it simply as another artist's medium, capable of being moulded to the same concerns.

The popular belief that harmony and beauty were the only fitting subjects for art was exploded by photography. From its earliest manifestations, the mirror that photography held up to nature was uncompromising; it was no looking-glass to be used exclusively for happy faces and pretty scenes. Even Nature is sometimes disagreeable and plain, but always she is reflected in the photograph with the freshness of an actual presence.

Beyond the subject itself, the photograph possesses physical attributes whose individuality and sensuality we do not always take the time to appreciate. These, too, are peculiar to the medium. Each of the printing processes, whether salted paper, albumen silver, gelatin silver, cyanotype, bromoil, or platinum, has its special qualities of tone, colour, and line that describe surface information and form according to

their own logic. These are often used by the photographer to inform the meaning of the image. When we look at Edward Weston's *Piramide del Sol*, for example, we are not simply looking at a reproduction of a monument. We participate in an experience that involves, in addition to a record of certain details of the external world, how one individual has experienced these details, how light has been used to transform them, how camera optics and the chemistry of the medium have been used to change, enrich, and create from them a totally new object that provides us, the viewers, with an altogether new and unique experience.

Photography is the visual memory of humankind, a storehouse of information, and a witness to things that no one has ever seen or will see directly. Photographs can reflect the world, or they can reveal the photographer. More disturbing, they can reveal ourselves to ourselves. The photograph is a model for a point in time that has been selected, crystallized, and held out to us for contemplation. The ambivalent relationships that exist in a photograph between different realities – the reality of the physical world, objective reality and subjective reality, fact and fiction – stimulate, intrigue, and demand that we confront the meaning of the world in which we live. In its final challenge, the photograph forces us to take the spiritual measure of fact.

The National Gallery has been among the earliest in the museum community world-wide to recognize the many dimensions of photography. Through its exhibition program, the Gallery has been involved with the medium since 1934, when it organized the *First Canadian International Salon of Photographic Art*. Subsequent annual exhibitions included work by Margaret Bourke-White, Pierre Dubreuil, Frank Fraperie, Yousuf Karsh, Alexander Keighley, Harold Kells, and Leonard Misonne, among others. With the outbreak of war, they ceased. Although photography was shown at the Gallery following the war, most of the exhibitions were organized by other institutions. Notable exceptions were *The Art of Early Photography*, 1965, selected from the collection of Ralph Greenhill, the first serious Canadian collector of photography as an art form, and *Photography in the Twentieth Century*, 1967, chosen from the holdings of the George Eastman House. Since 1965, the Gallery has held some sixty exhibitions drawn from its own collection as well as other public and private sources.

In the spring of 1967 the National Gallery formally recognized the photograph as a collectible object and made the decision to establish a Photographs Collection. It started from nothing, although it later transpired that there were two albums from the mid-1860s by William Notman and one album of railway bridges by Alexander Henderson from 1878 in the institution's library. How and when they got there remains a mystery. A broad collecting policy soon took shape that embraced rare incunabula from the early years of photography, as well as work by living photographers. In fact, the very first purchase consisted of four prints from the 1840s by

William Henry Fox Talbot, inventor of the negative-positive process, followed immediately by eighteen platinum prints by Frederick H. Evans made around the turn of the century, and then five works by the young contemporary photographer Leslie Krims. As these acquisitions would indicate, the purpose of the new Collection was to illustrate the history of photography — specifically its history as an image-making process (or art form), not as a technical concern. Within two years, the federal government, which also funds the collections of the National Archives of Canada and the Canadian Museum of Contemporary Photography (at that time known as the National Film Board's Stills Division and now an affiliate of the National Gallery), determined a policy that gave responsibility for collecting Canadian photography to these two institutions. The National Gallery's mandate was confined essentially to the collecting of the international history of the medium from its invention to our own time.

A public collection, by its nature, demands that the needs of a varied public be served. Both the general viewer searching for personal enjoyment and the scholar requiring extensive resources for serious research must be satisfied. Therefore, in addition to breadth, emphasis has been placed upon collecting in depth. More so than do paintings, photographs tend to operate sequentially. In the length of time it takes to paint one portrait, a thousand or more photographs can be made, each showing a new facet of the subject. Where one or two photographs will tell us little of the photographer's vocabulary and concerns, a quantity will open the door to understanding.

The first purchase to establish the policy of acquiring significant bodies of work by selected photographers was that of a group of 107 photographs by Charles Nègre, one of the first generation of painters to turn to photography in the 1840s and one of the early inventors of the photogravure process. These were acquired in 1968 and have since been added to. In the next few years, large groups of work by W. H. F. Talbot, D. O. Hill and Robert Adamson, Eugène Atget, and Walker Evans were acquired, thus forming a solid historical basis for the Collection, since each of these individuals was influential in the development of the medium.

In its broad outlines, the strengths of the Photographs Collection lie partly in nineteenth-century English, French, American, German, and Middle Eastern topographical and portrait work, but also in the early contributions made by trained artists, and in clusters revolving around the art photographers from the 1890s to the Photo-Secessionists of the early twentieth century. The beginnings of social documentary photography may be traced from Hill and Adamson through the Crimean War, the second Opium War in China, and the American Civil War, the latter being represented by an important group of over 500 works; to Lewis Hine in the early decades of this century; and to the work of the Photo League and Walker Evans in the middle

years. Equally important to these strong holdings is the representation in the Collection of the modernist movement that began in the 1920s, with works by Paul Strand, Ralph Steiner, Edward Weston, and the New Vision photographers of Europe, such as Man Ray, Alexandur Rodchenko, and August Sander. The exploration of the formal and expressive potential of the medium may be seen in work from the 1940s to the 1970s in the in-depth holdings of such artists as Harry Callahan, Aaron Siskind, Lisette Model, Dave Heath, Diane Arbus, Eikoh Hosoe, Robert Frank, and Nathan Lyons; and in those of a generation of photographers from the 1970s and later, including Betty Hahn, Bea Nettles, Roger Mertin, Robert Fichter, Robert Bourdeau, Lynne Cohen, Tom Gibson, Stephen Livick, Michael Schreier, and Joel-Peter Witkin, to name only a few.

The range extends from the unassuming to the artful. At one extreme are the early topographical photographers, who made no pretense to art, but who, because of the sensitivity of their perception, produced work that transcends the original purpose and that today we find emotionally or intellectually stimulating. At the other extreme are those men and women who consider themselves as artists, and the photographs they produce as works of art.

Photographs alone are not enough, however, to meet the needs of the public in exploring the history and nature of the medium. The Collection also contains etchings, engravings, lithographs, and drawings relevant to the pre-history and early history of photography from the sixteenth century to 1925. A library of nineteenth- and twentieth-century photographic literature, both periodic and monographic, is also available for research, and includes a complete run of *Camera Work* (1904–1916), and of *Galerie contemporaine* (1876–1884). Through a collection of rare books, the history of the photograph used for illustration purposes may be traced from 1846, starting with Talbot's *Sun Sketches of Scotland*, containing original salted paper prints tipped onto its pages.

A group of handsome, historic cameras has also been assembled to enhance exhibitions and the public's understanding of both the artistic and the cultural history of photography. This includes apparatus pre-dating the invention of the medium, beginning with several examples of the *camera obscura* used by painters to help render correct perspective, and ending with equipment from the 1930s.

Today, the Collection contains over 18,000 individual images. A very small selection has been reproduced in this book to indicate the range. Each image is accompanied by an essay that suggests ways of looking at the photograph. Not all the works have been made by well-known photographers but all have been chosen because they have an ability to heighten perception, stimulate the mind, arouse emotions, or contribute to

our understanding of the nature of photography. Defining the medium itself, its essential nature, has become a burning issue in the photographic community in the second half of the twentieth century. One of the motivations stated in guiding the Gallery's collecting policy has been and is to provide a sufficient quantity of material to enable "the search for a vocabulary that would permit clear description, analysis, and communication of the complex structures of photographs: a way to gain access to the myriad visual facts, accidents, and associations that [animate] the paper's surface."[1] The development of a critical vocabulary to assist in our understanding of the photograph is still in its early years, but collections such as this must inevitably play a part in achieving such ends. The problem of meaning in photography may, in the final analysis, be too complex to unlock. But if we are to come anywhere near to understanding the nature of the art form, it will be as a result of examining the objects themselves. This, after all, is what justifies museum collections.

The most difficult problem is to learn to see.

All else is comparatively simple.

ALFRED STIEGLITZ, 1911

WILLIAM HENRY FOX TALBOT

British (Melbury, 11 February 1800 – Lacock, 17 September 1877)

Doorway at Lacock Abbey: The Ladder before April 1845

Salted paper print, 17.1 × 18.3 cm
From *The Pencil of Nature*, 1844–46, pl. 14
Purchased 1975

WILLIAM HENRY FOX TALBOT, physicist, mathematician, Assyriologist, and landowner, began in 1834 to experiment with a means of making images through a collaboration of chemistry and sunlight, unaided by the human hand. Although he announced his invention publicly in 1839, several more years were required to bring it to perfection. Photography as we know it today, based upon the negative-positive process, derives from his discoveries. Some say Talbot was more scientist than artist, some that his best photographs were made by others. What is certainly true is that the remarkable invention he brought into the world was capable of producing images that have changed forever the way we see.

Between 1844 and 1846, Talbot published installments of *The Pencil of Nature*, the world's first book to illustrate the potential of the new medium. It contained twenty-four salted paper prints laid onto the page; *Doorway at Lacock Abbey: The Ladder* is plate number 14. Ostensibly included as an example of group portraiture, it is Talbot's most enigmatic photograph. Although we know the scene was posed, the interaction between the three men raises intriguing but unanswerable questions about their activities and their relationship. The coat lying in a heap beneath the vine, because it appears to have been so carelessly discarded, stirs the imagination to further speculation.

Talbot's commentary accompanying the photograph stresses the advantage of his invention over the handmade portrait: "Groups of figures take no longer time to obtain than single figures would require, since the camera depicts them all at once, however numerous they may be." A more radical thought occurred to him: from now on, future generations would know what their ancestors actually looked like.

But *The Ladder* reveals even more of photography's potential. We are impressed by the sunniness of the scene, and by the manner in which light models the forms of the men, brings to life the flaming movement of the vines, and renders tactile the surfaces of stone and wood. We are witnessing here an extraordinary union between the textures of the real world and the materials of a process – in this example, the fibres of both Talbot's paper negative and the positive print coated with silver salts. Light is the catalyst in a physical as well as an aesthetic sense. For light is the photographer's principal tool, transforming the mundane into the poetic.

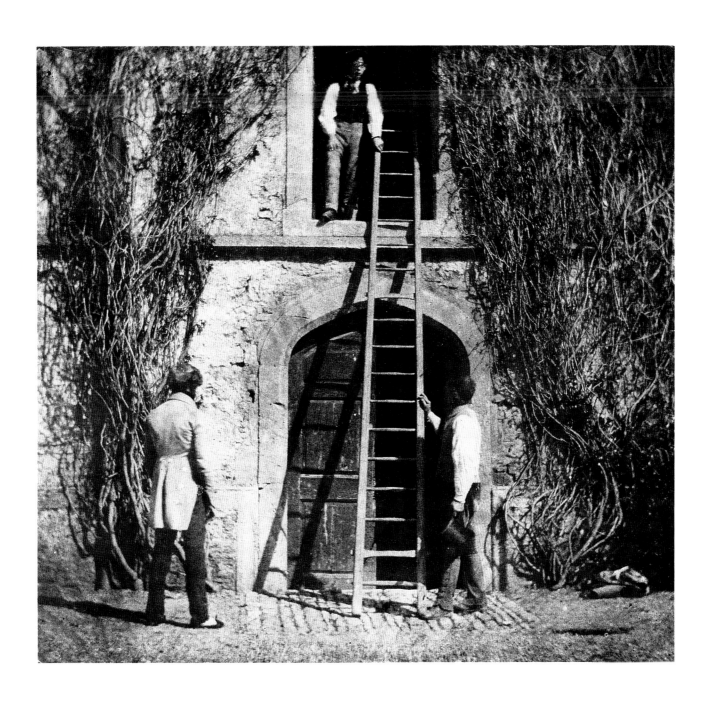

Jean-Gabriel Eynard-Lullin

Swiss (Lyons, 28 December 1775 – Geneva?, 5 February 1863)

Self-Portrait with Wife under the Trees 1843 or earlier

Daguerreotype, 10 × 14.7 cm

Gift of Phyllis Lambert, 1988

ALTHOUGH NO ONE PERSON CAN BE CREDITED with the discovery of photography, the French inventor Nicéphore Niepce produced the earliest extant photographic image in 1827. Primitive, indistinct, and quite unsuccessful, this first image nevertheless encouraged Louis Jacques Mandé Daguerre, who claimed to be working along similar lines, to become Niepce's partner in 1829. Only after the latter's death did Daguerre bring the experiments to a successful conclusion, although in a direction quite different from that advocated by Niepce. Success was achieved more through accident, determination, and good luck than through knowledge, for Daguerre was no scientist. It is appropriate, however, that the man who accomplished this feat was a meticulously realistic painter.

Daguerre and the Englishman William Henry Fox Talbot became rivals. Announcing his process, which he named after himself, to the press on 6 January 1839, a week before Talbot's declaration, Daguerre did not however disclose its details until 19 August 1939, after the French government had purchased his invention with a life-long pension. The daguerreotype process, using a silver-coated copper plate made light-sensitive with iodine fumes and developed with mercury vapour, produced a unique image, one that cannot be repeated except by rephotographing the original plate. The image we see is the one that was exposed in the camera. Its surface is fragile, for the mercury powder may be rubbed off all too easily. (Typically, therefore, plates were protected with careful packaging.) Special viewing conditions are required for daguerreotypes because the shadows in the image are nothing more than the polished silver surface of the plate. The angle of lighting must be such that these areas will appear dark to the eye.

The daguerreotype, with its jewel-like quality, its minute tonal gradations, its precise attention to infinite detail, and its truth to nature, was an instant success with the public. Amateurs and artists throughout Europe hastened to become daguerreotypists. The enthusiasm surrounding the daguerreotype in its first year amounted almost to a mania, if one is to believe the biting humour of satirists of the day. Jean-Gabriel Eynard-Lullin, a wealthy banker reputed to be the first Swiss amateur daguerreotypist, made his first plates in 1839. The Parisian optician and early camera-maker, N. M. P. Lerebours, described Eynard's daguerreotypes in 1843 as "amongst the most beautiful proofs we have ever seen…"[1]

Shown with his wife under a bower of trees, this self-portrait may serve as a family souvenir, but, at another level, Eynard has gone right to the core of one of the themes of nineteenth-century romanticism, the dialogue between nature and humankind. Romanticism was in its high summer when he made this plate, and its energies pervaded the spirit of the times. In his photograph, "The shadow-casting race of trees" lift their foliaged heads "in cloud-like majesty."[2] Had Eynard known these lines from William Wordsworth's "Vernal Ode," he might have recognized a kindred soul. Modulated by the texture of thousands of glinting leaves, his daguerreotype gives us an image of humanity sheltering in peaceful union at the heart of nature's immensity.

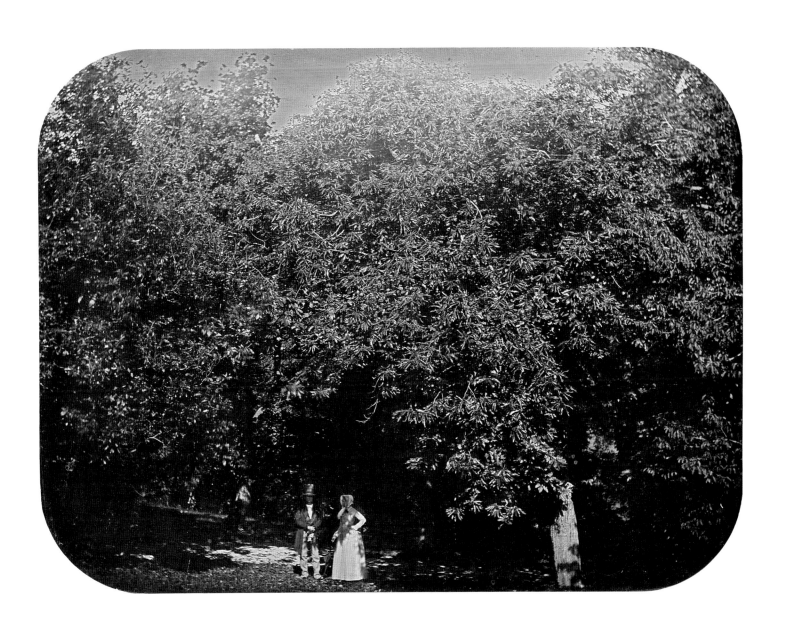

DAVID OCTAVIUS HILL

British (Perth, 1802 – Edinburgh, 17 May 1870)

ROBERT ADAMSON

British (Saint Andrews, 26 April 1821 – Saint Andrews, 14 January 1848)

Henry Dunlop, Lord Provost of Glasgow probably 1843

Salted paper print, 20.5 × 14.7 cm
Purchased 1977

AN EMPHASIS OF LIGHT UPON THE HEAD AND HANDS, in a setting markedly plain – this describes the portrait tradition of such Scottish painters as George Romney and Henry Raeburn to which David Octavius Hill and Robert Adamson were heirs. Its purpose was partly to enliven the surface of the picture but also to serve a symbolic end. The broad planes of the face in *Henry Dunlop* suggest a strong, rugged character. Concentration of the brightest highlight on the forehead creates a luminous, heroic brow. Dunlop's great dome becomes a symbol of power. In an 1843 essay on photography, *The Edinburgh Review* described the impact of this pictorial device on the Victorian psyche: "The picture is connected with its prototype by sensibilities peculiarly touching. It was the very light which radiated from his brow…that pencilled the cherished image, and fixed themselves forever there."[1]

That Hill should have begun as a landscape painter, and not an especially gifted one at that, and yet through his photographic portraits created "the last blooming of the broadest artistic development the land had ever known,"[2] is ironic. For he was not and never had been a portrait painter. What led him to this venture was the founding of the Free Church of Scotland in Edinburgh, May 1843, when almost 500 delegates met to sign the Act of Separation from the established church. Hill was so moved that he vowed to make a huge commemorative painting showing all the signatories. Convinced that photography would be the quickest way of amassing likenesses as sketches for the painting, he formed a partnership with Robert Adamson, a young chemist trained in W. H. F. Talbot's new process. The portrait of Henry Dunlop is one of these. But this was only the beginning. In the almost five years their studio existed, Hill and Adamson produced hundreds of portraits of Edinburgh society, including almost every famous visitor to the city. As well, they made architectural views and what might be called the first social documentary use of the medium: their photographs of the Newhaven fisherfolk.

Talbot's process appealed to Hill because of the way the paper negative combined with the matte surface of the salted paper print to suppress surface information, permitting him to see his subjects in terms of the masses of light and shade that formed his vision as a painter. Since the eighteenth century, theorists had held that a picture was based on broad areas of light and dark in opposition to each other as a means of directing attention to the principal parts of the composition and establishing the mood. This technique of animating the picture's surface was called the pictorial effect. The paper negative easily permitted handwork (pencil shading or the use of an opaquing fluid such as India ink), allowing Hill to enhance the effect, for Talbot's process was not always successful in creating the desired intensities of light and dark. Dunlop's head, hands, and shirt show signs of work on the negative to brighten the highlights.

Twenty years of effort on the Separation painting produced an abysmal, artistic failure, but Hill and Adamson's photographs endure as the most successful artistic accomplishment of the new medium's first decade.

HERMANN CARL EDUARD BIEWEND

German (Rottehütte, Hanover, 28 August 1814 – Hamburg, 31 December 1888)

Helene with Her Friend Emily Frömke in the Garden 1846

Daguerreotype, 7.8 × 6.3 cm

Gift of Phyllis Lambert, 1988

EDUARD BIEWEND WAS A SCIENTIST, metallurgist, Assay Master, and Master of the Mint for the Bank of Hamburg from September 1843 until his retirement in 1876. Like a number of well-educated and affluent individuals of the time, he was also an amateur daguerreotypist, having begun to photograph at least as early as 1846. He was one of the few Germans to photograph landscapes and architecture as well as people. There is reason to believe that Biewend may have collaborated with P. F. Voigtländer, the Viennese optician and camera-maker, in testing lenses. Although Daguerre made his invention public in 1839, portraits did not become practical until 1841. In the beginning, exposures were too long – anywhere from five to twenty minutes. But with improvements that increased the sensitivity of the silver iodide plates, and the new rapid lenses made by Voigtländer, exposures in full sunshine could be made in one to four seconds.

Although slow in establishing itself because of the initial long exposure times, portraiture eventually became the dominant occupation of daguerreotypists. Millions of portraits were made in the 1840s and 1850s, before the process became outmoded by 1860. The vast majority of these were made in studios under formal conditions, often using headclamps to keep the sitter rigidly still. It is unusual, therefore, to find a daguerreotype portrait made out-of-doors, with the sitters showing the casual pose that we see in Biewend's portrait of his wife Helene (seated at the right) and her friend Emily in the garden. Biewend often photographed his family and friends under such circumstances, suggesting that perhaps he was testing the limits of the daguerreotype process. But this image also comes from a much earlier portrait tradition in painting known as the conversation piece. Popular in the eighteenth and nineteenth centuries, the conversation piece depicted couples, friends, or family groups occupied in some domestic routine – conversing, playing games, reading, or performing music. Biewend's portrait fulfils the requirements of the conversation piece, but adds a vitality that is missing in such paintings because of their formal and idealized compositions, and unexpected in the daguerreotype because the lengthy exposure times generally resulted in poses of a stiff formality. The snapshot-like spontaneity that animates Biewend's portrait has a surprisingly modern flavour.

Like the scientist he was, Biewend usually recorded detailed information on the reverse of his daguerreotypes, including date, time of day, weather and exposure. In one instance, however, he showed a more human side, when he also noted the comment of his favourite sitter, his wife: "I am angry with you because you do not like my pose, but I love you anyway."

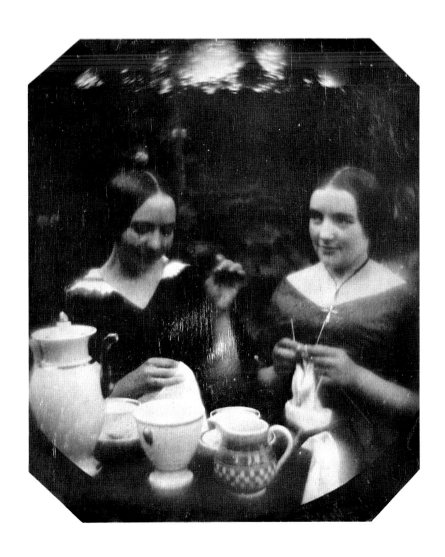

GIACOMO CANEVA

Italian (Venice, 1810 – Rome, 1890)

Entrance to a Church c. 1850

Salted paper print, 20.8 × 16 cm
Purchased 1982

LADDERS OFTEN APPEAR IN EARLY PHOTOGRAPHS. We wonder why, to which the simple answer would be that the nineteenth century busied itself much with construction. To stop there, however, would take the speculation out of art, an activity that is one of its most rewarding pleasures. If Giacomo Caneva's purpose was only to record a construction project, this photograph is singularly uninformative. More likely he was struck by the beauty of the portal itself – its architectural ornamentation and the manner of its rendering by sunlight and shadow – and the ladders were incidental. Their presence, however, lurking in the shadows of the doorway, lifts this photograph out of the ordinary by suggesting a mystery. For the photographer, the world is full of signs waiting to be read. Whether the inclusion of the ladders is incidental or not, we wonder about their meaning. A ladder may symbolize upward striving. In this context, the image of the "ladder to heaven" might seem appropriate; in scenes of the crucifixion in Christian painting, the symbol is associated also with the descent from the cross. At the very least, the ladders here are a haunting trace of human activity.

Caneva was born in Venice, studied painting in Padua, and, in 1838, moved to Rome. Although his involvement in photography began with the daguerreotype, by 1847 he was making calotypes, that is to say, paper negatives, and photographing Rome's historic monuments and the sculptures in the Vatican Museum. Not content with this, he became an amateur balloonist. From 1850 to 1852, he was a member of the Rome Photographic Circle, along with Count Flachéron and Eugène Constant, all early enthusiasts of the paper process. At the end of this period, Caneva opened a studio and became one of Rome's most financially successful suppliers of topographical photographs. In 1855 he published a practical treatise on photography.

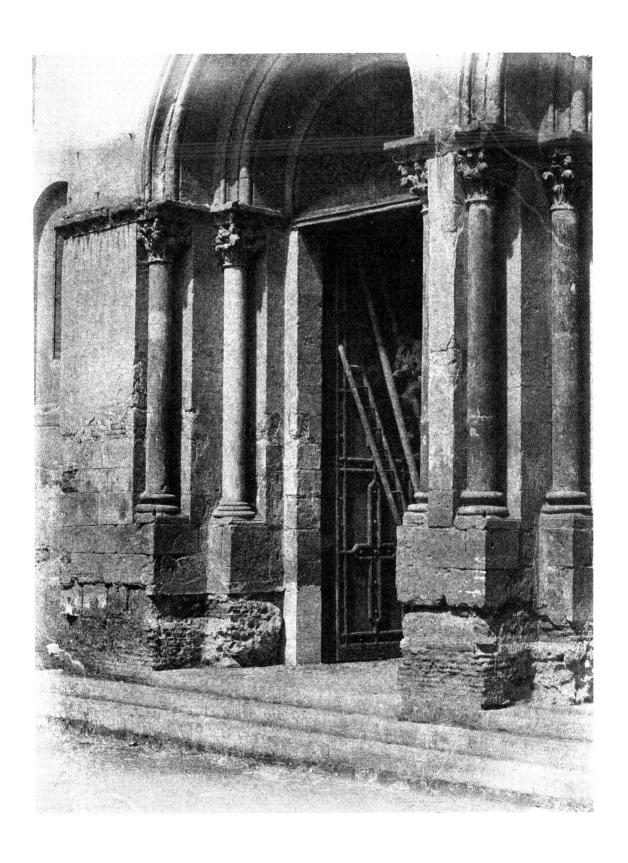

FÉLIX JACQUES A. MOULIN

French (Paris, c. 1800 – Paris?, after 1875)

Académie c. 1845

Daguerreotype, 7.2 × 5.6 cm
Gift of Phyllis Lambert, 1988

FROM ITS BEGINNING, photography was recognized as a useful source of information for painters and sculptors. Studies of the nude figure, known in France as *académies*, a term applied to all such studies in any medium, were produced by photographers for artists as a substitute for the live model. They soon appealed to a larger market, however. Paris, often more adventurous than other places in its exploration of the new invention, appears to have been the centre for such photographs. F. Jacques Moulin began as a daguerreotypist specializing in erotica in the 1840s, although he also went on to produce other kinds of genre scenes posed in the studio, as well as landscapes, topographical views of Algeria, and stereographs, and eventually images using the paper and glass processes of the 1850s. He operated a studio at 31 Faubourg-Montmartre, in Paris, with the help of his wife and daughter. The first photographer to register nude studies with the Legal Deposit at the National Archives, Paris, in 1853, Moulin was praised by the critics for the artistic quality of his work.

Nude studies were far less common as daguerreotype themes than portraits, but they provided the photographer with an opportunity to relate directly to well established art motifs. Although acceptable in painting and sculpture, the nude was frowned upon in photography because of both the stark realism and the reputed immorality of those who posed for and indulged in the genre. Moulin, whose reputation was made by such work, produced this *académie* filled with artistic devices designed to make it palatable to those of tender sensibilities: a classical, Italianate landscape as the studio background, the coy pose of the bather who has shed her clothing and is about to enter the pool, and the reference to a biblical Susanna at her bath, which sanctified the whole. That the clothing, an elaborate still life in its own right, should be Victorian, no doubt added a further piquancy for nineteenth-century viewers.

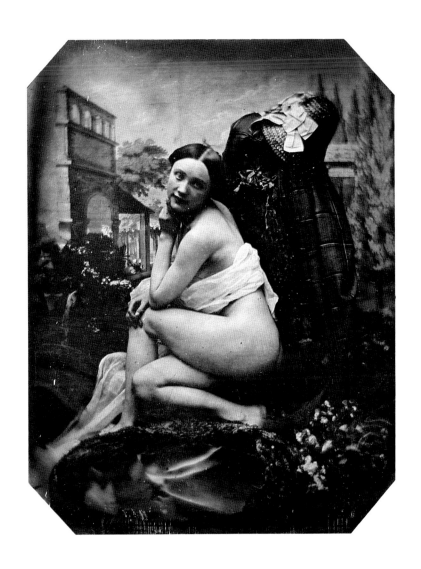

HUGH OWEN

British (1804 – 1881)

Camel Gun September 1851

Salted paper print, 17.5 × 22 cm
Purchased 1990

PHOTOGRAPHS HAVE THE ABILITY TO ENDOW commonplace objects with more significance than we might initially suppose them to have. This is partly because a moment in time is presented to us for contemplation at our leisure. It is also because the camera has an infallible way of concentrating our attention by isolating objects from the clutter that often surrounds them. How a visitor to the Exhibition of the Works of Industry of All Nations in 1851 would have responded to the actual camel gun, a technical marvel of mid-nineteenth century warfare which we see in Hugh Owen's photograph, is not readily discernible. No doubt with some awe. We, too, from our vantage point of over 140 years later, may respond with wonder, but for different reasons. The simple, crude ingenuity of such an ungainly device, together with its elaborate and fanciful decoration, casts warfare in an absurd new light. And what of the camel's ears? The photographer has given the gun and its saddle mount a special presence. The manner in which these objects emerge from the shadowy depths of the salted paper enhances their strangeness, even mystery. The drawing – if we may use the term – has both a precision and a softness that emphasizes the brutish appearance of the weapon and at the same time its primitive, antique character. Perhaps the antique effect is reinforced by the vignetting, a product of the passage of time resulting in edge fading. The most common cause of such image destruction in nineteenth century photographs appears to be the action upon silver salts of certain types of adhesives used to attach a print to its mount.

Apart from the fact that he was one of twelve members who founded the Calotype Club – the first photographic society to be formed in England – in 1847, Hugh Owen's impact upon the early history of photography appears to have been minimal. The body of work for which he is best remembered consists of the photographs made for the Executive Committee of the Great Exhibition of 1851, held at the Crystal Palace in London. He and a French photographer, C. M. Ferrier, were commissioned to make 155 photographs as illustrations for the presentation copies of the *Reports by the Juries*. The prints from Owen's paper negatives were made in 130 copies each by Nikolas Henneman using W. H. F. Talbot's salted paper process. As the first attempt to employ photography to document the contents of an exhibition, the event is a landmark for both the history of photography and the publication of exhibition catalogues. Although photography had been included in the Paris exhibitions of 1844 and 1849, the Crystal Palace exhibition contained the largest display thus far, with upwards of 700 photographs from six nations. The jury reports contain a perceptive comment on the dialectic nature of the medium, referring to the manner in which photography links "together the known and the unknown."[1]

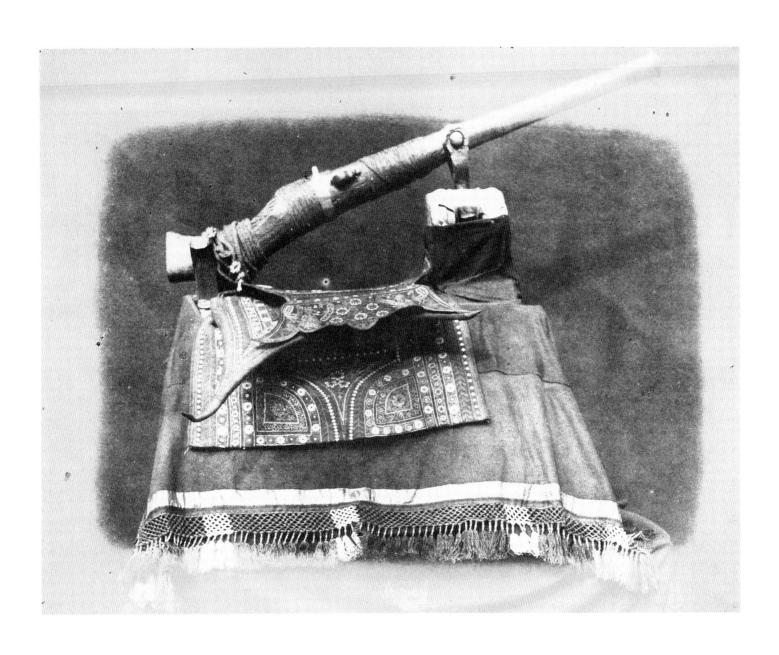

UNKNOWN PHOTOGRAPHER

American? (mid-nineteenth century)

Horses and Sleigh in Front of a Bank c. 1845

Daguerreotype, 8.8 × 11.8 cm
Purchased from the Ralph Greenhill Collection, 1972

THERE IS IN THE DAGUERREOTYPE PROCESS an inherent technical problem that sometimes produces a happy result. Because the plate is overly sensitive to blue light as well as to bright white, overexposure may result, thus causing a reversal of tone known as solarization, with a peculiar introduction of a touch of colour, seen here in an example by an unknown daguerreotypist. The snow in the foreground is most heavily affected with a lilac blue, while that in the distance has a paler tint. Curiously, the picket fence retains, by contrast, a creamy white tone. Sitters were cautioned not to wear white when posing for a daguerreotype in order to avoid solarization of the image. The blue in *Horses and Sleigh in Front of a Bank* nicely adds a dimension to the texture of the snow and increases the sombre mood of a grey, shadowless day.

Another problem of the process may be seen in the bank's sign: it is backwards, as though viewed in a mirror. This lateral reversal occurs because the daguerreotype is a direct positive, the product of rays of light being shifted to opposite sides while passing through the camera lens. When desired, daguerreotypists would correct this either by making a daguerreotype copy of the original plate, thus placing things back in their original order, or by using a reversing prism in front of the lens.

Images such as this give us cause to reflect upon their making. Here we have no spontaneous snapshot taken on the spur of the moment, for the daguerreotypist has gone to the trouble of mounting the camera on an upper level of the building opposite the bank, while someone holds the horses steady for the duration of the exposure, and two employees of the bank gaze fixedly at the event from their window. Are we in the presence of a gentleman proudly posing with his new cutter, perhaps the one who turns his head to look at the camera? Maybe he is even the owner of the bank. Whatever the purpose, the photographer has given us an image with a feeling for space, for the rhythm of verticals, and for the balance between the heavy symmetry of the bank building and the delicate, slanting line of the men, horses, and sleigh, resulting in an image of grace and charm, which also, perhaps, gives us an insight into a vanity of the Victorian era.

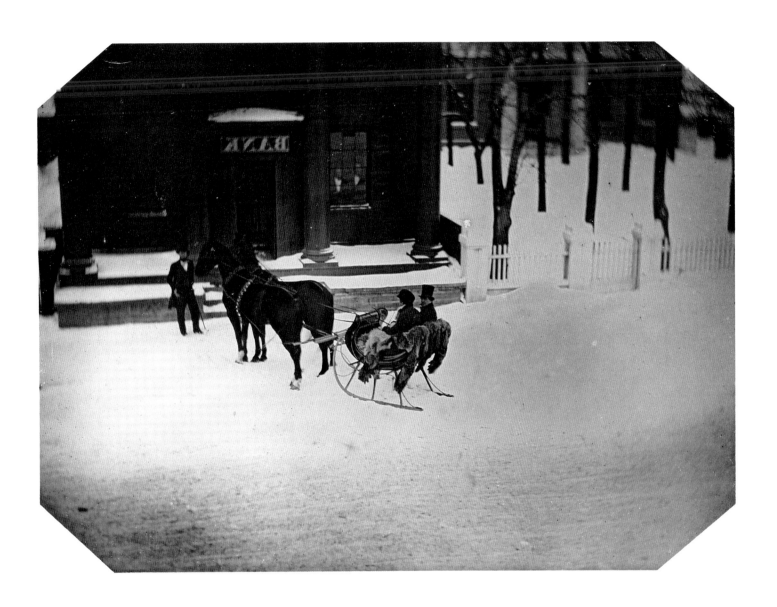

CHARLES NÈGRE

French (Grasse, 9 May 1820 – Grasse, 16 January 1880)

Chimney Sweeps Walking autumn 1851

Salted paper print, 15.2 x 19.8 cm

Purchased 1968

NOWHERE ELSE IN THE WORLD were so many artists testing the scope of photography in the 1850s as in France. Their spirit of adventure is summed up in the work of Charles Nègre. His instantaneous market scenes, studies of street trades and road workers, archeological views of the Midi and Paris, nude studies, portraits, photogravures using his own patented process – all show the inventiveness of the best of that generation.

Nègre arrived in Paris in 1839 to study history painting with Paul Delaroche, reputed to be the most talented artist of the day. It was a propitious time for picture-makers. Daguerre and Talbot each announced their new photographic processes in that year. Even more fortunately for Nègre, Delaroche was the artist who sat on the government commission to determine the worth of Daguerre's invention. Daguerreotypes, he declared, were objects worthy "of observation and study for painters."[1]

Thus encouraged, Nègre began making daguerreotypes around 1844, moving on to paper photographs by 1849 at the latest. At first, he produced them as aids to painting and even as a means of copying his own paintings. One work, shown in the 1853 Paris Salon (where he first exhibited in 1843, and won a medal in 1850), was a painting over a photograph, a device that passed unnoticed by critics, who praised the "painting's" realism.

By 1851, Nègre was exploring other possibilities for the medium – to the astonishment of art critics. One such, writing in May 1852, praised *Chimney Sweeps Walking,* comparing it to a Rembrandt drawing and the paintings of Murillo: "There they go, these sombre birds of winter, throwing to the icy blast their monotonous cry that announces the hard season, just as the swallow's call is the joyful signal of spring. Their sacks on their backs, limbs shivering beneath their rags…"[2]

Chimney Sweeps Walking displays concerns found throughout Nègre's work. The photograph comes from a series made in 1851 along the quays in Paris. In these, the first of their kind, he used his camera to extend the painter's vision in a search for visual information on human activities, and, more specifically, for studies of motion. Here, however, the sweeps have been posed to simulate movement. The subject matter itself comes from an earlier tradition among painters, that of depicting the street trades of Paris as romantically picturesque. Nègre was the earliest of the street photographers.

If critics were able to claim that Nègre's photographs were the equal of pictures made by hand, it was partly because he drew upon his training in the painter's use of the general effect (broad masses of light and dark areas used to establish the thrust of the composition and the mood). In this instance, pencil shading on the negative suppresses background information to enhance the atmospheric perspective, and animates the surface of the print by strengthening the highlights on the parapet and the men's caps. The salted paper print revels in the sensuous sheen of light on the stone work and in the vaporous quality of the distant background. Although this photograph was likely intended as a study for a painting, the fact that Nègre signed the print suggests he also recognized it as a finished picture in its own right.

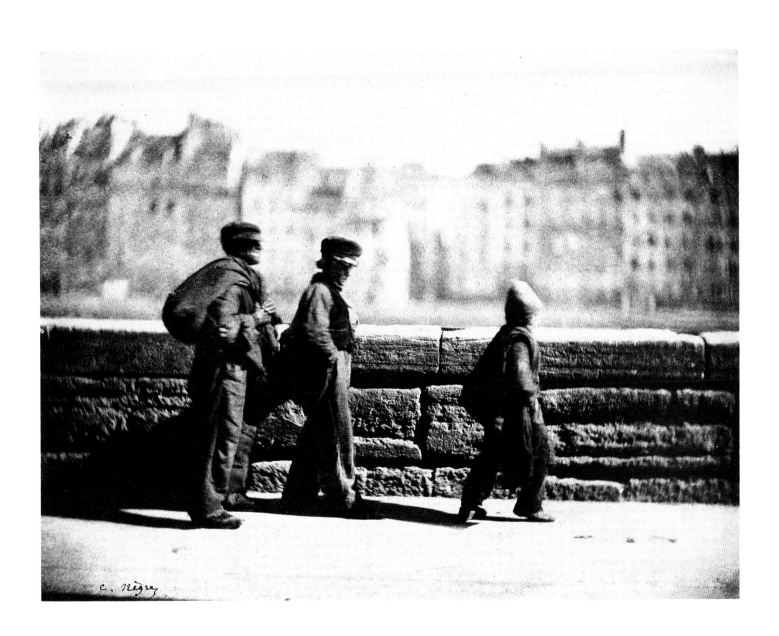

MAXIME DU CAMP

French (Paris, 8 February 1822 – Baden-Baden, Germany, 9 February 1894)

East Side of the Peristyle of the Palace of Ramses-Méiamoun, Medinet Habu, Thebes 1850

Salted paper print, 21 × 15.5 cm
From *Égypte, Nubie, Palestine et Syrie,* 1852, pl. 51
Purchased 1971

ALL LANGUAGES, WHETHER VERBAL OR VISUAL, have their own rules of grammar, syntax, and logic. Within the visual arts, by the mid-nineteenth century, strict attitudes toward such elements as scale, foreshortening, overlapping, composition, and perspective had been established. The rules fixed the proper connection between foreground, middleground, and background. They established the functions of negative and positive space and their relationship to the picture plane. Evolved over centuries, the rules created a firmly established set of visual hierarchies that ordained what a picture should look like.

In the space of a few short years, the camera destroyed this elaborate structure and challenged the viewer with a new set of visual priorities. Among other things, the camera discovered the world was layered in a way far different from the formulas of the painter and the printmaker. Overlapping of objects and boundaries in the photograph created startling and arbitrary relationships responsible for initiating a new pictorial logic. How odd must Maxime Du Camp's *East Side of the Peristyle* have appeared to his contemporaries, although it is only one example among many from the early years of photography in which traditional pictorial relationships are radically assaulted by camera optics and the tonal scale of photographic paper. No trained artist would have produced an image with so many visual enigmas. The blunt foreshortening of the foreground, tied as it is to the dark frame at the right and to the bottom of the image with black impenetrable shadows, is a graphic artist's dream, but it is in strange contrast to the background with its appearance of being a collage of flat spaces. How are we to explain the human figure on the column right of centre? Du Camp frequently posed one of his bearers in his photographs to establish scale, but here we are left more confused than enlightened. Is the rectangular view in the central dark space a receding or advancing form? *East Side of the Peristyle* contains the seeds of a new language, modern in its ambiguities and the questions it raises about reality.

Poet, novelist, journalist, traveller, and critic, Du Camp appears to have spent some time studying painting, although he was never a professional artist. In October 1849, with his novelist friend Gustave Flaubert, he set sail for a two-year voyage through Egypt, Nubia, Palestine, and Syria, visiting the famous archaeological monuments so dear to the hearts of the nineteenth-century French. Before leaving, he took a few lessons in photography from Gustave Le Gray. The record of their travels was published in a handsome album beginning in June 1852, containing 125 photographs printed by Louis-Désiré Blanquart-Évrard of Lille from Du Camp's paper negatives. The publication, the first archaeological study illustrated exclusively with photographs, was hailed by critic Louis de Cormenin as "one of the most notable works of art to be produced in a long time,"[1] and an example of how photography could be used to supplement museum collections. De Cormenin claimed that Du Camp's success lay in the fact that he was not a photographer. France immediately made him an Officer of the Legion of Honour. Ironically, he never photographed again.

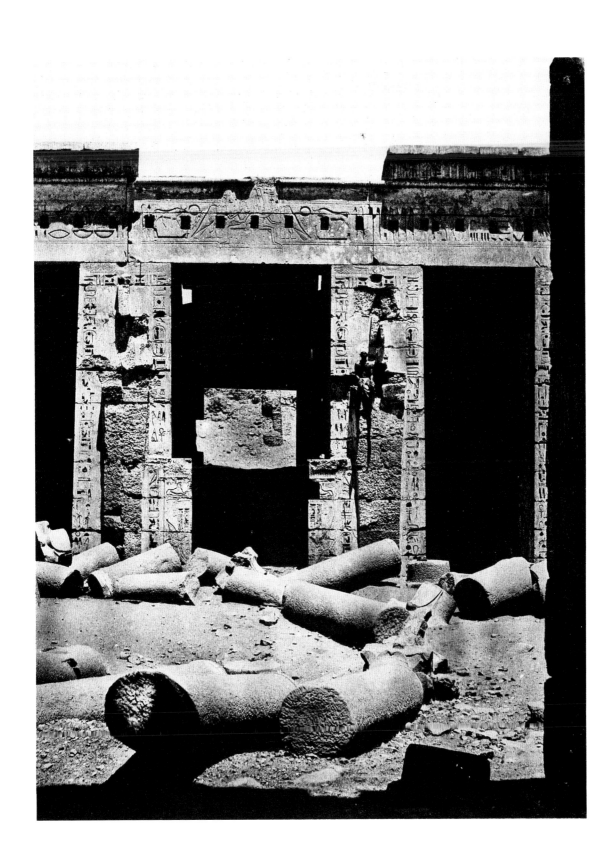

CHARLES MARVILLE, attributed to

French (18 July 1816 – Paris, 1879?)

Pont de la Réforme and the Quai des Ormes, Paris 1851

Salted paper print, 14.9 × 20.7 cm
Purchased 1972

THIS VIEW OF THE PONT DE LA RÉFORME appeared in *Mélanges photographiques,* an album of photographs published serially by Louis-Désiré Blanquart-Évrard beginning in 1851. The bridge began life in 1833 as the Pont Louis-Philippe, after the King of France, was renamed Pont de la Réforme in 1842, and returned to its original designation in 1852. An early example of a suspension bridge, it was an engineering marvel of its time, but it no longer exists in its original form. Engineers now may wonder about the exact design of its suspension chains or cables, however the combination of a paper negative and salted paper print has resulted in the suppression of such detail. But therein lies part of the photograph's charm. Such sacrifice of detail in favour of the broad effect provided the qualities that art critics of the 1850s found attractive. The emphasis upon tone, which allows the image to evolve from shadows, offers a graphic quality that lends solid structural support to the composition. Surface textures of stone, water, and sand blend together in harmony. Photographs of this period made in public places are usually devoid of people because the lengthy exposure times did not record the moving figure; the little group on the far shore is so indistinct as to be insignificant. Our attention, however, is engaged by the boats drawn onto the embankment. It is here that human beings have left a poignant reminder of themselves.

Blanquart-Évrard, a wealthy merchant, chemist, and miniaturist, had modified W. H. F. Talbot's photographic process by 1846 and made it practical enough to allow him to open a photographic printing establishment at Lille in 1851 using assembly-line techniques. As well as printing for other photographers, he published a series of portfolios over the next five years aimed at artists, art collectors, and antiquarians, and intended both to prove that photographs could be mass-produced and to show the variety of their uses. The portfolios included paintings, sculpture, historic monuments, and topographical views.

Blanquart-Évrard contracted with a number of photographers to make the negatives from which he produced prints for publication. Marville may have been his most prolific contributor, an artist whose production up until then had been limited to a few lithographs in publications including *La propagande socialiste* between 1848 and 1850. His earliest known photographs appear in Blanquart-Évrard's portfolios, beginning in September 1851. Eventually Marville opened his own firm, becoming the official photographer for the city of Paris, a duty that involved photographing the medieval quarters of the city a jump ahead of Baron Haussmann's wrecking crews as they made way for the big boulevards. Although chiefly known for this documentation, begun around 1856, for which he used glass negatives and albumen prints, it is in his early work for Blanquart-Évrard that we find a special appeal, perhaps, if only partially, for his use of the paper negative and salted paper process.

Of the sixty-three plates in *Mélanges photographiques,* nine have been identified as being by Marville; others, including *Pont de la Réforme,* are unsigned, a problem challenging the connoisseur and historian alike. Although not conclusive, the framing of the subject, the point of view, and the image structure all strongly support an attribution to Marville. Lacking the idiosyncratic movements of the hand as they may be traced in painting or drawing, the answers to such questions where photographs are concerned are often more elusive.

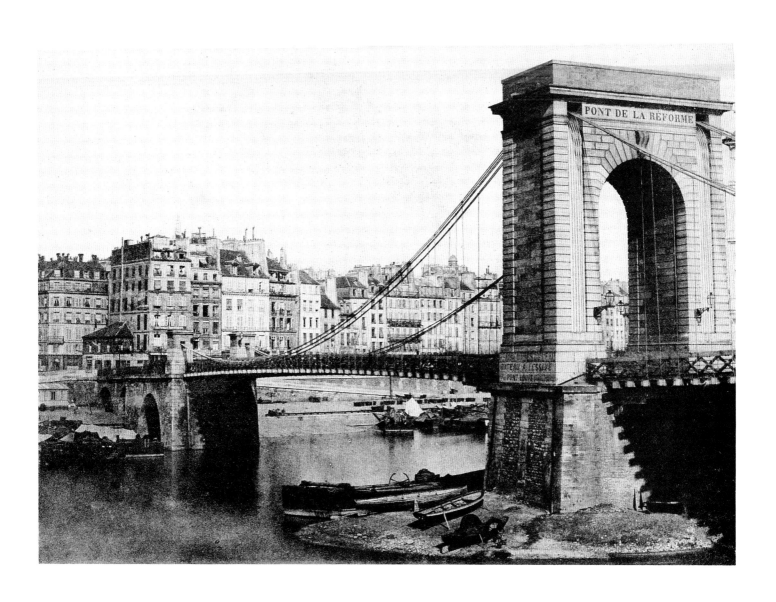

UNKNOWN PHOTOGRAPHER

American (mid-nineteenth century)

Youth with Freckles c. 1850

Daguerreotype, 9 × 7.1 cm
Gift of Phyllis Lambert, 1988

ACCORDING TO NINETEENTH-CENTURY BRITISH ART CRITIC JOHN RUSKIN, "The greatest thing a human soul ever does in this world is to see something, and tell what it saw in a plain way."[1] The daguerreotype set a standard for plain seeing. Although a French invention, the first commercial portrait studio for making daguerreotypes was opened in New York by Woolcott and Johnson in March 1840. But the problem of slow exposures (anywhere from five to twenty minutes) delayed its success. Indeed, for the first year or so, sitting perfectly still to have one's portrait made was an excruciating torture. Eventually technical improvements reduced exposure times to a few seconds. Portraits soon became the dominant occupation for daguerreotypists. Millions of the little images were made in the 1840s and 1850s, thus fulfilling the worst fears of the portrait painters and the miniaturists.

The unknown daguerreotypist who made this portrait of a young man has shown exceptional feeling for the characteristics of the process by making an extraordinarily convincing likeness. Most daguerreotype portraits are full- or half-length; seldom do they show such daring concentration upon the close-up. Each strand of hair, each freckle has been rendered so lovingly and with such precision and polish that we are utterly persuaded of the truth of the portrait – we find ourselves in awe of the sitter's individuality and we marvel at his beauty. The pose is unusual for another reason, too. In this instance, the daguerreotypist has not only understood the value of such close observation, but he or she has recognized that the profile was the perfect point of view for representing this sitter's distinctive features. Fortunately for us, the photographer did not follow the advice of one photography manual to obliterate the freckles "by smartly rubbing the whole face immediately before the sitting, with a soft scarlet flannel cloth…or even the bare hand; the result of which is a glowing flush upon the surface."[2]

The daguerreotype was the product of a 400-year search for verisimilitude. The trend to realism that developed in portraiture out of a detailed observation of the world in the early fifteenth century is the result of two kinds of vision, one concerned to render the surface of things, the other to capture the inner person. The debate that raged between painters and daguerreotypists in the mid-nineteenth century resolved itself into an argument between these two polarities. No mere mechanical process could render the soul of a human being, said the painters. And yet, it was the photograph that eventually confirmed the artist's faith in reality. The camera lens slices through reality's veneer to an unyielding truth beneath, but does so, ironically, by stressing the value of surface. As the nineteenth century Munich painter Wilhelm Leibl once proclaimed, "Man should be painted as he is, the soul is included anyway."[3]

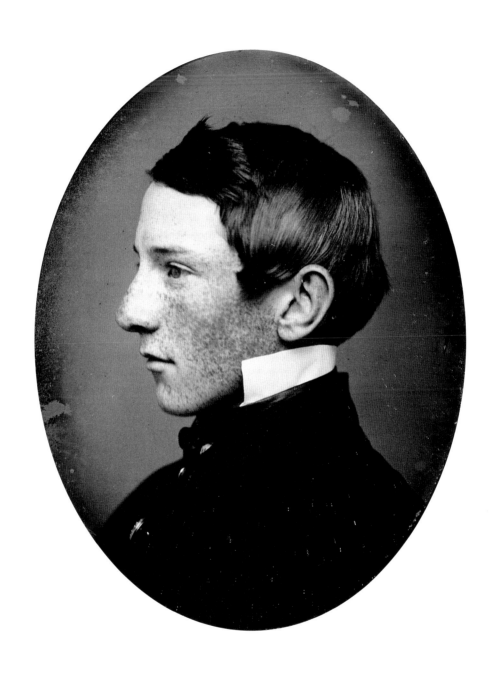

A. LE BLONDEL

French (active Lille, c. 1842 – c. 1870)

Wine Drinkers c. 1852

Salted paper print, 12.7 × 10.6 cm
Purchased with the Phyllis Lambert Fund, 1983

WE HAVE ONLY TO THINK OF THE DUTCH SCHOOL of genre painting with its "low life" scenes of smokers and topers to realize the origins of Le Blondel's *Wine Drinkers*. Closer to home were the seventeenth century Le Nain brothers and their homey scenes of French peasant life. The nineteenth century, with its appetite for realism, saw a flowering of genre painting. Because of its close link with fact, photography would appear to be a natural medium for this class of picture-making. Genre photography, both for its own sake as well as for its use as source material for painters, was highly regarded by the critics during the 1850s. Yet, relatively little work of this nature was produced or has survived. Not until fast shutter speeds and more sensitive negative emulsions become available do we find the camera searching out what many have come to feel is its natural element.

For Le Blondel and his contemporaries, exposure times were slow enough to require that such scenes be posed. Perhaps the inherent theatricality of these images, seen to be antithetical to photography, made them less popular with the public. Le Blondel's little study of conviviality follows certain requirements of French genre painting: the representation of persons thoroughly absorbed in their own actions or thoughts as though no viewer were present, and the convention of having at least one figure establish a relationship with the viewer through a direct glance, thus creating a paradox in the fiction. Although Le Blondel may have added nothing to painting of this kind, in *Wine Drinkers* he has achieved, nonetheless, a quality of intimacy and a mood of reflection that is admirable.

Little is known of Le Blondel, other than that he worked in Lille. No references are made to him in the standard histories of photography, yet he was of sufficient standing in his own day to have been included in the prestigious exhibitions of the Société française de photographie between 1857 and 1861. In fact, one critic singled him out for the quality of his architectural views, portraits, studies of animals, genre images, and activities in the street. Because the 1857 exhibition included a group of his daguerreotypes, we may assume that his photographic beginnings occurred with this process in the 1840s, when it was the dominant means of making photographs. His name disappears from the literature after 1861.

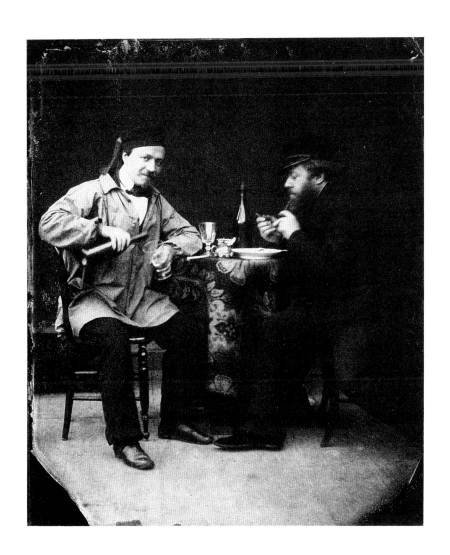

UNKNOWN PHOTOGRAPHER

American (mid-nineteenth century)

Two New Houses c. 1850

Daguerreotype, 8.8 × 12 cm
Purchased 1981

ALTHOUGH THE DAGUERREOTYPE WAS A FRENCH INVENTION, Americans soon became adept practitioners. Within a few years, they were taking most of the prizes at international exhibitions for their technical perfection. The daguerreotype dominated photographic production in the United States for two decades, thus laying the foundation for an American photographic aesthetic that emphasized the uniqueness of the medium: an unqualified objectivity, a prodigious subtlety of detail, a clarity of definition, and an exquisite delicacy of tonal gradation. From the beginning, Americans exploited, and accepted without question, the miraculous machine-like precision of the daguerreotype, with its wealth of information spread uniformly across the surface of the plate. Unlike their European counterparts, American artists, photographers, and critics did not debate the virtues of the daguerreotype versus those of the paper negative and the salted paper print. The ability of the latter to suppress surface information in favour of form, thus emphasizing the broad effect and the drama of light and shadow, was never an issue of any consequence during the early decades of American photography. Not only did the daguerreotype set the standard for photographic rendering of information and form, it also established a style for seeing photographically. American daguerreotypists framed their subjects with simple directness. The purpose was to provide convincing proof of the subject's existence.

These aspects of daguerrean style became the trademark of a vernacular tradition in American photography, a tradition that lies behind the works of Mathew Brady, Alexander Gardner, and T. H. O'Sullivan, made during the Civil War, and those of Lewis Hine made for his child labour project in the first decades of the twentieth century. Walker Evans revived the tradition in the 1930s as a conscious aesthetic choice. The convention of the commonplace object seen as part of our everyday environment and rendered with bold frontality and emotional reserve in a manner to persuade the viewer of the photographer's apparent objectivity still survives in the current generation of photographers.

The unknown daguerreotypist who made *Two New Houses* has produced an exemplary work in this tradition. Perhaps the daguerreotype was commissioned by the proud builder of the houses, for pride has as tangible a presence in this image as does the reality of the buildings themselves. Although the dwellings are identical, to the point of sharing the carriage house at the back, the individual occupants have placed upon each the stamp of their own identities. The house at the left has trellises for climbing vines that are yet to appear, while a fence surrounds the garden, which sprouts spindly saplings. The garden at the right is limited to a neatly manicured lawn edged with a border of stones. The newness, the emptiness of the landscape behind the houses suggests that we are looking at a nineteenth-century suburban development, as bleak in its own way as its twentieth-century counterpart.

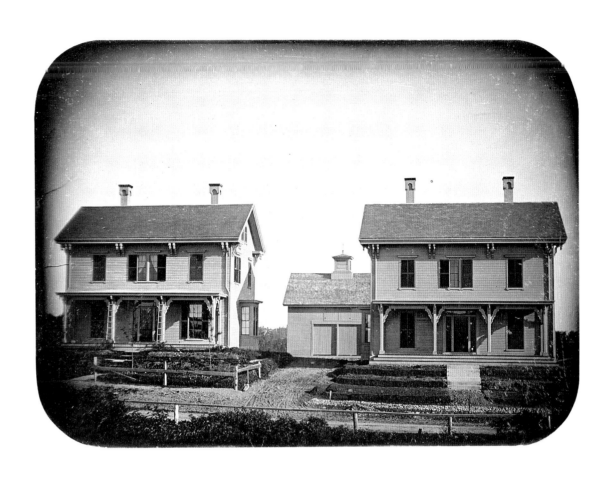

FÉLIX TEYNARD

French (Grenoble?, 1817 – Saint-Martin-le-Vinoux, 28 August 1892)

Rock-Cut Architecture – Tomb of Amenemhat, Beni-Hasan, Egypt between 1851 and 1852

Salted paper print, 24.7 × 31 cm
From *Voyages en Égypte et Nubie,* 1858, pl. 13
Purchased 1992

THE HISTORY OF PHOTOGRAPHY contains a number of instances in which individuals with little experience in photography or art, and whose intervention with the medium was brief, have succeeded nonetheless in producing some of photography's finest images. Félix Teynard was one of these. He graduated as a civil engineer in 1839. Probably of independent means, he was able to pursue his own interests; as with many educated Frenchmen of the period, these led him to Egyptology. In the late fall of 1851, he began a year's journey up the Nile River, setting sail at Alexandria and turning around at the Second Cataract in Nubia. On the way, he photographed not only the principal archaeological sites, but also the landscape, modern municipal buildings, and "the miserable dwellings of the fellahs."[1]

Teynard may have taken up photography specifically for his trip, for the earliest known photograph by him was made only in the summer of 1851. Using his boat or a tent as a darkroom, patiently enduring the rocking of the former on the water and the extreme heat of the latter in the middle of the desert, he made enough paper negatives to publish in 1858 a limited edition of *Voyages en Égypte et Nubie*, with 160 salted paper prints. No record exists of his ever photographing again.

Teynard made this photograph about a third of the way up the Nile at Beni-Hasan where, around 2500 B.C., princes of the Old Kingdom began to quarry granite for their palaces. The quarries, cut in the form of large chambers, were used as burial tombs. Amenemhat I, who ruled from 1991 to 1962 B.C. and whose tomb this was, was the founder of the twelfth dynasty. He is remembered as an able administrator, restoring unity to Egypt after civil wars and extending Egyptian control into Nubia.

Teynard regretted that darkness did not allow him to photograph the mural paintings inside the tomb. But what he saw on the outside more than compensates. Nothing in his career tells us why he had such an extraordinary sense of form, but there it is, a sensitivity to the geometry of massive shapes that gives a powerful structure to his photograph. Perhaps the answer lies partly in the image Teynard saw on the ground glass of his camera – always, of course, upside down, which is the way it comes in a view camera. Looked at in this way, the shadows have an obvious design, ringing a series of changes on abstract rectangular shapes across the picture plane. *Rock-Cut Architecture*'s structure depends as much on Teynard's reading of shadows as pictorial form as it does on the objects that cast them. His clever use of light has given the image a monumentality and a palpable sense of gritty surfaces, enhanced by the union between the fibres of the paper negative and the salted paper print. His poetic sensibility has conveyed the mystery of this place through the photograph's deep and vibrant shadows and through the inclusion of both the graffiti and the slender cane with its even more fragile shadow. These last two introduce a note of poignancy by reminding us that civilizations come and go, and humans leave their traces in many ways. But perhaps it is the cane and what its presence signifies that gives Teynard's remarkable photograph its elusive, haunting quality.

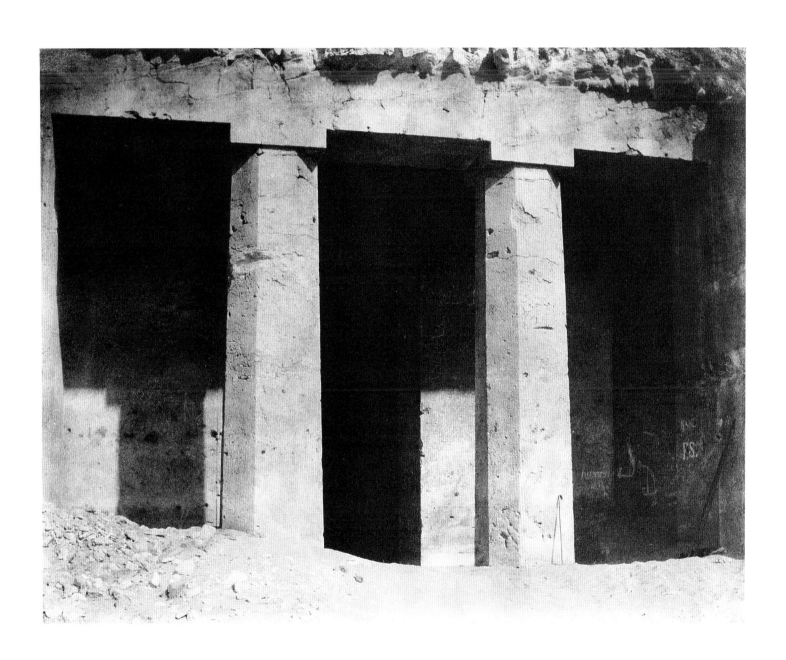

ÉDOUARD BALDUS

French (Westphalia, Saxony, 5 June 1813 – Paris, c. 1890)

The Railroad Station at Clermont c. 1855

Salted paper print, 31 × 43.9 cm
From *Chemin de fer du Nord: Ligne de Paris à Boulogne*, 1860–61, pl. 25
Purchased 1990

THE FACTS OF ÉDOUARD BALDUS'S LIFE REMAIN SKETCHY, and in dispute. He may have been born in Westphalia, and may have served in the Prussian army, leaving the military to become a painter. The Paris Salon catalogues, in which he is first listed as exhibiting in 1842, describe him as a painter of portraits and religious subjects. In 1849, he became a French citizen. His beginnings in photography are unrecorded. He simply appears among the first generation of French painters to turn to the new medium sometime in the second half of the 1840s. By 1851, his reputation was sufficiently advanced that he was chosen by the government as one of five photographers to document endangered architectural monuments of France's historic patrimony. Other government commissions followed, including photographing the construction of the New Louvre beginning about 1854, the work for which he is best known. After 1860, Baldus concentrated on publishing his earlier work in photogravure form. In spite of being made a member of the Legion of Honour in 1860, an honour seldom given to photographers, he died in obscurity.

In August 1855, Queen Victoria of Britain was to travel over the recently completed railway line from Boulogne to Paris to visit the *Exposition universelle*. To mark the occasion, Baron James de Rothschild, Chairman of the Chemin de fer du Nord, commissioned Baldus to prepare a commemorative album containing fifty photographs for presentation to Her Majesty. Some five years later, Rothschild requested another twenty-five presentation copies based on the Queen's album but also with new images.[1] *The Railroad Station at Clermont* is from one of these albums.

Baldus's best photographs combine a sensitive perception of light, space, and abstract structure with a sensual feeling for the tonal beauty of the salted paper print. *Station at Clermont* exhibits all of these, including the atmospheric perspective that often results from the paper negative and salted paper print combination. The light is soft, producing subtle tonal modelling. Lines and forms are as much a quality of the paper as they are reflections of the world. The freight cars blend unobtrusively into the foliage of the trees. The lines of the track accentuate the rush into far space. At the same time, because of the manner in which the salted paper suppresses surface information and emphasizes breadth of form, the tracks also serve as the delicate ribs of a pictorial planar geometry. Simultaneously, we undergo two startlingly different experiences of space – the deep space of the three-dimensional and the flat space of the picture plane. *Station at Clermont* has an almost dreamlike mood because of the delicate balance between the shadowy objects shown and the gentle precision with which they are rendered. Seen from our perspective of time, it is as though the age of the railroad, only just beginning, is already fading into history.

Photographs often contain evidence of how unruly the world is, or, at least, how out of the photographer's control. The refuse between the tracks in the foreground is unidentifiable and certainly not of the photographer's choosing. Yet, it sits there, unexplained and apparently irrelevant to the picture's purpose. Such accidental intrusions of the commonplace shift the meaning of a photograph and even add to its power to define reality, offering reminders that life also consists of the ungraceful, the humble, and the repulsive.

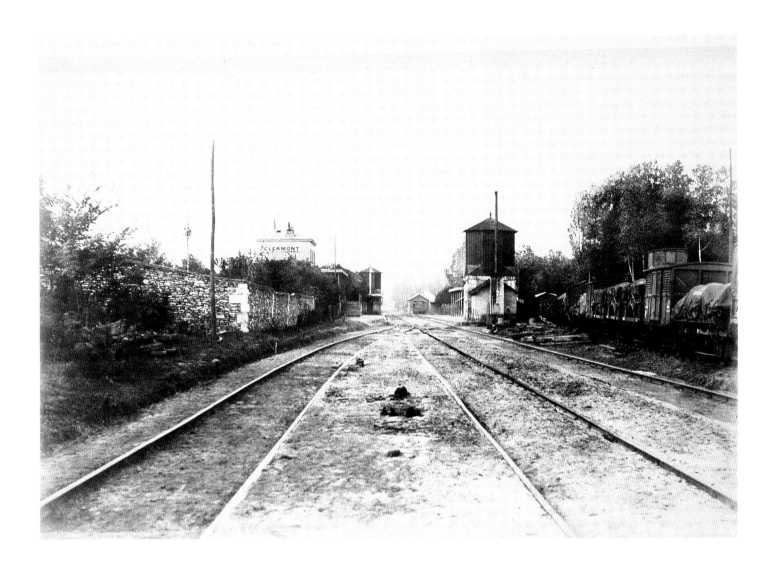

UNKNOWN PHOTOGRAPHER

American (active 1850s)

J. C. Stoddard and His Steam Calliope possibly 1855

Ambrotype, 8.7 × 14.3 cm
Purchased 1982

THE STEAM CALLIOPE WAS INVENTED ABOUT 1850 in America by A. S. Denny and patented in 1855 by Joshua C. Stoddard. It consisted of a boiler that forced steam through a set of whistle pipes. In time, it came to be mounted on a brightly coloured wagon drawn by a team of horses, its shrill sounds heralding the arrival of the circus in town.

There is good reason to assume that the gentleman posing proudly with his musical instrument is Stoddard himself, as the sign in front of the calliope would suggest. It is an image that fits into a tradition of daguerreotype and ambrotype portraits of individuals posing with the tools of their trade. Sometimes known as occupational portraits, they are more rare and sometimes of more interest than the straightforward studio portrait that concentrates entirely upon the sitter. Often enough the reason for this difference is to be found in the tools themselves or in the ingenuity with which the photographer has made them part of the portrait. Certainly, in this instance, the machinery of the calliope is an ideal subject for the camera, which renders its machine-like quality with the requisite amount of precision to force our attention upon the character and beauty of the object itself. Studio portraits of this period usually rely on the simple formula of the frontal and central pose, and occupational portraits generally show the instruments of the sitter's profession casually held in the hand or discreetly placed on a table at the elbow. In this instance, however, the instrument threatens to overwhelm the sitter, so much so that the photographer's only recourse was to an amusingly eccentric composition in which Stoddard, almost as an afterthought, is included at the extreme right, peering over the row of pistons.

The first ambrotypes were made in England in 1851 by Frederick Scott Archer, inventor of the collodion glass negative, and by Peter Wickens Fry, one of the founders of the Calotype Club of London. Essentially nothing more than a glass negative with a black backing that reversed the tones to make a positive image, each one was, like the daguerreotype, a unique image. By 1852 the process had become common in England as a cheap substitute for the latter. Its name comes from America, where it was patented in 1854 by James Ambrose Cutting. By the mid-1860s, it, too, was superseded by the even cheaper ferrotype. Although the surface of the ambrotype is less fragile than that of the daguerreotype, the fact of its being on glass has engendered its own mortality, with the result that fewer ambrotypes have survived.

UNKNOWN PHOTOGRAPHER

British (active 1850s?)

"Puffing Billy" Locomotive, Wylam Colliery, Northumberland c. 1855

Albumen silver print, 23.3 × 29.7 cm

Purchased 1985

THE "PUFFING BILLYS" ARE SAID TO BE the earliest railway engines of which photographs exist. Three were built in England by the inventor William Hedley, the first in 1814, and they were taken out of service in 1862. This particular one may be the "Lady Mary" as it looked after being rebuilt about 1828.[1] The Puffing Billys were originally used to haul coal from the Wylam Colliery, near Newcastle. In 1824 the *Encyclopaedia Britannica* claimed that "this application of steam has not yet arrived at such perfection as to have brought it into general use." The photograph would attest to that. But it also attests to something else: the inventiveness of human beings. At first glance, this is one of those photographs that appear to derive their interest exclusively from the subject matter – for the Puffing Billy has the crude whimsy of a barnyard invention and the craziness of a Rube Goldberg contraption. All the elements in the image join forces to emphasize these qualities, from the repetitive forms of the stakes in the foreground to the stick-like distortions of the men tending the engine. That these distortions may be the result of the happy accidents of camera optics and lengthy exposure times does nothing to lessen the photographer's contribution to the image, particularly in the choice of camera position, by which the relationship between the crudeness of both the stakes and the engine is emphasized. There the Puffing Billy sits, inexplicably in the midst of turf and brush, a reminder of the origins of twentieth century technology in subject and in icon.

The unknown person who took this photograph may have had no pretension toward making great art. Nor is it so. But it is a pointed reminder of how the combination of the photographer's eye, the camera, and a piece of the world may conspire to produce an image that, without regard to the conventions of art, memorializes, provokes, mystifies, and amuses. That it also delights the eye through the quality of its line and tone is further reason for paying close attention. The date of the photograph's making is problematic. Since the photographer has used a glass negative (probably wet collodion on glass) and albumen silver paper for the print, it would have to be later than 1851, the year in which these two processes came into general use.

PLATT D. BABBITT

American (? – 1879)

Niagara Falls from Prospect Point c. 1855

Daguerreotype, 13.5 × 18.6 cm
Gift of Phyllis Lambert, 1988

PLATT BABBITT'S *Niagara Falls from Prospect Point* was made as a tourist souvenir by a professional daguerreotypist. Establishing himself on the American side as early as 1853, Babbitt constructed an open pavilion both to announce his enterprise and to shelter his camera. From this fixed position, he was able to point the camera at Horseshoe Falls and photograph visitors who stood on the brink admiring North America's most popular attraction. Tourists, perhaps often photographed unawares by Babbitt, were usually pleased to take home such mementos of their visit. Although Babbitt continued to operate the stand until sometime in the 1870s, he exchanged his daguerreotype apparatus for the less costly wet collodion process probably by the end of the 1850s.

Although praised for its "prodigious delicacy of details"[1] by the press when the invention was first announced in 1839, the daguerreotype was found to be wanting by art critics. Such minute rendering of detail was contrary to the then current principles of art, which called for the broad effect. Surface detail, it was said, destroyed form. Such images were too mechanical to be considered as art. A decade and a half later, however, landscape painters began to see the aesthetic value of detail as a means of giving viewers a sense of the reality of a scene. Babbitt's view of the falls is a nice compromise between photographic clarity and artistic effect. In the foreground, detail is recorded with enough precision to convince us of the earthy existence of the scene, while the composition is framed with dark masses of trees and foliage sufficiently broad in form to satisfy the demands of the critics. Because of the camera's slow exposure, even the water has a fluid breadth of form. Given the brilliance of the scene, Babbitt was able to expose for the highlights, thus permitting a delicate rendering of clouds, unusual in photographs of the period.

Babbitt's daguerreotypes of the falls may have had humble origins, but they do reflect the nineteenth-century taste for the sublime. We have no way of knowing whether his contemporaries recognized the common bond between his views of Niagara and the grand themes produced by such painters as Asher B. Durand in the 1850s. But the similarity is present. American landscape painting, as one writer of the time put it, showed an awareness of "God's sensuous image of revelation."[2] Moral benefits were to be derived from such aesthetic contemplation. Balanced on the brink, as though defying fate, Babbitt's eight tiny figures commune with the forces of nature, while we, the audience, are given pause to reflect upon the meaning of transient human frailty in the face of such awesome power.

BENJAMIN BRECKNELL TURNER

British (1815 – 1894)

Causeway, Head of the Lake, Losely Park, Surrey between 1852 and 1854

Salted paper print, 27 9 × 37.5 cm
Purchased 1984

THE LANDSCAPE AS A SUBJECT for art came into its own in the nineteenth century. It helps to remember that in England the generation of Benjamin Brecknell Turner were also the inheritors of the romanticism of William Wordsworth:

> One impulse from a vernal wood
> May teach you more of man,
> Of moral evil and of good
> Than all the sages can.[1]

What often passes for landscape in early photography might best be described as topographical documentation. Such views were the bread and butter of many commercial photographers. It is among the wealthy amateurs such as Turner, those with leisure time, that we find a taste for the poetic and symbolic in such images. In painting, the term "landscape" implied certain pictorial conventions used to express a concept of and a sensibility toward nature. The guiding aesthetic for landscape artists since the end of the eighteenth century was that of the picturesque, which voiced a nostalgia for a supposedly innocent past. Thus, its settings were usually rural or wilderness environments. The images of the picturesque are characterized by roughness, irregularity, or intricacy. Dark trees serve as an organic frame for composition. Light and shadow create distinctive oppositions, yet flow into harmonious designs. Such scenes were meant to convey both idea and feeling. Turner, who photographed for his own amusement "the rural repose and sheltered quiet"[2] of the English countryside, was among the most skilled practitioners of the picturesque in photography.

Inheritor of a successful candle and saddle soap manufacturing firm, he began to photograph with W. H. F. Talbot's calotype process in 1849, and soon achieved a reputation for both the large size and high quality of his prints. A founding member of the London Photographic Society, he was a regular contributor to its exhibitions from 1854. Because his production was relatively small (apparently he stopped photographing in 1862), his work is rare. Even more rare are his salted paper prints, for at some point he changed to albumen paper, which, when used with a paper negative, unfortunately flattens the tonal range of the print, reducing both its luminosity and its tactile qualities. The example shown here, however, is on salted paper and most certainly is an early print.

The challenge for the artist is to find order in disorder. But not too much, for the picturesque thrives on the irregularities of nature. By using the pathway to lead our eye into the picture's depth, Turner has employed a favourite device of the picturesque to create order. At the same time, he has taken advantage of the wild tangle of branches to provide an intricate design across the picture plane. His choice of a paper negative combined with a salted paper print subdues detail, giving breadth and massiveness to form and emphasizing the brilliant splashes of light that define the quality of the day. For Turner, the texture of the landscape and the fabric of his photographic materials have become one.

LÉON-EUGÈNE MÉHÉDIN

French (Laigle, 1828 – Blosseville-Bonsecours, 1905)

Fragment of the Great Curtain Wall, Sebastopol November? 1855

Salted paper print, 25 × 32 cm
From *Souvenir de la Guerre de Crimée,* 1855
Purchased 1967

PHOTOGRAPHS BY THEIR NATURE ARE MUTE, and they are eloquent beyond words. Léon-Eugène Méhédin's photograph does not tell us that, at noon on 8 September 1855, a year and a half into the Crimean War, French and British troops swarmed up to the Malakoff Tower, storming along the whole line of the flanking ramparts known as the Redan, taking and retaking in severe hand-to-hand combat with the Russians every casemate and every traverse. Throughout the day the walls of the ramparts were churned with heavy bombardment until, with nightfall, Malakoff and the Redan succumbed to their attackers, marking the beginning of the end of the long seige of the Russian naval base of Sebastopol. Nor does it tell us that the British and French suffered the death of 10,000 men and the Russians 13,000 in that assault. The fall of Sebastopol was the turning point in the Crimean War.

About all of this, *Fragment of the Great Curtain Wall* remains silent. But what it does tell us is something of the brute power of warfare and the overwhelming desolation it leaves behind, all the more persuasive because of the photograph's understatement. The Crimean War was the first major conflict to be covered extensively by photographers. But the battles themselves could not be recorded because of the complications of sensitizing and developing the glass negative – this darkroom work had to be performed on the spot. Therefore, the aftermath of the battles became the subject, and the photographer learned to look for the telling detail. In his careful selection of detail, Méhédin has quietly and reverently memorialized the tragedy, the blanket of snow both contributing to the picture's bleak stillness and reminding us of the healing and purifying element of time. The broad effect resulting from the combination of paper negative and salted paper print has enhanced the starkness of the scene, adding to the brutal reality of fact.

Méhédin was born and raised in Normandy, and studied architecture in Paris, where he also took up photography, possibly around 1850. He was sent officially to the Crimea as a photographer, perhaps to work with Colonel Charles Langlois, a painter of panoramas depicting French military triumphs. Some individual photographs bear the signatures of both men. It is known that Langlois arrived in the Crimea on 13 November 1855.[1] Although Méhédin continued his career as an architect, he conducted photographic expeditions into Nubia, Egypt, Italy, and Mexico. In 1858, he was the first to photograph inside the temple of Abu Simbel, using huge reflectors made of silvered paper. In 1859, he was commissioned to photograph the battle sites of Napoleon III's victories in Sardinia. And from 1864 to 1866, he photographed pre-Columbian art in Mexico. The 1861 exhibition of the Société française de photographie, in Paris, included thirty-one photographs by Méhédin of the Crimean and Italian campaigns and of Egypt and Nubia.

PHILIP HENRY DELAMOTTE

British (London, 1820 – London, 1889)

JOSEPH CUNDALL

British (Norwich, 22 September 1818 – Wallington, 10 January 1895)

Kirkstall Abbey, Doorway on the North Side 1854

Albumen silver print, 28.6 × 23.3 cm
From *A Photographic Tour among the Abbeys of Yorkshire,* 1856, pl. 21
Purchased with the Phyllis Lambert Fund, 1982

"WITH THE EXCEPTION OF THOSE who have had occasion to investigate scientifically the topography of England, few, comparatively, know what treasures of art or picturesque passages of nature lie concealed among the lone and sequestered places of our own country."[1] The French and Italians seem to have been more successful at promoting their ruins, for it was to the continent the English went in search of picturesque monuments. The French, in particular, began to seriously document their monuments as early as 1820 with the publication of *Voyages pittoresques.* This private venture was followed in 1837 by the formation of a government body to prepare an inventory of national monuments. Photographers were enrolled in the enterprise in 1851.

In England, the first serious photographic project to document historic ruins was the luxurious folio publication in 1856 of *A Photographic Tour among the Abbeys of Yorkshire,* with twenty-three photographs by Cundall and Delamotte and descriptions by archaeologists J. R. Walbran and William Jones. Joseph Cundall, painter, author, art historian, and publisher, was a member of the first photographic society in England, the Calotype Club. In 1852, he established the Photographic Institution, intending to teach photography and publish, exhibit, and sell photographs. In 1853, Philip Delamotte, illustrator, antiquarian, and photographer to Queen Victoria, joined the Institution. A year later, the two combined forces to photograph the ruins at Fountains, Easby, Rievaulx, Kirkstall, and Bolton Priory. Partway through, Delamotte had to leave to apply for the post of drawing master at King's College.

The nature of their collaboration is unrecorded, but two visions appear in the work. The overall views are dry, plain, and unimaginative, offering a utilitarian, topographical record. The detailed views, however, are complex, rhythmical, and graceful, concerned with giving aesthetic pleasure and influenced by ideas of the picturesque, in which crumbling stonework and lush foliage serve to frame the composition. Ivy and moss soften rough stone, and light and dark flow into one another in harmonious designs that convey romantic feelings of nostalgia for a remote past. One maker of these images has been enchanted by the poetry and mystery of the place.

Kirkstall Abbey was founded by Cistercian monks in 1158, then surrendered to Henry VIII in 1540 during the Reformation, and despoiled of its treasure – "lead, bells, timber, and everything of value which could be removed…for the king's use, and thus, one of the fairest monastic edifices in England was left to the inroads of time and decay…"[2] In Cundall's and Delamotte's time, the ruins, in an isolated valley near Leeds, were admired for "the gloom of those ancient cells…and the remnants of the Abbey shattered by the encroachments of ivy…[which] detain for many delightful hours."[3] The architecture is Norman and early Gothic; the doorway in the photograph was known for its massive proportions and curious zigzag motif. It was, as the two figures suggest, a place for quiet contemplation. The albumen silver of the print casts a mellow texture over all, offering a soft and sensuous glow.

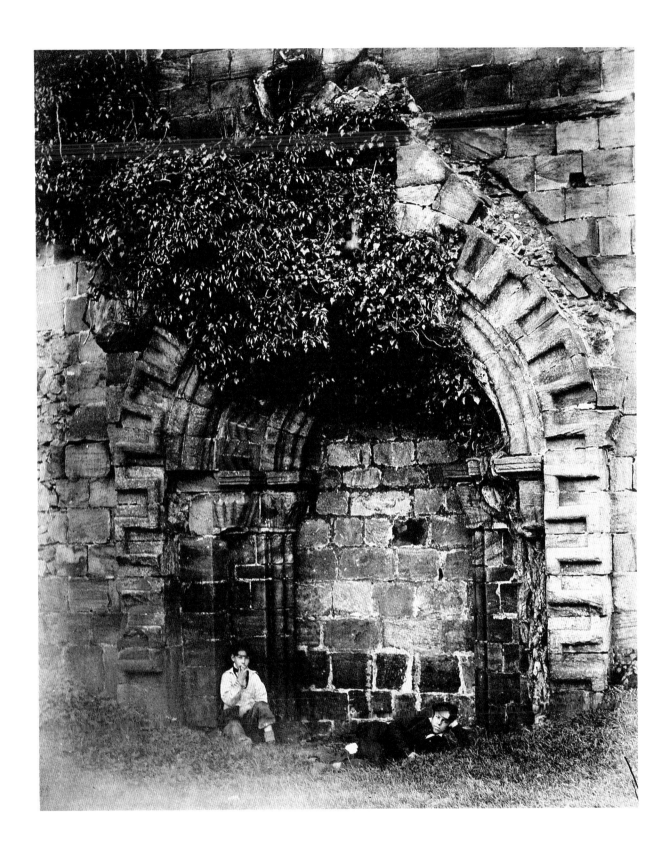

GEORGE N. BARNARD

American (Coventry, Connecticut, 23 December 1819 – Cedarvale, New York, 4 February 1902)

Lu-La Lake, Lookout Mountain February 1864 or spring 1866

Albumen silver print, 25.6 × 35.7 cm
From *Photographic Views of Sherman's Campaign,* 1866, pl. 15
Purchased 1975

WHILE ALEXANDER GARDNER'S *Photographic Sketch Book of the War*, published in the same year as George Barnard's *Photographic Views of Sherman's Campaign,* showed the specifics of battle, with photographs often made within hours of an engagement, Barnard's photographs generalize and de-humanize warfare as though there were few, if any, survivors. The sixty-one photographs in his album were made anywhere from months to almost two years after the battles. Damaged buildings, remains of rotting defence works in fields, rusting cannonballs half hidden by a new growth of weeds are scenes of silence and tranquillity, memorials to the past, not records of current turmoil. The waste and emptiness in the landscape are metaphors for a profound tragedy.

Barnard opened a daguerreotype studio in Oswego, New York, in 1846. At the beginning of the American Civil War, he photographed battle sites first for Mathew Brady, then for Gardner. The Department of Engineers of the Army of Cumberland hired him in December 1863 to run its photographic operations, with headquarters at Nashville. Shortly after General Sherman captured Atlanta in September 1864, he accompanied the army on its march to the sea as far as Savannah. With the end of hostilities, Barnard foresaw the commercial advantages of publishing a collection of photographs about Sherman's campaign in the south, which had fired the nation's imagination. Between April and June 1866, he retraced Sherman's path from Nashville to Charleston. Although Barnard was able to use some photographs made earlier, a number of locations had to be rephotographed because negatives had been damaged during the army's movements.

Concerned with showing feats of military engineering as well as the devastation of battle, Barnard also wished to depict the terrain through which the army had passed, which explains the inclusion in his album of such images as *Lu-La Lake, Lookout Mountain.* Lookout Mountain, overlooking Chattanooga, had been captured by Union forces in November 1863, but the lake itself does not appear to have featured in any engagement. It had a reputation with the locals, however, as a favourite meeting place for "swain and lass," and with the Indian population for its healing waters.[1]

Barnard's mastery of bold composition in *Lu-La Lake* may have come from his experience of the stereograph, in which the trick was to create the illusion of deep space by ensuring dramatic movement from foreground to background. Certainly, his choice of camera location, which placed the rock in such a prominent position, was designed to be arresting and to lead our eye into the distance. The sharp definition of both foreground and background, however, puts them at odds with each other, producing a feeling of ambiguity about the picture's space. It is this sensation of shapes being collaged one on top of the other regardless of their true distance apart that makes us aware of the picture's abstract structure. Space and scale become confused, creating a feeling of unreality, an unreality enhanced by the magical quality of the light that brushes the surface textures on rock, lichen, leaves, and weathered logs. Light is the photographer's medium that transforms the world into poetry. Barnard's creation extols the nineteenth-century view of the sublime landscape as a wild and disorderly force.

AUGUSTE SALZMANN

French (Ribeauvillé, Alsace, 1824 – France?, 1872)

Pediment of the Tomb of Jehosaphat, Valley of Jehosaphat, Jerusalem 1854

Salted paper print, 23.5 × 33 cm
From *Jérusalem,* 1856
Purchased 1973

AUGUSTE SALZMANN'S INVOLVEMENT WITH PHOTOGRAPHY is known through two projects only, his photographic expeditions to Jerusalem in 1854 and his documentation of the archaeological excavations on the island of Rhodes between 1858 and 1865. Born in Alsace, he studied painting under his brother Gustave, moved to Paris in 1847, and exhibited in the Salons of 1847, 1849, and 1850. Today, however, his reputation rests upon his photographs. By 1853, he must have learned the paper negative process because on December 12 of that year he set sail to photograph Jerusalem with an assistant identified only as Durheim, making his first exposures on 1 January 1854. What inspired Salzmann to make the trip was a recently published book by Louis Félicien de Saulcy, military man and antiquarian, claiming that many of the city's remains dated back to the Kings of Judah, to Herod (73?–4 B.C.), and even to Solomon (tenth century B.C.), contrary to prevailing beliefs that held the ruins to be no older than late Roman. De Saulcy's book caused a storm in the archaeological community in France, most of whom rejected its findings.

On arrival, Salzmann began with the Temple walls, and here he recorded the presence of Herodian stone. After four months of working under difficult conditions that included holding off Bedouins with a brace of pistols, he succumbed to a fever and returned to France, bringing with him 150 paper negatives. Durheim stayed on to make another fifty. Who was Durheim? No one knows. Nor do we have any indication of which fifty he made. An exhibition of some of the prints held in Paris at the time referred only to Salzmann.

The negatives were handed over to Louis-Désiré Blanquart-Évrard of Lille for printing, which resulted in the publication in 1856 of a two-volume deluxe edition with text, including 174 salted paper prints. A less expensive edition, with only forty plates and text, appeared in the same year, the illustrations having been reduced to almost half size by making copy photographs of the originals. The die-hards among France's archaeologists remained unimpressed, but reviews in the press recognized the publication as one of the major photographic achievements of its time. Unusual for the sense of place that is created through the sequence of images, now seeing its subjects from a distance, now examining them up close, now approaching from one side, then coming from the other, the work is closer to the photographic vision of our time than to its own age.

Although Salzmann's purpose was utilitarian – to provide hard evidence in support of an archaeological theory – he saw his subject with the eye of a painter. For us, the original intent is no longer relevant. Light and shadow, form and design give a shape to these images with an artistry that surpasses the informational content and captures the spirit of unending time. Aided by the combination of the salted paper print and the paper negative, bold areas of tone predominate. Line frequently mimics the delicacy of drawing. Nowhere is this more apparent than in his photograph of the tomb of Jehosaphat, a king of Judah who died in 849 B.C. It is a mark of Salzmann's genius that he was able to invest the minimal with so much. A leaf motif, a simple triangle, neither shown in their entirety, and we have a picture that is a graceful balance of quiet simplicity and subtle tension.

ROGER FENTON

British (Rochdale, Lancashire, March 1819 – London, 8 August 1869)

Landing Place, Railway Stores, Balaklava possibly 28 March 1855

Salted paper print, 28.5 × 35.7 cm
Purchased 1990

ALTHOUGH NOT THE FIRST TO PHOTOGRAPH WAR, Roger Fenton is considered to be the first photographer accredited as a war correspondent. He is certainly the earliest to have covered the subject so extensively, and may be the first to have faced the dilemma of producing photographs for propaganda purposes during wartime. Whether or not this is so, those he made in the appalling heat of the Crimea between 8 March and 25 June 1855, with his two assistants, five cameras, and thirty-six cases of supplies, have a stark simplicity that to our eyes is utterly convincing and oddly moving. Sent to the Crimea at the expense of the British government and a private publisher, there is some reason for believing that his mandate was to provide the British public with evidence that the troops were properly housed and well-provisioned, evidence necessary to quell growing fears at home that the management of the campaign was grossly inefficient.

According to historians of the Crimean War, the village of Balaclava was a garden paradise prior to its capture by the British, its harbour a clear sheet of silver mirroring the surrounding hills. Overnight, 25,000 British troops trampled its gardens, smashed its cottages, and tore up its orchards. The harbour was soon overcrowded with ships, its clean waters turned into a cesspool with refuse floating everywhere. This is the setting for Fenton's *Landing Place, Railway Stores, Balaklava.* From the disorder created by the army, he has constructed an image of contrasts – diagonals, curves, massive shapes, delicate highlights, and rich, deep shadows. The dark, almost purplish matte brown tones have the appearance of being part of the structure of the paper itself. The solid volumes of hulls of ships and piles of lumber are relieved by the empty, abstract spaces of water and sky. The contrast between the men who are aware of being photographed and those huddling groups who remain absorbed by their own interests adds authenticity to the scene. In the midst of this disorder sits a pile of supplies covered with a canvas. What are we to think of the graceful elegance of its drapery, so reminiscent of the ruins of a classical monument? This ironic comment on the state of affairs, unintended though it may have been, is difficult for us to avoid. Such accidental intrusions often contribute to the charm of a photograph.

Fenton was a major force in British photography, not only as one of its most important pioneers but as one of its most active promoters. Trained as a painter in Paul Delaroche's Paris studio from 1841 to 1843, at the same time as other artists who also turned to photography such as Gustave Le Gray, Henri Le Secq, and Charles Nègre, Fenton qualified as a solicitor after his return to London. He gave up photography abruptly in 1862, we don't know why. In spite of the wide range of his work over a period of almost twenty years, he is still best known for his photographs of the Crimea. His are among the first images to show the world that war was not the glorious and colourful enterprise artists had been depicting for hundreds of years. From this moment on, the means was at hand to make us aware of its bleak reality.

JOHN BEASLY GREENE

American (France, 1832 – Cairo, November 1856)

Constantine, Algeria 1855 or 1856

Salted paper print, 23.5 × 29.7 cm

Gift of Ward C. Pitfield, Toronto, 1981

JOHN B. GREENE WAS BORN IN FRANCE of an American father, a banker from Boston resident first in Le Havre, then in Paris. Although brought up in France, where he appears to have spent most of his life, he retained his American citizenship.[1] An archaeologist and member of the Sociéte asiatique, Greene's name appeared on the first published membership roll of the Société française de photographie, Paris, in 1855, which suggests he may have been a founding member. His photographic origins are unknown, but it is likely they derived from his archaeological pursuits. From his expeditions to Egypt, beginning in 1853, Greene brought back over 200 paper negatives, from which Louis-Désiré Blanquart-Évrard made the salted paper prints. A portion of these were published in 1854, but their rarity suggests they were for private circulation only. A year later, the first installment of an album on the diggings at Thebes appeared, but the series was never completed. Quite likely all these publications were interrupted by Greene's untimely death in November 1856 at the age of twenty-four. As far as we know, Greene's main photographic work was confined to Egypt and, in the winter of 1855 to 1856, to Algeria, although one early landscape made in France exists in the collection of Canada's National Gallery.

Greene's sense of form and pictorial space, and his emphasis upon tonal masses, show him to have been a master of the paper negative process, as is evident in this view of Constantine. Elizabeth Eastlake's words written about photography in general only a year later come to mind: "There is no doubt that the forte of the camera lies in the imitation of …the texture of stone, whether rough in the quarry or hewn on the wall…[This is] its special delight. Thus a face of rugged rock…[is] treated with a perfection that no human skill can approach…"[2] That this view of Constantine may be the left portion of a panorama of the city explains Greene's oblique approach to his subject, but the knowledge does nothing to lessen the force of the photograph's eccentric composition. The glimpse of the city – reduced to simple white geometric shapes – neatly balances the dark, massive rock formation that dominates the image. In a perfect blending of paper, tone, and subject, light and shadow are palpable. Small wonder that Greene's contemporaries could refer to the macabre quality of his images as well as to their beauty.[3]

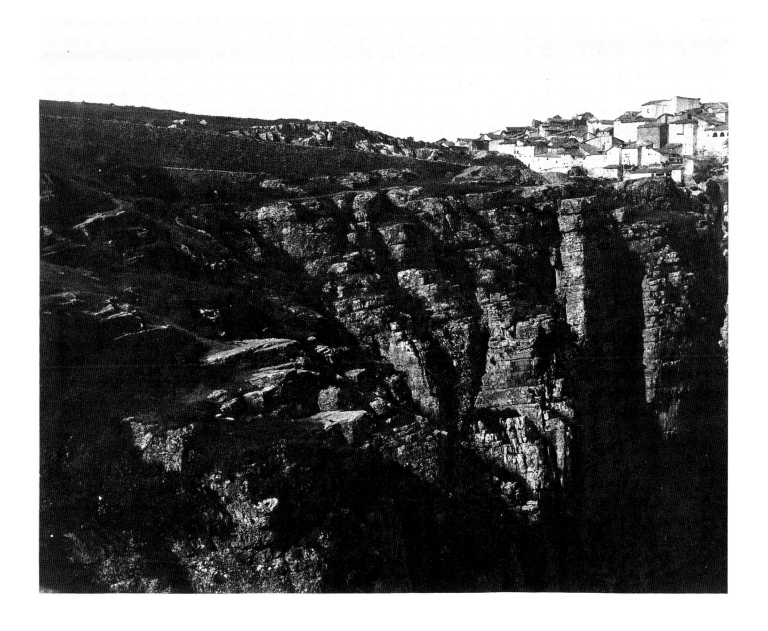

GUSTAVE LE GRAY

French (Villiers-le-Bel, 30 August 1820 – Cairo, 26 December 1882)

Camp de Châlons 1857

Albumen silver print, 30.1 × 34.5 cm
Purchased 1979

IDEAS ABOUT PICTORIAL SPACE in the nineteenth century were based upon painterly conventions. Nevertheless, a sense of photographic space began to emerge, sometimes unconsciously and sometimes in direct conflict with established conventions. Because the world is recalcitrant and does not always shape itself to the picture-maker's needs, the photographer, unlike the painter, must take it as it comes. Thus the way in which the camera places a frame around the world often takes on a uniquely photographic character. We might imagine the shocked response of art critics to Gustave Le Gray's *Camp de Châlons* with all that empty space between the edges of the picture. Such a departure would have been all the more unexpected because Le Gray was a trained painter. Contrary to the principles of the picturesque, there is no lush foliage here to frame the composition, gently curving pathways do not lead the eye into the distance. Instead, the world presents a loose, disorganized face. With daring, Le Gray has exploited the scene's stark geometry. A puny, lone tree marks the left boundary, while the straight horizon line shoots off the edge at right. More than half the surface is blank, the result of the inability of the negative emulsions of the time to record both clouds and ground with the same exposure. Photographers sometimes solved this problem by printing in clouds with a separate negative. Le Gray, a master of this technique, was known for his dramatic skies. To his credit, in this instance he opaqued the sky with black varnish on his glass negative to present a clean space, thereby avoiding competition with the drama unfolding on the plain. Caught by the morning sun, the woman's bonnet and apron and the three white horses shift our eyes across the emptiness to the huddle of spectators at right.

Perhaps, if we have an inclination for history, the ghostly battalions in the distance may remind us this plain is thought to be where Attila the Hun was defeated by Rome in 451 A.D. Here, also, Aurelian's army recovered Gaul for the Roman empire around 273 A.D. No doubt Napoleon III was aware of the area's historic importance when he established this huge military camp near Châlons-sur-Marne in 1856. Le Gray's documentation of the army's summer manoeuvres was probably commissioned by the Emperor – a commission that attests to the photographer's reputation.

Le Gray had become seriously involved in photography by 1847 as a student[1] (together with Roger Fenton and Charles Nègre) of Paul Delaroche, the history painter. By 1850, perfecting W. H. F. Talbot's process, he had invented the dry waxed paper negative, a boon to travellers because it remained sensitive for up to eight days. That same year, he published the first of many of manuals on photography, in 1851 he was a founding member of the Société héliographique, and in 1853 he became an executive member of the Société française de photographie when it was formed. Influential as both a teacher and an exhibitor, he was known for the beauty of his salted paper prints of forest scenes at Fontainebleau, and for his seascapes with dramatic cloud effects. Finally unable to make a living with photography, he left Paris in 1860, and by 1865 was teaching drawing and painting in Egypt, where he died.

FRANCIS FRITH
British (Chesterfield, 1822 – Cannes, 1898)

View in the Quarries at Hager Silsilis 1857

Albumen silver print, 22.2 × 15.8 cm
From *Upper Egypt and Ethiopia,* 1862?, pl. 3
Purchased 1972

FRANCIS FRITH, A SUCCESSFUL BUSINESSMAN (first in groceries, then in printing), began to photograph about 1850. He helped found the Liverpool Photographic Society in 1853, and went on to become one of the most prolific of the nineteenth-century view photographers. Fascinated by the Middle East, as were many Victorians, and recognizing its business potential, he embarked upon a photographic expedition to Egypt in September 1856, sailing up the Nile as far as Abu Simbel, and returning to England in July 1857. Two more trips followed in 1858 and 1859, the last taking him above the sixth cataract on the Nile – the first photographer to venture so far. So much in demand were the photographs from these trips that he opened his own photographic publishing house at Reigate in 1859. Seven handsome folio-size books resulted, with original albumen prints and text by Frith from his travels to Egypt, Ethiopia, Palestine, and Syria. The firm soon became one of the largest suppliers of topographic views of England, Europe, and the Middle East.

Between Idfu and Aswan in Egypt, overlooking the Nile river, lie the quarries of Silsilis whence came the sandstone for building the great temples at Thebes and Idfu beginning in the second millennium B.C. Frith's photograph shows, in his own words, "where a singular column of rock, which has been left in quarrying, has probably suggested the legend which gave the name to the place ... that from it was stretched to the opposite side a chain for the purpose of obstructing the navigation or levying toll; hence Hager Silsilis, 'the rock of the chain.'"[1] The photograph, from his first voyage, also shows a small chapel cut in the sandstone during the reign of Horemheb (from 1348 to 1320 B.C.). The men who worked the quarries carved many such chapels into the rock.

If we are not inclined to credit the shape of the rock to the legend, we might find an explanation in erosion by wind, whose presence is rendered through the feather-like movement of bushes in the foreground, a compelling contrast to the inert and timeless sandstone. The exquisite detail of this scene was made possible by the invention in 1851 of the glass negative with an emulsion of wet collodion and silver salts (called "wet" because the glass plate had to be exposed and developed within fifteen minutes of being coated, before drying) and the albumen silver positive print. This combination produced an image with more clarity and definition than was possible with the paper negative and salted paper print, coming close, as Frith himself said, to the "delicacy and detail" of the daguerreotype.[2] It was this type of photographic image, rather than the broad effect provided by W. H. F. Talbot's process and preferred by "art" photographers, that captured the imagination of a general public hungry for precise facts about the world. Indeed, the nineteenth century saw a photograph as a catalogue of an event rich with information and full of surprises. Fact is piled on fact until the viewer is overwhelmed by the tangible presence of reality. The image of nature reflects upon itself with perfect verisimilitude to the point where it can become a substitute for reality and even a source for new experience. "What we cared not for in nature," wrote an unknown critic in 1857, "becomes a joy and a wonder in the photographic picture."[3]

HUMPHREY LLOYD HIME

Canadian (Moy, Ireland, 17 September 1833 – Toronto, 31 October 1903)

Wigwam, an Ojibwa-Métis, Lake Superior September – October 1858

Albumen silver print, 17.6 × 14 cm

Purchased 1988

HUMPHREY LLOYD HIME left Ireland for England at the age of fifteen to learn textile manufacturing and acquire a business education. Six years later, in 1854, he arrived in Canada. In 1856, he began to work for Armstrong and Beere in Toronto, and in January 1857 became a junior partner in the firm, described in the 1857/58 *Canada Directory* as "ambrotypists" and "photographists" as well as "civil engineers and draughtsmen." Hime may have learned photography in England, or he may have been trained by Armstrong and Beere. Certainly, by 1858, he had acquired his own reputation as "an excellent photographer,"[1] according to Henry Youle Hind, a professor at Trinity College. Hind had been commissioned by the government to conduct a geological expedition to explore the area bounded by Lake Winnipeg and the Assiniboine and Saskatchewan rivers, and he hired Hime as the expedition's photographer. The party reached the Red River Settlement in June 1858, where Hime made his most successful photographs in September and October. How many is unknown: accidents occurred to the glass plates, and only forty-nine survived. In 1860, Hind published his report on the *Canadian Red River Exploring Expedition of 1857 and of the Assiniboine and Saskatchewan Expedition of 1858,* containing woodcuts after Hime's photographs. A separate supplement of thirty photographs was published in London. As far as we know, Hime never photographed again. By 1864 he had left Armstrong, Beere and Hime to become a stockbroker.

Hime's photographs are the first of the western frontier to be made in Canada. They are also the earliest surviving examples of the use of photography for government explorations anywhere in North America. More important, they are some of the finest early photographs made in Canada. Hime shows a sophisticated and radical sense of composition and design, especially in his bleak views of the prairie and the settlements along the Red River. His portraits of "Native Races," as they are termed in the portfolio, are a surprising blend of the Victorian picturesque and frontier life. In their dignity and simplicity they are remarkably similar to Hill and Adamson's portraits made a decade earlier in Scotland. Hime's use of the buffalo robe here recalls the rugs Hill and Adamson hung behind their sitters to create dark backgrounds of texture and shallow space, a device that allowed them to introduce a Rembrandt-like chiaroscuro of light and shadow. White patches of snow, the zigzag edging of the robe, the knee bands, together add energy to the composition and enhance the rich tones of the print. The native people of the Red River accused the explorers of taking their photographs in order to deprive them of their lands through black magic. In spite of this, Wigwam, a Métis guide with a French father and Chippewa mother, exhibits both confidence and serenity before the lens. That the folds and edge of the robe uncannily imply the bulk and shape of the animal from which the skin came may or may not be accidental, but we cannot ignore its potential as a metaphor. Wigwam sits companionably with both the tools of his trade and his quarry, symbolizing the hunter's union with his environment.

UNKNOWN PHOTOGRAPHER

American (active 1850s)

View on the Baltimore & Ohio Railway, Martinsburg Station, and Coal Trains, West Virginia 1 June 1858

Salted paper print, 19.5 × 25.2 cm
Purchased from the Ralph Greenhill Collection, 1985

THE VERNACULAR PHOTOGRAPH – characterized by the commonplace, the popular, and the utilitarian –served the nineteenth-century need for clearly defined, straightforward information. Its charm often comes from a combination of casual observation and the specificity of photographic delineation. The photographer who made *View on the Baltimore & Ohio Railway, Martinsburg Station* appears to have been concerned with information only. Little attention was paid to composition, other than to centre the main event. A souvenir snapshot, if you will. Except that the act of taking this photograph required deliberation – placing camera and tripod and sensitizing a glass plate.

But the value of a photograph is often not fully apparent at the time. Writer Oliver Wendell Holmes wrote in the *Atlantic Monthly* in 1859 that photography was a kind of "skin" collecting: "Form is henceforth divorced from matter. In fact, matter as a visible object is of no great use any longer, except as the mould of a thing worth seeing, taken from different points of view, and that is all we want of it. Pull it down or burn it up, if you please."[1] Although penned with tongue in cheek, this was a prophetic statement for the Martinsburg railway yards, which were destroyed three years later in the American Civil War. Holmes saw that, among other things, photography eventually would provide an immense archival record of civilization. Our unknown photographer's contribution shows us the curious locomotives known as Camels because the engineer's cab was mounted like a hump over the boiler instead of behind it. The resulting short wheel base allowed the engine to negotiate sharp curves. Most of the Camels shown here were built to haul coal, hence the hoppers in the foreground.[2]

If this photograph tells us something about nineteenth-century ingenuity, it also speaks of the impulse in that period towards decorating strictly utilitarian objects. The barge-boards on the roundhouse, its splendid conical turret, the cartouche surrounding the name B & O, all show a sense of elegance. And what of the crowd of people? In June 1858, the B & O conducted a 758-mile (1223-km) excursion for some fifty writers, painters, poets, and photographers, between Baltimore and Wheeling, West Virginia, to celebrate its thirtieth anniversary. When the train stopped briefly at Martinsburg, our photographer took the opportunity to record the visit.

In his same essay, Holmes referred to "incidental truths which interest us more than the central object of the picture."[3] Such things as the vague figures by the cowcatcher and the roundhouse – gliding shadows melting into air – he saw as reminders of the fleeting nature of life. Of course, they were also the result of a technical problem – an exposure time too long to arrest movement. But accidents such as this were, he held, one of photography's charms. We might add to this the accident of the slightly faded state of the print, which speaks of the encroaching mists of time, time that obliterated the people who posed for the picture, destroyed the machines that fed the nation's economy, erased the wild flowers growing exuberantly by the roadbed. Our photographer has given us, perhaps, more than intended. Such photographs were, for Holmes, "infinite volumes of poems."[4]

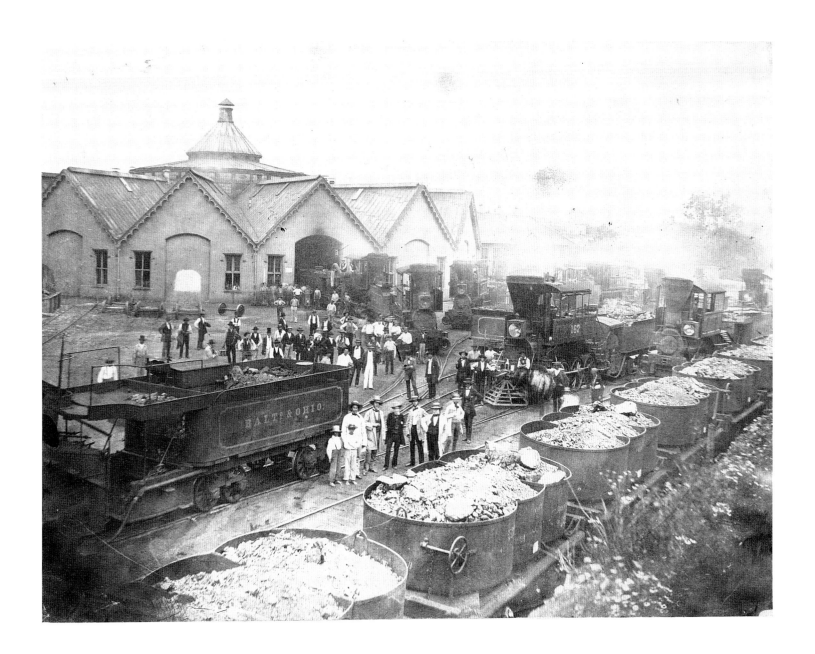

WILLIAM ENGLAND

British (1816 – London, 1896)

The Railway Suspension Bridge from the "Maid of the Mist" Dock, Niagara 1859

Albumen silver print, 23.7 × 28.2 cm
Purchased 1985

WILLIAM ENGLAND BEGAN as a daguerreotypist in London in 1840, then became a staff photographer for the London Stereoscopic Company when it was founded in 1854, travelling throughout England, Ireland, and Europe for the firm until 1863, after which he worked independently. He was one of the few nineteenth-century European topographical photographers to photograph in North America, visiting the United States and Canada in 1859. His best known views made during that trip are of the suspension bridge at Niagara Falls, the first and only major railway suspension bridge in the world,[1] with a span of 821 feet (246 m) and a height of 245 feet (74 m). A double-deck structure, the bridge carried the railway on its upper deck and pedestrian and road traffic below. Built by J. A. Roebling, the engineer who created the original design for the Brooklyn Bridge, and constructed between 1852 and 1855, it was immediately recognized as one of the engineering marvels of the world, drawing as much attention as the nearby falls itself.

In England's photograph, the toylike character of the train suspended over the Niagara gorge on a bridge that has all the appearance of being nothing more than a fragile web of lines adds a dreamlike fantasy element to the solidity of the structure in the foreground. The latter, a landing constructed of rough-hewn logs and filled with dirt, is in startling contrast to the sophisticated engineering of the bridge, and indeed to the clothing of the three figures, a contrast that must have intrigued the British audience for which the photograph was made, and emphasized the exotic nature of the New World. Although England's glass negative has provided the albumen print with much sharp detail of the surfaces of things, the camera's slow exposure, through the flux of time, has given to the river's surface the sheen of ice, an incongruity that adds to the picture's charm.

Although the pictorial antecedents of England's photograph may be found in paintings and engravings of similar subjects earlier in the century, down to and including the Victorian group posing in the foreground, the intractable and hostile character of the landscape has prevented the photographer from creating the conventional, picturesque composition that was fashionable at the time. Rather than being defeated by the absence of the mellow luxuriance of the European picturesque, England has exploited the rugged brutishness of the gorge to produce an image that is at once original, informative, and captivating.

While we may ponder upon the fragile balance that his photograph shows us between the forces of nature and the attempts of human beings to exert control, the trailing rope in the foreground, leading to who knows where, reminds us of unfinished business.

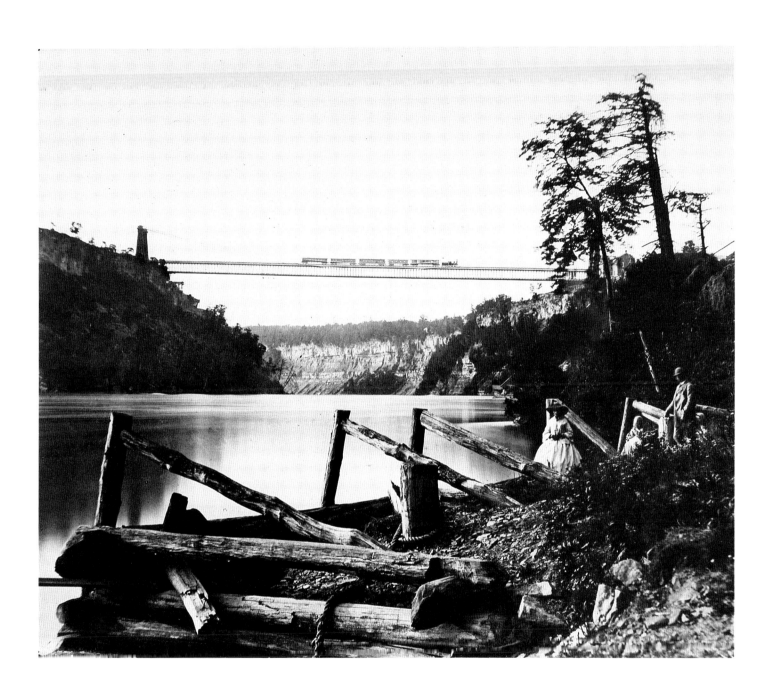

WILLIAM NOTMAN

Canadian (Paisley, Scotland, 8 March 1826 – Montreal, 25 November 1891)

"Trevithick" Engine, Grand Trunk Railway, Montreal May 1859

Albumen silver print, 22.9 × 29.1 cm
Purchased 1985

WITH THE SPREAD OF PHOTOGRAPHY in the nineteenth century, its chief purpose became the communication of information. Undoubtedly this was William Notman's intention in photographing the "Trevithick," engine no. 209 of the Grand Trunk Railway. Of the 200 or so locomotives in use by the G. T. R., incorporated in 1852, this was the first to be made in Canada. Notman had already photographed the engine under construction at the Point Saint Charles Shop in Montreal in the same year. The designer was Frederick Henry Trevithick, first locomotive superintendent of the G. T. R. and son of Richard Trevithick, who built the world's first railway engine in England in 1804.[1]

Since Notman recorded the construction of the engine, we might reasonably suppose that his photograph represents its "launching." Certainly the manner of the grouping, accompanied by an air of pride, would suggest so. According to photographer and historian Ralph Greenhill, Trevithick himself is shown standing by the front driving wheel with his hand on the running board. We are meant to be impressed, no doubt, by the importance of the occasion, as well as by the engineering accomplishment. Notman's photograph adds something more, however. We are moved by the relationship that the photographer has seen between man and machine. Those who were its makers are now in the engine's thrall. The ancient Greek myth of Pygmalion takes a new form in the age of the machine.

Either consciously or unconsciously, Notman has understood that literal description is a powerful element of the photographic aesthetic. His glass negative and albumen print record the sheen of metal and the detail of machinery with a precision and clarity that is fitting to the subject and seductive to the eye. The funnel's dark cone against the sky's white space draws our attention to the rhythm of other geometrical shapes in the photograph.

That Notman should have placed his tripod where he did is no accident – his early work shows a sophisticated sense of form and design, no doubt sharpened by his art training in Glasgow, where he had moved as a youth with his family. After brief art studies, he entered the family wholesale cloth firm, but at the age of thirty was forced to flee Scotland to avoid criminal proceedings in a bankruptcy charge, arriving at Montreal in August 1856. After a short period spent working as a clerk for a dry goods firm, he opened a studio in 1859 (he had been an amateur photographer in Scotland). Six years later, the Notman Studio had thirty-five full-time employees.[2] By the time the William Notman and Son partnership was formed in 1882, the firm was a thriving enterprise with studios in many cities in Canada and the United States. But when he was commissioned to photograph the "Trevithick," he was still the firm's sole photographer.

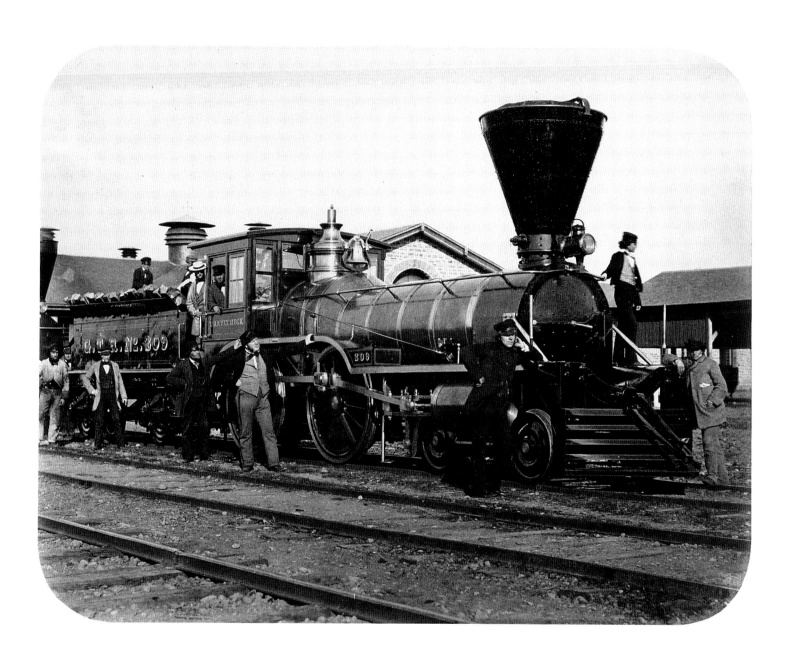

FELICE BEATO

British (Venice, c. 1825 – after 1904)

Headquarters Staff, Pehtang Fort 1 August 1860

Albumen silver print, 25.3 × 29.3 cm
From *China,* 1860, pl. 14
Purchased 1981

BORN IN VENICE, Felice Beato moved to England and became a British subject, where he may have been introduced to photography by Roger Fenton.[1] In the 1850s, he worked with his brother-in-law James Robertson, photographer and superintendent of the Imperial Mint at Constantinople. Together, sometimes with Felice's brother Antonio, also a photographer, they worked in Constantinople, Malta, Palestine, Cairo, and Greece, in Sebastopol during the Crimean War, and in India for the British army, recording the aftermath of the Lucknow mutiny in the first photographs to show the carnage of battle.

In 1860, Beato, now working alone, accompanied the British expeditionary force to China in the Second Opium War. *Headquarters Staff, Pehtang Fort* was made at this time. Britain and France had joined forces to compel China's acceptance of the opium trade. In 1781, the British East India Company had taken over the profitable but illegal importing of opium into China in exchange for tea. The Chinese government attempted to suppress the trade in dangerous drugs, but throughout the nineteenth century, Britain, and later France, periodically resorted to armed intervention to keep the shipping ports open to trade. In 1857, the British sent a diplomatic mission headed by Lord Elgin, with 11,000 troops, to force the issue by establishing embassies in Peking, the nation's capital. The French assisted with an army of 7000. The final stage of the campaign began with the landing of troops at Pehtang Fort on the Gulf of Chihli, 1 August 1860. Pehtang provided the back door to an attack on the forts at Taku, which guarded the entrance to the Peiho River, gateway to Peking. The capital fell to its attackers on 24 October, and the Convention of Peking ratified the 1858 treaty, including the legalization of the opium trade.

None of this appears in the peaceful scene photographed by Beato. The attack on Pehtang Fort began at nine in the morning. The hardest part proved to be the landing from the troop ships, involving wading waist deep through the mud flats that lay between the sea and the fort. As it turned out, the fort was unoccupied. The debris suggests a hasty retreat. The landing was scarcely more than a few hours old when Beato set up his tripod inside an angle of the fort, but the British have had time to erect several bell tents atop the ramparts, while members of General Hope Grant's headquarters staff stand about in proper attitudes of victory. At first, we may be impressed by the formal qualities of Beato's photograph – the massive shapes of the ramparts, the circles and curves of wheels, cannon balls, and coiled ropes, and the carefully balanced grouping of men. Even the lone figure seated on the wall at the upper left is part of the balancing act. On reflection, we may be even more fascinated by the tension that exists between the photograph's carefully observed geometry, solid and timeless, and its evidence of the fugitive – the Union Jack dissolving in the wind, the flapping of the Chinese battle flag in the picture's lower left, and the debris in the foreground, all manifestations of time passing. Such images are food for thought on the passing of empires, and, indeed, of civilizations.

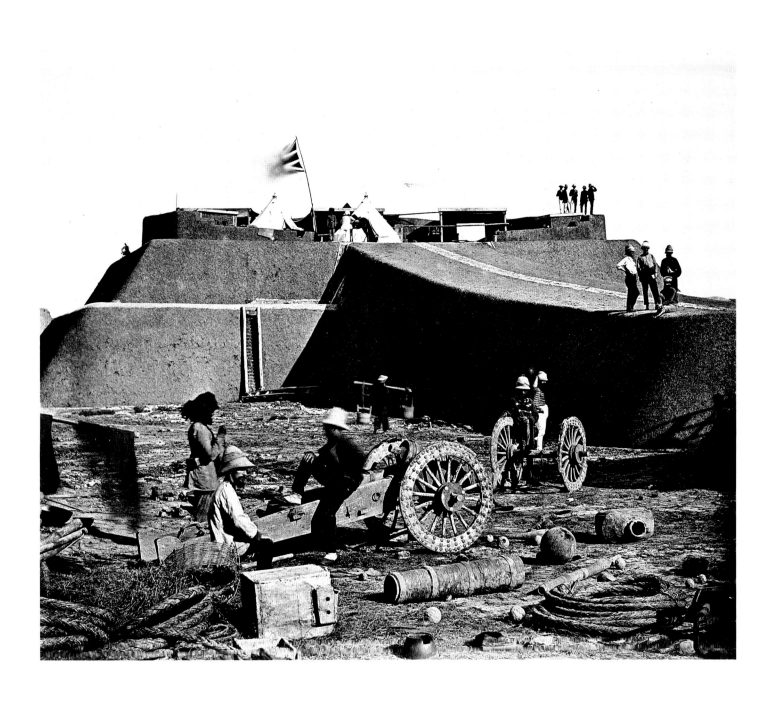

ROBERT MACPHERSON

British (Edinburgh, 1811 – Rome, 1872)

Falls of Terni c. 1857

Albumen silver print, 27.6 × 37.4 cm
Purchased 1987

TOPOGRAPHICAL ART IS PRIMARILY CONCERNED with supplying information about specific places rather than with offering aesthetic enjoyment. Its origins lie in illustrated maps and its practice spread with the introduction of printing from woodcuts in the fifteenth century. By the end of the sixteenth, painters were producing decorative views, known as *vedute,* of Italian ruins and landscape. Often more fanciful than accurate, *vedute* were in demand because of the growing interest in foreign countries. The Grand Tour, essentially an activity of the British aristocracy of the eighteenth and nineteenth centuries, brought an increasing need for souvenirs of places visited. Rome, the "Eternal City," with its classical antiquities and ancient culture, figured prominently on the list of attractions. By the mid-nineteenth century, photography, because of its inherent accuracy, soon replaced handmade topographical art, leading in our time to the ubiquitous postcard.

When Robert Macpherson, a qualified surgeon, left Edinburgh in 1840 to settle in Rome for reasons of health, he quickly discovered the tourist's appetite for souvenirs. Under the circumstances, painting seemed more profitable than surgery. Exchanging the scalpel for the brush, he earned his living by both painting and dealing in art. The latter activity led to a number of important finds, including a Michelangelo, which he sold to the National Gallery in London. The visit of a medical friend from Scotland, who arrived with a camera in 1851, encouraged Macpherson to try his hand at photography. He was soon making successful photographs from glass negatives as large as 18 × 22 inches (46 × 56 cm) of architectural monuments in and around Rome and of paintings and sculptures in the Vatican collection. Before long, he had acquired a reputation for being the best view photographer in Rome. Although the emphasis in his work was upon antiquities, occasionally he ventured into landscape photography. *Falls at Terni* was one of these rare exceptions. Some forty miles (65 km) north of Rome, Terni has as its chief attraction the Cascata della Marmore, a three-tiered waterfall created by the Roman consul Curius Dentatus around 271 B.C. by diverting the waters of the nearby Velino River. The Cascata was held in high esteem by nineteenth-century tourists, ranking among the most important of European waterfalls because of its beauty and volume.

Unlike much topographical imagery, Macpherson's views are as concerned with aesthetics as with information. Aesthetics may be even more of an issue in *Falls at Terni,* for he seems less interested in establishing such facts as its enormous height of 650 feet (195 m) than with giving a sense of the sublime. The S-curve of the falls, emphasized through the contrast between the milky white of the rushing water and the dark mystery of the surroundings that tells us little of the texture of rock and foliage, states the theme with a simplicity and an elegance that is gracefully enhanced by the oval cropping of the print.

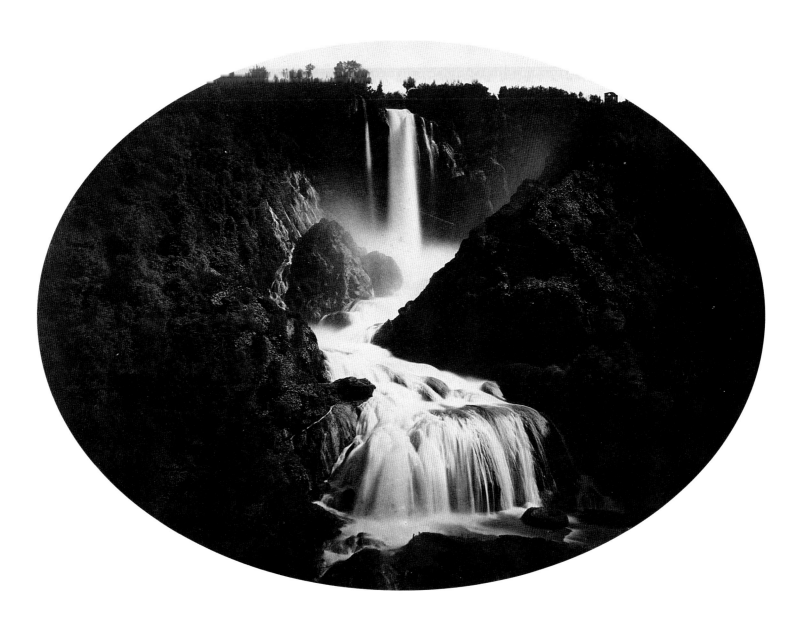

GEORGE WILLIAM ELLISSON

Canadian (Ireland?, c. 1818 – Quebec?, c. 1879)

Grey Nuns c. 1860

Albumen silver print, 20.2 × 17.6 cm
Purchased 1972

WE SHALL NEVER KNOW WHAT WENT THROUGH George Ellisson's mind when he photographed the two nuns. But one thing is clear – the symmetry pleased him. This we know from the care he has taken in the arrangement of the hands, the crosses, and the black ribbons that hang down the front of the nuns' robes. Such symmetry would seem appropriate, for not only was he faced with the challenge of photographing two persons in identical costume, it appears likely that the sitters, if not twins, were at least sisters. In order to avoid perfect repetition, however, which might be boring, the hands are not crossed identically. One nun looks at the camera, one looks away. The folds of one of the robes have an elegant sweep to the right, becoming part of the vertical column of drapery. Ellisson's photograph contains a rich physicality that is strangely at odds with the plain, even austere, sobriety that would have marked these women's lives. No doubt this provides some of its charm. In the end, however, our response is to a deeper truth than the photograph's formal beauty. We have been given a glimpse into the nature of human relationships and into the courage and vulnerability that lie within the human soul.

By the early 1860s, George Ellisson was considered to have the foremost photographic studio in Quebec City. Having arrived in 1840, possibly from Ireland, or Saint John, New Brunswick, he had established a daguerreotype studio in 1848 – one of the earliest to do so, for prior to that year the city had been served only by itinerant daguerreotypists. Ellisson was known for his stereo views of Quebec City and its environs as well as for his portraits of prominent national figures. In 1879, he sold his studio to L. P. Vallée,[1] and after that disappears from the record, leaving behind as his legacy to us a few splendid photographs, glimpses into our history.

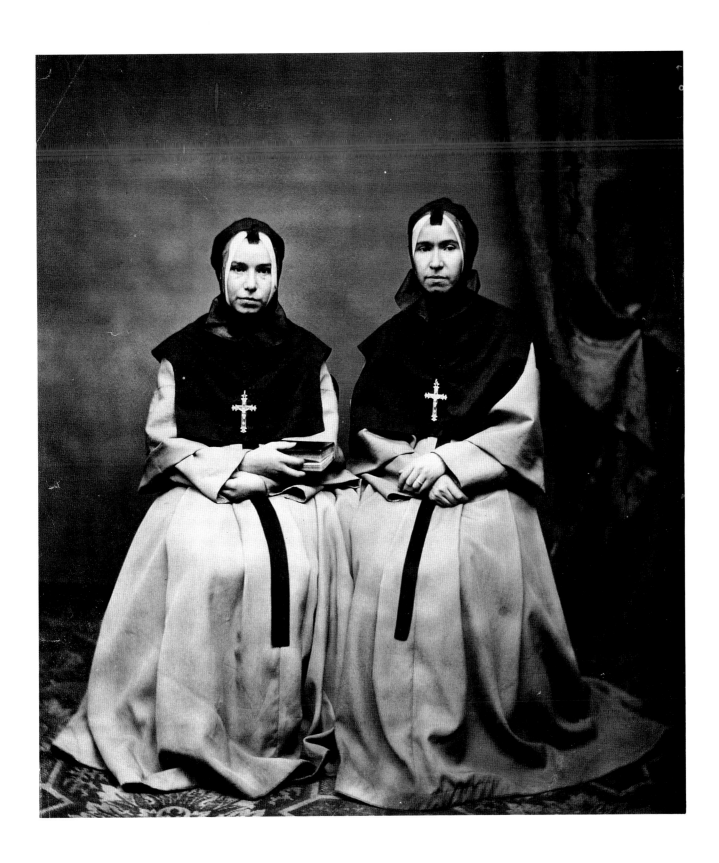

ALEXANDER HENDERSON

Canadian (Press Castle, Scotland, 1831 – Montreal, 4 April 1913)

Spring Inundation 1865 – Bank of St Lawrence River 1865

Albumen silver print, 11.1 × 19 cm
From *Canadian Views and Studies, Photographed from Nature*, c. 1865, pl. 14
Purchased 1972

ALEXANDER HENDERSON ARRIVED FROM SCOTLAND to settle in Montreal in 1855. His move to Canada appears to have been made more in the spirit of adventure than for financial gain, since he was already independently wealthy. Nothing is known of his photographic origins except that in 1859 *The Photographic News*, published in London, listed his name as the first North American member of the Stereoscopic Exchange Club, a group of amateurs who swapped stereographs of their own making.[1] He remained an amateur, in the nineteenth-century sense of that word, as one who is dedicated to an art out of sheer love rather than for monetary profit, at least until the mid-1860s, when he began to issue albums of his photographs under such titles as *Photographic Views and Studies of Canadian Scenery.* Unlike his contemporaries, including William Notman and George Ellisson, he was not tied to a studio or to the making of views from commercial necessity. Therefore, we find in Henderson's work the reflection of a personal fascination with life in the Canadian wilderness. Many of his photographs were made on hunting and fishing trips, and show camping in tents or rough-hewn lean-tos, canoes on the water, and portaging canoes through thick bush, as well as scenes of Indian encampments and of lumbering operations. His trips took him up the Lièvre River near Ottawa, down to the Eastern Townships and Lake Memphremagog, up the Saint Maurice River north of Trois Rivières, along the north shore of the Gulf of Saint Lawrence as far as Mingan and on to Manitoulin Falls in Labrador, salmon fishing on the Restigouche in New Brunswick, and fishing in Nova Scotia and on the Métis River in the Gaspé. Henderson's photographs give us an authentic picture of nineteenth-century life in the bush, unlike the scenes fabricated in the studios of his contemporaries.

In his own time, Henderson's work was recognized by the international community. He received an honorable mention in the Paris *Exposition universelle* in 1867, and a silver medal in the 1878 *Exposition.* Whether he ever relinquished his status as an amateur is debatable, for as late as the end of the 1860s his work was included in the *Amateur Photographic Association Album*, London. Although an album he produced in 1878 for the government, with photographs of the iron railway bridges between Montreal and Ottawa on the newly opened Quebec, Montreal, Ottawa, and Occidental Railway line, contains prints 11 × 14 inches (28 × 38.5 cm) in size, Henderson seems to have worked mostly with the relatively small whole-plate camera capable of making negatives 6½ × 8½ inches (16.5 × 21.5 cm). The constraints of backpacking no doubt determined the size of his equipment. We should remember that we are still in an era when enlargements from the negative are rare. Size, however, does not determine quality. Richness of texture, clarity of detail, and a fine sense of pictorial space mark the best of Henderson's work.

Light was important, as it should be for every good photographer – whether he was photographing moonlight, or the clouds, a sunset in Kamouraska, or the glaring light of a summer's day in the bush. *Spring Inundation* is an image of dreamlike fantasy. Suspended amid the fanciful calligraphy of a mirror world of reflection, the boat and its occupants float through a soft and pure light. Henderson's photograph is elegant, poetic, and pensive.

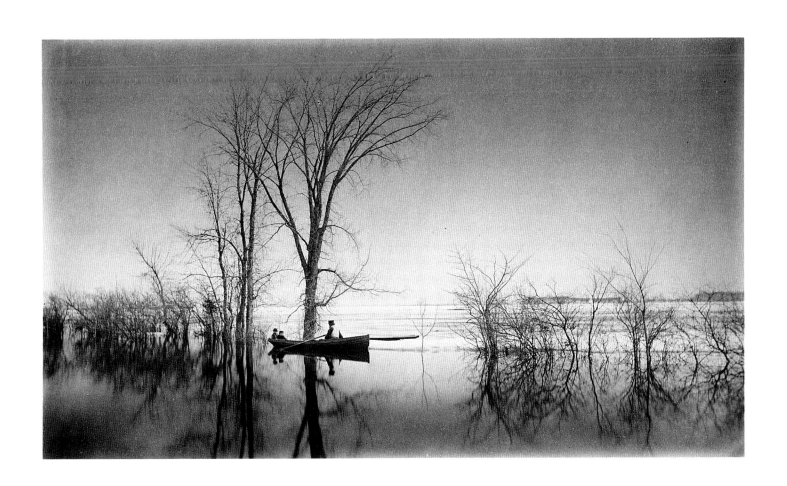

ÉTIENNE CARJAT

French (Fareins, Ain, 1 April 1828 – Paris, 1906)

Charles Baudelaire c. 1863

Woodburytype, 23.1 × 18.2 cm
From *La galerie contemporaine,* 1878
Purchased 1973

CHARLES BAUDELAIRE, author of *Les Fleurs du mal* (1857), is France's most notorious nineteenth-century poet, and certainly one of its best. Étienne Carjat has given us one of the most unremittingly truthful portraits in the history of photographic portraiture, a masterpiece of its genre, the image of a bitterly disillusioned man. Even if we have never heard of Baudelaire, we recognize the terrible beauty and power of the force that lies within this face.

Carjat originally studied industrial design, then turned to vaudeville, and in 1854 began to publish as lithographic prints his caricatures of personalities. Four years later, he apprenticed himself to photographer Pierre Petit. Like his contemporary Nadar, Carjat concentrated on photographing the French cultural and social elite during the approximately fourteen years, from around 1861 to 1876, that he operated a studio. Undoubtedly his skills as a caricaturist made him uncommonly sensitive to the essential and most telling attributes of his sitters.

In his portrait of Baudelaire, Carjat shows us, with utmost economy and simplicity, the face of a driven genius. Nothing is allowed to compete with the presence of the sitter. The eyes make direct contact with the viewer so forcefully that we are momentarily stunned. The vitality of the image is intensified by the simple manner in which the shoulder at the left of the picture falls out of focus – as though powered by a life force that cannot be constrained.

Some fifteen years after this portrait was made, it was published in the *Galerie contemporaine.* Launched in 1878, and published serially for eight years, the *Galerie contemporaine* consisted of portfolios of photographs of the great men and women in literature, art, music, science, and politics of France, made by some of the most celebrated portrait photographers of Paris, including Nadar, Pierre Petit, and Antoine-Samuel Adam-Salomon. Each portrait, printed using the woodburytype process – a continuous-tone ink printing technique that mimicked the colour and appeal of an albumen silver print so well as to be almost indistinguishable from it – was accompanied by a three- to four-page biographical text. It was photography's earliest elaborate attempt to satisfy the public's insatiable hunger for likenesses of celebrities.

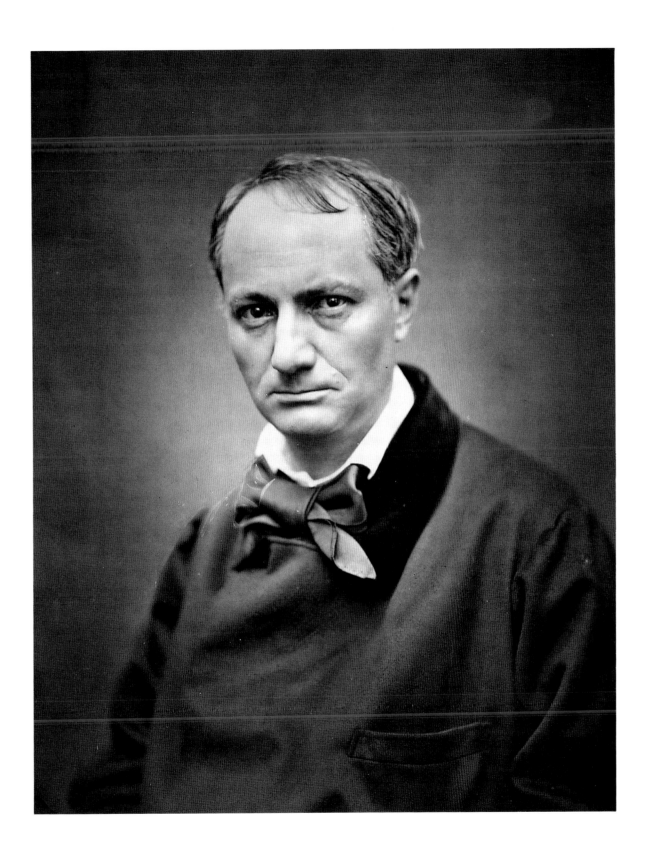

CARLO PONTI

Italian (Sagno, Switzerland, 1822? – Venice, 16 November 1893)

Venice, Church of the Salute before 1863

Albumen silver print, 26.1 × 35.4 cm
Purchased 1970

THE STRUCTURE OF CARLO PONTI'S PHOTOGRAPH of the water entrance to the Piazza San Marco, with the dome of the church of Santa Maria della Salute in the distance, is open, orderly, spacious, and rhythmical. Its architecture has been rendered with the geometric precision and rigorous accuracy that the nineteenth century had come to expect of photography. It is the perfect example of the topographical photograph, intended to provide information based upon strict observation and a loyalty to the subject. The surfaces of things are presented in minute detail and rendered with sensuous texture. Fact is piled upon fact until the viewer is overwhelmed by the tangible presence of reality. We are convinced by the information and seduced by the beauty of the photographic process.

A closer examination of Ponti's photograph, however, goes beyond the expected to reveal some surprises. "Theoretically," wrote Oliver Wendell Holmes in 1859, "a perfect photograph is absolutely inexhaustible. In a picture you will find nothing which the artist has not seen before you; but in a perfect photograph there will be as many beauties lurking, unobserved, as there are flowers that blush unseen in forests and meadows."[1] Once we have feasted our eyes on the architecture and its spaces, our attention may be drawn to the amorphous, cocoon-like shapes to the left of the quay, dark blurs that are so out of place in Ponti's photographic world of frozen clarity, regularity, and precision. This city that appeared at first to be devoid of human activity has, in fact, a bustling waterfront life. During the camera's lengthy exposure, gondolas have come and gone, discharging passengers. And what has become of them? Did they all immediately transgress the barrier of time to disappear into the ages? If we look more closely, we shall see them near the centre of the terrace, where they remained just long enough to register a shadowy presence. Look again and we shall see by a lamppost a ghostly ladder and a ghostly figure at its top, ministering to the lamp. The operation has been repeated a second time during the exposure as the same ghostly ladder and figure appear at the next lamppost. These fleeting shapes, the residual images of people's actions, remind us that the city we see here, with its air of solid timelessness, was built and is occupied by ephemeral and transient human beings. This tension between such opposites gives us pause to wonder about the enigma of time. Perhaps therein lies the real theme of Ponti's photograph.

Ponti left Switzerland for Venice, probably sometime in the 1840s, where he became a successful dealer in optical instruments, eventually making camera lenses. By 1854, he was making and selling photographs of Venice. Although he photographed in Rome and parts of northern Italy, including Padua and Verona, he is best known for his images of Venice, and especially for his views along the canals, with motionless water looking like burnished bronze.

SAMUEL BOURNE

British (Mucklestone, 30 October 1834 – Nottingham, 24 April 1912)

On the Marqual Canal, Kashmir July – September 1864

Albumen silver print, 23.5 × 29.8 cm

Gift of Donald C. Thom, Ottawa, 1981

WHEN SAMUEL BOURNE WROTE FROM INDIA in 1865 that "the photographer can only deal successfully with 'bits' and comparatively short distances"[1] he was expressing his frustration with the inability of the camera to deal with the hugeness of the Indian landscape and especially with the Himalayan mountains. He was the first to photograph in the Himalayas, and during one of his two arduous expeditions he set a record at the time for photographing at the highest elevation – 18,600 feet (5,580 m) above sea level.

Bourne had begun to photograph as an amateur in England in 1853. His passion was landscape photography, and his search for picturesque views took him to the highlands of Scotland, to Wales, to the Lake District, and eventually to India. Abandoning his position as a bank employee in Nottingham, he spent the next six years in India, from January 1863 to the end of 1869, as a professional photographer for the publisher Charles Shepherd, of Simla. The firm, now known as Bourne and Shepherd, opened a branch at Calcutta in 1867. Bourne's photographs of exotic Indian scenery quickly gained a worldwide reputation.

But Bourne was more at home with the English landscape, a landscape of a more human scale, of luxuriant foliage and quiet waterways, a landscape of the picturesque. That is why, during his Indian sojourn, he was happiest photographing in Kashmir, where he spent the summer of 1864. Here, the rivers, lakeside views, and houses of Srinagar that "lean and slant in all directions as though only waiting for a push to topple them over"[2] gave him the picturesque subjects with which he was most comfortable. He was especially intrigued by the bridges that spanned the canals of the city, waterways "overhung with four-, five- and six-storied wooden houses, which are generally built on props and leaning, some one way and some another, spanned in several places with a single-arched stone bridge dark and hoary, the whole here and there relieved by vines and creepers…"[3] Although in *On the Marqual Canal, Kashmir* we are looking at a landscape of precise fact, which is part of its charm, we are also experiencing Bourne's emotional response to the scene – a peaceful view in which the luminous effect of sky and water is set off by dark shadows along the banks of the canal and under the bridge.

Bourne recognized a fundamental truth about photography when he wrote about "bits." Only by carefully selecting a detail that symbolizes the whole, by singling out the most suggestive aspect, does the photographer order the world and give it meaning. With his view of the Marqual Canal, Bourne has succeeded in doing just that. This "bit" gives us more insight into the character of Srinagar than any overall view of that city could provide. In addition, his sensitivity to the drama of light and shadow and to the design of shapes across the picture plane is pleasing to the eye. Further, this bit of the landscape is rich with a number of other bits that could be isolated to make individual pictures in their own right. Bourne's photograph is a landscape of details, of pictures within pictures for infinite study.

DAVID KNOX

American (active 1860s)

A Fancy Group, in Front of Petersburg August 1864

Albumen silver print, 17.3 × 22.4 cm

From Alexander Gardner, *Gardner's Photographic Sketch Book of the War,* 1866, pl. 76

Purchased with funds provided by Phyllis Lambert, 1976

DAVID KNOX IS KNOWN TO HAVE BEEN on Mathew Brady's staff as a field photographer at the beginning of the Civil War. Later, he may have joined Alexander Gardner's group of photographers attached to the Army of the Potomac. Since only four of the 100 images in Gardner's *Photographic Sketch Book of the War* were made by Knox, all at Petersburg, it is possible that he was employed principally to make photographic copies of army maps, the main purpose of Gardner's unit. Petersburg was an important rail centre near Richmond, Virginia, and a strategic point for the defence of the Confederate capital. In June 1864, the Union army began a siege of the city that ended 9 April the following year with General Lee's surrender of his Confederate army.

Not all the photographs in Gardner's *Sketch Book* show the ravages of war. Many give us a picture of how an army spends much of its time – waiting. *A Fancy Group in Front of Petersburg* depicts northern troops encamped near the city during the siege. As Gardner commented in his accompanying text, "The monotony of camp life was relieved by every variety of amusement that was known, or could be devised." But, he was quick to point out, cockfighting, shown in the photograph, "was quite unusual, and seldom permitted,"[1] for reasons of cruelty. We might, however, question Gardner's statement, for if we are to judge by their expressions, these "fanciers" of cockfighting are not concerned with cruelty to animals. On the contrary, they appear to be thoroughly entertained. What is unusual about the photograph, which had to have been carefully posed because of the cumbersome photographic equipment employed, is the degree to which the photographer has endowed his picture with spontaneity. Out of time he has carved a fleeting moment in which the intense concentration of the participants is almost palpable.

A Fancy Group tells us that time was passed in other pursuits, as well. The soldier seated to the left of the pole at centre holds a copy of the *Atlantic Monthly,* to which Oliver Wendell Holmes, who occasionally wrote about photography, was a frequent contributor – so that its discreet presence in this photograph takes on a special meaning. But the strength of Knox's image does not lie only in its narrative content. Its visual qualities are highly photographic. Only photography could render the feathery texture of pine branches in such detail, or record the play of light on the tents' surfaces with such subtle tones. Light and shadow, combined with the intricacies of space and depth, become in Knox's photograph both a sensual pleasure and an intriguing puzzle for the eye.

ALEXANDER GARDNER

American (Paisley, Scotland, 17 October 1821 – Washington, D.C., December 1882)

A Sharpshooter's Last Sleep, Gettysburg, Pennsylvania 6 July 1863

Albumen silver print, 17.7 × 23 cm
From *Gardner's Photographic Sketch Book of the War*, 1866, pl. 40
Gift of Phyllis Lambert, 1976

PHOTOGRAPHERS HAVE OFTEN CHERISHED THE HOPE that their images will improve the human condition. Photography has never prevented a war, although photographs have sometimes helped bring about its end. When Alexander Gardner published his *Photographic Sketch Book of the War* a year after the Civil War had ceased, he intended to show "the blank horror and reality of war, in opposition to its pageantry. Here are the dreadful details! Let them aid in preventing another such calamity falling upon the nation."[1] The two-volume publication was a commercial failure: the conflict was over and Americans wanted to forget. It contained 100 mounted albumen silver prints made from negatives by himself and photographers in his employ, each accompanied by a text written by Gardner. Although these were not the first photographs to show the grisly details of battle (Felice Beato photographed the Indian Mutiny in 1858 and the Opium War in 1860), the Civil War was the first to receive extensive coverage showing the human carnage of battle.

Gardner grew up in Paisley, Scotland, became a reporter, then editor of the Glasgow Sentinel, and acquired a reputation for his knowledge of the wet collodion process in photography. For this reason, the daguerreotypist Mathew Brady paid his fare to America in 1856 to be his assistant. When Brady began to photograph the Civil War in 1861, Gardner was present. In 1863 he formed his own photographic unit under contract to the Army of the Potomac. Because the wet collodion process was slow and cumbersome, we see only the aftermath of fighting in these views.

The Union and Confederate armies clashed at Gettysburg in the first three days of July 1863, with 43,000 casualties. When Gardner and his associates arrived, the North had won, and gravediggers were burying the dead. The only bodies left were those of Confederate soldiers and they became the subject of Gardner's most moving photographs. Probably the corpse in *A Sharpshooter's Last Sleep* was one of the last still unburied, for it was moved to be photographed in several locations. It is doubtful, however, that this soldier was a sharpshooter because the rifle shown is the wrong type.[2] Nor was this the "Devil's Den" from which they operated. The body is lying in the "Slaughter Pen," between Big Round Top and the Den. Gardner made more than one photograph at this site, moving the cup and the hat to different positions between exposures. Obviously, he thought it important to illustrate the legend of the southern sharpshooters, who had wreaked such havoc on the northern troops from their hiding places in the Den forty yards away.

But none of this manipulation lessens the impact of the image. The lone corpse we see here becomes a symbol for all the men who died in battle so tragically young, the disorder of rocks, tree roots, and branches a fitting environment. Nature was out of joint. Part of the strength of *A Sharpshooter's Last Sleep* lies in the tension between its shocking realism and the abstracting power of both the camera and the albumen print as the body takes its place among the rest of the shapes on the flat picture plane. The result is an emotional detachment, a detachment that has made so many of the Civil War photographs the most potent images of war ever produced.

W. L. H. Skeen and Co.

British (active Ceylon, 1862 or 1863 – 1903)

Breadfruit between 1862 and 1903

Albumen silver print, 27.9 × 21.6 cm
Purchased 1976

PHOTOGRAPHS SUCH AS THIS WERE made to satisfy the nineteenth century's desire for information about the exotic. W. L. H. Skeen and Company was in the business of supplying topographical views to satisfy that need. Their catalogue of photographs ranged through portraits of native peoples, landscapes, archaeological ruins, and documentation of the commerce and industry of Ceylon (now Sri Lanka). Subjects included the growing, harvesting, and shipping of tea, coffee, cinnamon, cocoa, and rubber, and as well as other aspects of the island's economy. We may assume that Skeen's photograph of breadfruit, a food staple of the island, fell into the latter category.

The firm of Skeen and Co. had its origins in J. Parting's daguerreotype studio, opened in 1854 at Colombo. Purchased by the island's government printer, William Skeen, in 1860, it was operated by his son, William Louis Henry Skeen, from about 1862 or 1863, when he returned from studying at the London School of Photography in England, until his death in 1903. During the 1860s, W. L. H. Skeen worked in partnership with John Edward Wilshaw; and then, beginning in 1878, with his brother, F. A. E. Skeen, for about the nine following years. As with other photographic firms of this kind, it is often difficult to ascribe authorship to individual photographs, although an exhibition review in the *Photographic News* from 7 January 1881 refers to "The finest instantaneous sea views...photographed by Mr Skeen."[1]

We may be sure that whoever made *Breadfruit* took considerable pleasure in recording the intricacies of the fruit's geometry. From the beginning, photography had been used for the close observation of nature's forms. W. H. F. Talbot's photogenic drawings (photograms) of plant specimens and the daguerreotypes made through a microscope by the scientist Leon Foucault in the 1840s provide us with early examples of such imagery. Talbot saw that an important advantage of photography lay in its ability "to introduce into our pictures a multitude of minute details which add to the truth and reality of the representation, but which no artist would take the trouble to copy faithfully from nature."[2] This ability of the medium to copy every accident of light and shade, every line and indentation, as witnessed in the carefully delineated triangular facets of the breadfruit, may remind us of the obsessive and fantastic architectural drawings of the eighteenth century mannerist Giovanni Battista Piranesi, or, closer to our own time, of the work of M. C. Escher. Because the photographer has chosen to isolate the breadfruit from its context and to photograph it in a flat light, thus emphasizing the graphic quality of the fruit's scaly armour, the object acquires an ambiguous quality both as to its size and its substance. We are intrigued by images of the minutely depicted, perhaps from childhood memories of the close examination of small things. When, however, we add to that the mathematical formalism and nightmarish nature of the breadfruit's exterior as shown in the Skeen photograph, this combination of the logical and irrational reserves a special *frisson* for us, not unlike that which we experience before a surrealist work of art.

THOMAS ANNAN

British (Dairsie, Fife, 1829 – Lenzie, 11 December 1887)

Close, No. 193 High Street 1868

Carbon print, 28.1 × 23.1 cm
From *Photographs of the Old Closes and Streets of Glasgow*, 1878 or 1879, pl. 9
Purchased 1981

THOMAS ANNAN WAS ORIGINALLY A COPPERPLATE ENGRAVER in Glasgow. In 1855 he took up photography, acquiring a reputation for art reproductions, views, and portraits. The latter were said to show the influence of his friend David Octavius Hill. By the 1860s, he had become the leading commercial photographer in Glasgow. The work for which he is best known today is his documentation of the notorious slums of that city.

During the first half of the nineteenth century, Britain's population shifted from predominantly rural to largely urban. Only London surpassed Glasgow in its growth, the latter increasing five-fold between 1800 and 1860. Since no change to the inner city occurred during these years, the growth of slums was inevitable. By 1866, they had become so unsanitary that the city council embarked upon a massive urban renewal project, the first of its kind anywhere. Eighty-eight-acres were to be completely demolished and modern housing rebuilt for the poor. Annan was commissioned to photograph the area with its old closes and wynds as a record of the historic Glasgow that was to be razed. He produced an album with thirty-one albumen silver prints in at least two copies in 1868. By 1877, the housing project had ground to a halt. Annan was asked to add more photographs to the original group and produce albums that could be used to rekindle public interest. Late in 1878 or early 1879, the Glasgow City Improvement Trust published 100 bound copies of *Photographs of the Old Closes and Streets of Glasgow,* with forty carbon prints by Annan. It was re-issued twice in 1900 with fifty photogravure plates in editions of 100 each.

The publication is important for several reasons. Although Annan was not a social reformer, it constitutes the first photographic documentation of the first major slum clearance project. Partly meant to record the "many old and interesting landmarks"[1] about to disappear, reflecting the general concern that Glasgow was destroying its historical roots, Annan's work was in the tradition of Hill and Adamson's architectural views of Edinburgh made between 1843 and 1848, of France's *Commission des monuments historiques* produced from 1851, and of Bool and Dixon's photographs made for the Society for Photographing Relics of Old London in the 1870s and 1880s.

His photographs, however, are as much symbolic and interpretive as they are antiquarian records. In *Close, No. 193 High Street*, the quality of Annan's observation may be seen in the structure of repetitive shapes that form the picture. He positioned his camera so that the rectangles of doorways, windows, and sheets provide a strong vertical thrust to the composition, enhanced by the horizontal rhythm of highlights on both sets of stairs. By this means, the restricted and narrow confines are emphasized. The only people in evidence are vaporous shapes of two seated children whose lives have been recognized only marginally by the camera, but the laundry provides ample evidence of human existence and of crowded living conditions. The rich tones of the carbon print emphasize the sad and gloomy nature of that existence. If his lengthy exposure time has imbued the laundry with ghost-like qualities, it has been to the picture's advantage, for these sculptural forms seem animated by the breath of some spectral life, poignant reminders of their human associations.

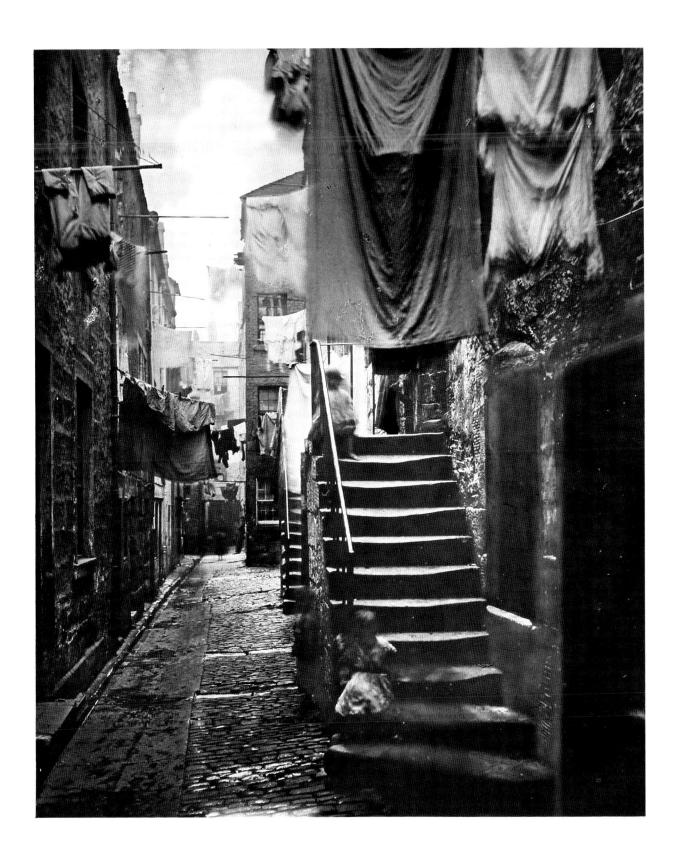

JULES ANDRIEU

French (active 1860s – 1870s)

Disasters of the War: Pont d'Argenteuil 1870 or 1871

Albumen silver print, 37.7 × 29.4 cm
Purchased 1975

IT IS A SAD COMMENTARY ON HUMANITY that disasters figure so prominently among photography's subjects. But no other medium is so capable of bringing us the bad news in such convincing detail. Jules Andrieu made his living in the 1860s and 1870s as the official photographer for the Admiralty from his Paris studio, first located at 33 Montholon and later at 7 Saint-Lazare.[1] In 1868, he made stereographic views of the Near East, including Syria, Egypt, and Palestine, with an emphasis on the Holy Land. He also published stereo views of the Pyrenees, Italy, Switzerland, and Spain. His name disappears from the list of Paris photographers in 1876.[2]

Although the subject of his series *Disasters of the War* might suggest he was a forerunner of the photojournalist, in fact he was a commercial photographer who saw such material as potentially profitable. The series focused on the destruction of Paris and surrounding area during the Franco-Prussian War of 1869/70. The German bombardment wrought heavy damage, as can be seen in Andrieu's photograph. His choice of a head-on camera position, with the massive piers dominating the view in perfect symmetry, seems designed to emphasize the enormity of the devastation. The freight car lying on its side, half hidden by the left pier near the far shore, subtly reminds us of the wider implications of the destruction. There appears to be no other evidence of human activity, until we notice the ladder leaning against the building in the upper left corner (perhaps a sign of repairs) and the tiny figure seated on a box to the immediate left of the bridge at the top of the embankment.

Detail is so lovingly rendered in the photograph that we are tempted to question reality. From the rubble in the foreground to the rivets on the girders and the lines of the railway tracks in the background, everything is so precisely delineated that we find ourselves in a world of heightened actuality, almost like that of a carefully constructed toy model. The slow exposure, together with the colour of the albumen print, has turned the water into a thick caramel-like soup, very unlike water. Into this, the rigid forms of the bridge's railings are dipped and appear to melt away in two curving ripples. In *Pont d'Argenteuil,* we experience that strange transformation of reality which is characteristic of the photograph and which, to the unwary viewer, can be so misleading. Photography, more than any other pictorial medium, falls prey to confusion over the nature of the viewing experience, over the relationship of subject matter to image. We forget all too easily that the subject matter in a photograph is experienced by the viewer only at second-hand. What we really encounter while looking at a photograph is a two-dimensional sheet of paper, with a surface marked by shapes and tones that function as signs and symbols. This is our actual experience. The ambiguity between the vicarious and the first-hand creates a tension in the viewer that gives photography its mystery. Often enough, the more the photograph appears to function as a mirror, the more the mystery deepens. It is at this point, too, that a photographer's style may be at its most elusive – sensed, but indescribable.

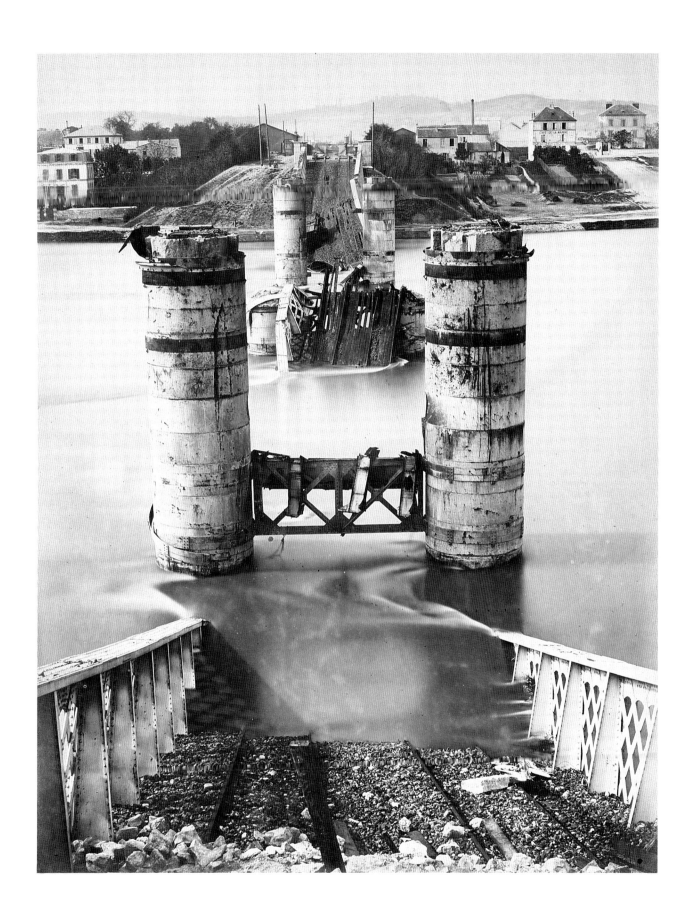

JULIA MARGARET CAMERON

British (Calcutta, India, 11 June 1815 – Kalutara, Ceylon, 26 January 1879)

Alethia (Alice Liddell) October 1872

Albumen silver print, 32.4 × 25.7 cm

Purchased 1974

WE SELDOM THINK OF THE HEROINE of *Alice in Wonderland* as a grown woman. Yet here she is, at age twenty, the person for whom as a young girl Lewis Carroll had written his stories.

Self-taught, Julia Margaret Cameron began to photograph only in middle age. In 1863, during her forty-ninth year, while living at Freshwater on the Isle of Wight, her eldest daughter presented her with a camera to distract her from the loneliness brought on by her husband's absence in Ceylon. It was a primitive affair, no more than two wooden boxes that slid one into the other to permit focusing, and an enormous brass barrel lens that produced a 9 × 12 inch (23 × 30 cm) wet collodion glass negative. Later she was to buy a 12 × 15 inch (30 × 38 cm) camera. The chicken-house was soon converted into a studio and the coal shed into a darkroom, and in January 1864 she announced her first success, a portrait of a little girl called Annie. Family members, servants, neighbours, and visitors became her subjects. Since among her friends were counted some of the most famous poets, writers, artists, scientists, and civil servants of her time, the body of work she produced provided a gallery of the fair women and famous men of that era.

Professional photographers found her technique clumsy. Images were out of focus. Subjects moved during exposures, which were sometimes as long as ten minutes. Her photographs lacked the crisp finish of the professional studio. Cameron was, in fact, the greatest innovator in nineteenth-century photographic portraiture. Her emphasis upon the dramatic close-up, rather than the usual three-quarter or half-length view, represented a radical departure. More than that, her out-of-focus technique, stumbled upon from the beginning either by accident or design, became the basis for the pictorialist school that began to flourish at the end of the nineteenth century. As with Hill and Adamson, her purpose was to emphasize form and character through the broad effect, a quality she achieved through lighting and by throwing much of her subject out of focus.

We are surrounded by things, as art historian Kenneth Clark has said, with a life and structure different from our own.[1] The artist's purpose is often to find a meaningful harmony between ourselves and the world in which we live. Cameron frequently gave her portraits allegorical titles to draw our attention to the presence of deeper meanings in her images. To her portrait of Alice she has given the title *Alethia*, after the goddess of fruit trees – an apt title, reflecting as it does the symbolic union between the foliage and Alice's long hair, flowing in waves from the tangled branches.

The role that the photographic print has played in this bonding between actuality and symbol is important. It lies in the process of abstraction. The artist who is sensitive to the materials of the craft will instinctively understand that it is the properties of physical substances that make possible the translation from one level of meaning to another. The tones of the hair and the leaves in *Alethia*, for instance, are united by the warm tones of albumen silver in the print, thus turning a mirror image of reality into a moving and mystical statement about that reality.

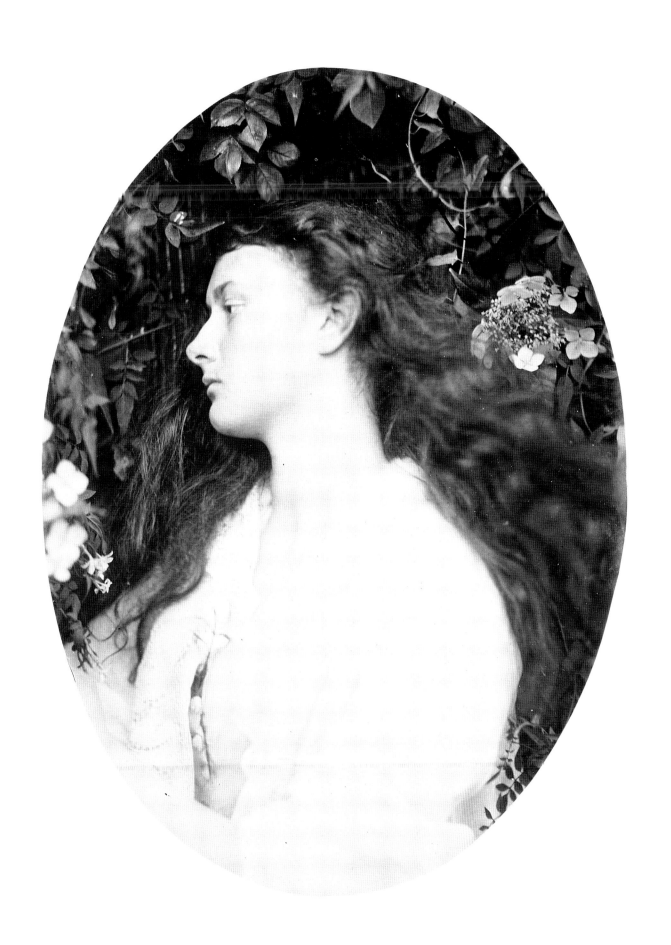

CHARLES LEANDER WEED

American (New York, 17 July 1824 – Oakland, 31 August 1903)

Yosemite Valley from the Mariposa Trail: California, no. 1 1865?

Albumen silver print, 39.9 × 51.6 cm
Purchased 1972

"STANDING ON THE BARE GROUND," wrote the American philosopher Ralph Waldo Emerson in 1836, "my head bathed by the blithe air, and uplifted into infinite space – all mean egotism vanishes. I become a transparent eyeball; I am nothing; I see all; the currents of the universal Being circulate through me; I am part or parcel of God."[1] The metaphysical relationship between human beings and nature these lines describe was a belief widely held in mid-nineteenth century America. Emerson's transcendentalism, an idealistic philosophy that saw in sensuous experience the existence of the spiritual, was an outgrowth of the romantic movement. In the visual arts, it manifested itself in the work of such painters as the American Asher B. Durand and the German Caspar David Friedrich, in which individuals are sometimes portrayed gazing out over a wild and sublime landscape, giving the viewer a human link with that landscape and suggesting a philosophical attitude toward the relationship between humankind and the universe.

Yosemite Valley is located in central California, east of San Francisco. Tourists began to travel there in 1856. Three years later, Weed was the first to photograph its wonders, but it is believed that his mammoth plate views of the valley were not made until 1865, possibly with Eadweard Muybridge as his assistant. How much of the compelling attraction of this photograph lies in its subject matter, and how much is the result of the quality of Weed's observation and the richness of the print's tone and colour is difficult to decide. He has certainly succeeded in translating the awesome nature of the scene into an emotional experience. The nineteenth century reverence for sublime beauty is present in the two people who inhabit the landscape – the man (who may be Muybridge) as a dark, silhouetted figure gazing out over the vista, and the woman sitting on the brink of the precipice at the picture's left, reading a book. With the inclusion of both male and female in such a primeval setting, the reference to Adam and Eve – in Victorian clothing – is hard to ignore. Even the man's attachment to the tree, which, in its stark formality, unites heaven and earth, has a symbolic content that may or may not have been intended by the photographer. As for the woman, she reflects a typical nineteenth century romantic attitude: nature contemplated through literature. Was she reading Wordsworth? Coleridge? Or perhaps even the lines by Emerson quoted above? Whatever pantheistic outlook is implied by her activity on that precarious perch, the photographer was not gambling on the protection of a benign god. From the lower left corner of the photograph, a stout rope snakes through the brush toward the edge of the cliff, no doubt to be tied around the woman's waist.

Yosemite Valley is a superb example of a photographer's artistry brought to bear on the rendering of the world into albumen and silver on a two-dimensional sheet of paper. The change in values between the darker tones implies spatial depth, but the difference is handled so subtly that the picture plane becomes an arena for a rhythm of abstract shapes, lines, and textures. The stark, white space of the sky emphasizes the delicate line of the horizon and is a foil to the density of the photograph's textures.

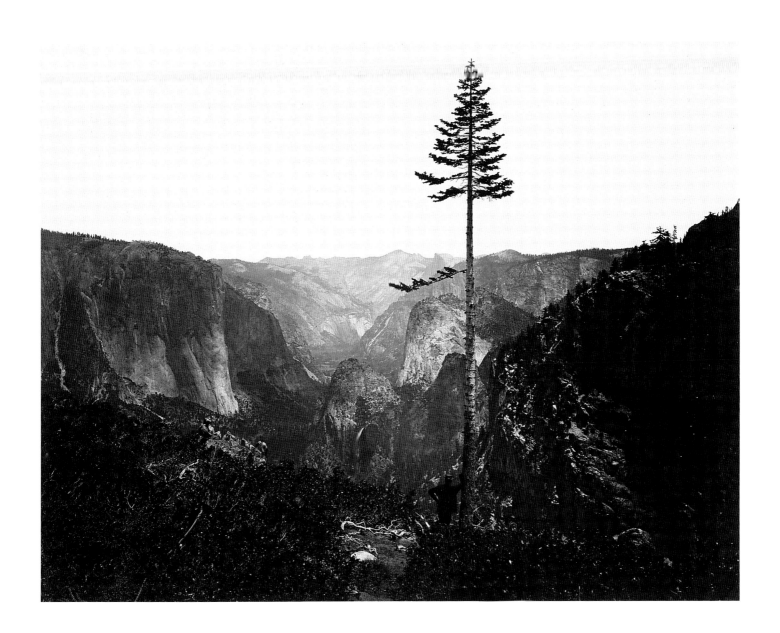

TIMOTHY H. O'SULLIVAN

American (Ireland?, 1840 – New York, 14 January 1882)

Aboriginal Life among the Navaho Indians
Near Old Fort Defiance, New Mexico 1071

Albumen silver print, 27.6 × 20.2 cm
From *United States Explorations and Surveys West of the 100th Meridian, 1874–75*
Purchased 1986

KNOWN AS A "SHADOW CATCHER," T. H. O'Sullivan was eyed suspiciously by the aboriginal inhabitants of the southwest, who were fearful that his camera might capture their souls. How he managed to photograph this group is not known, but we assume he may have resorted to bribery or threats.

O'Sullivan is thought to have been born in Ireland and to have arrived in the United States at the age of two. He began to apprentice as a photographer around age sixteen. By the end of the late 1850s, he was working in Mathew Brady's Washington studio under Alexander Gardner's management. During the Civil War, he became superintendent of field work for the Army of the Potomac, making some of the most moving photographs to come out of that war. The experience prepared O'Sullivan for the hardships of the lengthy surveys conducted by the War Department in the American southwest beginning in 1867. After his last expedition in 1874, he continued to work for the government in Washington, but ill-health forced him to resign in 1880. Two years later, he died of tuberculosis.

The mandate of Lieutenant George Wheeler's expeditions to the region of the Grand Canyon from 1871 to 1875 was to gather geological, meteorological, and topographical information for the army, with special reference to mining possibilities, and the best routes for troop movements (required because the Apache and Navaho wars still continued intermittently). O'Sullivan, hired as the expedition's civilian photographer, became the first to photograph these regions. The albums he published attracted attention because of the exotic magnificence of the harsh land they portrayed. Today, we recognize that O'Sullivan's intuitive grasp of his subject matter and whole-hearted exploitation of the camera's special way of seeing combined to bring a new understanding to landscape art. Although his purpose was to provide a clear and direct report on the land's potential, his photographs occasionally reminds us that the regions were already home to the Navaho. Then scattered throughout Arizona and New Mexico, it is believed they had migrated from Canada sometime between 900 and 1200 A.D. Essentially farmers, at the time of the photograph they were also skilled in the crafts of painted pottery, sand painting, silversmithing, and weaving. In commenting on *Aboriginal Life among the Navaho Indians* O'Sullivan wrote that the woman "is weaving blankets on the native loom ... of the best quality."[1] As an ethnographic photograph it tells us a number of things – about Navaho clothing, weapons, the structure of the upright loom, and their method of drying corn. In fact, it gives us so much information, rendered in such a careful and precise manner, that we might be looking at a museum diorama, an interpretation supported by the out-of-focus background that suggests a shallow space. The group of people seem to be immobilized and abandoned at the centre of a timeless and static capsule, while the rest of the world races on in a frantic whirl behind them. A photograph often has more meanings than the photographer intended. Although O'Sullivan may not have been reflecting upon the passing of a way of life, it is abundantly clear to us now that his photograph contains a sad premonition of its extinction.

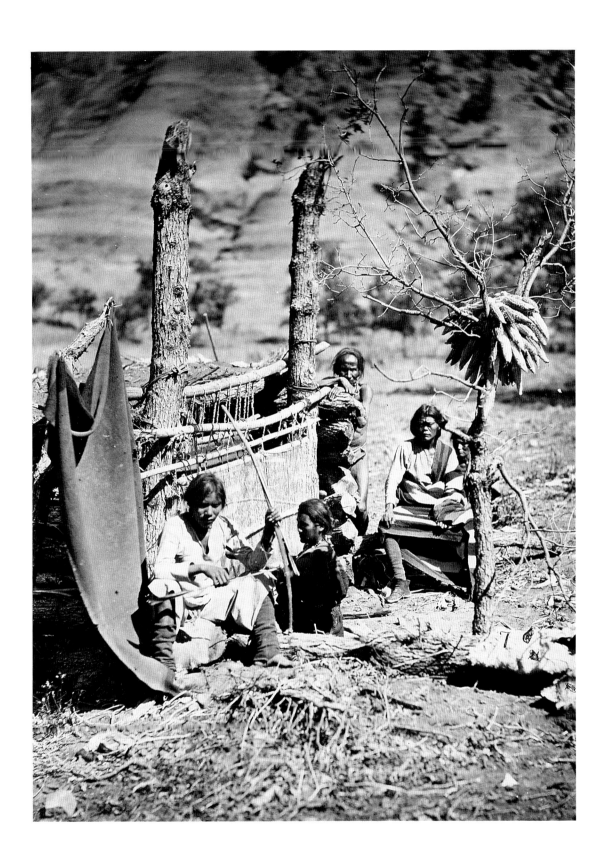

JOHN BURKE

British (active c.1860 – 1907)

Ruins of a Temple at Norwah October – November 1868

Carbon print, 20.2 × 15.1 cm
From Henry Hardy Cole, *Illustrations of Ancient Buildings in Kashmir*, 1869, pl. 34
Purchased 1976

THE ARCHAEOLOGICAL SURVEY OF INDIA was established by the British Secretary of State for India in 1862. Its purpose was to inventory the country's monuments and make recommendations for their preservation. Henry Hardy Cole, a lieutenant in the Royal Engineers and Superintendent of the Survey in the Northwest Provinces, conducted an expedition to record temples in Kashmir from 10 October to 3 November 1868. He hired John Burke, a commercial photographer from Peshawar and Murree, now in Pakistan, to produce photographs that would supplement the usual plans and drawings, an innovation for the survey. Perhaps Burke was chosen because of his proximity to Kashmir or perhaps for his military connection – he specialized in scenes of military life and, later, became known for his photographs of the Second Afghan War (1878 to 1880). In 1869, *Illustrations of Ancient Buildings in Kashmir*, with forty-three carbon print photographs by Burke, was published in London.

The temple at Norwah, shown here, was one of two near the village of Pathan, sixteen miles (25 km) from Srinagar. It was described by Cole as being "circular in the interior and square externally," with only the north face still standing.[1] Much of it was buried under fourteen feet (4 m) of rubble. According to Cole, a king named Sankara Varmma, who reigned from 883 to 901 A.D., was supposed to have built both temples. Although the temple is small, Burke chose a viewpoint that emphasizes a massive quality in its structure. Both this and the rich, velvety tones of the print give the building a dark and brooding presence. The tension between figure and ground – between the bulky mass of the stones and the open space of the sky – is so riveting that, at first, we may miss the subtle presence of the two rods forming a cross in the lower centre of the picture. How strangely out of place they seem with their simple and delicate geometry. Burke has borrowed two surveyor's rods, or range poles, to establish the building's scale. These usually have alternating one-foot bands of red and white and are used as sighting points to measure distances. So much for their practical function. The more we study these poles, however, the more they take hold of the imagination. Often the incidental in a photograph acquires a significance beyond its original intention. Of the forty-three photographs in the book, thirty include range poles, sometimes prominently located, other times so discreetly located as to be almost hidden. As we proceed through the book, we find ourselves hunting for the rods. We cannot be but impressed by their peripatetic nature. Conceptual art, in the sense of images recording abstract ideas imposed upon the landscape, is a recent phenomenon. There seems little possibility this was Burke's intention, but for modern eyes the interpretation is difficult to avoid. One of the rewarding aspects of a work of art is the potential it has for reaching beyond the artist's conscious purpose once it is given to the world. Sometimes the eye knows more than the mind at the time of a picture's making. Even if we see only this one photograph from the series, we are inclined to interpret the presence of the rods as a commentary on the interfacing of two cultures and two ages.

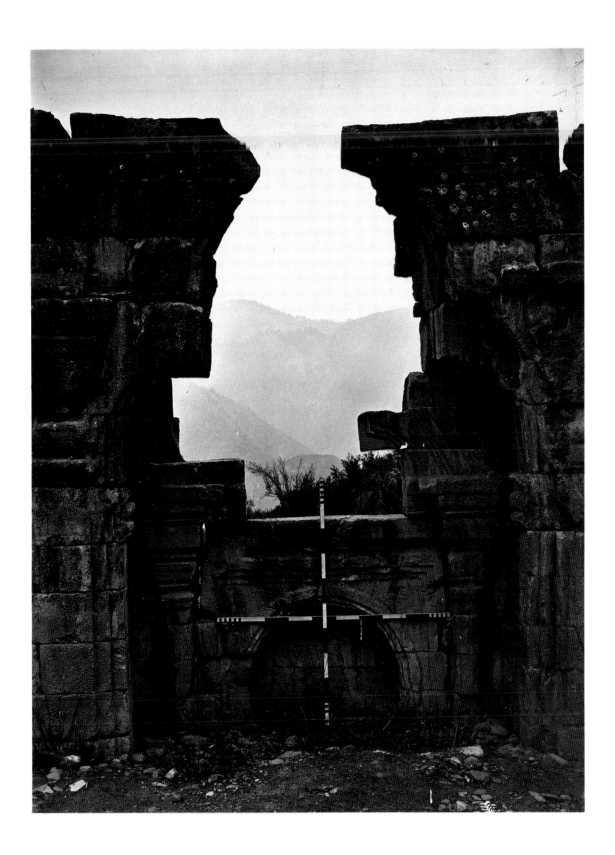

WILLIAM BELL

American (Liverpool, England, 1830 – Philadelphia, 28 January 1910)

Perched Rock, Rocker Creek, Arizona 1872

Albumen silver print, 27.6 × 20.3 cm

From *United States Explorations and Surveys West of the 100th Meridian,* 1874–75

Purchased 1986

NO DATE IS KNOWN FOR WILLIAM BELL'S ARRIVAL in the United States, but he was in Philadelphia at the beginning of 1848, where he operated a daguerreotype studio with his brother-in-law, John Kee. In 1850, he opened his own studio. As a Civil War photographer, Bell is best known for his work as Chief Photographer for the Army Medical Museum, producing some of the most disturbing images of the war. In 1878, he was photographer for the Pennsylvania Railroad. Photography continued in the family, for his daughter Louise and her husband, William Rau, also were photographers.

No doubt Bell's experience as a field photographer and his association with the war department, which sponsored the geological surveys west of the 100th meridian, led by Lieutenant George Wheeler between 1871 and 1875, helped qualify him for the 1872 expedition into Arizona. His mandate was to collect visual evidence to illustrate the theory of mechanical geology that was favoured by the expedition's geologists – who believed that all changes to the earth's surface were the result of movement caused by the earth lifting or subsiding, by volcanic flows, or by erosion. The perched rock we see in Bell's photograph is in the vicinity of the Grand Canyon. Such precariously balanced boulders are formed in place by erosion or transported to their present sites by tectonic forces or glaciers. This particular rock is a dramatic example of geological change through wind erosion.

In *Perched Rock, Rocker Creek, Arizona,* the act of seeing in which Bell has engaged is both scientific and poetic. The subject has been centrally framed as is fitting for its importance. Its surface detail has been recorded with precision. Reality is tangible. The figure has been introduced to give a sense of scale. But the fact that Bell should choose to show the figure crouching is evidence of his artistic sensibilities. A visual association is being made between the figure's curved back and the edge of the rock's undersurface, while dramatic tension (and perhaps even humour) has been introduced through the visual precariousness of the relationship between rock and man. The deep tones of the albumen print add to the rock's presence and imbue it with both menace and mystery. The photographer begs us to look upon his subject bare, and in it see an icon for the forces that shape the world in which we live. His image falls into a class of photographs that, without explanatory captions, are ambiguous and bizarre, and with captions are matter-of-fact records of specific things. The psychological tension provided by the two divergent levels of communication frequently creates out of a mundane event a surrealism of a magnitude beyond the reach of any other visual medium. The cool, vernacular style of Bell's photograph, tense with immobility, is simplicity itself. But the relationship (both spatial and psychological) of rock, man, and universe, fixed for contemplation, poses complex questions about the manner in which the things of our world are bound up with the things that go on in our minds. In the end, the importance of the photograph lies not in its subject, but in the photographer's intimate and subtle perception of it.

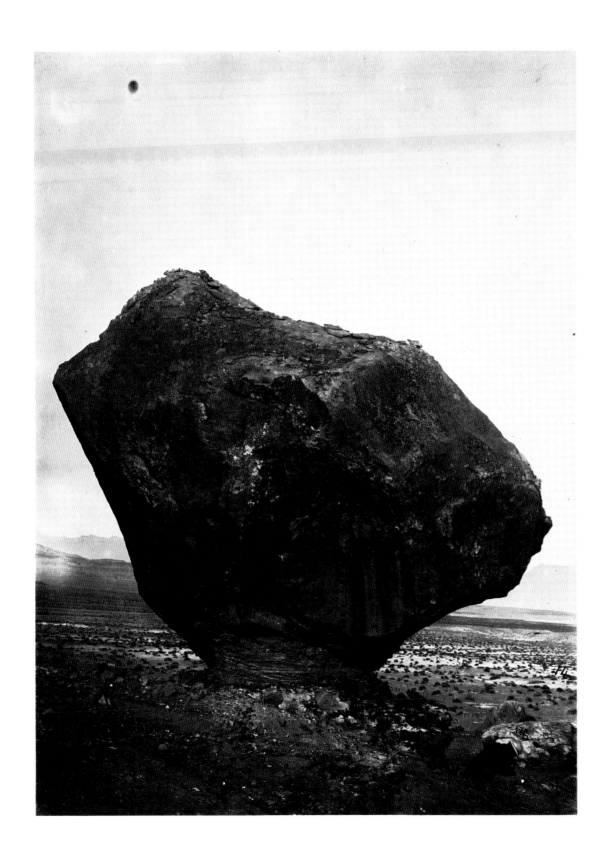

EADWEARD MUYBRIDGE

British (Kingston upon Thames, 9 April 1830 – Kingston upon Thames, 8 May 1904)

Arising from couch and stretching arms between 1885 and 1886

Collotype print, 18.2 × 39.1 cm

From *Animal Locomotion,* 1887, vol. 1, pl. 260

Purchased 1973

THE PHOTOGRAPHER IS ENGAGED IN THE PORTRAYAL OF TIME. A photograph presents us with a frozen moment, either expanded or contracted, that remains to haunt us. Were it not for one man's obsession with race horses, Eadweard Muybridge might have remained a view photographer of such places as Yosemite Valley, the Sierra Nevada Mountains, San Francisco, and Alaska. As it was, his landscapes had already earned him worldwide fame when Leland Stanford, former governor of California, commissioned him in 1872 to photograph a horse at full gallop to prove that, at some point, all four of the animal's legs were off the ground at the same time.

Muybridge, born Edward J. Muggeridge, arrived in America in 1852, and settled in San Francisco as a successful book dealer. In 1860 he returned to England to recuperate from a severe head injury caused by a stagecoach accident. During his convalescence he began to photograph. In 1866 or 1867, he returned to San Francisco, changed his name to Eadweard Muybridge, and established himself as a landscape photographer. In 1878, he made his first successful photographs of Stanford's horse, using an electrically triggered shutter of his own invention, proving Stanford's theory. By 1881, he had made several thousand photographs of various animals in motion and published the results in ten albums. Around this time he adapted the zoetrope (an educational toy that turned a strip of drawings into a moving image) by combining it with a magic lantern to produce the world's first motion picture projector. This invention, which he called a zoopraxiscope, recreated the motion of his photographs of animals. He toured England and Europe in 1881 and 1882, giving lectures and demonstrations. A year later, the University of Pennsylvania agreed to sponsor Muybridge's project to make an exhaustive study of human and animal movements. By 1886, he had made over 20,000 negatives of 1540 subjects, and in 1887 a selection of 781 collotype plates was published in eleven volumes. The rest of his life was largely spent in lecture tours to promote the sale of the work to repay the original investors.

Animal Locomotion remains the most exhaustive pictorial analysis of the subject ever made. It deeply affected artists and scientists alike. Artists such as Edgar Degas turned to his photographs as source material for paintings. Curiously, however, the work had little impact upon the photographic community, which saw it as purely a scientific study. Muybridge undoubtedly intended his photographs to be seen as single slices of time or, with the zoopraxiscope, as reconstructed motion. However, if we consider a sequence of frames as a whole image, then compare not only the change of the figure from frame to frame but also the shift of space above and below as well as to either side, we realize that Muybridge created a new concept of photographic space. Not until the dadaists in the 1920s used photomontage to produce the visual shock of spatial dislocation do we see a serious attempt to explore non-traditional photographic space. But it was another forty years before the photographic community began to pay attention to Muybridge. The rediscovery of his work during the 1960s coincides with the explorations of such photographers as Ray Metzker, Alice Wells, and John Wood of the repetition and disruption in the space-time continuum in the photographic image.

JOHN THOMSON

British (Edinburgh, 14 June 1837 – London, October 1921)

The Crawlers 1877 or earlier
Woodburytype, 11.6 × 8.8 cm
From *Street Life in London*, 1877, opp. p. 81
Purchased 1985

"HUDDLED TOGETHER ON THE WORKHOUSE STEPS in Short's Garden, those wrecks of humanity, the Crawlers of St Giles, may be seen both day and night seeking mutual warmth and mutual consolation in their extreme misery. As a rule, they are old women reduced by vice and poverty to that degree of wretchedness which destroys even the energy to beg." So begins the text describing the unfortunate woman who is the subject of John Thomson's photograph, *The Crawlers*. It goes on to explain that these women are called "crawlers" because, on the rare occasions when they can scrape together enough tea leaves for a cup of tea, they have only enough energy to crawl to the nearest pub for boiling water. The woman here was a widow of ten years, who had been living with her son-in-law. When he fell on hard times through ill health, she realized that her presence was aggravating her daughter's circumstances, and took to the streets, finding shelter in doorways. Once able to earn money as a seamstress, she had to abandon that work due to poor eyesight. We see her minding the baby of a poor working woman in return for a crust of bread and some tea leaves, and sometimes not even that, according to the text.

The Crawlers is one of thirty-six plates in *Street Life in London,* published in twelve monthly installments between February 1877 and January 1878, illustrating the life and occupations of the London poor. Each installment contained several photographs by Thomson printed with the Woodburytype process, accompanied by case histories written by Adolphe Smith (also Adolphe Smith Headingly), a journalist and trades union activist. Thomson had become a photographer probably before leaving Edinburgh for the Far East in 1861, where he operated studios in Singapore and Hong Kong before returning to London in 1873. *Street Life in London* is a landmark in the history of photography and the work for which Thomson is best known. It follows in the footsteps of Hill and Adamson's photographs of Newhaven fishermen of 1845, and Henry Mayhew's *London Labour and London Poor,* 1851 (illustrated with handmade engravings after daguerreotypes). *Street Life* was the first photographically illustrated publication produced with the intention of bringing about social change. Through "the precision of photography," the authors sought to remind Britons that, even as "our national wealth increases,…poverty…nevertheless still exists in our midst."[1]

Although obviously posed, *The Crawlers* has the ring of truth about it. Thomson's problem was to provide an image unquestionable in its accuracy that neither overstated or underrated the case. He has succeeded with simplicity and grace. His style communicates detailed information about the woman's haggard face, the tattered shawl that covers her shoulders and the baby, and the cold, inhospitable setting. Thomson uses his sense of form and space to frame the woman, allowing her presence to dominate the image. Nothing else is required, save the evocative presence of the tea cup and pot, reminders that these are her sole possessions. We are convinced by the authenticity of his seeing and, across the ages, remain troubled by this direct and unsentimental image, a prototype for what was to become known in the twentieth century as a social documentary photograph.

PETER HENRY EMERSON

British (Cuba, 13 May 1856 – Falmouth, 12 May 1936)

Coming Home from the Marshes 1885

Platinum print, 19.9 x 28.6 cm
From *Life and Landscape on the Norfolk Broads*, 1886, pl. 1
Purchased 1975

"WE CANNOT RECORD TOO MANY FACTS IN SCIENCE; the fewer facts we record in art ... the better."[1] With these words, P. H. Emerson established his credo and set out to revolutionize art photography. Born to a wealthy New England family, with an English mother and educated in England, he obtained a medical degree from King's College in 1879. This energetic sportsman acquired his first camera in 1882 to photograph birds during a vacation. A year later, holidaying in East Anglia on the edge of the North Sea, he discovered a land and a way of life that so inspired him to use the camera for something more than the making of holiday pictures that he gave up medicine to devote the next seventeen years to photography. The "something more" was the revelation that the medium had the potential for giving aesthetic pleasure. In his view, art – good art – must be based upon truth to nature, not on the sharp and undiscriminating detail of the realist in which every vein of the leaf must be recorded, but on a naturalism based upon what the eye sees in a landscape modified by light and atmosphere. The sharply focused photograph was a source of information for the scientist, but the artist must capture that "harmony and union of parts," which is the result of nature's "atmospheric veil."[2] Details must be suppressed in favour of form and breadth of effect. Emerson was reacting against the artificiality he found prevalent in photography exhibitions of the time – models posed in ways unnatural and inappropriate to their settings and photographed with an edge-to-edge and front-to-back sharpness too mechanical to be true to human vision. The principal object and its plane should be "slightly ... out of focus"[3] because the eye does not see as sharply as the lens. Everything else should be somewhat more out of focus, although not enough to destroy structure.

Emerson's emphasis upon artistic photography has often caused us to overlook the documentary side of his work. His first book, *Life and Landscape on the Norfolk Broads,* 1886, captures a way of life that was even then disappearing. Each of the forty platinum prints is accompanied by a text. Emerson's book combines the anthropologist's and the artist's concerns in one of the most important and beautiful groups of photographs to be found in the history of the medium.

In the text that accompanies *Coming Home from the Marshes,* the photographer describes his subjects as "Typical specimens ... of the Norfolk peasant – wiry in body, pleasant in manner, intelligent in mind. Their lot, though hard, is not unpleasant."[4] They have just returned from a day of cutting reeds in the marshes, tired but happy and healthy.

We do not need to read Emerson's words to sense the dignity he saw in these people and the admiration he held for their adaptation to a hard land. It is there in his photograph. Completed by the scythes, the four individuals form a triangle that dominates the flat landscape. The emphasis, through selective focusing, on the figure in the foreground provides the central energy in a setting that fades gradually to a hazy horizon. The soft tonal range of the platinum paper from pale greys to charcoal contributes to the peacefulness of the scene. We must assume the composition has been carefully orchestrated, because the large-format camera Emerson used would, of necessity, have been set up in advance.

HEINRICH KÜHN

Austrian (Dresden, 25 February 1866 – Birgitz-bei-Innsbruck, 14 September 1944)

Study of a Youth c. 1908

Gum bichromate and platinum print, 47.7 x 36.5 cm

Purchased with the Phyllis Lambert Fund, 1979

FOR HEINRICH KÜHN, THE CAMERA'S ABILITY to record the smallest and most unimportant details with wonderful accuracy was photography's greatest obstacle to achieving artistic expression. Although truth to nature was essential, literal transcripts of reality were not to be tolerated. In his view, the photograph's main problem was to reproduce the *impression* of nature on the spectator, not to offer a mirror image of reality with a catalogue of distracting facts. The principal constituents in solving the problem were to be the purely aesthetic elements of line, tone, mass, and the distribution of light and dark in space. To this end, Kühn employed, among other processes, gum-bichromate printing because it allowed him to suppress surface information, introduce breadth of form, and enhance chiaroscuro. During development in the water bath, the surface of a gum print may be manipulated to the point where whole areas are almost or completely wiped out. When applied over an existing image on platinum paper as in *Study of a Youth*, surfaces and shapes are simplified, highlights brightened, and shadows made deeper. As Kühn was to write in 1914, "all visual and pictorial simplification results in an increase in the impact of the photographer's statement and essence."[1] Although these were radical ideas for the German and Austrian photographic communities of the 1890s, they were derived from French impressionism and even had roots in the work of Hill and Adamson, whose photographs of the 1840s he had seen and admired. In fact, Kühn was instrumental in reviving the concept of the pictorial effect in photography at the end of the century, a movement that became known as pictorialism.

Kühn was born into a prosperous family of merchants, a family that included the painter Caspar David Friedrich among its ranks. At the age of seventeen, Heinrich began to photograph. In 1888, after completing studies in science and medicine, he moved to Innsbruck, Austria, in an attempt to cure his chronic asthma. From that moment on he devoted himself entirely to photography. By 1894, he was exhibiting internationally and was recognized as one of the most innovative photographers working in Europe. Like P. H. Emerson in England and Alfred Stieglitz in America, Kühn was the leader in Austria and Germany in the fight against the contrived photograph that posed models in elaborate costumes and artificial settings, often mimicking, in mechanical detail, Dutch and German portrait or genre painting of previous centuries. Although, from the perspective of our time, Kühn appears very much a tradionalist in his adherence to aesthetic theories derived from painting, it is important to recognize the radical nature of these ideas for the photographers of his generation.

Study of a Youth, possibly showing the photographer's son Walter, represents the epitome of Kühn's ideas, with its almost total emphasis upon mass and value. There seems, on the surface, little to say about this portrait, except that it is simple, uncomplicated, and very beautiful. By keeping all the picture's elements under control, Kühn has eliminated the accidental and the incidental that we often find so provocative. Nonetheless, he has produced a compelling portrait of a boy in a pensive mood – a portrait that, through its mellow glow, is pregnant with both the promise and the nostalgia of youth.

ALICE M. BOUGHTON

American (Brooklyn, New York, 1866 – Bayshore, Long Island, New York, 21 June 1943)

Rockefeller Gardens between 1902 and 1911

Platinum print, 20.7 × 15.9 cm

Purchased 1973

AT A TIME WHEN PHOTOGRAPHERS were attempting to establish the medium as a serious art form by making photographs look like carefully composed conventional paintings, Alice Boughton took the unusual step of making a photograph that looks like an impromptu snapshot. Her inspiration may have come from impressionist paintings, for artists such as Edgar Degas and Claude Monet were mimicking the unposed spontaneity to be found in the snapshot – the casual, off-centre composition, the figure truncated by the picture's edge, the hurried, passing glance. Or perhaps she had taken her lesson from Alfred Stieglitz, who began to use the hand-held camera as early as 1892 and, indeed, eventually gave to some of his photographs the title of *Snapshot*. George Eastman had invented the Kodak in 1888, which marked the beginning of the snapshot era, when even the most unsophisticated could point, press the shutter, and let the camera do the rest.

Boughton, who had studied painting in Paris and Rome before the turn of the century, had also worked as an assistant in Gertrude Käsebier's photographic portrait studio in New York. In 1904 she was listed as a member of the recently formed Photo-Secession led by Stieglitz. She continued to both paint and photograph, and in 1907 she exhibited her photographs at Stieglitz's gallery 291. Although little attention is paid to her work today, at one time her studio drew such personalities for clients as Maxim Gorky and William Butler Yeats. She was also known for her portraits of children and her open-air nude studies.

In *Rockefeller Gardens*, Boughton is searching for the innocent vision of the casual amateur, for the disorder that suggests a moment of spontaneity, for that instinctive reaction to a fleeting moment of activity, of ephemeral light or a passing mood. The trick, however, was to avoid the look of the studied accident, for the genuine snapshot is chaotic and unstructured. Although we sense in Boughton's photograph an instance of casual observation, as though the camera's shutter had acted on its own initiative, yet we are left with the feeling that everything has fallen into its rightful place – just enough to achieve a fragile equilibrium appropriate to the moment, like a dream obliquely glimpsed. Much later in the century, photographers were to exploit the snapshot aesthetic, but not always with the freshness we see in Boughton's tender moment of a woman in a garden.

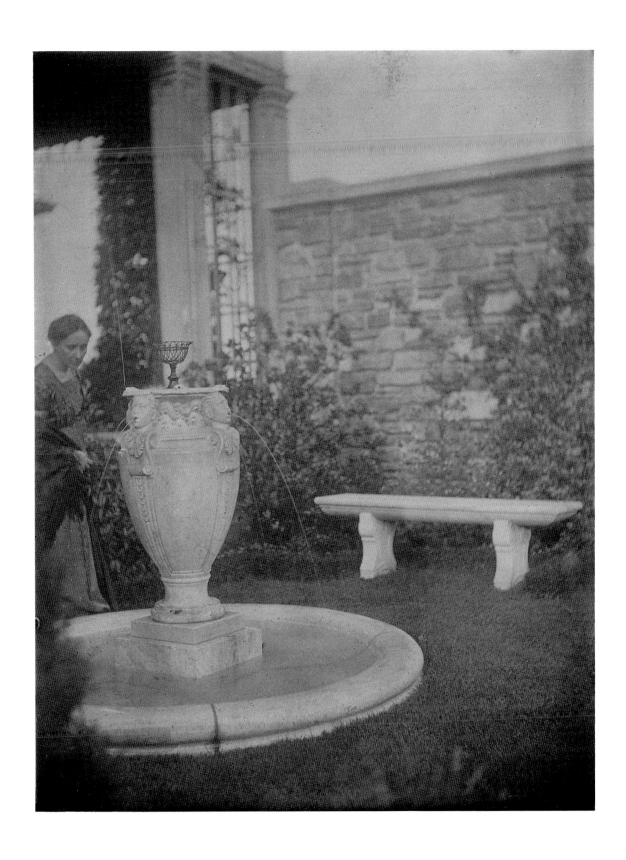

PAUL B. HAVILAND

French (Paris, 17 June 1880 – Yzeures-sur-Creuse, 21 December 1950)

Entrance to Luna Park 1909

Platinum print, 12.1 × 9.4 cm
Purchased with funds from the Prospero Foundation, 1990

PAUL BURTY HAVILAND inherited his middle name from his maternal grandfather, an art critic who, in the 1850s, had also reviewed photography exhibitions. He earned a degree from the University of Paris in 1898 and another from Harvard in 1901, which led to him becoming the New York representative for his father's porcelain manufacturing firm in Limoges, France. While in New York, in January 1908, Haviland visited the Little Galleries of the Photo-Secession, otherwise known as 291, where he met its founder, Alfred Stieglitz. He was so impressed that, when 291 developed financial problems several months later, he came to the rescue and remained a benefactor until his return to France in 1915. During the intervening years he served as the associate editor for *Camera Work,* probably the most influential and certainly the most handsome periodical ever published to promote photography as art. In addition to being a photographer, which probably dates from his childhood, Haviland was an astute art collector, owning works by Claude Monet and John Marin, among others. Falling upon hard times in France in 1928, he was forced to supplement his income for a while doing portrait photography, but the engaging inventiveness of some of his work seems confined to his New York period, when he photographed as an amateur. His last years were spent as a gentleman farmer, specializing in viniculture.[1]

Entrance to Luna Park is one of a series of night studies made by Haviland in the streets of New York in 1909. As a photographic enterprise, it shows considerable daring, given the limitations of negative emulsions at the beginning of the century. It is important, however, for a different reason. The modernist movement that swept through European art in the first several decades of the twentieth century emphasized the flat picture plane and the abstract geometric structure of pictorial space. Although its full impact upon photography was felt only in the 1920s, glimpses of things to come appear shortly after the turn of the century. *Luna Park* is one of these. The vertical and horizontal division of its space by means of wires, telephone posts, the entrance gate to the park, and the walls of the buildings, together with the contrasting curves of the architecture create a geometry on the two-dimensional picture plane that forecasts the modernist aesthetic in photography. Even Haviland's use of verbal signage as part of the image's design is a harbinger of things to come fifteen or twenty years later. *Luna Park* remains a transitional work, however, for its soft focus reduces the harder edge of geometric construction, thereby relating it to the vogue of broad effects of tone current among pictorialists of the time.

Luna Park was one of the great amusement centres on Coney Island in the early part of the century. Illuminated by thousands of light bulbs, it was, among other things, a showcase for the new age of electricity. As a subject for the photographer interested in modernity it was ideal, not only because it represented the new technology but because that technology provided both subject and medium for this picture. Light is the photographer's true medium, and out of this Haviland has created a luminous visual fantasy.

GERTRUDE KÄSEBIER

American (Fort Des Moines, Iowa, 19 May 1852 – New York, 13 October 1934)

Thanksgiving, Oceanside between 1905 and 1909

Platinum print, highlighted with watercolour, 11.2 × 21.4 cm

Purchased 1986

LIKE JULIA MARGARET CAMERON, Gertrude Käsebier came late to photography. Born Gertrude Stanton, she married Eduard Käsebier, a shellac importer from Wiesbaden, Germany, at the age of twenty-two. Not until she was thirty-seven and her three children had become teenagers did she decide upon a career in art. After studying painting at the Pratt Institute, New York, she began to explore photography, apprenticing herself to a chemist in Germany from 1893 to 1894 to learn the technical aspects. In 1897 she opened a studio in New York, and soon had a thriving business, specializing in portraits of women and children.

The critic Arthur Wesley Dow, writing in 1899, saw Käsebier as combining two functions in a photograph, one "as a record of truth, the other as a work of fine art."[1] This dual commitment takes on a particularly photographic character in *Oceanside*, which has a precision and a pictorial complexity unusual for Käsebier. In much of her work line is non-existent and breadth of form everything, emphasizing the painterly. Here, our immediate response is to patterns of white shapes glowing out of soft darkness and to the intricacy of the miniature vignettes within the photograph. Unlike her posed studio portraits, it contains a degree of spontaneity, perhaps because she is recording a family event. Artifice does enter into the image, however, in the careful grouping, selective focusing, and effect of light and shadow.

The setting for *Oceanside* is the dining room of the Käsebier residence on Long Island. The woman at the head of the table is probably Käsebier's daughter Gertrude. The other daughter, Hermine, is seated at right. The remaining figures are the grandchildren, two sons-in-law, and son Frederick. The man in silhouette is the photographer's husband, Eduard. It was he who purchased the house at Oceanside in 1904 or 1905. Eduard died in December 1909 and the house was sold in 1910.[2] The photograph, therefore, falls within that period.

The grouping in *Oceanside* sets off individual images against each other through contrast and surrounding passages of shadow. Dominating the composition are two areas of conflict: Eduard, framed by the window, and his daughter, at the head of the table. The daughter symbolizes the virtues of home, motherhood, and domestic tranquillity, a favourite theme for Käsebier. She is seen in full, three-dimensional volume, surrounded by signs of domesticity: the baby, the shelves of glassware that provide her with a glowing frame, and the tea service on the table before her, creating a luminous little still life. Eduard is a separate study – a flat, sharp silhouette, dark against white space. He seems more menacing than paternal, his form less real than the lamp at his back. The other daughter and the three men provide a foil for the central action. They are muted and absorbed in their own communion. Only the grandchildren sense the photographer's presence, but they are unaware of the family drama being played out before the camera. We are told that Gertrude and Eduard's marriage was not a happy one.[3] Oceanside is a portrait, not of individuals, but of a family situation, and possibly even intentionally autobiographical. Sometimes, however, a photographer introduces more into the photograph than was consciously planned. Perhaps, too, the photographer has given us more here than she intended.

ALVIN LANGDON COBURN

British (Boston, 11 June 1882 – Colwyn Bay, Wales, 23 October 1966)

Long Beach, California 1911

Gum bichromate and platinum print, 40.8 × 29.7 cm

Purchased 1974

THE PHOTOGRAPHER IS A MAGICIAN OF LIGHT. With lens and in the darkroom he shapes it into novel delicacies and miracles of form. In the first years of photography what caught the public's imagination about the new medium was the idea that, through it, the sun "draws" nature in its own image.[1] This simplistic notion was certainly one reason why many critics denied photography the status of art. Even by conventional definitions, which imply inventiveness, choice, and creative control, the more liberal-minded recognized that it was not the medium that made art but rather the creative imagination of the maker. Photography, however, in some ways is both a more mental and at the same time a more intuitive activity than, say, painting. It relies heavily on two abilities – the power of acute observation and a sensitive response to light. Toward the end of his life, Alvin Langdon Coburn said that, "Photography teaches its devotees how to look lovingly and intelligently at the world."[2] With *Long Beach, California,* Coburn has done just that with the simplest of subjects – a scattering of tiny figures on a strip of sand. All the rest is delicate tonalities and blank space, but a space alive with the shimmering light of a sunny day.

Of this child prodigy, who took up the camera at age eight, had his first exhibition in Boston at fifteen, and became a founding member of the Photo-Secession at twenty, Alfred Stieglitz once said he was the youngest star on the horizon. On Coburn's first trip to Europe in 1899, he met the photographic greats of the day, including Frederick Evans in London, who admired the young man's knowledge of technique, and Robert Demachy in Paris, of whose work Coburn thought little because the French photographer seemed to him to be too interested in making his photographs look like etchings or drawings. Coburn insisted that photography must be accepted on its own merits, and he was determined to jolt the medium from its rut of worn-out subjects and formulas. There followed a brief period of working with Gertrude Käsebier in New York before opening his own portrait studio in Boston. On another trip to England in 1904, Coburn made a portrait of George Bernard Shaw, the first in a series of some of the most memorable portraits of the literary and artistic giants of the time. Later published in portfolio form as *Men of Mark*, with photogravures made by himself, they included among others G. K. Chesterton, Mark Twain, William Butler Yeats, and Henry James.

Coburn finally moved to England in 1912, where he became briefly associated with Wyndham Lewis and the Vorticist movement (a group of avant-garde painters, writers, and poets) in 1917 to 1918. Although he never gave up photography completely, by the mid-1920s he had turned his most passionate attention to the study of the mystical poets, writers, and scholars, and to comparative religion. At the cutting edge of photography for the first two decades of the century, Coburn pushed the need to understand the photograph in terms of its abstract elements of line, form, tone, and the flat picture plane. He also understood that, if it was to be a vital art form, photography must find its subjects in the modern world – all ideas current in the community of avant-garde artists of the day.

EDWARD STEICHEN

American (Luxembourg, 27 March 1879 – West Redding, Connecticut, 25 March 1973)

Nocturne – Orangery Staircase, Versailles 1908

Gum bichromate and platinum print, 29.5 × 38.3 cm
Purchased 1976

IN THE EARLY WORKS OF EDWARD STEICHEN and other members of the Photo-Secession, P. H. Emerson's advice to suppress information for artistic purposes was carried to far greater lengths than he ever intended. At the turn of the century, photographers who aspired to art believed the artist's true aim was to record, not facts, but the impression of facts in order to express emotions. Thus they turned away from the straight photograph towards the manipulated print. As the French photographer Robert Demachy wrote in 1907, "Meddling with a gum print may or may not add the vital spark, though without the meddling there will surely be no spark whatever."[1] The gum bichromate process, sometimes combined with platinum paper, was widely used to suppress detailed surface information, add tonal breadth, and enhance the contrast of light and dark. It was even possible during development to introduce brush strokes on the surface of the gum print to suggest the mark of the handmade object – surely the sign of high art, or so it was thought.

Steichen and his family arrived in America in 1881. Apprenticed to a Milwaukee lithographic firm as a designer at the age of fifteen, he began to make photographs a year later as models for his designs. He also painted. It was during this four-year apprenticeship that Steichen began to realize that the quality he was responding to in nature was light itself, "mysterious and ever-changing light with its accompanying shadows rich and full of mystery."[2] In 1900, Steichen moved to Paris, took a studio in the Latin Quarter, and enrolled briefly in the Académie Julian, continuing to exhibit both paintings and photographs. In 1902 he and Alfred Stieglitz founded the Photo-Secession, and he became an active partner in the exhibition program at the gallery 291, sending to New York works by Rodin, Cézanne, Picasso, and Matisse, the first by these artists to be seen in America. Steichen's early photographs are marked by heavy manipulation in the pictorialist style, and influenced by the romantic themes of the symbolists, who believed every work of art to be an equivalent for a state of mind or sensation. He left Paris with the outbreak of war in 1914, then served with the United States Army in the France from 1917 to 1919 as an aerial reconnaissance photographer. Following the war, he turned his back on pictorialism and showed a new appreciation for the straight photograph with its distinctive qualities of definition and delicate tonal gradation.

Nocturne – Orangery Staircase, Versailles is typical of Steichen's early period and reflects his emotional response to the mood of place. About these works he later wrote, "Because I found nature most beautiful in twilight and moonlight, all my efforts were directed toward interpreting such moments."[3] We are looking at a corner of the main palace of Versailles gleaming out of the penumbra over the Staircase of the Hundred Steps, behind which are the Orangery gardens. Probably no photograph of Versailles has ever so thoroughly symbolized the setting of the glory of the kings of France. The shining brilliance of the palace is being slowly eclipsed by the gathering gloom of history, but nevertheless still gives off a radiance that has lasted over centuries. Steichen has dealt with a grand theme in the simplest terms, but the result is visually seductive, engagingly symbolic, and deeply moody.

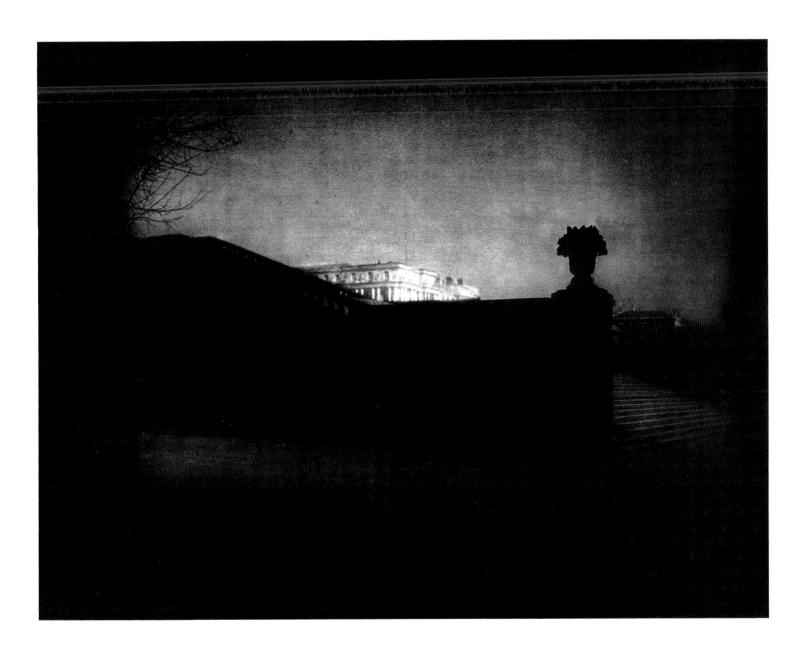

EUGÈNE ATGET

French (Libourne, 12 February 1857 – Paris, 4 August 1927)

Saint-Cloud 1907

Albumen silver print, 21.0 × 18 cm

Purchased 1974

ATGET'S STORY, LIKE THE LIVES OF SO MANY, appears to be one of quiet desperation and bitter disappointment. His first love was the theatre. Several years of study at the Théâtre national de France in Paris were followed by a decade of hardship with touring companies throughout the country. But it finally became clear to him that he had no future in theatre. Only then did he find his true vocation. Having begun to photograph sometime before 1888, possibly while still with the theatre, he established himself in Paris around 1890 as a specialist in photographs for artists, architects, and collectors of documentation on old Paris and its environs, a decision perhaps made easier because of his long-standing friendships within Paris's artistic community. However, for someone who had, for so long, been part of that community, how galling it must have been to become a nonentity on its fringes. Atget had to await death to emerge as a profound force in shaping the nature of photography in the twentieth century, but his place in the history of art is now secure. The reflective and glancing nature of his vision, its unsentimental accuracy and originality, have been a major influence on later generations of photographers.

Although Atget's work may be seen as a continuation of the concerns of the nineteenth-century photographer, he is, in fact, an artist for our own time. Atget did more than any other photographer to prepare the way for our acceptance of the complexity of layered meaning in the photograph. His photographs record the passing of a civilization, but behind this lie other implications. No photographer has ever surpassed the subtlety with which Atget combined the image as descriptive information with the image as expression in photographs both provocative and evocative and at the same time sumptuously beautiful. When he photographed the top of the Grand Cascade in the park at Saint-Cloud, established as a royal residence in the sixteenth century, Atget was as concerned with the mood of the place as with the cataloguing of facts. True to his nature, he gives us only a glimpse. But what a world of brooding melancholy lies therein! Perversely, he shows us only the backs of the river gods Seine and Marne sculptured by Lambert Sigisbert Adam between 1730 and 1734. No longer mere ornaments to a decorative waterfall, they have been transformed by Atget into obscure metaphors. Turning their backs to the viewer, they have become witnesses to who knows what sad events. Even the spiky and leafless trees are symptoms of morbidity. The light of a wintry sun, as though in one ultimate and final burst, reinforces the deepening shadows and viscous depths of the pool. *Saint-Cloud* is a stunning example of how Atget was able to use the sensuous qualities of albumen silver paper, with its deep tones and burnished colour, to translate the world into shapes that give a picture its structure and feed its mood.

Photographs often pose more questions than they answer. But the central thought in *Saint-Cloud* revolves around Atget's passion for documenting the remains of the Old Regime and what those remains signified when taken out of the context of their time and transported to another age. In sum, Atget's *Saint-Cloud* is mysterious, ambiguous, graceful and elegiac.

FREDERICK H. EVANS

British (London, 26 June 1853 – London, 24 June 1943)

In Deerleap Woods, Surrey (in memory of George Meredith) probably 1909

Platinum print, 29.1 x 22.1 cm

Purchased 1967

PHOTOGRAPHERS HAVE BEEN KNOWN to wait for days and even weeks for the right light. Frederick Evans advised observing the effects of light on a subject throughout the day, writing down those worth photographing, as well as the time, the sun's direction, and its degree of strength, and returning again at the appropriate moment to make the photograph. If the scene could not be photographed in its best light, "give it up," he said.[1] The enchanted light he saw shimmering on the tree trunks of *In Deerleap Woods* must have been the result of careful observation beforehand, for it is exactly right.

Evans was first employed as a bank clerk. He then owned a bookshop in London in the early 1880s that was frequented by Aubrey Beardsley, George Bernard Shaw, and other members of the artistic and intellectual community. He may have begun to photograph around 1880, for by 1883 he was making photographs of minute shells and parts of insects through a microscope. A friend, George Smith, owner of a firm that published lantern slides, declared Evans's photographs were not scientific records, but "artistic studies in the fullest sense."[2] Smith also convinced him that the straight photograph could be a work of art. Evans remained faithful to that belief in a period when the pictorialists' mode of soft focus and the manipulated gum print held sway in the exhibitions. He became a master at exploiting the subtle range of tones in the platinum print and combining this with photographic definition, an unusual union of delicacy and precision. When he turned to photography full-time after selling his shop in 1903, his favourite subject was architecture, especially the cathedrals of England. In photographing architecture, he advised photographers to "find our pictures in ourselves…try for a record of emotion rather than a piece of topography. Wait until the building makes you feel intensely…"[3]

In Deerleap Woods was made for the 1909/11 memorial edition of the complete works of George Meredith, novelist, poet, and friend of Evans, who died in 1909. Evans took his camera to the woods because it was a favourite haunt of the author. The image that resulted seems particularly appropriate for its purpose, since Meredith himself had used metaphor and symbol from the natural world to express states of mind. The mood of solemnity that is illuminated here brings with it an eerie quality whose source is difficult to fathom. The glowing patches of light on the tree trunk in the foreground together with the trunk's rim shadow have created a sinuous shape that seems to writhe or dance like some passing spirit. Wood sprites, it appears, were alive in Deerleap Woods. An intensely felt work from Evans's late period, its effect is ominous, whimsical, and, finally, enigmatic.

ALFRED STIEGLITZ

American (Hoboken, New Jersey, 1 January 1864 – New York, 14 July 1946)

Ellen Morton at Lake George 1915

Gelatin silver print, 11.6 × 8.6 cm
Purchased 1976

"IN MY OPINION you cannot say you have thoroughly seen anything until you have photographed it ..."[1] So said novelist and amateur photographer Émile Zola. Undoubtedly, Alfred Stieglitz's photograph of a bather allows us to discover a number of things, but above all we are permitted to see the transformation of the body into monumental sculptural form. What he wanted to achieve, however, was not the traditional view handed down to us by classical sculpture, but one that followed the dictates of the new ideas of modern art in which form was paramount, both for its own sake and for expressive purposes. For Stieglitz, however, the inner and outer worlds were inseparable. In the photograph, abstract form could not be divorced from objective fact. It is precisely the tension between these two poles that makes his photographs so compelling.

If any one person was responsible for the acceptance of photography as an art form in America, it was Stieglitz. Photographer, teacher, lecturer, publisher, and gallery owner, he encouraged and guided other photographers for almost half a century. At the age of seventeen, he was sent to Germany to study engineering. Halfway through his course he switched to photography and photo-chemistry. Before he returned to New York in 1890, he had already received international recognition with the award of a medal from P. H. Emerson. In 1902, he formed the Photo-Secession, a group whose purpose was, through exhibitions, to "loosely hold together those Americans devoted to pictorial photography in their endeavor to compel its recognition ... as a distinctive medium of individual expression."[2] A year later, he founded the quarterly *Camera Work* – which became the voice of the movement and certainly the most handsome photography periodical ever published. Through the Little Galleries of the Photo-Secession (popularly known as "291" for the address on Park Avenue), opened in 1905, he promoted not only the most progressive photography of the time, but modern art in various forms. He was the first to show works by Picasso, Matisse, and Rodin in North America. Eventually the movement became divided into two camps – those who favoured the painterly approach to photography, and the proponents of the straight photograph. Although Stieglitz had at one time indulged in the pictorialist style of soft focus, by 1913 he was writing, "A smudge in 'gum' has less value from an aesthetic point of view than an ordinary tintype."[3] He had become convinced that photography must find its own aesthetic based upon a straightforward use of its unique characteristics – clarity of definition, exactitude, and the exquisite delicacy of its tonal gradations. Earlier, he had written that the photographer's "most difficult problem is to learn to see. All else is comparatively simple..."[4]

Observation is what *Ellen Morton at Lake George* is all about. It is one of a group of about a dozen photographs Stieglitz made of this bather at his summer home. A number of them suggest athletic poses to emphasize muscles. But in this instance, the photographer has seen something out of the ordinary. Poised with one foot on a post, the bather's form seems to defy gravity. Imbalance is held in perfect equilibrium. Stieglitz's emphasis upon detail in the figure and his judicious elimination through selective focusing of all else that is unimportant reduces the picture to one single effect of telling simplicity.

PAUL STRAND

American (New York, 16 October 1890 – Orgeval, France, 31 March 1976)

Rock, Port Lorne, Nova Scotia 1919

Gelatin silver print, 24.3 × 19.5 cm

Purchased with assistance of a grant from the Government of Canada under the terms
of the Cultural Property Export and Import Act, 1978

PERHAPS THE FIRST AMERICAN PHOTOGRAPHER to be wholeheartedly influenced by cubism and other aspects of modernism of the early twentieth century was Paul Strand. While still a student at the Ethical Culture School in New York, he was taken by Lewis Hine to Alfred Stieglitz's gallery 291 to see exhibitions of work by Picasso, Braque, and other artists of the avant-garde. Strand began to photograph under Hine's guidance in 1907. By 1915, he was applying the lessons of spatial design and abstract patterning found in modernist painting so successfully to photography that Stieglitz devoted the final two issues of *Camera Work* to Strand and gave him a solo exhibition in 1916.

As well as emphasizing the abstract elements of pictorial form, Strand advocated photographic realism. "Objectivity is the very essence of photography," he wrote in 1917, involving "a real respect for the thing," expressed "through a range of almost infinite tonal values which lie beyond the skill of the human hand."[1] At this time, his still lifes, close-ups of machinery, and street photographs were far in advance of any other explorations being made in combining the theories of modern art with a pure photographic aesthetic. Although this vitality and freedom continued into the 1920s, his work gradually took on a more conventional look as his interest shifted to humanitarian concerns. Traditional photographic space replaced the two-dimensional abstract rhythms of the earlier work. He was later to say about this first period that he was trying to understand the aesthetic principles of abstract art; once having understood, he applied them to more objective reality.[2]

Strand devoted himself to cinematography as well as photography over the next two decades, working on such films as *The Wave* and *The Plow That Broke the Plains*, documentaries about human struggles to wrest a living from sea and land. His book of photographs, *Time in New England*, 1950, expressed his romantic idealism about plain folk and their relationship with the natural environment. Disillusioned with the political conservatism that culminated in the McCarthy years, he left America in 1950 to settle in France.

Strand's first landscapes and microcosmic views of nature were made in 1919 at Port Lorne, Nova Scotia, during a holiday. *Rock, Port Lorne* was among these. Its two-dimensional, interlocking graphic forms show that he is still under the influence of cubism. But the tension between its abstract nature and its precisely detailed surface realism provides the kind of visual shock for which the new photography of the 1920s was searching. It precedes the work of Albert Renger-Patzsch and the New Objectivity movement in Germany by several years. *Rock, Port Lorne* invites questions of scale. The subject's actual size eludes us, but the impression, even in Strand's 8 × 10 inch (20 × 25 cm) contact print, is of heroic form. At first glance, light appears to be absent, for external reflected light is subdued. We soon became aware, however, of a luminous inner glow that endows the rock with a quality of elusive magic. Later, Edward Weston was to say about his own work in this vein that the impulse was, "to photograph a rock, have it look like a rock, but be *more* than a rock."[3] The success of Strand's transformation lies in both his powers of observation and the superb technical control of his printing. The print has a faintly warm, mauve tone that vibrates with light.

EDWARD WESTON

American (Highland Park, Illinois, 24 March 1886 – Carmel, California, 1 June 1958)

Piramide del Sol November? 1923

Platinum print, 19 × 24.1 cm
Purchased 1978

IN 1923, WHEN EDWARD WESTON MADE his photograph of the Pyramid of the Sun, he was hardly more than a year into his conversion from the soft focus and artificiality of the pictorialist style. To photograph the thing for itself, sharply and clearly defined so that the viewer "is seeing not just a symbol for the object, but the thing itself revealed for the first time,"[1] with all its mystery and its poetry, had become his goal. But the thing itself, in this instance, is not only the stone structure, but the field in which it rests, the sky under which it sits, and the light that illuminates the vision.

At age sixteen, Weston was given a box camera by his father. In 1908, he attended the Illinois College of Photography, and three years later opened a portrait studio in Tropico, California. For the next few years, he exhibited work in pictorialist salons, earning honours and awards. In 1920, influenced by his discovery of modern painting, he began to make semi-abstract photographs, but still in a soft, pictorialist mode. Then, while passing through Ohio on a trip to New York to meet Alfred Stieglitz, Paul Strand, and Charles Sheeler, he made the first of the photographs we have come to associate with the Weston style – sharply focused, clearly defined from edge to edge, with an emphasis upon surface detail and fine tonal gradation.

In July 1923, Weston moved to Mexico City, where he hoped for greater recognition as an artist. In November, he made a trip to San Juan Teotihuacán with some friends, his son Chandler, and his companion Tina Modotti to photograph the Pyramids of the Sun and the Moon. In 1927, he returned to California, eventually settling permanently in Carmel. He was one of the organizers of and contributors to the exhibition *Film und Foto,* held at Stuttgart, Germany in 1929. His work had become highly respected by the European photographic community in its search for New Vision photographers.

A work such as *Piramide del Sol,* with its balanced tension between a detailed, three-dimensional real world and the abstract structure of the flat picture plane made of inter-locking masses of positive and negative shapes, perfectly suited the principles of modernism. The play of textures from plane to plane is a marvel of visual delight to be appreciated both for what it represents as well as for the reality of the print itself – its surface, tone, colour, and graphic character. The repetition of rectilinear forms in bold passages of light and dark is harmoniously interrupted by tufts of grass glowing like flames in the shadow at the top of the pyramid's first level, by the delicate, luminous lines in the clump of trees in the fore-ground, and by the bright, curving path of steps at the top level. Weston has concentrated our attention on these delicacies by his tight composition, crowding only the partial bulk of the structure within the frame of his photograph so that it looms large. His real subject, however, is light – shining and alive – light that makes us aware of the strangeness of things as well as of its own unfathomable existence. In this platinum print, light glows with a warm radiance that comes deep from within the paper itself.

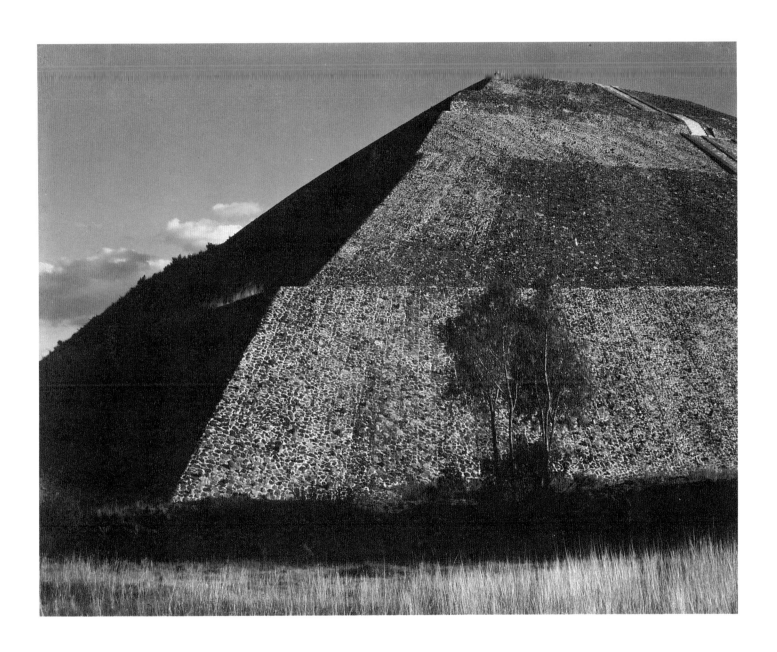

MARGARET WATKINS

Canadian (Hamilton, 8 November 1884 – Glasgow, Scotland, November 1969)

The Kitchen Sink c. 1919

Palladium print, 21.3 × 16.4 cm

Purchased with assistance of a grant from the Government of Canada under the terms
of the Cultural Property Export and Import Act, 1984

DURING THE FIRST DECADE OF THE CENTURY, photography was promoted increasingly as a desirable profession for women. Over 1600 women operated commercial studios in America alone in 1911. The strong feminist movement in photography was credited with "breaking down forever the old traditions of professional posing and lighting and introducing freedom, variety and individuality into professional portraiture."[1] Into this scene stepped Margaret Watkins, baptised Meta Gladys. Born into a family that operated a prosperous dry goods store in Hamilton, she probably learned photography in her teens from an uncle who was an art collector and member of the local camera club.

In 1914, at age thirty, she left for New York to study at the Clarence White School of Photography,[2] where Max Weber and Alfred Stieglitz, both of whom promoted the cause of modern art, were on the faculty. White himself was so impressed with Watkins that she was appointed to the teaching staff around 1916. Through her writings, we sense a personality that is articulate, perceptive, imaginative, witty, and zestful. The 1920s were prolific and successful years for her. She was represented in major pictorialist exhibitions around the world and acquired a considerable reputation as a teacher. Among her students were Laura Gilpen, Paul Outerbridge, Ralph Steiner, and Doris Ulmann. In 1929, at the peak of her career, she began a grand tour of Europe and the Soviet Union. Returning home in 1931, she stopped in Glasgow to visit two maiden aunts. Tragic circumstances kept her there as she nursed first one then the other through fatal illnesses, until 1939, when the war finally prevented her return to America. She remained in Scotland, forgotten, her meteoric career having ended in 1929. Writing in her diary, she confessed she was "living in a state of curdled despair...I miss the artistic crowd most desperately."[3]

The Kitchen Sink, exhibited from 1921 to 1924 in New York, San Francisco, London, and Paris, along with other similar still lifes, offended some critics, elated others. She acquired a reputation for the unconventional in a time dominated by pictorialist ideas in which only certain subjects, treated nobly, and composed to avoid the extraneous, were considered suitable. Her work undermined these genteel notions. A cluttered sink with unwashed cream jug and milk bottle was hardly a fitting subject for art – not one, as *Photograms of the Year 1923* said, that "anyone would beg to contemplate in his dying moments."[4] But the San Francisco exhibition awarded the photograph second prize, and the periodical *Camera Craft* devoted nearly two pages to its merits, especially its radical composition.[5] That the dominant objects appear only at the edges was seen as a shocking but healthy design solution, a way out of the rut of pictorialism. Watkins was one of the earliest to recognize the dynamic role of the photograph's edge in creating visual energy.

Women photographers followed the traditional categories of landscape, portrait, still life, and the nude; the one female theme they introduced was motherhood, but accompanied by a sentimentality that generated no innovations. Watkins was the first to turn to what could be considered, for her time, an even more fundamental and exclusively female issue: the environment that faced woman as kitchen drudge. That this could be a subject for art was indeed a revolutionary idea.

MAN RAY (EMMANUEL RUDNITSKY)

American (Philadelphia, 27 August 1890 – Paris, 18 November 1976)

Rayograph 1922

Gelatin silver print, 23.9 × 17.0 cm

Purchased 1982

SOMETIMES THE MAGIC IN PHOTOGRAPHY is created exclusively in the darkroom. When Man Ray made his first "Rayographs", as he later called them, he was elaborating on a technique he had tried as a boy – placing leaves on a piece of unexposed printing-out paper until the paper darkened in the sunlight, leaving behind white silhouettes. Perhaps he did not realize that making camera-less photographs is as old as photography itself, for that is where William Henry Fox Talbot began his experiments in 1834. Christian Schad, a member of the Dada Group in Zurich, had produced "Schadographs" in 1918 by exposing cut pieces of newspaper arranged on photographic paper to light to produce designs that resembled cubist collages.

What was different about May Ray's technique, which he stumbled across by accident in his makeshift darkroom one night in Paris either in 1921 or 1922, was the use of three-dimensional objects around which he moved the light so that not only outlines were recorded but shadows, too, with a variety of densities, depending upon exposure time. Sometimes he used transparent objects that refracted the light. "For Man Ray, to whom art was a sublime kind of play, the technique was perfect,"[1] wrote art historian John Szarkowski in 1973. Tristan Tzara, the dada poet who was the first to see these images, called them pure dada for their element of "anti-art" – any non-traditional way of making art that would shock the public. The surrealists, who were born of the dada movement, saw Rayographs as examples of art created by both the accidental and the subconscious, akin to automatic writing in their unpredictability.

In July 1921, May Ray arrived in Paris from New York, where he had been a commercial illustrator and member of a group of avant-garde painters, including Marcel Duchamp and Francis Picabia. Although a frequent visitor to Alfred Stieglitz's gallery 291 in previous years, his involvement with photography had come about only in 1915 when he decided to make the copy photographs of his paintings for the catalogue for his first solo exhibition. From then on, he supported his painting through commissions from fellow artists to photograph their work. In Paris, portrait and fashion photography provided his bread and butter, but he saw no distinction between the media – all were legitimate tools in the hands of an artist.

The Rayograph shown here is unusual in its complexity and ambiguity. The range of qualities from flat to three-dimensional, from organic to geometric, from opaque to transparent, goes beyond Man Ray's usual simple and recognizable forms in which, for example, a pistol is paired with a hotel-room key, a gyroscope with hands, or a wine glass with a face in profile. It is as though he were testing the limits of his new technique. Prisms provide shimmering, luminous spaces with precise planes and subtle permutations of perspective. These are contrasted to a looming amorphous form with vague allusions to the human body or even a landscape. In the lower right corner, the edges of a prism accidentally trace the lines of a tripod, symbol of photography. Beautiful in its tonalities and seamless transitions from shape to shape, *Rayograph* might be seen as a glimpse into photography's inner dialogue with itself or possibly as an image conjured up from the surrealist's dream world – mystifying, dematerialized, and thoroughly sensual.

PAUL OUTERBRIDGE

American (New York, 15 August 1896 – Laguna Beach, California, 17 October 1958)

Knife and Cheese 1922

Platinum print, 10.2 × 9.6 cm
Purchased 1991

PAUL OUTERBRIDGE'S STILL LIFE with a wedge of cheese, two crackers, a knife, and a board is deceptively simple. The photographer, however, has produced a complex and elegant image. Influenced by cubism, he has arranged objects in geometric structures across the two-dimensional picture plane. A rhythm of angles and triangles has been cleverly created from shadows and from oblique lines that cross the picture's corners at various distances, playing off positive and negative spaces against each other. This visual game ensues with the rivet heads on the knife and the hole in the board's handle, as well as the more organic indentations on the surfaces of the crackers and the cheese. As much as its formal theme may derive from cubism, Outerbridge's image is purely photographic. The palpable surface textures of the objects could only have been rendered through photography. The tonal subtlety has been made even more exquisite by printing the picture on platinum paper.

It is this combination of design and photography that was emphasized at the Clarence White School of Photography. Teachers such as the painter Max Weber and the photographer Margaret Watkins promoted the new ideas of modern art and encouraged their application to photography. Simple everyday objects seen at unusual angles and close quarters in a manner meant to emphasize the formal, abstract geometry of the picture plane were used as design exercises at the school when Outerbridge was enrolled there as a student in 1921 and 1922. He had already studied painting at the Art Student's League from 1915 to 1917.

Because photographers have to live, the new ideas that began to emerge among the students and teachers at the Clarence White School were soon applied to commercial photography. Outerbridge's *Knife and Cheese* may even have been produced as an exercise for an advertisement. Advertising photography until the 1920s showed little pictorial imagination. Margaret Watkins was one of several teachers at the school who promoted the use of attractive designs and intriguing images for such purposes. Outerbridge, one of the school's most brilliant graduates, went on to a successful career in fashion and advertising photography. It is perhaps an unfortunate commentary upon the goals of the commercial world that we find that Outerbridge's freshest and most inventive photographs were made during his student years.

Josef Sudek

Czechoslovakian (Kolín, Bohemia, 17 March 1896 – Prague, 15 September 1976)

Portrait of My Friend Funke 1924

Gelatin silver print, 28.5 × 22.6 cm
Purchased 1985

TO THE PEOPLE OF PRAGUE, Josef Sudek was known as "the poet with a lens." A veteran of World War I, in which he lost his right arm, Sudek had been an amateur photographer in his teens. Following the war and his convalescence, he studied photography at the School of Graphic Design in Prague from 1922 to 1924. During that period he produced his first serious portfolio, photographs of disabled soldiers at the Veteran's Hospital. Next came a series of photographs documenting the final stage of the construction of Saint Vitus Cathedral, a gothic monument begun in the fourteenth century. As was typical of his work of this period, both portfolios are in a soft-focus pictorial style, heavily charged with a romantic mood. The better-known later work – private gardens, panoramas of the city of Prague, and views from his steamed-up studio windows – has surrealist overtones inherited from his early romanticism. Although Sudek, like Eugène Atget, has become a cult figure for photographers beginning in the 1960s, only a fraction of his work has been seen outside Czechoslovakia.

Portrait of My Friend Funke dates from the beginning of Sudek's career and the same year in which he and Jaromír Funke founded the Czech Photographic Society. It is an accomplished portrait and provides an indication of how quickly he matured as an artist. Direct and unsentimental in its vision, it is devoid of the soft-focus pictorialism that is typical of most of his work of this period. The extent to which Funke's own style may have influenced the portrait remains an intriguing puzzle. Funke, a professional photographer, used dramatic shadows in his advertising photographs, his nude studies, and his still lifes to break up the picture plane and to compose energetic patterns. The profile shadow at the upper right of Sudek's portrait seems to be a subtle reference to Funke's own pictorial strategies. Prague was a centre for theories of modernism in art during the 1920s. Some of these ideas – an awareness of the picture plane and of the abstract pattern of the picture's structure – are similarly evident in Sudek's portrait of his friend.

It comes as no surprise to learn that Funke had studied medicine, law, and philosophy, for we sense here an urbane and sophisticated individual. Not only has Sudek produced a portrait that is poised and knowing, he has created an image that boldly reflects the art trends of his time with an emphasis on the elements of line, rhythm, repetition, texture and shape. The quality of the paper upon which the photograph has been printed, with its warm tones and soft surface, lends itself to the wonderfully fluid relationships that exist between Funke's profile curving down to the gleaming white collar and the line of the rough-textured overcoat, between shadow and light, and between the ambivalence of the background and the space the sitter occupies.

ALBERT RUDOMINE

French (Kiev, Russia, 27 April 1892 – Paris, 4 April 1975)

Suzy Solidor's Legs 1924

Bromoil print, 22.8 × 16.8 cm

Purchased 1990

ALBERT RUDOMINE WAS BORN IN RUSSIA of a Russian father and a Polish mother. The family settled in Paris in 1895, then moved to New York in 1901. In 1915, Rudomine returned to France where he joined the Foreign Legion. Invalided out of the army in 1917, he worked for the fashion house of Patou as a dress designer. By 1919, he had begun to photograph, and a year later he joined the staff of *Illustration* as a journalist. His stay with the magazine was short-lived, however, and by 1921 he had opened his own studio. Much of his work was with cinema personalities, artists, musicians, and international celebrities. In the 1940s, he did photographic work for the Louvre and the Rodin Museum. Although his great passion was portraiture, he also had a reputation for his nude studies.

Suzy Solidor was a young woman of twenty-four when she posed for Rudomine in 1924. She claimed to have begun her career as an antique dealer. By 1931, she had become a music-hall singer and eventually owned several cabarets in Paris, including Chez Suzy Solidor. She also appeared in films, was a published author, and, at the time of her death in 1983, owned a large collection of paintings. But this photograph is not about Suzy Solidor. Rather, it is about the naked body, its volumes and its surfaces. Most of all, it is about an artist's lyrical response to the abstract shapes of the body's design and to the alchemy of glowing light.

Legs seen caught like slices of light in the shape of an X, emphasized by the distinctly cast shadow, reflect the purpose of the modernist movement in art of the 1920s – to reduce a picture to its abstract design, a challenge, indeed, for such a highly charged subject. Part of Rudomine's success in doing so resides in his use of a printing process that belongs more to the earlier pictorialist movement than to the revival of sharp definition and minute detail being promoted by the avant-garde photographers of post-World War I. The texture of the bromoil paper diffuses the image and enhances its glowing quality. Rudomine's photograph is a provocative mixture of the old and the new. The two levels of existence in his photograph – the abstract and the sensual – counterbalance and emphasize each other. Light is the body's erotic agent and becomes erotic in itself. And therein lies a graceful and a witty irony.

ANDRÉ KERTÉSZ

American (Budapest, 2 July 1894 – New York, 27 September 1985)

Fork, Paris 1928

Gelatin silver print, 7.5 × 9.2 cm
Purchased 1978

AMONG THE YOUNGER GENERATION OF PHOTOGRAPHERS who thought of themselves as artists, the most characteristic development in the 1920s was the radical idea that form alone, divorced from narrative content and expressed according to a pure photographic aesthetic, could result in a photograph with a legitimate claim to art. Formal problems had become a key issue – experiments that explored the structure and geometry of the picture plane. André Kertész's photograph *Fork, Paris* is the ultimate answer to the challenge of making a picture from the simplest objects. Its bold rhythms focus our attention on the simple beauty of two purely functional tools – a fork and a bowl. Or it does so at first glance. What really commands our attention is the clarity and purity of photographic surface, space, and light. These are the picture's real subjects.

Kertész learned to photograph as an amateur at the age of nineteen while working at the Budapest Stock Exchange. In 1914, he joined the army, but was seriously wounded and demobilized a year later. He returned to the Stock Exchange and continued to photograph in his spare time. Some success with his hobby and the growing political repression in Hungary encouraged him to emigrate to Paris, where he became a freelance photographer. Within little more than a year, he had his first exhibition, was selling photographs to some major magazines, and was making a reputation for himself as an important new artist. In October 1936, Kertész went to New York on a year's contract with Keystone Pictures and ended by doing something new to him – making commercial portraits, advertising pictures, and fashion photographs in a studio. When the contract was over, he continued to eke out a living in New York with assignments for fashion magazines. The reportage photographs for which he had been known in Paris were not appreciated by American publishers: for one thing, he demanded absolute freedom in his approach to his subject, and for another, he refused to work with the large-format press cameras. Kertész was one of the earliest professional photographers to adopt the new 35 mm camera, which American magazines such as *Life* in the 1930s considered a toy.[1] In 1944, he became an American citizen, and his first solo exhibition in America was held at the Art Institute of Chicago in 1946. From 1949 to 1966 he worked for Condé Nast publications.

Fork, Paris was Kertész's choice when asked to submit a photograph to illustrate an article on the new photography in the popular German magazine *Uhu* in 1929. It was shown at the *Film und Foto* exhibition at Stuttgart in that same year, as well as having been exhibited the previous year in Paris at the first Independent Salon of Photography, along with work by Eugène Atget, Man Ray, Berenice Abbott, Paul Outerbridge, and others. One reviewer praised it as the only photograph in the Paris exhibition that impressed him as being a real work of art, "moving for its purity and its tones."[2] One of the sponsors of the *Film und Foto* exhibition, Peter Bruckmann, asked that he be allowed to use *Fork, Paris* as an advertisement for his silverware company, even though the fork itself was a very ordinary one Kertész had found at the equivalent of a five-and-dime store in Paris – proof that artistry lies not in the subject, but in the vision.[3]

JAROMÍR FUNKE

Czechoslovakian (Skutec, Bohemia, 1 August 1896 – Prague, 22 March 1945)

Untitled 1924?

Gelatin silver print, 22.9 × 28.9 cm
Purchased 1989

DURING THE 1920s, CZECHOSLOVAKIA saw itself as the geographical centre of current trends in modernist art theories in Europe – the New Objectivity and the Bauhaus movements from Germany, the constructivists from Russia, cubism, dadaism, and surrealism from Switzerland and France, and from America the return to the aesthetic of the straight photograph. Evidence of the principal pictorial ideas that bound most of these movements together – a concern for the picture plane, for the abstract pattern of the picture's structure, and, where photography was concerned, for the distinctive attributes of the medium – are present in Jaromír Funke's untitled work reproduced here.

Funke studied medicine from 1915 to 1918, then law for four years, followed by studies in philosophy. At the age of twenty-four, he began to photograph, and two years later, in 1922, left university to become a freelance photographer. He and Sudek were co-founders of the Czech Photographic Society in 1924. By 1926, he was exhibiting abroad, including in England, Canada, and the United States. In 1931, he began to teach photography, first in Bratislava and later at the School of Graphic Arts in Prague. Funke's early work, like Sudek's, consists of dramatically lit street scenes in a soft-focus pictorialist style, laden with romantic atmosphere. By 1923, however, he had begun to experiment with the ideas of modernism. Although he never abandoned those concerns, he turned to social documentary photography in the early 1930s, joining a group known as Sociofoto, in a desire to plead the cause of the poor.

The still life with copies of *Tribuna* may have been made as early as 1924, if we go by the dates on the newspaper. If so, it is among Funke's earliest experimental works. Although radical for its time, the slight diffusion in the image shows that he had not yet completely broken with pictorialism. No doubt influenced by cubism, with its shallow space, overlapping planes, and use of typography as a design element, it is however thoroughly photographic. The soft light that glows from the surfaces of the newspapers is given a pearly quality by the paper on which the photograph has been printed. Light suffuses the space around and under the papers. It is almost palpable, and becomes, itself, the real theme of the picture. For Funke, as he was to write later, the play of light and shadow and the structural layering of shapes and simple realities may create enigmatic images with "a novel and evocative poetic value," giving to the commonplace "a real photographic magic."[1] Although the sensuous nature of the light occupies our attention, we may wonder about the drama created by the glimpses of the front-page images that the artist has chosen to let us see – perhaps a personal fantasy to which we shall never be privy.

ANTON BRUEHL

American (Hawker, Australia, 11 March 1900 – San Francisco, 10 August 1982)

Crankshaft and Pistons c. 1935

Gelatin silver print, 34.5 x 27.6 cm
Purchased 1991

THE NEW VISION IN PHOTOGRAPHY that spread across the western world after World War I took on many forms. Its favourite subject, however, was the life and times of the modern age. Photographers, as inheritors of machine technology, often saw the machine as a symbol of the new age and as a particularly apt subject for the photograph, one perfectly matched to the picture-making process in its method and polished precision.

The machine as a subject for the photograph may be traced back at least to 1851 when salted paper prints were used to illustrate the *Reports by the Juries* for the Crystal Palace exhibition in London. With improvement in the precision and clarity of the photographic image through the combining of the glass negative with albumen paper, we see photography later in the century increasingly in use to illustrate such objects as farm machinery for manufacturers' catalogues. Although James Mudd's photographs of locomotives made in the 1870s and 1880s show a distinct pleasure in capturing the engines' polished beauty, they remain strictly utilitarian records of fact. Beginning in the 1920s, the growing use of photographs in the mass media to sell products to mass markets gave employment to a generation of gifted young photographers who, at the same time, were inspired by the ideas of the New Vision. Frequently they continued in their commercial work experiments begun in private. Among them was Anton Bruehl. As a child in Australia, he took a keen interest in things mechanical. He also photographed. Later, he became an electrical engineer, emigrating to New York in 1919, where he worked for a big electrical corporation. During this period, he was so inspired by an exhibition of photographs from the Clarence White School of Photography that he enrolled in the school, where, in a short while, he became an instructor. Influenced by Paul Outerbridge's advertising photographs, Bruehl then launched himself into the world of photography, opening an advertising and celebrity portrait studio with his brother Martin in 1927. His work was exhibited at The Museum of Modern Art and the Julien Levy Gallery, and eventually he became head of colour photography for Condé Nast publications.

Crankshaft with Pistons was probably made for a client who wished to advertise a powerful new inner combustion engine. Yet, the existence of the print in such a large format on beautifully toned warm paper indicates Bruehl also saw it as an exhibitable object independent of its original purpose, a combination of the artistic and the utilitarian. The strange appeal of the subject has prompted him to express a personal reaction, creating an image that glorifies the engine as an object and at the same time presents it as a symbol of power reduced to its raw and naked skeleton. Although static, the contrapuntal arrangement of the piston heads suggests the frenzied chaos of a nightmare world inhabited by robots – a vision dear to the heart of surrealism. That Bruehl has chosen to crop the edges of the nearer pistons accentuates the barely contained, thrusting power of the machine. As if by the wave of a wand, the photographer's light has transformed a working tool into an object of unexpected beauty.

LUCIA MOHOLY

British (Prague, 18 January 1899 – Zürich, 1989)

Portrait of a Woman between 1928 and 1932

Gelatin silver print, 37.5 × 27.6 cm

Purchased 1990

LUCIA MOHOLY WAS BORN LUCIA SCHULZ. She studied philosophy, philology, and art history at the University of Prague, and in 1920 began working for a publisher of art books in Hamburg. She met Hungarian artist and later photographer László Moholy-Nagy in Berlin that same year and married him in January 1921. Two years later, when her husband was appointed as a professor at the Bauhaus, they moved to Weimar. There, she began to photograph, as well as take courses at the Academy of Graphic Arts at Leipzig. For the next five years she was involved in portraiture, in photographing the buildings of the new Bauhaus campus in Dessau, and in making photographs to interpret László's ideas. They settled in Berlin in 1928, where she began to photograph theatrical productions, and in the following year her work was included in the important exhibition of new photography, *Film und Foto*, at Stuttgart. She and László separated in 1932 when she left Berlin for Paris. Two years later, she moved to London, where she opened a studio and taught at the School of Printing and Graphic Arts as well as the Central School of Arts and Crafts. She became a British citizen in 1947, and twelve years later moved to Zürich. In addition to the photograms made with her husband, she is known for her portraits, reportage, and architectural photographs. While in Germany, she had photographed friends and colleagues, many of whom were artists and theatrical people. In England, her sitters were often intellectuals, artists, and members of the social elite.

Lucia Moholy was among the most innovative of the European avant-garde portrait photographers of the 1920s and 1930s. True to the aims of the New Objectivity movement in Germany, which strove in photography to intensify an appreciation of reality through startling new ways of observing nature, her close-up views of the human face provide an emphasis upon strong, formal structure and sharply defined detail. The portraits are distinctive for their suggestions of character and their sense of form. They are straightforward and, at the same time, intimate, often showing the face only, without props. The sitter's features are moulded by light and translated into strong graphic elements.

The lyrical portrait we see here of a young woman in profile shows Moholy's ability to use the structure of the face as a basic part of the photograph's design motif. She exhibits an elegant playfulness in contrasting the broad, curving rhythms of the overall image with the tight curls of hair falling over the sitter's face. The photographer's purified vision has seen in the woman's profile, like a pale crescent moon floating across a sky partially lit with a billowing cloud or a halo (interpret it as you will), a look that is both ethereal and primordial.

ALEXANDER RODCHENKO

Russian (Saint Petersburg, 23 November 1891 – Moscow, 3 September 1956)

Courtyard, Moscow 1926

Gelatin silver print, 28.6 × 20 cm

Purchased 1991

"MY PATH LEADS TO A FRESH PERCEPTION OF THE WORLD. I decipher in a new way a world unknown to you."[1] These words by the Russian photographer and filmmaker Dziga Vertov convey the spirit of the revolt in the 1920s against outworn pictorial ideas held over from the turn of the century and still prevalent in photography salons. The avant-garde movement, led by such artists as László Moholy-Nagy in Germany and Alexander Rodchenko in the Soviet Union, was out to break old habits of perception. Rodchenko studied painting at the Kazan School of Art from 1907 to 1914, then moved to Moscow where he soon became one of the leading members of the constructivists. By the early 1920s, he had changed from painting to collage and graphic design, then to photomontage and, through his association with Vertov in 1924, to making photographs. Convinced that photography was the most potent medium to "unlock the world of the visible"[2] and to overthrow the conventional vision of traditional painting, Rodchenko experimented with extreme close-ups, exaggerated high and low viewpoints, and tilted horizons organized into geometric structures that exploited the dynamics of the photograph's two-dimensional space. His new and startling view of reality was not to everyone's liking, for in 1928 he was forced from his position as head of the photography section of the artists' union, October. His work was attacked for being beyond the comprehension of the masses. In every generation there have been artists who sought a fresh vision of reality, either by choosing subject matter hitherto considered inappropriate for art or by adopting a new perception of the traditional motifs of art. Rodchenko combined both to such a degree that he left an indelible mark on the way we see photographically.

Courtyard, Moscow was made during the most fertile period of his photographic experiments. Its viewpoint is so radical that our perception is disoriented. At first we interpret the image as a design of flat, abstract shapes organized in a bold geometry of tensions. The oblique thrust of its composition is charged with unsettling energy exaggerated by the bristling nature of the graphic filigree that surrounds the dominant ovoid form, which strains against its vertical axis and, as we become aware of what we are really observing, also pulls away from the plane of the picture at its upper end. We are in danger of having the ground shift and whirl beneath our feet. But as we pay closer attention to the view and distinguish the trees from their shadows, the photograph takes on three-dimensional depth. Then the contour line within the park becomes apparent, and we take pleasure in its elegance. Several of the patterns of spots at the upper right dissolve into foreshortened silhouettes of figures striding across the pavement. Thus the human presence is signalled, and we discover other figures within the park, especially the more life-like form of the seated man at the photograph's centre. Does he suspect the vertiginous nature of the world in which he lives? Rodchenko's *Courtyard* is a complex, graceful, and unsettling visual game that questions the nature of the world in which we live.

AUGUST SANDER

German (Herdorf, 17 November 1876 – Cologne, 20 April 1964)

Customs Officials, Hamburg 1928

Gelatin silver printed 1958?, 50.3 × 37.1 cm

Purchased 1989

PICTORIALISM WAS THE FASHION AMONG ART PHOTOGRAPHERS from the turn of the century well into the 1930s. In portraiture, it emphasized breadth of form and suppressed surface information. One of the earliest photographers to break away from this prevailing style was August Sander, who began to photograph at the age of sixteen. He studied both painting and photography, opening his own studio in 1902. His description of a typical studio at the turn of the century, in which painted Italianate scenery and Rembrandt lighting was used to transform "a kitchen maid into an elegant lady and a simple soldier into a general,"[1] reflected his own approach in the early years. In 1910, he opened a studio in Cologne, renouncing the prevailing vogue by advertising that he would make "simple, natural portraits, that show subjects in an environment corresponding to their own individuality, portraits that claim the right to be evaluated as works of art..."[2] Sander was one of the first of his generation to understand that photography had an aesthetic of its own, uniquely different from the other arts, and based upon a clear depiction of literal fact.

About the same time, he conceived the idea of assembling a large series of portraits to project an image of his time and reveal how the collective power of human society produces common types of appearances at different social and cultural levels. Using photographs from his commissioned portraits as well as from personal work made specifically for the project, which he called "Man in the Twentieth Century," he published a selection in 1929 as *Faces of Our Time*. The book was a clinical examination of society, seen with unsentimental accuracy and directness. By grouping images, Sander believed he was establishing archetypes that defined the characteristics of social classes. In 1934, the Nazis confiscated the printing plates and ordered the copies of the book destroyed.

The ability to group two or more figures in a manner that avoids stiffness or the contrived pose is rare. Sander's double portraits use simple poses derived naturally from the subjects' personalities, poses that resonate with the meaning of human relationships. In *Customs Officials,* two men, the ubiquitous functionaries in uniform symbolizing authority in the Weimar Republic, stand like a wall obstructing our passage to the sunlight beyond. Sander's portraits, however, are never one-dimensional, but present "two truths simultaneously and in delicate tension: the social abstraction of occupation and the individual who serves it."[3] The impassive face of the younger man may not reflect the other's vulnerable expression, but the slight lean of his body and the shifting of one foot forward betray a dependency upon the authority of his more experienced colleague, who stands foursquare.

Customs Officials is one of Sander's most complex and allegorical images, not only because of its commentary on authority and the banal and passionless mask it wears, but because of its unusual formal treatment. Often, the context in which his subjects appear is not so specific – a blank space or a nondescript wall suffices. Here, the location has a precise character that serves both the meaning of the photograph and its composition. The gothic arch frames the younger official; it also symbolizes boundaries and the weight of authority. Sander has obviously derived pleasure from the background's dramatic chiaroscuro, with its soft, rich shadows and splashes of light.

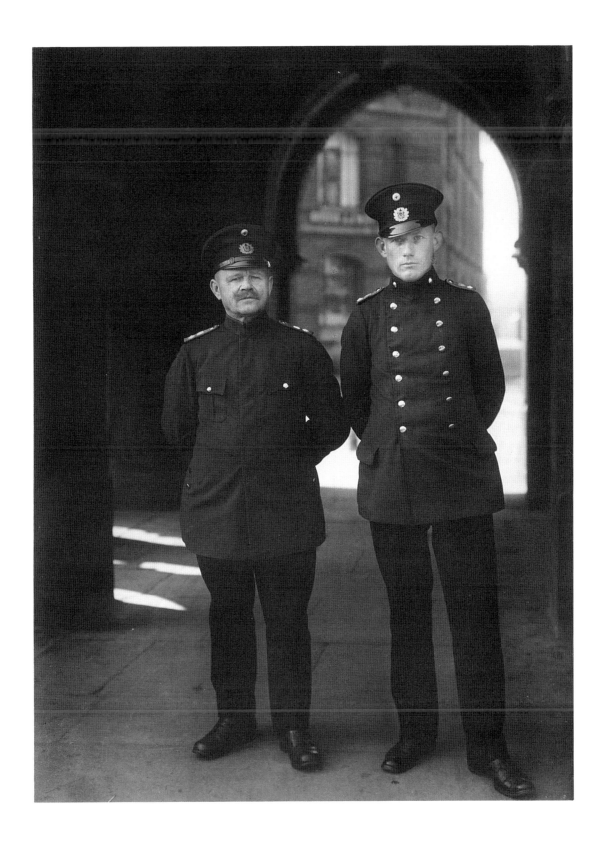

ALBERT RENGER-PATZSCH

German (Würzburg, 22 June 1897 – Wamel-bei-Soest, 27 September 1966)

Sempervivum 1928

Gelatin silver print, 22.8 × 16.8 cm
Purchased 1992

ALBERT RENGER-PATZSCH WAS RAISED in a household of melody and imagery, his father having been a musician and keen amateur photographer. After military service in World War I, he studied chemistry, then in 1925 began to work as a photojournalist. He taught at the Folkwangschule in Essen beginning in 1933, where he also became the photographer for the Folkwang Museum.

In 1928, Renger-Patzsch published the book for which he is best known, *Die Welt Ist Schön* (the world is beautiful). *Sempervivum* is among its 100 photographs. In addition to plant and animal forms, the book also contains images of manufactured objects such as the products of industry and architecture. Although it met with a hostile reception in conservative photographic circles, its stark realism, unconventional vision, and sometimes cruel view of the world was received as an important advance in art. It was "evidence that the time has found in the photographer a more sensitive instrument for the expression of its artistic needs than in the painter,"[1] as art historian Heinrich Schwarz declared. With the book's publication, Renger-Patzsch was hailed as the leader of the *Neue Sachlichkeit* in photography.

The *Neue Sachlichkeit* – New Objectivity or new realism – began as a movement among certain artists in Germany who adopted a neo-realist style in reaction to expressionism. In visual art, influenced by the spirit of disillusion following World War I, their paintings went from the simply factual and unsentimental to the hard and brutal. In photography, the movement translated into looking at the world through the unconventional perspective of exaggerated angles or extreme close-ups, and rendering it with photographic clarity.

Renger-Patzsch wrote in 1927 that "Photography has its own techniques and its own means. It gets into trouble if it undertakes…to create effects that are appropriate to painting …The secret of a good photograph with qualities that may be considered artistic stems from its realism."[2] The trick, however, was to transcend the literalness that comes with photographic realism. One way of doing this was to show a reality unusual enough to cause us to question its meaning. Renger-Patzsch's view of a sempervivum (a succulent commonly known as houseleek) tells us little of its appearance in an ordinary way. Certainly it tells us nothing of its history: that, for instance, in the eighth century the Emperor Charlemagne caused this herb to be grown on rooftops as a protection against lightning, a practice still common among some regions of Europe. But it does tell us how extraordinarily beautiful the forms of nature can be when they are dislocated by the camera, and we are impelled to wonder if the plant's surface provides a clue to its meaning. Most of all, we are amazed by the artist's eye, his sense of design, and his control over his craft, all of which have been combined to create a voluptuously glowing object that is, after all, only a sheet of paper covered with an emulsion of gelatin and some light-sensitive silver salts.

HERBERT BAYER

American (Haag, Austria, 5 April 1900 – Montecito, California, 27 September 1985)

Knight with Flowers 1930

Gelatin silver print, 23.9 × 30.2 cm
Purchased 1985

PHOTOGRAPHS ARE NOT NOTED FOR THEIR HUMOUR. Perhaps life is thought to be too serious a business. Herbert Bayer's photographs, however, sometimes suggest the contrary. A knight smelling a flower would seem to be an amusing fable for several different times – the postwar world of Germany in 1930, when militarism was not held in high esteem in some circles, and the later decades of the twentieth century when the widespread use of chemical fertilizers and pesticides might suggest that we require to be protected from nature. The latter explanation, of course, was never in Bayer's mind, unless it was to say that strong men should guard against the seduction of flowers. More likely, he was amused by the idea of an outmoded metal helmet (symbol of military virtues) that turned man into a snout-like, unseeing creature trying to enjoy life's fragile pleasures.

Incongruities are the stuff of surrealism, of which there are at least two different kinds – real situations that illustrate the bizarre in life, and fabrications that invent the bizarre. Surrealist painters fall into the latter category. Some photographers fall into one, some into the other, and some, such as Bayer, are to be found in both. In this artist's work, we find straight photographs containing absurd relationships, staged situations such as *Knight with Flowers,* or photomontages that create artificial relationships between otherwise unrelated images.

In 1919, after war service with the Austrian army, Bayer was apprenticed to an architect in Linz, then became a graphic design assistant for an architect in Darmstadt, Germany. Two years after, he enrolled as a student again at the Bauhaus in Weimar, the centre of radical, new ideas in art, where he studied painting and design under Wassily Kandinsky, Paul Klee, and Johannes Itten. From 1925 to 1928, he taught typography and design at the Bauhaus in its new location in Dessau. It was his first wife, Irene Hecht, who introduced Bayer to photography in 1924. In 1928, he became a freelance photographer, an art director for *Vogue* magazine in Berlin from 1928 to 1930, and director of the Dorland Design Studio from 1928 to 1938. His work was included in the *Film und Foto* exhibition at Stuttgart in 1929 and in the exhibition of "degenerate art" organized by the Nazis in 1936. Two years later, he emigrated to the United States, where he became a design consultant.

Bayer's photographic activity was pretty well restricted to the period between 1924 and 1937. During those years, he made an important contribution to the New Vision in photography. In addition to his surrealist themes, he shared many of the concerns to be found among other members of the Bauhaus, including László Moholy-Nagy, director of the Bauhaus, who said of photography, "Everyone will be compelled to see that which is optically true, is explicable in its own terms, is objective, before he can arrive at any subjective position."[1] Through photography the tension between the real and the subjective becomes provocative and mysterious.

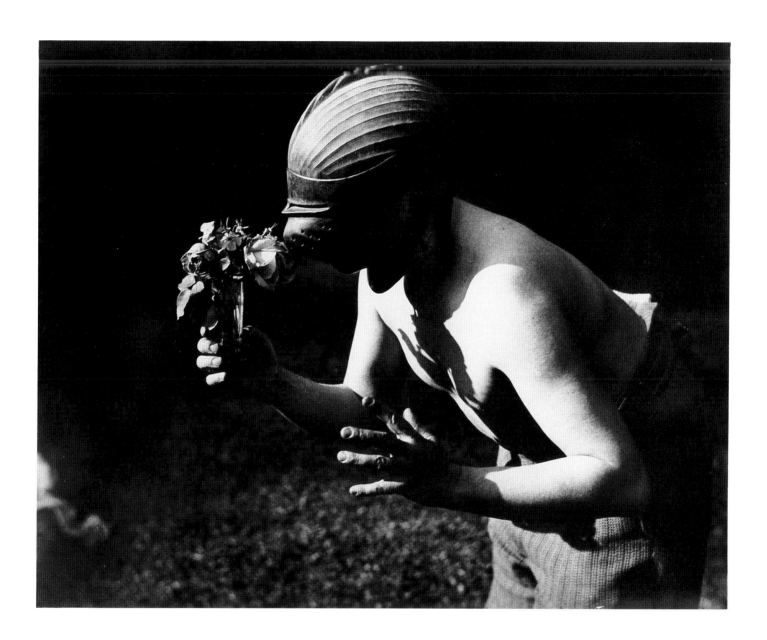

BORIS IGNATOVICH

Russian (Loutzk, Ukraine, 1899 – Moscow, June 1976)

The Showers 1931?

Gelatin silver print, 49.6 × 34.5 cm

Purchased 1990

BORIS IGNATOVICH ORIGINALLY WORKED AS A PRINT JOURNALIST, editing several humorous magazines in Leningrad from 1922 to 1925. He began to photograph in 1923, apparently because of the influence of Alexander Rodchenko, and three years later moved to Moscow, where he worked for a number of journals as a photographer. Ignatovich was a pioneer in collectivism in photojournalism. In 1928, he succeeded Rodchenko as head of the October group, an artists' collective. While working for another collective, Soyuzfoto, he formed a group known as the Ignatovich Brigade, consisting of his wife and his sister Olga, among others. During World War II, he worked as a reporter at the front.

Soviet photography between the two wars was experimental, energetic, and committed to the union of art and everyday life in the building of a new society. In the earlier years, it was very much a part of the modernist movement that was sweeping European art circles. Ignatovich, along with Rodchenko, El Lissitzky, and Dziga Vertov, was among its leaders. His work is characterized (like that of his compatriots in the movement) by dynamic framing, surprising angles, exaggerated foreshortening, and the geometry of structuralism. The subject of his photographs ranges from human interest to the abstract forms of machinery, but always its intended purpose was to promote the optimism of the workers' society.

The Showers, with its atmosphere of sunny warmth, suggests Ignatovich's belief in the power of human beings in a healthy society, qualified by a mood of quiet contemplation. We may be reminded of Auguste Rodin's sculpture, The Thinker, except that this man's thoughts have a focus. We might be forgiven the reference to Rodin for another reason: the massive figure in the foreground, with its dark, ball-shaped head, has the form and power of sculpture, particularly in contrast to the vaporous, dreamlike figures in the background. Because the seated man is so close to our own point of view, we are almost placed in the picture as observers, but in the end we are the watchers watching both the watcher and the watched. Ignatovich's photograph is, in fact, a visual game between several realities played out in formal terms on the flat field of modern art's picture plane. While respecting the dynamics of the picture plane, he tests its limits by contrasting the volumetric, sculptural form of the foreground figure with the two-dimensional shapes of the background figures that are like lightly drawn sketches on a shimmering curtain. Unity is provided by the gentle quality of the light and the tonal warmth of the print.

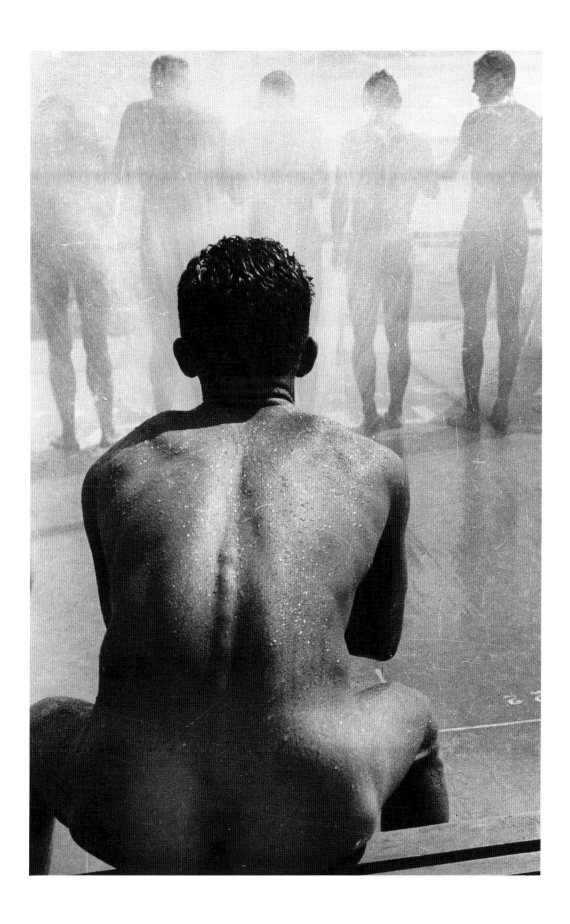

LEWIS WICKES HINE

American (Oshkosh, Wisconsin, 26 September 1874 – Hastings-on-Hudson, New York, 4 November 1940)

Top of the Mooring Mast, Empire State Building 1931

Gelatin silver printed c. 1939, 34.2 × 26.9 cm
Purchased 1989

FOR THOSE WHO INSIST THAT PHOTOGRAPHY'S REAL PURPOSE is to engage the social and humanitarian concerns of the day, Hine has long been the guiding light. The debate between aesthetics and politics often resolves itself into a simplistic choice between art for art's sake, or pictures for propaganda, with no middle ground. Behind the debate lies a distinction forced upon us by a materialistic society that confuses "the needs of survival and the needs of fulfilment; whereas man's life requires both . . ."[1] Those artists who are most successful in drawing attention to the necessity for political and social change understand that the power of a picture derives from the way its formal elements are used to connect the viewer with the message. That Hine understood this is often overlooked. His sense of graphic economy, expressive form, and where exactly to place the frame of his viewfinder are the keys to why his pictures are so powerful.

Hine studied drawing and sculpture part time after finishing high school in 1892. He left Wisconsin in 1900 to take sociology and education at the University of Chicago before going on to teach natural sciences at the Ethical Culture School in New York in 1901. In 1903 the School presented him with a camera, but his serious involvement with photography dates from 1904 when the School's principal asked him to make photographs that could be used to break down prejudices against immigrants. His best known projects are the series on immigrants of Ellis Island started in 1904, the child labour series begun in 1907 when he went to work full time for the Child Labour Committee, the photographs he made while serving with the Red Cross in Europe from 1918 to 1920, and his exploration of workers in relation to industry, resulting in *Men at Work,* published in 1932.

Top of the Mooring Mast belongs to the latter group. In May 1930, Hine was commissioned to photograph the Empire State Building in construction, a project that gave him, as he said to a friend, "a few extra thrills."[2] In 1931, the *Literary Digest* described the result as a unique collection of photographs about the human side of construction: "A saga of men who, outlined against the sky on dizzying heights, fuse the iron of their nerves with the steel of the girders they build into modern cities."[3]

Although in the first instance concerned with the human condition, Hine's vision in this series was also very much in the spirit of the modernist movement in art in which machines dominate the imagery and dictate the structure of the composition. *Top of the Mooring Mast* exhibits a theme close to the heart of modern art of the 1920s and 1930s – the ambivalent relationship between human beings and the new environment created by twentieth century engineering. The framework of the skyscraper lends itself to the geometric dynamics of the picture plane, played out against a background rendered two-dimensional by the misty atmosphere.

Hine's photographs were usually contact printed, at 5 × 7 inches (13 × 18 cm), for publication. Only occasionally did he make enlargements for exhibitions. Near the end of his life, however, he enlarged a number of those photographs that he felt to be the most successful. *Top of the Mooring Mast* is one of these. Both the print quality and its formal structure show the depth of Hine's understanding of the beauty of the medium.

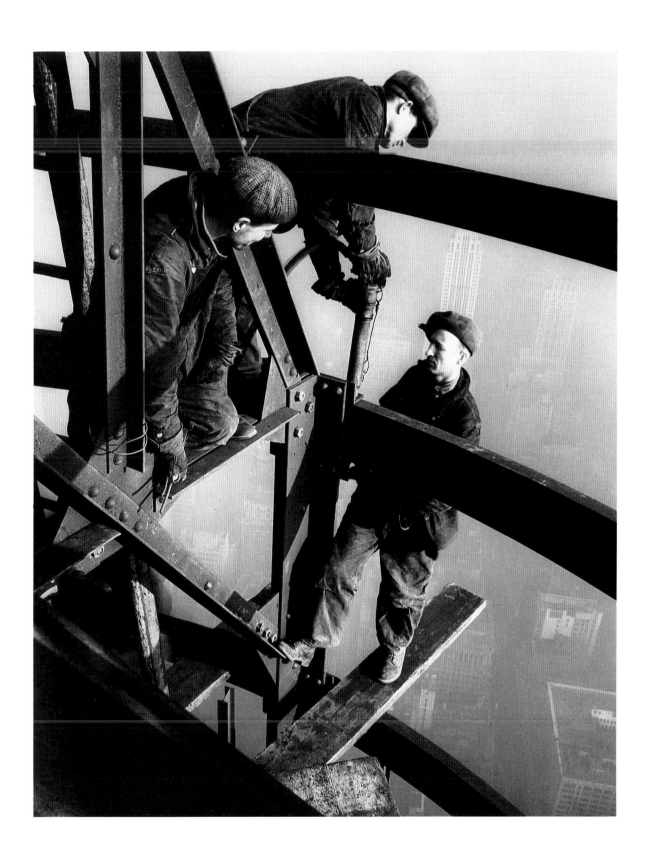

RALPH STEINER

American (Cleveland, 8 February 1899 – Hanover, New Hampshire, 13 July 1986)

Nude and Mannequin 1931

Gelatin silver print, 19 × 23.8 cm
Purchased 1988

THE 1920s BROUGHT RADICAL CHANGES to the look of the photograph. The dadaist technique of montage that created violent or disturbing oppositions within the image, the modernist theories that emphasized design and the picture plane, and the rediscovery of photography's unique ability to render the surface of things in crisp and minute detail – all contributed to the overthrow of pictorial photography's attempt to mimic painting through painterly composition and the broad effect. These were Ralph Steiner's formative years.

Steiner attended the Clarence White School of Photography in New York from 1921 to 1922 after graduating from Dartmouth College, Hanover, New Hampshire. He had begun to photograph at the age of fifteen, an interest that had continued through his Dartmouth years. His photographs of this period were soft-focus and pictorialist, but the Clarence White School soon sharpened his lens. Although White's teaching emphasized painterly design, Steiner's discovery of Edgar Degas while at the school reversed the influence. His recognition that the artist's paintings were often influenced by the look of the world on the camera's ground glass gave Steiner confidence to search for an approach to composition that was photographic.

Steiner was renowned for his sense of humour. One of the most significant individual elements in his work of the twenties and thirties is the visual joke, which is certainly evident in *Nude and Mannequin,* its humour being informed partly by autobiographical forces. In a letter to his dealer, Steiner jokingly referred to it as "a youthful indiscretion; probably an attempt to get back at my parents who'd not encouraged me to go to the nearby Cleveland Art Museum because they had NAKID ladies on the wall." Many an artist growing up in North America at this time harboured a similar resentment against parental mores. He went on to say that "One could put an old fashioned moral title on it: 'LUST AND MODESTY'."[1] As to which figure represents modesty, the ambiguity is no doubt intentional.

Nude and Mannequin is typical of avant-garde photography of the period with its emphasis upon the flat picture plane, the angular thrust of the composition, and the introduction of typography as a design element. It also represents a search for the alternative to the traditional romantic nude study – and is certainly one of the more startling examples of the time. Of greater consequence, however, are the surrealist overtones in the image. Steiner's emphasis upon the model's single, bright, staring eye we must assume to be intentional. As a member of New York's artistic community, there is reason to believe he was aware of the importance surrealists placed upon the eye as both an explosive force and a centre for creative activity. Luis Bunuel's film *Le chien andalou* had been made two years before, Man Ray's *Indestructible Object* from 1923, and his *Boule de neige* from 1927, to name only a few works in which the eye figures as a prominent symbol. Indeed, the Jungian interpretation of the eye as the maternal bosom and the pupil as its child is as old as Egyptian mythology. It is relevant, perhaps, to note that the model in his photograph was, according to Steiner, herself a "talented artist" who, around this time, worked for painter Rockwell Kent.[2]

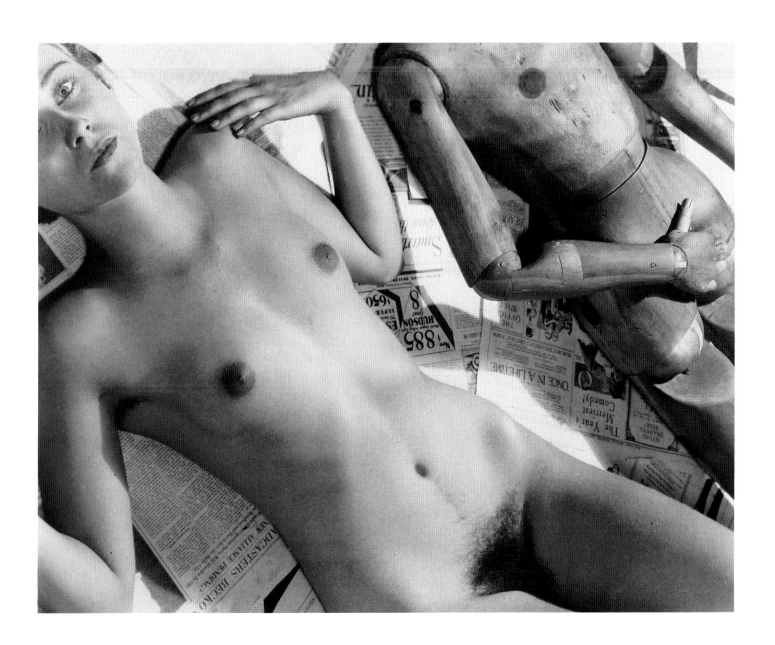

EDMUND KESTING

German (Dresden, 27 July 1892 – Birkenwerder, 21 October 1970)

Self-Portrait 1931

Gelatin silver print, 30 × 23.8 cm

Purchased 1989

IT MAY BE ARGUED that the psychological portrait is the single most powerful genre in the history of photography, for the portrait that reflects the inner workings of the mind or the soul of another enhances our own self-knowledge. We may find Edmund Kesting's self-portrait a revealing key to an artistic temperament, or we may find it to be simply disturbing. During the 1920s, Kesting was at the centre of the avant-garde movement in Germany. He first trained as a painter at the Akademie der Kunst in Dresden from 1911 to 1916. In the early 1920s, after service in World War I, he turned to collage and photography. An exhibitor at Berlin's Der Sturm gallery, which supported German expressionism and the Blue Rider group, Kesting also operated several private art schools. The last, Der Weg, was closed by the Nazis in 1933. Kesting's interest in the photographic portrait began in 1930, and often resulted in bold experimentation that provided some of the strongest examples of German expressionist portraiture in photography. In contrast to the objective naturalism of August Sander, his work is informed by the "Sturm und Drang" of the period – the storm and stress of the political, economic, and social unrest in Germany. After the war, in 1948, Kesting taught at the Kunsthochschule in Berlin-Weissensee.

Spatial ambivalence and the ambiguous relationship between hand and face both raise questions about the reality we are witnessing in *Self-Portrait*. The strong presence of the jaw detached from the background through selective focusing creates a sense of the face as a mask separated from its body. The brilliantly lit hand, so pale by comparison, seems to sit on a separate plane of its own, ensuring that we read it as an entity detached from the face – even detached from the same body? The question becomes, are we witnessing the model the artist is using for his portrait, or is the painter painting himself into existence with his own brush – a kind of Pygmalion in reverse in which the creator creates himself. Whether we wish to carry our interpretation to such lengths or not, the combination of the riveting eye and the eerie, glowing hand is unsettling.

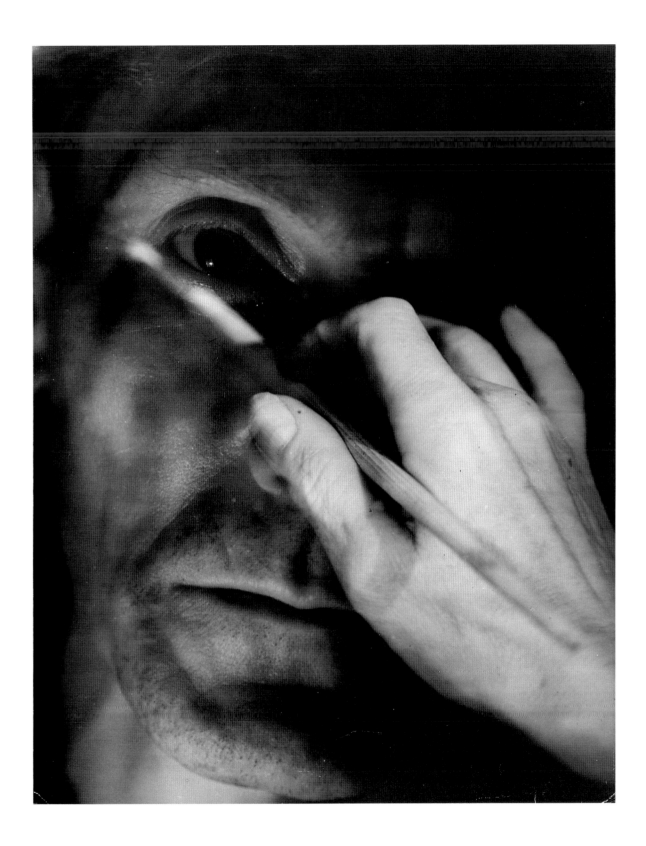

Brassaï (Gyula Halász)

French (Brassó, Transylvania, 9 September 1899 – Nice, 11 July 1984)

Portrait of Janet 1932

Gelatin silver print, 18 × 23.6 cm

Purchased 1990

IN 1933, THE SURREALIST PAINTER Salvador Dalí made a photomontage of heads and ears in which the head of Brassaï's *Portrait of Janet* appeared as the centrepiece.[1] Dalí called his own work *Le Phenomène de l'extase.* Whether we see Brassaï's portrait of his sister-in-law as representing ecstasy or simply as a picture of a young woman asleep is a personal matter. Each of us brings our own associations. What is certain, however, is that Brassaï saw the formal qualities of her dress, face, and hair in terms of strong, simple volumes that reflected the classic harmony of Greek sculpture or, closer to our own time, the neo-classicism of the nineteenth-century French painter Ingres, or, even closer, Picasso's post-cubist works of the 1920s. What Brassaï's portrait has, that the others lack, is the touch of realism we see in the hair, the shoulder straps, and the tear in the bedspread. These, but especially the latter, give us that slice of life, that tension between the ideal and the real, that can make a photograph so provocative and so poignant.

Following service in the Austro-Hungarian army during World War I, Brassaï studied at the Fine Arts Academy in Budapest from 1918 to 1919, and in 1922 obtained a Bachelor of Arts degree from the Academische Hochschule at Berlin. Two years later, he arrived in Paris where he worked as a painter, sculptor, and journalist for the next six years, associating himself with Picasso, Dalí, Braque, and the poets Henri Michaux and Jacques Prévert. A year after his arrival in the city, he took the pseudonym Brassaï, after his hometown, Brassó. For those first few years in Paris, he lived a nocturnal life, sleeping by day, walking the streets by night. His search for a way of capturing the images he saw on these walks led him to photography. Around 1926 a woman loaned him a camera and André Kertész gave him some advice. From that point, he was on his own. Photography became his main pre-occupation. "At that time," he claimed, "no one thought of photographing the cesspool cleaners, the inverts, the opium dens, the *bals musettes*, the bordellos, and the other seedy spots with their fauna."[2] His photographs of this period were published in 1933 in book form as *Paris de nuit,* and it is for these that he is best known.

Brassaï's *Portrait of Janet* has a gentle intimacy in distinct contrast to his photographs of Paris nightlife. But something interesting happens when we turn it on its side so that the head is uppermost. From a picture of a peacefully sleeping woman we move to an image with alarming possibilities. The tension within the composition changes, and we are faced with something more reminiscent of renaissance paintings of martyrs. Even the tear in the bedspread becomes more insistent. Although we know Brassaï made his portrait as a horizontal image, it is tempting to view it vertically. Photographs often take on a life of their own, unintended by the photographer.

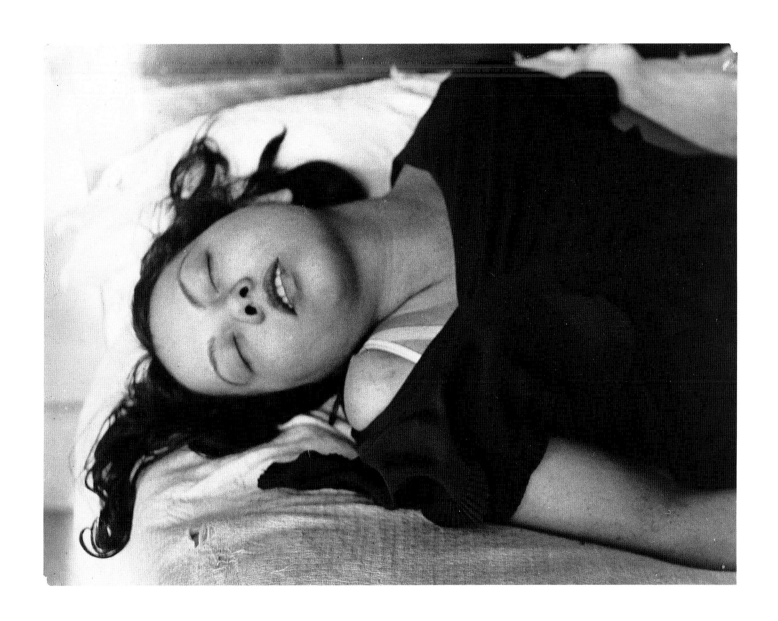

HEINZ HAJEK-HALKE

German (Berlin, 1 December 1898 – Berlin?, 1983)

Vile Gossip 1932

Gelatin silver print, 33.1 × 29.6 cm

Purchased 1986

FOLLOWING IN HIS FATHER'S FOOTSTEPS as a painter, Heinz Hajek-Halke studied art at the Königliche Kunstschule, Berlin, in 1915. His studies were interrupted by military service, but after the war he returned to art school until 1923, when he began to work as a copper engraver, a poster designer for film companies, and a picture editor for a publishing house. Between 1923 and 1925, he worked on a fishing boat out of Hamburg, and taught himself photography, and then, from 1925 on, became a photojournalist, an advertising photographer, and a teacher of photography at the Kunstgewerbeschule. Along the way he acquired such a reputation for his photomontages that in 1933 he was asked to modify documentary photographs for the Nazi Ministry of Propaganda. Refusing to do so, he changed his name to Halke and took refuge near the Swiss border until the outbreak of war, when he served as a German army photographer. He ended the war in a French prisoner-of-war camp, from which he escaped in 1945. Two years later he had reestablished himself as a freelance photographer in West Berlin, again under the name Hajek-Halke. There, he became a founding member of Fotoform, a group of avant-garde photographers, when it was organized by Otto Steinert in 1949, and continued to exhibit with the group until it was disbanded in 1955. In that year, he became a professor of graphic art at the Berlin Hochschule für Bildende Kunst, his final teaching post.

Hajek-Halke is known primarily for his photomontages made during the late 1920s and early 1930s and for his photograms and light drawings produced after the war. But it is the early photomontages that made the most impact, among which *Vile Gossip* is certainly the best known. Three gentlemen in frock coats and top hats, the symbol of traditional male, bourgeois values, talk together while standing on the pavement of a street which, at the same time, is the torso of a female nude. Two negatives were printed one after another to superimpose the separate images on the same sheet of paper. The device of combining unrelated photographic images for the purpose of irony and to create a "systematic derangement of the senses"[1] is part and parcel of the dadaist and surrealist enterprise. Although related to the photographic milieu of John Heartfield and Hannah Höch, his work is also part of the larger German avant-garde movement of the time. Perhaps less ferocious in its satire of societal corruption than George Grosz's caustic drawings of the period, *Vile Gossip* nevertheless is a biting commentary on current social or possibly political values, heaping abuse on the German bourgeoisie. Its meaning derives from the complex interweaving of objective fact with the subjective elements of the sensual and the sinister.

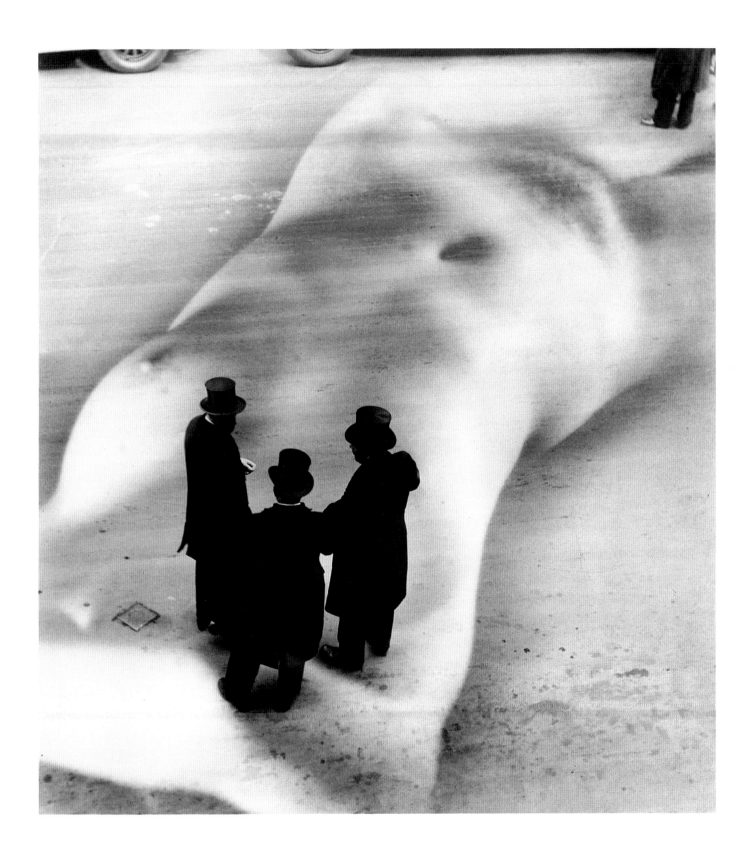

HENRI CARTIER-BRESSON

French (born Chanteloup, 22 August 1908)

Roman Amphitheatre, València, Spain 1933

Gelatin silver printed before 1947, 15.8 × 23.8 cm
Purchased 1984

WHAT IS IMPORTANT TO UNDERSTAND about Henri Cartier-Bresson's early work, such as *Roman Amphitheatre, València, Spain,* is its relationship to theories of modern art. This has been obscured by the popularity of the work he produced as a photojournalist following World War II, which led critics to emphasize his use of the "decisive moment" as a narrative device in his photographs. This had more to do with identifying the telling instant in the strips of images on his contact sheets than with making deliberate choices through the camera's viewfinder at the time of events.

Destined to enter the family textile business, Cartier-Bresson left school to study painting instead, under various painters. In 1927 he entered the studio of André Lhote, one of the most influential teachers of modernism in art between the two world wars. During the academic year of 1928 to 1929, he attended lectures at Cambridge University, and then, in 1930, went to Africa, where he became a professional game hunter, and began to photograph. Only after his return to France, perhaps as a result of his association with such surrealists as Max Ernst, André Breton, and Salvador Dalí, did he become seriously interested in photography. It was the surrealists, most open to chance encounters, who understood the camera's talent for capturing the magical affinities of fleeting gestures and mysterious situations.

By 1932, on trips through France and Spain, he was photographing continually. In 1934 while attached as photographer to an ethnographic expedition to Mexico, he met the Mexican photographer Manuel Alvarez Bravo. Subsequent periods of stay in the United States placed him in contact with younger American photographers such as Ralph Steiner. In 1935, the Julien Levy Gallery in New York exhibited Cartier-Bresson's photographs with those of Walker Evans and Bravo. From Paul Strand he learned the rudiments of cinematography, and upon his return to France in late 1935 or early 1936, he joined Jean Renoir's film crew, working on, among others, *Une partie de campagne* and *La règle du jeu.* World War II found him in the army. Soon after, he became a prisoner of war, but after thirty-five months of captivity in Germany, escaped to join the underground in Paris. In 1947, he helped found the photographic press agency Magnum, and has devoted most of the rest of his career to photojournalism and the production of picture books on various countries. In recent years, he has abandoned photography almost completely in favour of drawing.

"What I am after," Cartier-Bresson has said, "is geometry."[1] André Lhote's emphasis on the two-dimensionality of a painting's flat surface upon which a succession of planes or screens may be used to articulate space is evident in *Roman Amphitheatre*, made at a bull ring in València. The elegant formal structure of this photograph, certainly the result of conscious awareness, nonetheless retains the spontaneity of the glancing encounter, in which typography, gesture, and geometry combine to produce an image that is complex, evocative, and enigmatic. The functionary's head, framed like some omnipotent and implacable deity, the menacing reflection of his spectacle lens, its circle partially repeated in the bull's eye with its hidden number, and the vague figure of the child fleeing into a shadowy world create a drama dear to the surrealist's heart — the transformation of ordinary fact into a poetic force.

JOHN HEARTFIELD

German (Berlin, 19 June 1891 – Berlin, 26 April 1968)

Crisis-Immune Cattle 1934

Gelatin silver print, 23.8 × 18.8 cm

Purchased 1979

PHOTOMONTAGE — THE ASSEMBLING OF ELEMENTS from various photographs to create a new image – has roots in the nineteenth century. It was practised by art photographers as a means of artistic control, by commercial photographers to describe events they were unable to record on a single negative, and by anonymous Victorians to illustrate private family jokes in personal albums. Toward the end of World War I, the dadaists reinvented the technique as a form of anti-art to *épater le bourgeois*.[1] John Heartfield, a founder of German dada and one of the most adventurous experimenters in photomontage, soon turned it to propaganda purposes. Between 1929 and 1938, his biting caricatures appeared on the covers of *AIZ* (workers' illustrated news), a weekly magazine with a vigorous anti-Nazi message, and on numerous political posters. Much has been made of the notion that only the pure, untampered-with photograph can serve social documentary purposes. The photomontage, by using the photographic character of the image's elements and their associations with reality, can be equally convincing.

Heartfield, born Helmut Herzfeld, son of a socialist poet, dramatist, and prose writer, began to work for a painter in 1907. Two years later, he enrolled in the School of Applied Arts at Munich. After moving to Berlin in 1913, he studied under the painter Ernst Neumann. The anti-British hate campaign during the war convinced him to anglicize his name in 1916. With George Grosz he became co-founder of the dada movement in Germany. In addition to designing book jackets for the publishing firm he established with his brother, he did film work and stage designs, and edited several satirical magazines. His photomontages were widely exhibited between the wars, beginning with the International Dada Fair in Berlin in 1920, and continuing in Stuttgart, Moscow, Prague, Paris, New York, and London. However, because of his political activities he had to flee first to Prague in 1933, where *AIZ* continued to be published, then to England in 1940, where he remained until his return to East Germany in 1950.

Although Heartfield did himself make photographs, more often he appropriated the work of others for his montages, as in *Crisis-Immune Cattle*. The cattle, of course, are the German people, who refuse to see what is happening to them – the cow that cannibalizes itself becomes oblivious to other dangers. Satire relies upon metaphor, but metaphor turned upside down to hold human folly up to ridicule. Political satire of this kind, hand-drawn, might be more amusing than bitter. The photographic nature of Heartfield's montage manipulates our system of perception in a manner that permits four-legged creatures to sit upright and mutilate themselves. Photography lends a sharper edge to the image and gives it a degree of credibility. The mind recognizes the photographic reality first and analyzes the image's components after, thus taking us halfway to conviction.

Heartfield's specific message may elude us today. In 1934, Hitler promoted a particularly vicious, fratricidal bloodbath by having many of his followers as well as his opponents assassinated. In a general sense, however, the sarcasm of *Crisis-Immune Cattle* still remains potent. Our body politic continues to be bovine, short-sighted, and self-centred. Like a monster in a child's fairy tale or character in a surrealist play, the cow contentedly feeds upon itself, and today we are perhaps more amused and less horrified than we should be.

BERENICE ABBOTT

American (Springfield, Ohio, 17 July 1898 – Monson, Maine, 9 December 1991)

Barclay Street, Hoboken Ferry 1935

Gelatin silver print, 19.1 × 24.1 cm
Purchased 1984

PERHAPS NO PHOTOGRAPH SHOWS MORE than does this one how important light is to the photographer in transforming the commonplace into a poetic vision. In her book, *A Better Guide to Photography,* 1941, Berenice Abbott explains that "the slanting rays of the sun may cast shadows which bring the whole subject to life…" Photograph, she advised, when "the light is longer and yellower, facts which produce tonal quality in a print."[1] Indeed, the tonal quality in *Barclay Street, Hoboken Ferry,* with its luminous milky glow, has transformed an otherwise drab scene into a miraculous moment.

Berenice Abbott was educated in journalism at Columbia University, but soon turned to art. Between 1918 and 1921 she studied sculpture and painting, then went to Paris to study with sculptors Émile Bourdelle and Constantin Brancusi. In 1923, she attended the Kunstschule in Berlin, but returned to Paris that same year, and worked as an assistant to Man Ray. As she was to say later, "I took to photography like a duck to water. I never wanted to do anything else. Excitement about the subject is the voltage which pushes me over the mountain of drudgery necessary to produce the final photograph."[2] By 1926 she had opened her own studio, specializing in portraits of the artistic and intellectual elite of Paris, and held her first solo exhibition. Through Man Ray she met Eugène Atget, whose work considerably influenced her own photographs. With Atget's death in 1927, she acquired most of his archives, and upon her return to New York in 1929, embarked upon a series of exhibitions of his work and books about him, thus bringing this important photographer to the attention of the North American photographic community. During the 1930s she photographed New York as part of the Government's Federal Art Project. Her book *Changing New York* derives from this project. Around 1940, she became involved in photographing scientific subjects. She served as photographic editor for the periodical *Scientific American*, and between 1958 and 1962 worked for the Physical Study Committee of Educational Services, New York. In 1968, she retired to Abbott Village in Maine. "Essentially there have been three major interests for me," she wrote in 1975, "New York of the 30s, the field of science, and Paris portraits of the 20s."[3]

Barclay Street, Hoboken Ferry was made for Abbott's *Changing New York,* the purpose of which was to capture the spirit of "the metropolis, while remaining true to its essential fact, its hurrying tempo, its congested streets, the past jostling the present."[4] One aspect of this was the city's transportation systems. Since Abbott was a product of the European New Vision in photography, which stressed rhythm and design, she has used the shapes of rooftops, boxcars, windows, and the converging lines in the foreground, all emphasized by a caressing light, to create a satisfying geometry across the picture's surface. An arresting tension exists between the frozen moment and the almost palpable movement we sense in the shadows, especially in the elliptical shape that steals across the façade of the building at the right. If photography is principally concerned with observation, Abbott has shown a relentless fidelity to facts. And that alone is capable of giving us pleasure. Each tiny figure, each automobile has been turned into a pristine miniature, crystallized by light. Abbott has given us a place where time stands still, a place beyond the ravages of life, where the moment has become eternal.

WALKER EVANS

American (Saint Louis, Missouri, 3 November 1903 – New Haven, Connecticut, 10 April 1975)

Negro Barber Shop Interior, Atlanta, Georgia 1936

Gelatin silver print, 19.1 × 23.8 cm

Gift of Phyllis Lambert, 1982

AFTER A YEAR'S TRAVEL IN EUROPE, Walker Evans returned to New York in 1927, where he worked in a bookstore. He was still trying to decide whether to be a painter or a writer. Although he had made snapshots in France and Italy, only in the following year did he begin to photograph seriously. Soon he was caught up in the trends of the day – modernist ideas of formalism, extreme high and low vantage points, and angular composition. In 1929, he met Berenice Abbott and saw her large collection of photographs by Eugène Atget – a turning point for him. Atget's direct and honest vision made Evans aware that prosaic facts of ordinary life are capable of metaphorical meaning. From then on, he was in revolt against "accepted ideas of beauty," as he was to say later.[1] He was drawn instead "toward the enchantment, the visual power, of the aesthetically rejected subject."[2] Nothing is more remote from the contrived and manipulated imagery of the pictorialists of the 1920s and 1930s than the economy of Evans's style with its bold frontality, and its use of bare facts presented with emotional reserve in a clear and rational light. In this sense, Evans was a direct inheritor of an American photographic tradition founded in the 1840s and dominated by the daguerreotype aesthetic – clarity, sharp definition, precision, and direct simplicity.

Especially known for his photographs of the Great Depression, many made for the Farm Security Administration, a government agency whose purpose was to create a visual record of the impact of the New Deal on rural America, Evans has a reputation for being a documentary photographer. These photographs, which pleased Evans more than they pleased the FSA, hit so close to the bone of the American conscience that they have over-shadowed his other work. But his purpose was neither political nor social. It was, as he said, "reflective rather than tendentious and, in a certain way, disinterested."[3] In fact, Evans was linking art and documentary by making photographs that are convincing in their detail as records of fact but convey a deeper meaning that goes beyond the immediate issues to the larger concerns of the human spirit.

Our first impression of *Negro Barber Shop Interior* is of a room empty of people. We soon realize that this shop is, in fact, a portrait of humanity, from the newspaper photographs to the x-ray-like imprints of human bodies worn by time into the upholstery of the chairs. The barbershop is a crossroads for human intercourse, a theatre of local history. How many lives have trod this stage, ordinary folk whose reflections have been held in the mirrors for a brief instant. Evans's photograph dwells upon an infinite clutter of facts that whisper of lives that have passed, plain facts about plain people, facts to which we may have paid little heed but that for Evans are endowed with intrigue. Whether they yield up their secrets – and Evans himself found they were not prone to do so – is of little consequence in the end, for through the medium of photographic paper each fact is given a patina of beauty that seduces the senses. "The photographer," said Evans, "is a joyous sensualist, for the simple reason that the eye traffics in feelings, not in thoughts."[4]

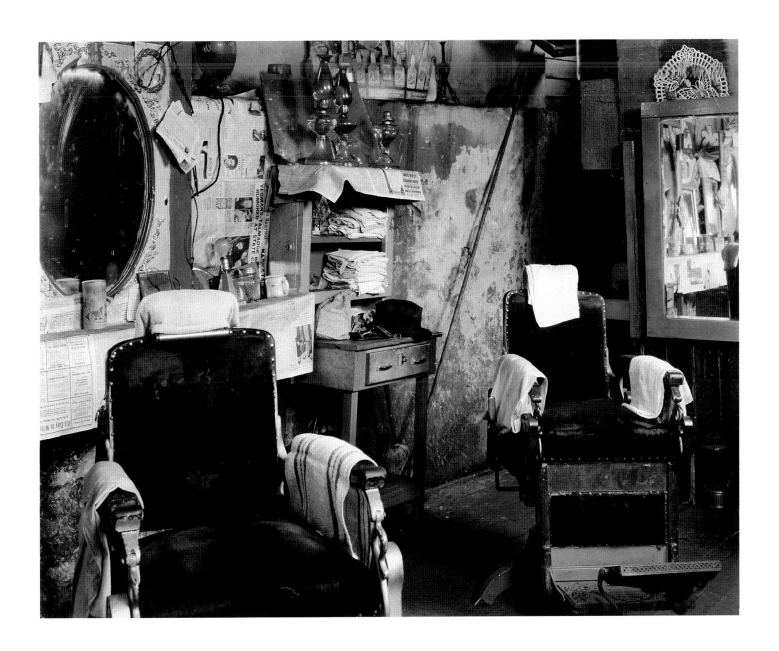

MORRIS ENGEL

American (born New York, 1918)

Sweet Evelyn 1939

Gelatin silver print, 23.5 × 19.1 cm

Purchased 1979

THE SO-CALLED "DOCUMENTARY PHOTOGRAPH" walks a fine line between topographical record and propaganda. Although its roots may be traced to the first decade of photography in the work of Hill and Adamson, the term did not come into use until the twentieth century. In the popular view, documentary photography provides evidence concerning the "truth" of the human condition in general and of social evils in particular. The extent to which this attitude has become entrenched depends upon the mutually reinforcing association of the two words "document" and "photograph." The more precise and detailed the photograph's information, the more we are convinced of its truthfulness. The documentary photographer relies on these two notions to achieve his or her goals. Although popularly seen as zealous reformers, documentary photographers are often found on the sidelines, observing society's manners and morals, providing a commentary that may be satiric, approving, or censorious.

Inspired by the Association of Worker Photographers formed in Germany in 1926, a group of politically conscious photographers in New York founded the Photo League in 1936. Its purpose was to promote photographs that would document social ills, to organize exhibitions, and to train photographers. "Photography," they said, "has long suffered, on the one hand, from the stultifying influence of the pictorialists, who photographically have never entered the twentieth century, and on the other, from the so-called 'modernists,' who retired into a cult of red filters and confusing angles...The Photo League's task [is] to put the camera back into the hands of honest photographers, who will use it to photograph America."[1] The League's plan of action consisted of forming feature groups to work collaboratively on projects such as the *Harlem Document* and *Dead-End: The Bowery,* both headed by Aaron Siskind. In his group was the young Morris Engel.

Siskind saw the need to understand the photograph in formal terms in order to better convey the message. Engel was obviously convinced. *Sweet Evelyn* is one of those photographs that successfully combines gritty reality with a superb formal elegance. Simultaneously, it contains a level of photographic observation radical for its time. The space within the photograph is so shallow that the image appears almost to be made of bits and pieces, of shapes and typography collaged together. By creating visual tensions, the picture's edges, with their truncated forms, contribute to the image's unusual energy. The principles of modernism, so vilified by the founders of the League, have been neatly conscripted to serve a purpose remote from the concerns of the more aesthetically-minded photographer.

Engel's photograph poses questions on the nature of the little human drama we see before us. It also makes an ironic comment on the contrast between the Botticelli-like purity of the woman's profile, the label on the box she carries, and the banal signs that surround her. Above all, this photograph is about the act of looking – the man who gazes upon the woman, the woman whose vision is fixed on something outside the frame, the sign that exhorts us to have our eyes examined, and the photographer who observes it all.

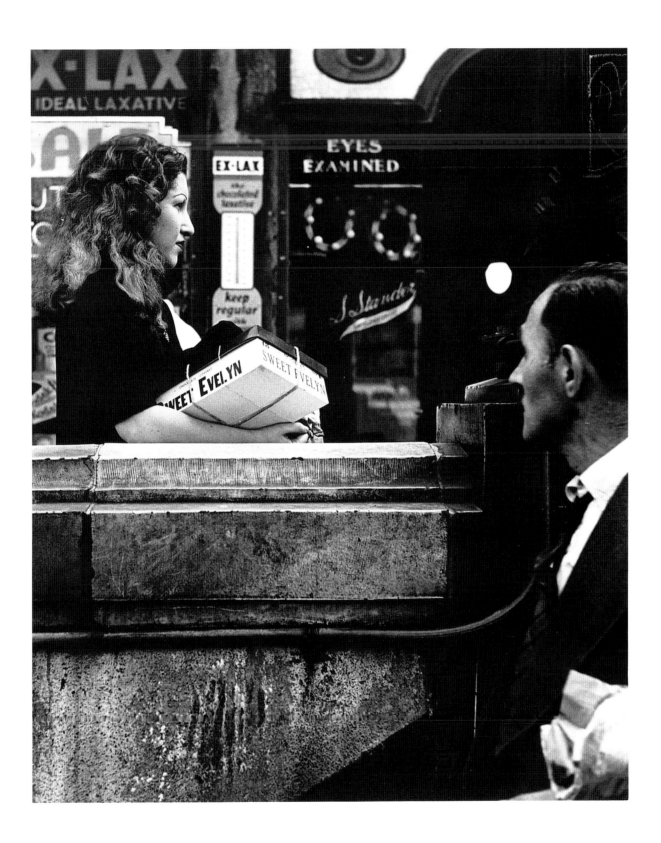

Frederick Sommer

American (born Angri, Italy, 7 September 1905)

Chicken Parts 1940

Gelatin silver print, 24.2 × 19.2
Purchased 1986

IT IS FREDERICK SOMMER'S BELIEF that the shock value of a work of art is the measure of its success. "When the world was young, images were strong," he once wrote.[1] If, with *Chicken Parts*, he meant to shock, the goal has been achieved. It may be relevant to remember that in 1939 and 1940, when Sommer produced his series of photographs of chicken organs, viscera, heads, and other discards from the butcher's block, the world was entering upon the largest scale slaughter in history. It was a time not only for reflecting upon the folly of the human race but for remembering that the reading of chicken entrails for divining the future is an ancient practice. In the search for hard-hitting images that dealt with profound issues on the level of metaphor, photographs such as this placed Sommer far in advance of any other photographer of his time. They also brought him into contact with such surrealist artists as Max Ernst and Yves Tanguy; he was the only photographer included in the International Surrealist Exhibition at the Galerie Maeght, Paris, in 1947.

Sommer moved with his family from Italy to São Paulo, Brazil, in 1913. Son of a landscape architect, he received a master's degree in landscape architecture from Cornell University in 1927. He then entered into partnership with his father, but in 1930 contracted tuberculosis and went to Switzerland for treatment. While convalescing, he became seriously interested in photography. In 1934, he settled in Prescott, Arizona, for his health. There, he began to paint and draw in earnest. On a trip to New York in 1935 he met Alfred Stieglitz and a year later Edward Weston in Los Angeles. Both encounters convinced him to make a stronger commitment to photography. Weston persuaded him to use the 8 × 10 view camera for its remarkable definition. In 1946, he was given his first solo exhibition at the Santa Barbara Museum, California.

Sommer's introduction to the large format camera resulted in hallucinatory landscapes of the Arizona desert in which there is no sky, no foreground, no background, no point of reference for the viewer's orientation. This same flat field characterizes most of his photographs, as does the extraordinary technical quality of his prints, with their exquisite tonal subtleties, sharp precision, and minute detail. In that sense, he was the inheritor of the formalism of the new photography of the 1920s. This same aesthetic was applied to what is his most difficult and probably most important work – the theme of death and decay. His series of discarded chicken parts is only one aspect of this, but it is the most disquieting. Arranged on a flat surface with uncompromising starkness, the dismembered parts seem at one moment to float in an empty, clinical space, but immediately the smear of body fluids draws our attention to the picture plane and reinforces the grisly nature of the situation, lest we tend to sanitize it by seeking shelter in the abstract. It is this tug of war between the overwhelming evidence of stark reality and our need to find meaning in horror that makes *Chicken Parts* so powerful. Knowing what we see, we are still compelled to find in these entrails anthropomorphic symbols. In the end, however, the photograph is unfathomable and we are left with disturbing questions about a profound and unsettling mystery.

ANSEL ADAMS

American (San Francisco, 20 February 1902 – Monterey, California, 22 April 1984)

Surf Sequence, no. 5, San Mateo County Coast, California 1940

Gelatin silver printed 1981, 28 × 32.3 cm

Purchased 1988

THE NINETEENTH CENTURY SAW THE PHOTOGRAPH essentially as a single image. Although there are notable exceptions, photographs were rarely sequenced as groups. When they were, it was usually to show an expanded view of topography, as in a panorama, or as a narrative of an event, or as a record as in Eadweard Muybridge's work on animal and human locomotion. Only in the twentieth century did photographers begin to explore the combining of photographs for expressive purposes. The dadaists' collages were constructed from fragments of unrelated photographs. Albert Renger-Patzsch in 1928, August Sander in 1929, and Walker Evans in 1938 each published books of diverse images originally without any relationship but arranged into sequences that stand as poetic expressions of their responses to the worlds in which they lived.

Perhaps the first photographer to consciously explore the possibilities of making a series of related images with an expressive intent was Ansel Adams. As an exception to his usual method of working, Adams made multiple photographs of a single subject as it changed before his eyes. Setting camera and tripod near a California beach in 1940, "I photographed from a cliff top, directing my camera almost straight down to the surf patterns washing upon the beach below in a continuous sequence of beautiful images. As I became aware of the relations between the changing light and surf, I began making exposure after exposure. Though each photograph can be shown separately, a group of five displayed together has the greatest effect."[1]

These lines were written years later. At the time, Adams seemed not to recognize the value of his photographs as a sequence, for he never returned to the form again. Nevertheless, it is a seminal work, eventually influencing others to explore the possibility more fully. As he pointed out, *Surf Sequence* may be appreciated in its entirety or in its individual parts. Although the fifth image has been reproduced here, any of the others would have been equally meaningful. Its abstract rhythms, brilliant luminosity, sharp definition, and emphasis upon the flat field of the picture plane are typical of the ideas of the modern movement in general between the two world wars. In reaction to the soft-focus pictorialism that still dominated the exhibitions, Adams promoted a return to exploiting the ability of the camera to record the power of fact in a way that the human eye is incapable of on its own, combined with awareness of a set of aesthetic principles that had nothing to do with traditional concepts of art.

Although *Surf Sequence* is unique in the body of Adams's work, because of its rhythmic nature and obvious musical references we should not be surprised to find it there — Adams delighted in comparing photography to music. The surf's movements may well reflect the surges of sound patterns, but they may also be compared to curtains of textured light frozen in time, creating ambiguities of scale, space, and weight. At one moment, the surf appears to be a landscape dotted with trees and eroded by ravines, at the next, a rolling wave transformed into a massive sculpture. Adams has shown us the power of photography and nature to deceive, delight, and disconcert.

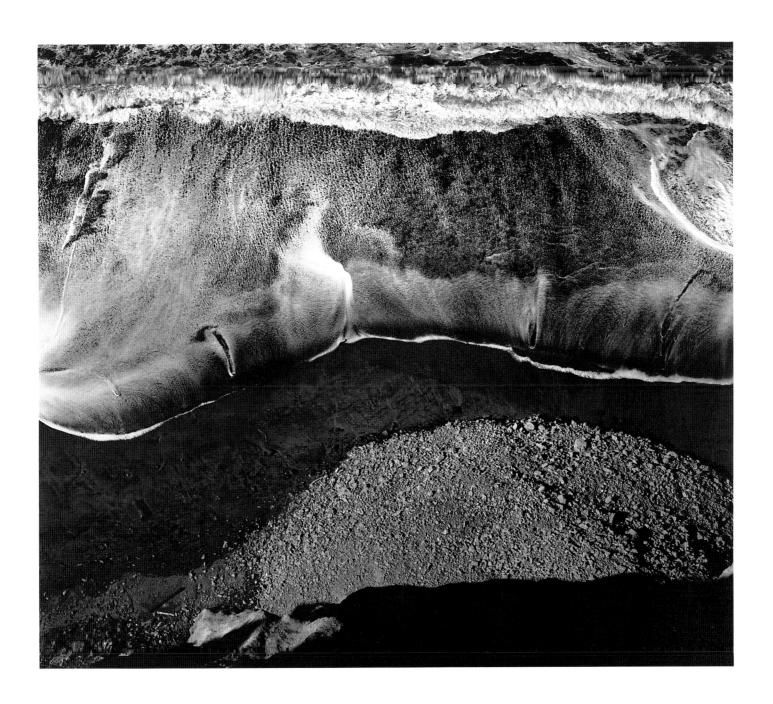

Weegee (Arthur H. Fellig)

American (Zloczew, Austro-Hungary, 12 June 1899 – New York, 26 December 1968)

Easter Sunday in Harlem 1940

Gelatin silver printed 1981, 34.5 × 27.1 cm
Purchased with the Phyllis Lambert Fund, 1981

BORN ARTHUR FELLIG, Weegee arrived in New York in 1909. His father was a pushcart peddlar who later became a rabbi. A child of poverty, Weegee started working as a dish-washer, then became a darkroom technician at Acme News when he was twenty-four, where he stayed for the next twelve years. In 1935, he left Acme to become a freelance news photographer. Events of human drama and tragedy became his specialty. So well known did he become that Hollywood's classic stereotype of the brash, tough, cigar-smoking photographer in the rumpled suit was based upon Weegee. Working mainly at night, he intercepted police radio calls to get to the scene of the crime or disaster.

The social significance of Weegee's photographs comes from the human misery they uncover, victims sprawled and huddled on the streets and alleyways as though carelessly discarded by some great destructive force. As a news photographer, he was an observer of the human condition, however, and not a social reformer. Although murder, violence, and disasters in the streets were his main fare, his fascination with humanity also led him to the less bizarre but more vital occurrences in which ordinary people showed their zest for life. But whether he was recording a shoddy street crime or the joy of people exhibiting their finery at an Easter parade, the style of his work remains the same – intense, forceful, and energetic. The exuberance of feeling that we experience from looking at *Easter Sunday in Harlem* comes as much from the photographer's own personality as it does from his subjects. The faces in his photograph are both moving and memorable. Only a genuine sympathy for people could bring about such an elegant and understanding observation.

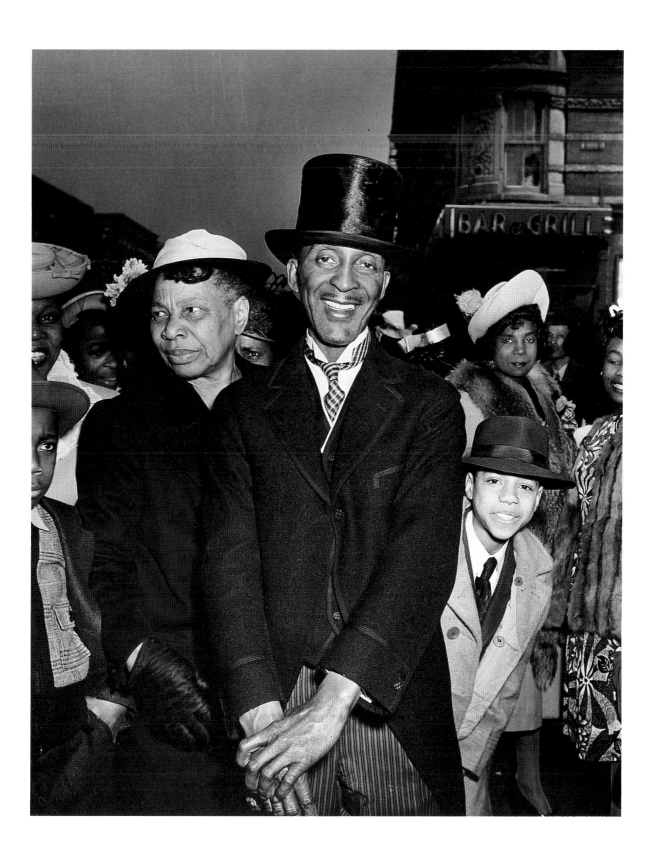

CECIL BEATON

British (London, 14 January 1904 – Broadchalke, 18 January 1980)

Marlene Dietrich 1940

Gelatin silver print, 24.6 × 19.4 cm

Gift of Rodney and Cozette de Charmoy Grey, 1978

FASHION PHOTOGRAPHERS and fashionable portrait photographers in the 1930s, such as Cecil Beaton, subjected the medium to a fun-loving and light-hearted imagination. It was an artistic game played with flair and wit. Their photographic style was drawn from the New Vision of the 1920s, which emphasized clarity and detail, and it was used with superb technical polish. Many of them found their direct antecedents in the surrealist movement of the time. Though their ostensible purpose may have been to serve paying clients, they also served their own private purposes. We cannot ignore the irony of Marlene Dietrich's compelling beauty contrasted with the cold alabaster image of classical features with its heavily pencilled eyebrows, especially since it was Marlene who established the fashion of the thin-line eyebrow. Cheeky though such antics may have been, Beaton's stylish approach was in demand by the great and famous.

Beaton was born into the upper levels of British society, and received his education in the traditional schools of that group. He began to photograph as a child, and both painting and photography had become a serious concern by 1922. After studying history and architecture at Cambridge, he became a freelance photographer in 1926, making portraits of the Royal Family and carrying out assignments for *Vogue* magazine, among others. Known for his fashion photographs and portraits of celebrities, he also designed sets and costumes for stage and screen, including those for the theatre production of *My Fair Lady*. During World War II, he made war reportage photographs, as he did later in Lebanon, China, India, and Africa. He also produced numerous books. In 1960, he was made a Chevalier of the Legion of Honour in France and in 1972 he was knighted by the Queen.

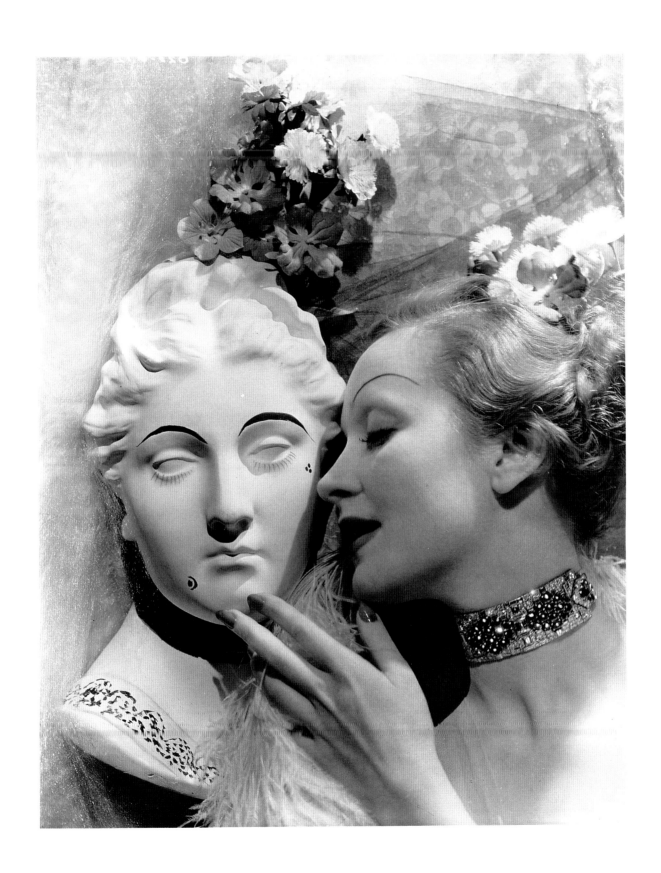

LISETTE MODEL

American (Vienna, 10 November 1901 – New York, 30 March 1983)

They Honor Their Sons, New York 1942 or earlier

Gelatin silver print, 34 × 26.7 cm
Purchased 1985

THE QUALITY OF SCULPTURE evident in Lisette Model's *They Honor Their Sons* is typical of her work. From her earliest photographs, she was drawn to the monumental both as a means of filling the space within their boundaries, and for its expressive impact. Her images of animals in the Paris zoo or of obese vacationers lounging on the French Riviera made in the 1930s are a response to massive and heroic shapes – something to which she remained alive throughout her career.

Born Elise Amelie Felicie Stern (the family name was changed to Seybert in 1903[1]), daughter of a wealthy Viennese physician, she moved to Paris in 1926 to continue her music studies begun in 1918. Around 1933, she gave up music to study painting with André Lhote, an influential teacher of the ideas of cubism. Within a year or so, she decided to take up photography as an easily transportable means of earning a livelihood at a time when she might have to flee the political turmoil of Europe. Some of the rudiments she learned from her younger sister Olga, already a photographer, and from Rogi André, André Kertész's first wife. In 1937, she served a brief apprenticeship with Florence Henri.

Between 1934 and 1938, her subjects ranged from the affluent vacationers of the Riviera to the dispossessed of Paris. In 1935, her photographs began to appear in publications such as *Regards,* which included among its contributors writers like André Gide and André Malraux. The gathering political storm in Europe convinced her and her husband Evsa Model, a painter whom she had married in 1937, to emigrate to New York in 1938. In 1940, The Museum of Modern Art purchased some work and included her in a group exhibition. Ralph Steiner, as picture editor of *PM Weekly,* began to publish her photographs in 1941, and she went on to earn a modest living through assignments for such magazines as *Harper's Bazaar, Ladies' Home Journal, Look,* and *Life,* and through teaching, first at the California School of Fine Arts in San Francisco, then at the New School for Social Research in New York. She also gave private lessons. She was an extremely influential teacher, including Diane Arbus among her many students. Model received a Guggenheim Fellowship in 1965.

Photographed by Model at a war rally, these modest women are like the effigies sculpted out of stone around the portal of a medieval gothic cathedral. Hollow-eyed and jut-jawed, every line and plane of their faces bearing witness to suffering, they are an incarnation of the *mater dolorosa* awaiting the inevitable tragedy. They are also an allegory of the stages of women. From the dark recesses of separate niches created by the vertical post, each stares across time to the future, the older of the two appropriately from a more remote position. Both the post and the stripes of the younger woman's jacket increase the vertical thrust of the composition, strengthening the gothic atmosphere and heroic mood. We might also find an allusion to the stars and stripes in the jacket and in the print in the older woman's dress. Model has cleverly used the rough texture of the jacket, the chiselled planes of the faces, and the balance between the woman's heavy hand at the lower left and the face at the upper right to create a feeling of timeless solidity. *They Honor Their Sons* invokes the ages.

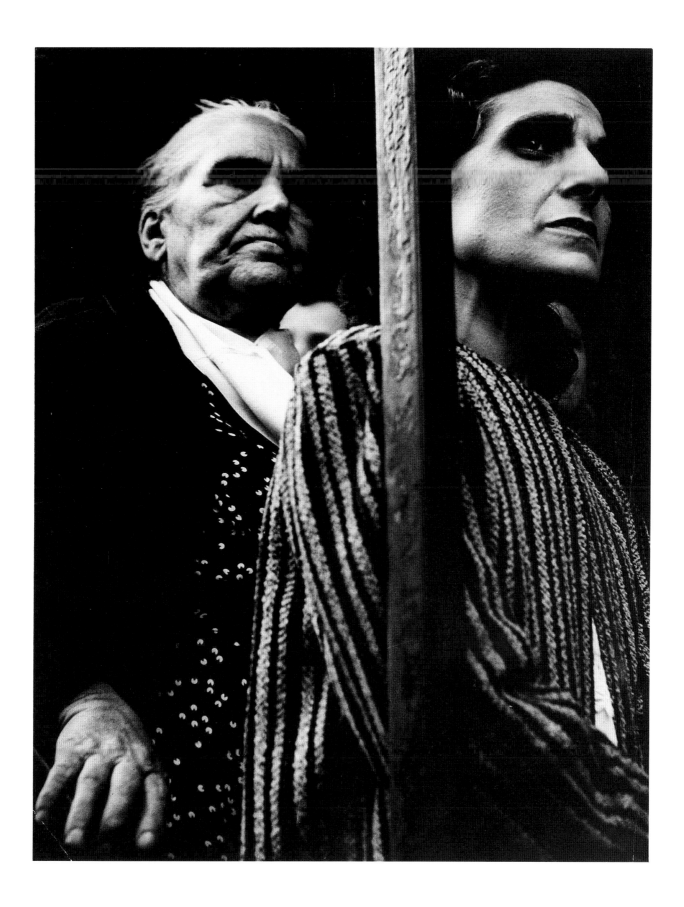

MAURICE TABARD

French (Lyons, France, 7 December 1897 – Nice, 23 February 1984)

Untitled 1942

Gelatin silver print, 29.7 × 23.9 cm
Purchased 1990

MAURICE TABARD WORKED in his father's silk manufacturing plant until 1918, when he moved to New York. From then until 1922, he studied at the New York Institute of Photography. During the following years, he operated branches of the Bachrach portrait studios in Cincinnati, Baltimore, and Washington and, in his personal work, became interested in surrealism. In 1928, when he returned to France to work as a freelancer, he became associated with Man Ray and other surrealists. His work was included in the exhibition of the New Vision in photography, *Film und Foto*, held at Stuttgart in 1929, and in the first exhibition of surrealist art held in America in 1931.

Photography played a major role in surrealism from the 1920s to the 1940s. In addition to the ambivalent reality to be found within the photographic image, such techniques as photomontage, double exposure, and solarization, which permitted the play of visual games, appealed to the surrealist's sense of quirky humour. Solarization, more properly called the Sabattier effect, is brought about by exposing either the negative film or the positive print to light during development in the darkroom, until some or all of the tones are reversed. The result is an image that is part negative and part positive. A further phenomenon, known as the Mackie line, occurs when a thin contour line is built up between adjacent highlight and shadow areas.

In the photograph shown here, Tabard solarized the negative, which allowed him to make any number of identical prints. The procedure appealed to the surrealists because of the element of contingency (the results are unpredictable), but also because of the quality of the dreamlike or the unreal – the shadow world – that was added thereby to the image. Not only are these elements present in Tabard's photograph, but this image is concerned as well with the intriguing problem of the nature of photographic creation. Tabard is exploring the mysteries of the process itself through the fortuitous activity of light and its impact upon the chemistry of photography. By including his shadow in the picture, he has underlined the role of the photographer as the conjurer at the centre of this magical enterprise. Such photographs, in which the photographer's presence is to be seen, offer an interesting parallel with the self-portrait of the painter at work in the studio – images that portray the secrets of picture-making.

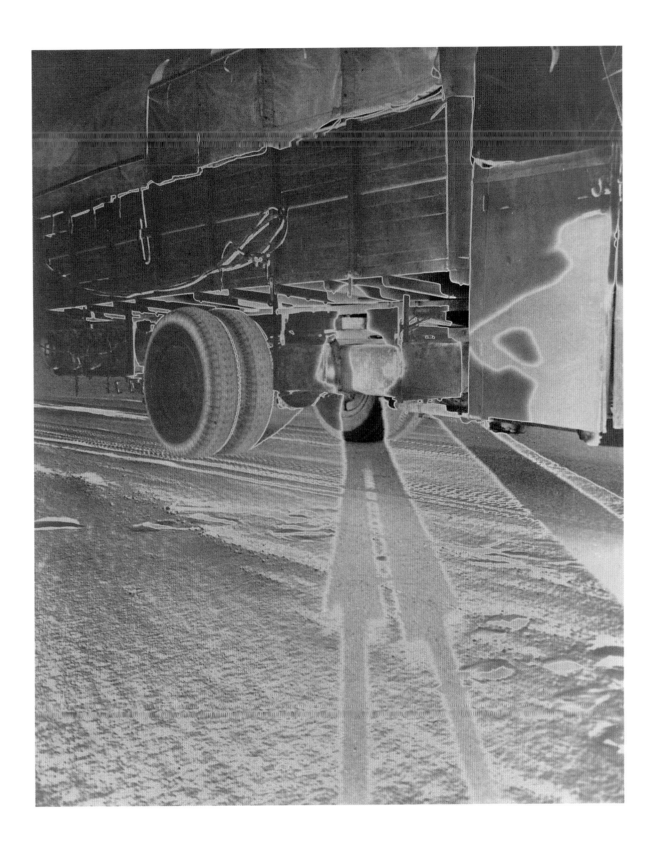

SID GROSSMAN

American (New York, 25 June 1913 – New York, 31 December 1955)

Black Christ Festival, Panama 1945

Gelatin silver print, 26.1 × 28.6 cm
Purchased 1979

IN 1926, THE GERMAN COMMUNIST WEEKLY magazine *AIZ* announced a competition for photographs made by the workers about the political and social life of the working class, thus launching the Association of Worker Photographers. The photographs were to be used to make the public aware of the plight of the dispossessed and to help bring about political and social reform. The association trained its own photographers from among the ranks of the workers. Although not affiliated with them, its ideals provided a model for a group of young photographers in New York who saw photography as a potent weapon in the class struggle. Sid Grossman was among those who were instrumental in forming the Photo League in 1936.

Grossman joined his high-school camera club in 1932, and that same year began studies in literature, music, philosophy, and history at City College, New York. In 1934 he founded a short-lived literary magazine and launched himself as a freelance photographer, but supported himself mostly by working as a manual labourer for the Works Progress Administration (WPA), a government make-work program. Although he held several positions with the Photo League, his main concern was the League's school, and he served at various times as its director. The League emphasized the importance of the photograph as social document. However, the influence of Paul Strand, Lewis Hine, Edward Weston, and Ansel Adams, among others, as advisors or guest lecturers, inevitably meant that formal problems also became an issue. In time, the photograph as personal expression took precedence over the photograph as public document at the League.

Grossman's own career followed a similar pattern, but his concern for the human condition remained his principal theme. Until 1943, when he was inducted into the Air Force, his photographic style, although containing a disquieting energy, had the objectivity of a classical topographical photograph. But the dark and brooding photographs he made of events such as the Black Christ Festival while stationed in Panama and Guatemala in 1945 were a remarkable departure from the early work. After the war, Grossman returned to New York where he lived meagrely on a number of small photographic assignments, while continuing his volunteer work at the Photo League – the officers, teachers, and speakers had always donated their time to the cause. Charges of subversion were brought against the League by the United States Attorney General in December 1947. As one of its principals, Grossman was singled out for investigation, which caused him to resign from the League in 1949. By 1951, the League itself had dissolved for lack of funds. For the remaining years of his life, Grossman studied painting with Hans Hofmann, although he continued to photograph.

Black Christ Festival shows us the physical exertion of transferring the supporting pole of a heavy platform carrying a religious statue from one man's shoulder to another. But it shows us a good deal more. The thrust of the composition and the riveting force of expression on the men's faces are charged with an energy that is alarming. We are in the presence of a disturbing mystery intensified by an unexplained light glowing at the end of the pole – a tiny flame nourished by a circle of hands. This troubled drama of dark and moody tones and contrasting luminous patches is eloquent with the photographer's passion.

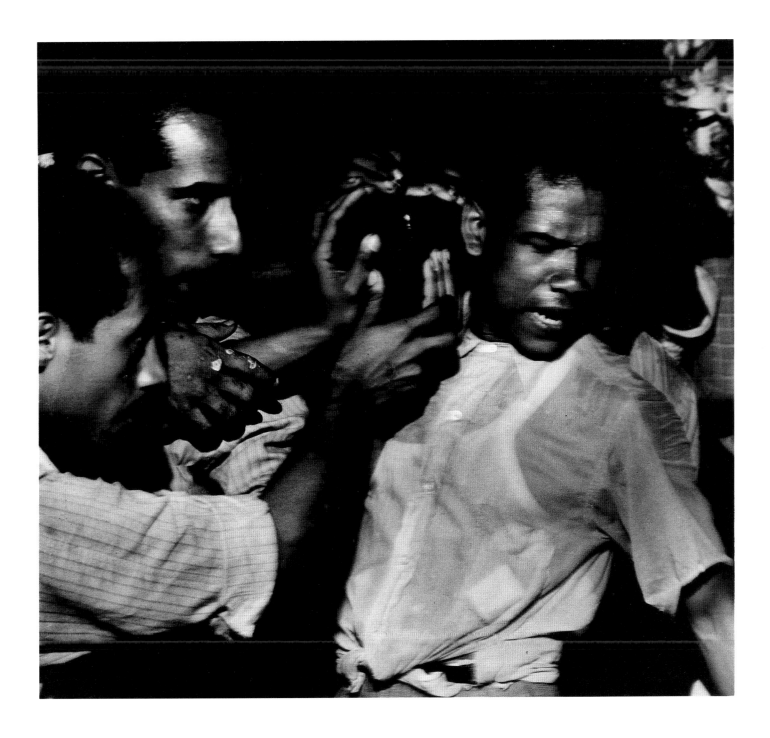

MINOR WHITE

American (Minneapolis, 9 July 1908 – Boston, 24 June 1976)

Sun in Rock (San Mateo County, California) 1947

Gelatin silver print, 9.1 × 11.8 cm
From *Song Without Words,* 1961?, no. 5
Gift of Phyllis Lambert, 1979

"THE FUNCTION OF CAMERA WORK, when treated as a treasure," wrote Minor White, in 1959, "is to invoke the invisible with the visible."[1] But the visible imposes a kind of tyranny, for the photographer is dependent upon surfaces and textures. The way of breaking free, in White's opinion, was to turn the photograph into a metaphor. That he should adopt this solution is perhaps not surprising when we realize he was also a poet.

White began to photograph at age twelve, but only became serious at age twenty-nine, after he had graduated from university in botany and English and trained himself as a poet. Following wartime service in the Pacific, he worked as a photographer at The Museum of Modern Art and studied art history at Columbia University. In 1946 he met Alfred Stieglitz, Edward Weston, and Ansel Adams – the turning point in his career. Adams improved his technique, Weston taught him to look at nature, and Stieglitz gave him a lifelong interest in the metaphorical possibilities of photography. Stieglitz's idea of equivalence – that a photograph can be equivalent to or evoke an emotional or psychological state within the viewer – showed White that the photograph could serve his psychological and spiritual needs.

Some consider White to be the medium's most influential teacher, writer, and photographer since Stieglitz. His principal contributions, beyond his photographs, are his ideas about sequencing and metaphor. "When any photograph functions for a given person as an equivalent," he wrote in 1963, "we can say that at that moment and for that reason the photograph acts as a symbol or plays the role of a metaphor for something that is beyond the subject photographed."[2] To make a photograph with this power, the photographer must "use the forms and shapes of objects in front of the camera for their expressive-evocative qualities."[3] Although a single image may operate this way, White usually relied on a sequence of three or more to build the metaphor. Most often his metaphors were preconceived, the result of searching for something in the landscape to serve an existing idea.

Song Without Words, his first poetic sequence, was assembled in 1948 from photographs made in 1947. The paradox between the identifiable reality of each one and the enigma of their relationships makes this sequence more subtle and enduring than later groupings. Interspersed portraits suggest the seaside landscapes of fog, surf, rocks, and beach represent his feelings toward a friend. White later added these lines to the published version: "So like you have these images / become they have usurped reality."[4] His growing interest in mysticism, perhaps as a release from the harrowing experiences of war, especially the death of friends, may explain the forbidding isolation and spiritual intensity of the light that pervades the images, references to the soul lost in a world of darkness.

To extract one image from the series is like taking a single stanza from a poem: the implications of its sequential position may be missing, yet it has its own beauty. *Sun in Rock,* with its contrasts of light and shadow (shapes seemingly torn out of space), hard and soft textures, the static and the flowing, reminds us in itself of conflict. Traditionally, light is equated with spirit and intellect. It also symbolizes creative force and cosmic energy. Light is the power that opposes darkness and transforms the actual into the poetic.

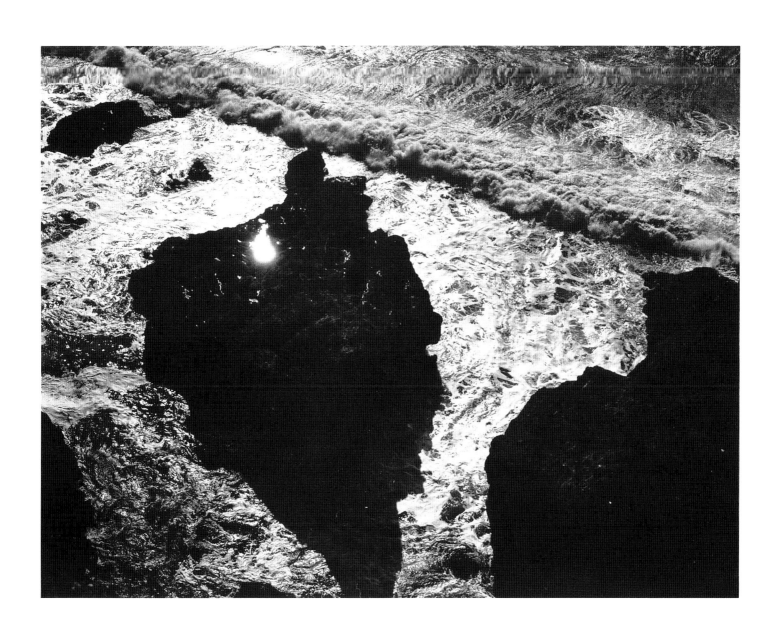

MARCEL MARIËN

Belgian (born Antwerp, 1920)

Stairs 1949

Gelatin silver print, 7 × 5 cm
Purchased 1985

IT MIGHT BE ARGUED THAT THE ROOTS OF SURREALISM are to be found in the very beginnings of photography. The idea of an image creating itself appealed to the surrealists' sense of humour. Certainly by 1916 the medium was a major force in the dada movement, the forerunner of surrealism. With their emphasis upon the ambivalent relationship between the conscious and the subconscious, the surrealists found that photography was at the very heart of their enterprise. Man Ray recognized this when he included both his own and Eugène Atget's photographs in the movement's magazine, *La Révolution surréaliste*, beginning in 1927.

Marcel Mariën has been one of the chief spokespersons for Belgian surrealism since the early 1940s. He produced a monograph on the surrealist painter René Magritte and served on the editorial committee of *Le Ciel bleu,* the organ of post-war Belgian surrealism. In 1954 he founded his own review, *Lèvres nues,* which continued until 1957. In addition to his writing, Mariën is known for his photographs, photomontages, and collages. He was a contributor to the first large surrealist exhibition to be held in Brussels, in December 1945, along with Jean Arp, Giorgio De Chirico, Max Ernst, Paul Klee, Magritte, and others.

The ability of the photograph to blur the lines between art and life, between reality and the dream world, comes from its special emphasis upon fact, as well as its inclination to court the accidental. In creating a duplicate world, the camera finds the illogical in the logical, the rational in the irrational, the subconscious in the physical, and the inexplicable in the commonplace. The quality with which the photograph evokes presences and questions time is presented in a manner that is both witty and haunting in Marcel Mariën's *Stairs.* The idea of self-directed shoes is the stuff of comic dreams or frightening nightmares, as is the idea of the invisible man. In one sense, Mariën's photograph is about traces (witness both the shoes and the places where the runner used to be on the stairs), and how they lead us on. In another sense, it is about the life of inanimate objects as they are bound up in our own lives.

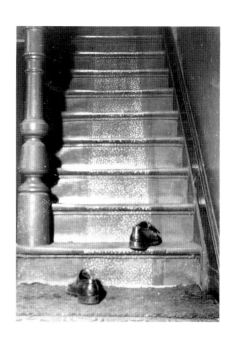

LEON LEVINSTEIN

American (Buckhannon, West Virginia, 20 September 1908 – New York, December 1988)

Coney Island, New York c. 1955

Gelatin silver print, 27.5 × 35.2 cm
Purchased 1990

LEON LEVINSTEIN WAS A SOLITARY STREET WALKER, photographing surreptitiously, seeing without being seen. Many of his photographs were taken in the poor and ethnic neighbourhoods of New York because he felt, as he said, "that is where life is."[1] His photographs combine a sense of powerful form with a deep interest in humanity. No propagandist for political reform, nor working with a social documentarian's agenda, he was simply a photographer with a consummate eye who observed the human condition.

Levinstein trained as a graphic artist at the Maryland Institute of Art, served with the army during World War II, then moved to New York in 1945, where he worked as a graphic designer while he studied painting under Stuart Davis and photography under Alexey Brodovitch. Lisette Model's husband, Evsa, also gave him lessons in painting. This association with the husband and wife may have stimulated his interest in photography, for there is certainly a spiritual kinship between his work and Model's. In 1948, Levinstein became a member of the Photo League, where he came under the influence of Sid Grossman, another photographer whose work had much in common with his. Although he did take on an occasional freelance assignment, for the most part his photography was confined to personal expression. New York was his territory, although upon retirement he made a number of photographic trips to India and to Haiti. In spite of being included in various group exhibitions at The Museum of Modern Art in New York during the 1950s and 1960s and of receiving a Guggenheim Fellowship, he remained a solitary figure in photography, shunning the limelight and living much as a recluse.

Coney Island, New York sums up Levinstein's talent for structuring his images with sculptural volume and form. His viewpoint involves us in an intimate relationship with his subjects, not as voyeurs but as participants. The textures of life, in all their grittiness, are made part of our viewing experience. The two bodies entwined here in a perfectly structured embrace are like massive architectural building blocks stacked in a harmonious conjunction. There is even a certain architectural ornamentation supplied by the symmetrical wrinkles of the man's bathing trunks, which are echoed in the pattern of the woman's shirt. The couple is watching the unfolding of a puzzling drama implied by the vague figure we see in the background, a little cameo framed by light – an image within an image. The strangeness is intensified by the print's moody tones. Levinstein's work is often about people watching each other. *Coney Island* is a moment of observation made quiet and held out to us for timeless contemplation. He has exalted a little corner of everyday life by revealing a kind of beauty that only the camera is capable of giving us.

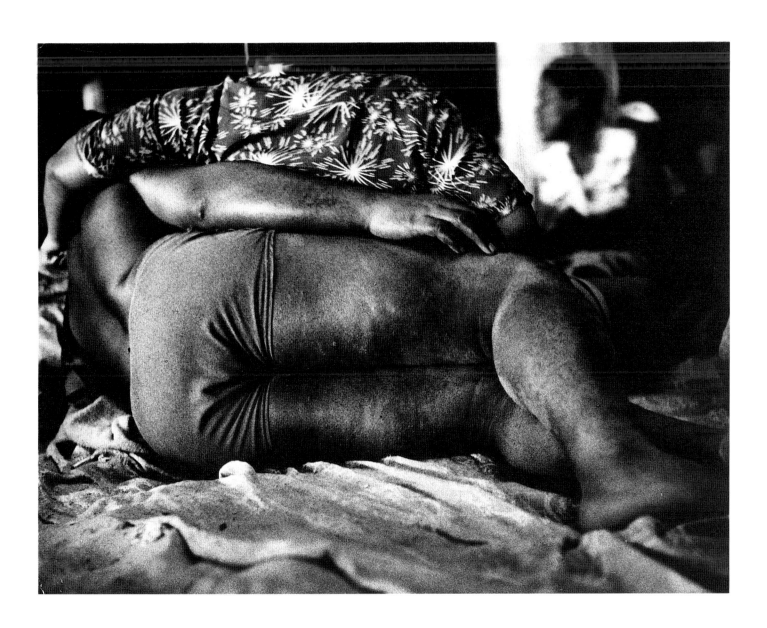

DAVE HEATH

American (born Philadelphia, 27 June 1931)

Chicago 1956

Gelatin silver print, 18.2 × 22.6 cm
From *A Dialogue with Solitude,* 1962, no. 72
Purchased 1974

THE ANGUISH THAT FILLS DAVE HEATH'S WORK is rooted in a traumatic childhood. Abandoned by both parents by the time he was four, he spent the rest of his youth until he was sixteen in foster homes and orphanages. Although *Chicago* is a spontaneous record of an actual event, it is also a metaphor for his memories of being the underdog in a foster home. Heath sees the boy writhing on the ground as himself, and the jubilant girl running away in triumph as the foster sister.

Although his was not a normal childhood, like most North American children Heath was fascinated by the camera. Just before his sixteenth birthday in 1947, however, he saw a photographic essay by Ralph Crane in *Life* magazine, "Bad Boy's Story," portraying "conditions similar to those of my own life: broken home, foster families, social withdrawal, and life in an orphanage. Through his essay I discovered photography to be a direct and moving form of expression. I decided to become a photographer."[1] Not only did he see himself reflected in the essay, he became aware for the first time, that the photograph could function on a level other than that of the family souvenir or the schoolbook illustration. From that point on, Heath became seriously interested in photography.

After taking commercial art for a year, he worked in a photofinishing laboratory, studied photography on his own, and looked at paintings in the Philadelphia Museum of Art in his free time. Between 1952 and 1954 he was in the United States Army, serving in Korea. On his release, he studied at the Philadelphia College of Art for a year, worked in a commercial studio in Chicago, then moved to New York in 1957 where he continued working in commercial studios. In 1959, he became a became a freelance photographer and studied under Eugene Smith. In the early years, the work of Minor White, Edward Weston, and Smith influenced him, followed by Henri Cartier-Bresson and Walker Evans.

In 1962, Heath completed *A Dialogue with Solitude,* a portfolio of eighty-two prints from negatives made between 1952 and 1962. The photographs had not been made originally to illustrate the portfolio's theme, although there is an underlying relationship throughout most of his work because of continuing personal concerns. Exhibited first at the Art Institute of Chicago in 1963, it was published as a book in 1965. As a means of personal expression in which photographs are used not as text illustrations but as the substance of the message in the same way a poet or novelist uses words, it was undoubtedly the most important book by a photographer to appear in that decade. In Heath's words, "it is mainly concerned with my individual and personal sense of alienation and loneliness ..."[2]

A Dialogue with Solitude is structured around people rather than ideas and things. Through the potential that photographs have to operate as symbolic equivalents for the human psychology – its emotions and ideals – Heath explores his own anguish as he responds to the loneliness he witnesses in others. In its emotional intimacy, *Chicago* reflects the extent of this involvement. Here, the medium is not used to transmit surface information as in the classic documentary photograph. Shapes grow from obscuring darkness. Heath has referred to "the subjective light of Rembrandt – the light that glows from within. My use of light is that kind of light."[3]

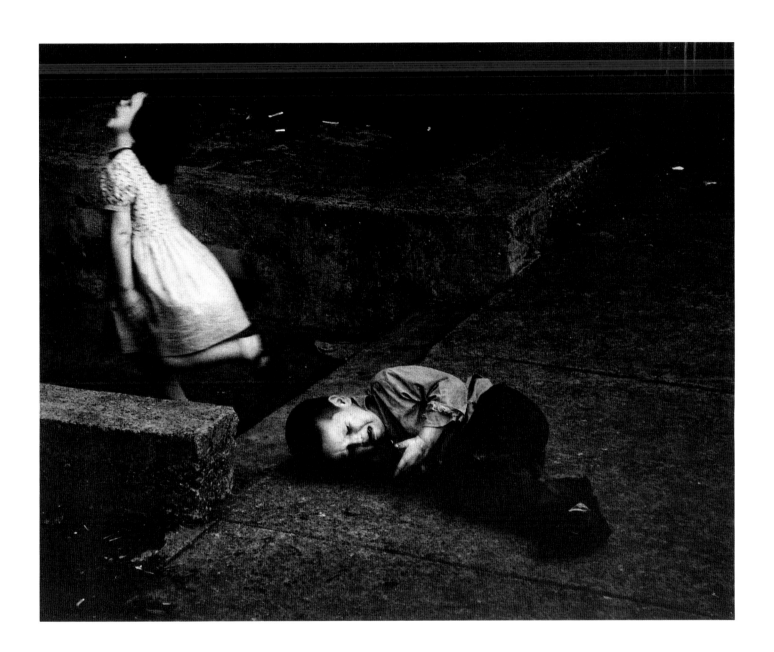

ROBERT FRANK

Swiss (born Zürich, 9 November 1924)

Coney Island, 4th of July 1958

Gelatin silver print, 31.1 × 42.3 cm

Purchased 1990

THE MOST CONTROVERSIAL PHOTOGRAPHS published in North America in the 1950s were those in Robert Frank's *The Americans*. First printed in France as *Les américains* in 1958, because no American publisher would touch it, the book finally appeared in the United States in 1959 amid uproar in the photographic community. The photographs were accused of being un-American; they were certainly anti-establishment. As a European, Frank saw a side of America that Americans glossed over, the daily human condition, a side that had little to do with ideals of family, justice, equality, and the beauty of nature. Americans resented such images being presented as a picture of their country. For Frank, the new land was brutal, raw, and scruffy, but nevertheless full of a vital energy. In the words of Jack Kerouac, leader of the Beat Generation, a movement having much in common with the spirit of Frank's photographs, Frank "sucked a sad poem right out of America onto film, taking rank among the tragic poets of the world."[1]

If the social criticism of his photographs upset the photographic community, so did the starkness and imbalance of his compositions, the snapshot directness, and the print quality that was often gritty, contrasty, and tonally spare. All this flew in the face of everything the photographic establishment held dear – clarity of definition and delicate tonal gradation, standards set by photographers such as Edward Weston and Ansel Adams.

Frank was apprenticed at sixteen to a photographer in Basel, Switzerland, then studied photography in Zürich and Geneva, worked for Gloria films in Zürich, and freelanced until moving to New York in 1947. There he undertook assignments for *Fortune, Life, Look,* and *Harper's Bazaar*. From 1949 to 1951, he worked in England and France, after which he returned to New York and magazine work. In 1969, he acquired property at Mabou, Nova Scotia, where he continues to reside from time to time. Frank was the first European photographer to receive a Guggenheim Fellowship; this enabled him to travel across the United States in 1956 and 1957, resulting in *The Americans*. He then turned to making films, including *Pull My Daisy*, 1959.

The sad desolation we sense in *Coney Island, 4th of July* becomes informed with a caustic irony when we realize Frank's title refers to the national holiday, a time of celebration. The theme of young lovers shown here is far from the Hollywood version of the American Dream. Clinging to each other in depressing darkness, beside a refuse bin, they are symbols of a disenfranchised subculture. The photograph, however, is charged with raw energy, a mixture of tough fact and dark lyricism. *Coney Island* presents the photographer as voyeur, running through the night, shooting fast and spontaneously, responding to secrets. The surreptitiousness of the moment is caught in the grainy out-of-focus quality of the image, and in the feeling of motion the flash bulb has imparted to the churned up sand, like waves rocking the couple in their embrace. If we have mixed feelings about this photograph – whether to despair for the couple or to see promise in life's renewal – it may be because we see reflected therein Frank's own ambivalence about America. "Criticism can come out of love," he wrote in 1958. "It is important to see what is invisible to others – perhaps the look of hope or the look of sadness. Also, it is always the instantaneous reaction to oneself that produces a photograph."[2]

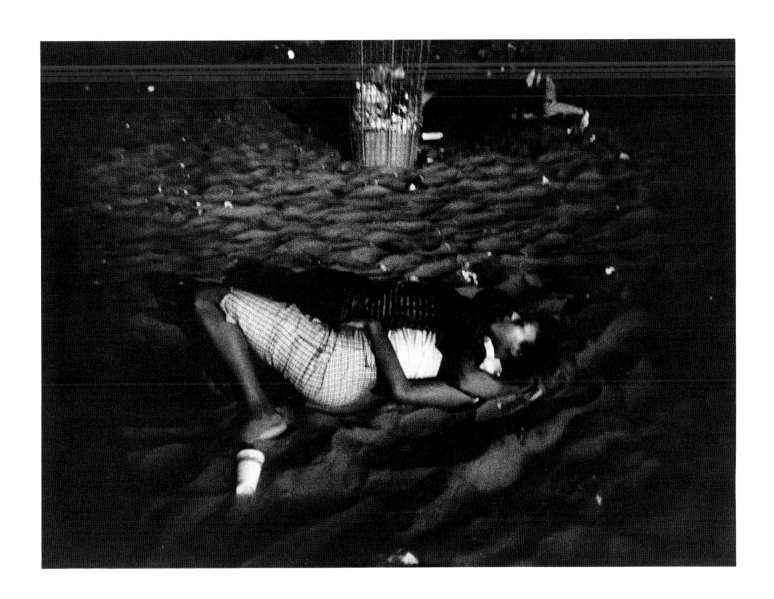

HARRY CALLAHAN

American (born Detroit, Michigan, 22 October 1912)

Chicago 1961

Gelatin silver print, 41.6 × 27 cm
Purchased 1978

TO ACCUSE HARRY CALLAHAN OF BEING simply a formalist is to miss the essential point of his work. It is true that he consciously broke from the documentary tradition with its emphasis upon the grittiness of everyday life. Subject matter has always been of prime importance for him; but, as he wrote in 1964, "I'm interested in revealing the subject in a new way to intensify it."[1] As a result, the subjects he looks at become archetypes with mythic associations.

Harry Callahan studied engineering at Michigan State University for two years, then worked for Chrysler Motor Parts Corporation. He first became interested in photography in 1938, as a hobby. His only education in the medium consisted of sporadic attendance at lectures given at the Detroit Photo Guild by invited guests such as Ansel Adams, whose work, along with that of Alfred Stieglitz, exerted the major influence upon his early career. From 1944 to 1945, he worked as a processor in the General Motors photography laboratory. In 1946, he met László Moholy-Nagy, who appointed him to the faculty of the Illinois Institute of Design, Chicago, where in 1949 he became head of the photography department. Callahan was the first photographer to receive a grant from the prestigious Graham Foundation, allowing him to travel in Europe for fifteen months from 1957 to 1958, living most of the time at Aix-en-Provence. In 1961, he began to teach at the Rhode Island School of Design, retiring in 1973. He continues to photograph and to exhibit.

For many years, Callahan has been a major influence on American photography, as both a teacher and a photographer. His themes have always been chosen from his personal environment, using as subject matter his family, the architecture and street scenes of the cities in which he has lived, and the places he has visited on vacation. At the same time, the formal concerns of the medium – those of line, shape, and tone – have played an important role in his work, reinforced by an interest in the direct and often original vision of the snapshot. His style is marked by his ability to see space as form and form as metaphor, all bound into a whole design of complex, interlocking shapes, and by his tendency to play with light either as a bold, graphic element or as a glowing presence that can suffuse the entire surface of a print. Although the textures both of the world and of the fine photographic print are of great concern to him, there is also an emphasis upon the camera's ability to see more than the eye can see, and to use this in ambiguous ways that sometimes border on the surreal.

The women in *Chicago* exist in isolation. Enclosed by cold and dehumanizing elements, they are as impressive as the structures that loom about them in the city's dark caverns. Light glistening on a stockinged leg, a leather handbag, or a billowing skirt gives shape to forms as cleanly moulded and as solidly sculptural as that of a lamp standard or a building. Such uncompromising starkness touches our collective memory – the source of myth – and *Chicago* becomes an evocative visual statement about the heroic grandeur and matriarchal power of woman.

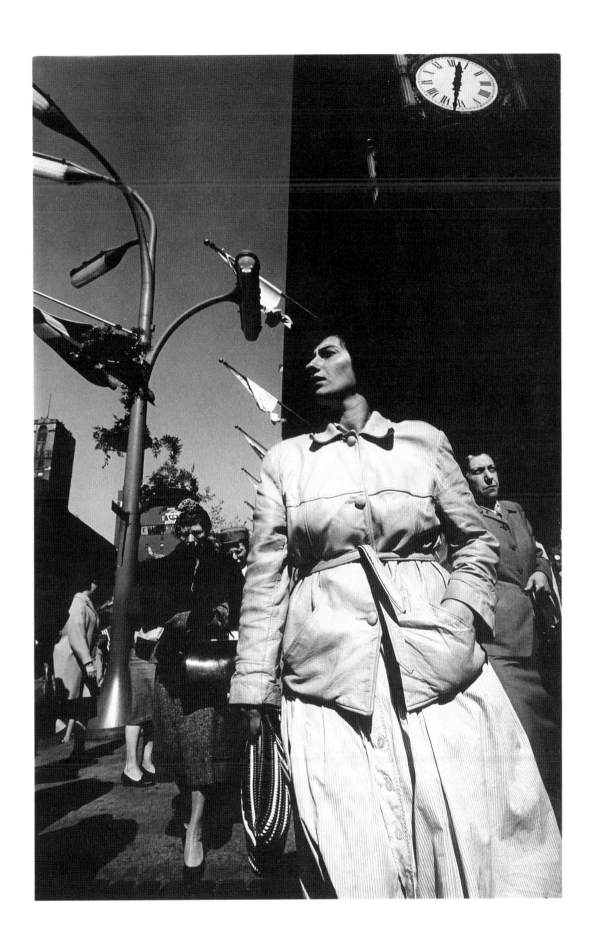

AARON SISKIND

American (New York, 4 December 1903 – Providence, Rhode Island, 8 February 1991)

Guadalajara 21 1961

Gelatin silver print, 38.7 × 48.9 cm

Purchased 1969

THE MARK OF NINETEENTH CENTURY PHOTOGRAPHY – the representation of deep space – continued well into the twentieth. Alvin Langdon Coburn's landscapes of 1910 and 1912 and Paul Strand's cubistic forms of 1916 are among the earliest attempts to create a photographic space based on the two-dimensional picture plane. This modernist concept reverses hierarchies so that the subject becomes less important than how space is filled. Not until Aaron Siskind's work of the mid-1940s does a new photographic space appear in which the picture plane is the primary frame of reference, with a set of relationships more connected to the photographer's inner vision than to objective reality.

When Weston wrote in 1930, "to photograph a rock, have it look like a rock, but be *more* than a rock,"[1] he laid the groundwork for Siskind who, twenty-six years later, declared, "When I make a photograph I want it to be an altogether new object, complete and self-contained ..."[2] At this point, we become conscious of the photograph as an object separate from the world it records, an object with its own laws and existence, a visual metaphor. "As the language or vocabulary of photography has been extended," Siskind wrote in 1958, "the emphasis of meaning has shifted – shifted from *what the world looks like* to *what we feel about the world* and what we *want* the world to mean."[3]

Siskind graduated in social sciences in 1926, taught English in New York public schools, and took up photography as a hobby in 1930. In the 1930s, he played a major role in the Photo League, but by 1941 the League was accusing Siskind of turning his back on social problems in favour of formal concerns. Disillusioned, he resigned. He began to teach photography at the Illinois Institute of Design from 1951, then at the Rhode Island School of Design from 1971 until his retirement in 1976.

Siskind's colleagues at the League should not have been surprised at the direction of his photographs. His concerns had always been formal. He had simply become increasingly involved in the metaphoric possibilities of the medium instead of its propagandistic functions. In 1943, with a series of photographs made at Martha's Vineyard, he broke completely with his past, eliminating deep space, and working with organic objects close up and on the flat picture plane, transforming them into haunting and dramatic symbols. From this point, "subject matter ceased to be of primary importance."[4] The strength of these works lies in the tension between their power of literal description and the subjective nature of Siskind's vision.

Guadalajara 21 may portray a wall in a Mexican town, but it is about a complex of deeply rooted emotions and fears, totems buried in the underworld of our collective unconscious. Its ambiguity begins with its formal treatment of space and scale. The white strip at the top, the dark edge of the wall, and the wall itself may all be read as a collage of flat bands across the picture's surface. But at the next moment, as in an optical game, it becomes a landscape of horizons and spatial depth. Even the main wall, flat at one moment, at the next shimmers like a scrim over distant mountains or the curved end of an arena in which two prehistoric animals confront each other. Siskind's photographs are often about dualities in conflict, a theme emphasized here by the political broadsides posted on the wall.

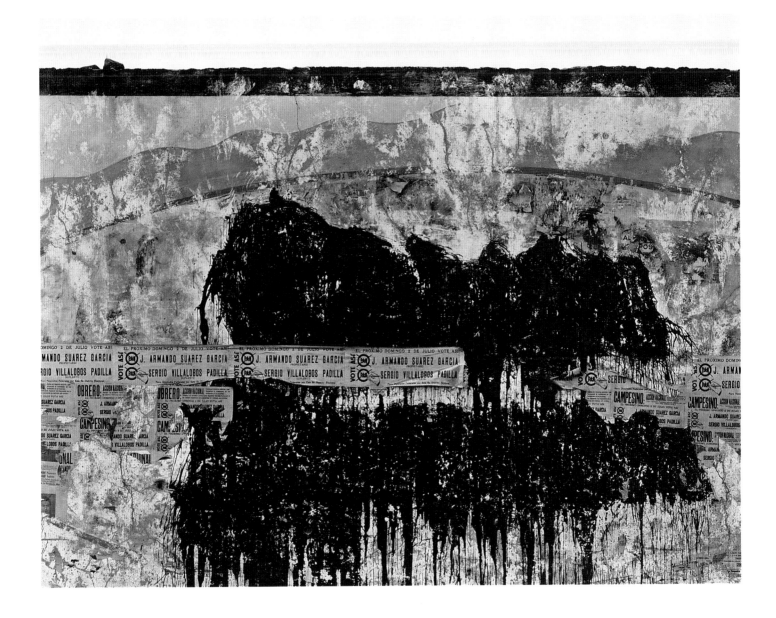

EIKOH HOSOE

Japanese (born Yonezawa, 18 March 1933)

Killed by Roses, no. 3 1962

Gelatin silver printed before 1970, 29.1 × 20.2 cm
From *Killed by Roses,* 1963
Purchased 1972

THE CHALLENGE FOR THE PORTRAIT ARTIST is to strip the public masks we all wear, to probe the workings of the mind, to reveal the intrinsic qualities of the sitter. The photographer faces an even greater challenge, for the camera deals best with surfaces and the moment. According to Alfred Stieglitz, who was perhaps the single strongest influence on North American photography, "To demand the portrait that will be a complete portrait of any person is as futile as to demand that a motion picture be condensed into a still."[1] Only through the composite of many moments can we begin to achieve the fullness of a personality. When the Japanese novelist, playwright, and actor Yukio Mishima commissioned Eikoh Hosoe to photograph him, both men understood that the only way of capturing his flamboyant and complicated personality was through a series of photographs staged to create an interior document as a testimony to the spiritual, emotional, and cultural forces that struggled within him. The collaboration between the two artists began in the autumn of 1961 and ended in the spring of the following year. In 1963, Hosoe assembled forty photographs into a portfolio under the title *Killed by Roses.* A book, with forty-six photographs, appeared in the same year.

Although the result of the collaboration between subject and photographer is tantamount to a theatrical performance, with elaborate poses and complex iconographical imagery, in a metaphoric way it does constitute a biography of a talented and tortured individual. The photographer's purpose was to explore the "theme of life and death through Mishima's body and flesh."[2] The final section of the portfolio deals with death and, in fact, presages Mishima's demise by ritual suicide, which occurred in 1970. Torn between the values of modern, westernized Japan and the ancient samurai militaristic culture, his death was intended as a protest against the loss of Japanese traditions.

Hosoe first acquired a camera at age fourteen and learned the rudiments of processing by watching his father in the darkroom. After winning a prize from the Fuji Film Company, he decided to become a photographer. Between 1951 and 1954, he studied at the College of Photography in Tokyo. Two years later, he was given his first exhibition. Since 1975, he has taught photography at the Tokyo Polytechnic.

Although *no. 3* appears in Part II of *Killed by Roses,* it was among the last photographs to be made. Realizing that he needed an infant to symbolize birth, Hosoe asked to photograph Mishima's son, but permission was refused. Instead, an anonymous child was brought into the house, and one of the simplest yet most photographically eloquent images of the series was made. The raw light, streaking across the photograph's surface, not only presents the essential ingredient of the act of photographing but also symbolizes the human condition of change, of birth to maturation – the child is father to the man. Flowing in a beautiful moment of evanescent energy, the child's body speeds towards its dark destiny.

DIANE ARBUS

American (New York, 14 March 1923 – New York, 26 July 1971)

Topless dancer in her dressing room, San Francisco, Cal., 1968

Gelatin silver printed 1973, 37.7 × 37.5 cm
Purchased 1977

THE DIFFERENCE BETWEEN A GREEK TEMPLE in the age of Pythagoras and a dancer's dressing room in twentieth century San Francisco may be slightly less than we imagine. Was it Diane Arbus's intention to make this apparent or are the references in *Topless dancer* to past ages unwitting reminders that everything is connected? At the time of making an exposure, a photographer's instinctive visual sense often recognizes inherent meaning without the mind having consciously understood its full implications. Such a photographer does not construct an artificial subject with set and models, but accepts the world as it comes, giving us a slice of day-to-day reality, as did Arbus who is reputed to have said she never arranged the subjects in her pictures, but let the subjects arrange her. She was a photographer with a ready eye for the incongruous, the psychological, the unexplained, in situations we might only recognize as banal.

After graduating from the Fieldstone High School in 1941, Diane Nemerov married Allan Arbus and the two worked together to create a successful commercial fashion photography studio. Between 1955 and 1957 she studied privately under Lisette Model. Her discovery of August Sander's photographs in the early 1960s was a turning point in her career. A Guggenheim grant in 1963 supported her interest in photographing the rites, mores, and customs of Americans, the work for which she is best known today.

The *kore* (maiden) is a stock type found in Greek sculpture from at least the seventh century B.C. Similar figures, sometimes bare-breasted dancers, can be traced back to Egyptian and even Sumerian times. Their purpose remains unknown, but they may have been images of goddesses or priestesses, votive offerings for temples and graves. The Venus de Milo in the Louvre is a direct descendant of the archaic *korai*, which were often shown bare-breasted, hips draped in a figure-hugging chiton. The head was crowned with cap-like hair, the features full and rounded, the lips gently curved in the "archaic smile," secretive and inviting. Some had a hand placed near or on a breast, perhaps to indicate their source of power, a gesture also found in both secular and religious European art from the renaissance on.

We could be describing Arbus's *Topless dancer in her dressing room.* Has she given us a mutation of the *kore,* translating a classical figure into a modern idiom? Although the setting may be tawdry, the rhythm of globular forms, from lampshades to drawer knobs and electric fan, stresses the dancer's opulent shape as a metaphor for the fruitfulness represented by the Venus figure as far back as the Willendorf Venus of paleolithic times. The abundance of clothing seen lurking at the left and shadowily in the mirror ironically refers to another order of opulence, perhaps even to the many forces of puritanism that have always waged war upon the earth goddess. But the vocabulary of symbols is more complex and puzzling than a first or even second glance reveals. Perhaps the real surprise is the book about Leonardo da Vinci half hidden in the background, its cover showing a detail from Leonardo's *Last Supper.* As though in silent comment, the apostle Thomas raises his finger heavenward. Are we to draw a parallel between his gesture and the dancer's pointing finger? Arbus has presented us with an intriguing example of the metamorphosis of imagery.

JERRY N. UELSMANN

American (born Detroit, 11 June 1934)

Untitled 1968

Gelatin silver print, toned, 34.2 × 25.8 cm
Purchased 1974

THE BASIC TECHNIQUE OF MAKING AN IMAGE through an exposure on a single nega-tive has not always satisfied photographers. In 1869, H. P. Robinson wrote, "photographers … have not the facilities which other artists possess, of making material alterations in land-scapes…"[1] Much later, Robinson was still frustrated, convinced "that a method that will not admit of modifications of the artist cannot be an art."[2] In the midst of such beliefs, O. G. Rejlander, sculptor turned photographer, produced *The Two Ways of Life,* shown at the Manchester Art Treasures Exhibition in 1857. It was made from thirty-two negatives, each intended as part of a preconceived design, and printed individually on a larger sheet of photographic paper until the entire composition was filled. The technique relied upon protecting other areas with opaque paper or cloth while each negative was being printed.

Rejlander's photograph was the most elaborate nineteenth century example of a com-bination print, but the idea of using several negatives to make a single image can be traced to 1851 in France. A year later, the method was used to add clouds to landscapes.[3] Only by this means, H. P. Robinson insisted, did the photographer achieve artistic control over his picture. By the end of the century, in their concern for truth to nature, serious photographers had turned against such manipulation. Not until Jerry Uelsmann revived the technique around 1960 do we find it once again being used as an art form.

Uelsmann's interest in photography began when he was fourteen. Between 1953 and 1960 he studied at the Rochester Institute of Photography, receiving a master's degree, and Indiana University, earning another master's. Minor White, Ralph Hattersley, and Henry Holmes Smith influenced his development as an artist. Since 1960, he has taught photo-graphy at the University of Florida at Gainesville.

Minor White used to challenge his students with the principle that objects should be photographed "not only for what they are, but for what else they are," as Uelsmann recalls.[4] The combination print eventually became the latter's solution to the problem of transcending literal subject matter, allowing him to create surprising relationships that bring new meanings to the commonplace, suggesting that the world holds a mysterious duality. *Untitled* relies for its shock value on the outrageous reversal of scale and the contrast between the lush-ness of the lotus blossom and the starkness of the tree. Oddly, however, the blossom exists within the earth's depths and the tree spreads it barren branches against the sky – a further act of reversal, for we are attuned to expecting blossoms to be above ground, while the branches seem more like roots. Has Uelsmann suggested in the lotus a hidden blueprint for the tree? Or is the lotus flaunting its graceful beauty in a sardonic mimicry of the tree's outstretched and awkward form? The blue and sepia tones – the result of placing the print in several toning baths – together with the starkness of the black and white, create a mood of portent, as though some cataclysmic event is about to unfold. But whether we take this photograph as a visual pun or even a mockery of the pun, a surrealistic fantasy, or a metaphor about life's vital forces matters little. In the end, whatever meaning we choose to find in the image must also come from within the print itself, its photographic qualities of tangible realism, glowing luminosity, exquisite tonal delicacy, and sensuous surface detail.

NATHAN LYONS

American (born Jamaica, New York, 10 January 1930)

Bolivar, New York 1969

Gelatin silver print, 11.3 × 17 cm
From *Notations in Passing,* 1970, no. 46
Purchased 1970

PHOTOGRAPHY MAY BE USED as a form of note taking in which the camera is the means of jotting down significant moments or recording places or objects for future consultation. Like the writer who notes impressions and thoughts while working towards a novel, Nathan Lyons assembles random images made over time and in many places into sequences that express inner realities and awaken our sensibilities.

Lyons has been a vital force in photography since the 1960s. He became interested in the medium at the age of sixteen. After studies in architectural drafting, business administration, philosophy, and creative writing at Alfred University, he enlisted in 1950 in the United States Air Force as a photographer. Returning to civilian life in 1954, he majored in English at Alfred, studied photography and design under John Wood, wrote and directed plays, and established a poetry workshop. On graduation in 1957 he became Director of Information at the George Eastman House, Rochester, and in 1960 the museum's assistant director, responsible for the publications program and many of the exhibitions, among the most influential being *Towards a Social Landscape,* 1966, and *The Persistence of Vision,* 1967. A founder of the Society for Photographic Education in 1962, and Oracle, an association for photography curators, in 1982, he also established the Visual Studies Workshop, Rochester, a school for graduate studies in photography, after leaving the Eastman House in 1969. He remains director of the workshop and continues to photograph and exhibit.

Two influences lie behind Lyons's photographs since the 1960s – the snapshot and the sequence. Before this, his photographs, made with a view camera, consisted mostly of abstract natural forms. His discovery around 1959 of several albums of anonymous snapshots changed all that. Here was a map for a territory peculiarly photographic – a map that had stimulated other artists but that photographers had shunned. These "outpourings of multiple exposures, distortions, unusual perspectives, foreshortening of planes, imbalance"[1] led Lyons to champion the snapshot as an authentic photographic form. The naïve tradition, simple and direct, became the basis for his own photographs – snapshots made in the wink of an eye with a hand-held camera as notes on the environment.

The second idea behind Lyons's work is that of the sequence, in which unrelated photographs are grouped, not to illustrate a preconceived meaning, but to discover a meaning by allowing the relationships between images to generate their own symbols. *Bolivar* is one of fifty grouped under the title *Notations in Passing.* "Photography has achieved an unprecedented mirroring of the things of our culture," Lyons wrote in 1966. "We have pictured so many aspects and objects of our environment...that the composite of these representations has assumed the proportions and identity of an *actual* environment."[2] *Notations* is a statement about modern humans as image-makers. It presents us to ourselves, through allusion and metaphor, using an iconography peopled with the strange and monstrous creatures we, as a social order, have fabricated. *Bolivar* is an ironic and potent example of one of Lyons's iconographic strategies – the shop window presented as shrine, as a religious altar to celebrate our heroes – surely the ultimate form of sanctity for the consumer society. We might also ponder the meaning of the clock – in its archaic form – at the image's centre.

ALICE WELLS

American (Erie, Pennsylvania, 26 November 1927 – Galisteo, New Mexico, December 1987)

Untitled 1970

Gelatin silver print, 14.2 × 14.6 cm
From *Found Moments Transformed*, 1990
Purchased 1970

THAT ARTISTS DRAW UPON THE ART OF PRECEDING GENERATIONS for inspiration is a common occurrence. Not often, however, is this viewed as a form of close collaboration between the different generations. When, near the end of her career as a photographer, Alice Wells made the photograph reproduced here, she was conscious of engaging in a form of partnership with another picture-maker, unknown and probably deceased.

After marrying Kenneth Myers, an employee of Eastman Kodak, Wells worked as a secretary there beginning in 1952. In 1959, the year of her divorce, an acquaintance at Kodak introduced her to the techniques of exposing and developing photographs. She soon became deeply involved in the medium, taking workshops first from Ansel Adams in 1961, then from Nathan Lyons in 1961 and 1962. By then she was working at the George Eastman House. During these early years, she was influenced by the work of Alfred Stieglitz, Walter Chappell, Imogen Cunningham, Aaron Siskind, and Minor White. In 1964, she was given a one-person exhibition at the Eastman House. Her subjects were traditional ones – still lifes, nudes, nature studies, with an increasing emphasis upon abstract forms drawn from nature and photographed close up. In 1965, a radical change occurred. Her subject matter became more personal and less abstract, the form more experimental. Friends and her own living space became her focus. She began to search for the accidental through double exposures, haphazard combinations of frames, solarization, and staining. By the end of the 1960s, she was a force within the Rochester photographic community, providing ideas for a younger generation of photographers to build upon. In 1969, Wells left the Eastman House to become Nathan Lyons's assistant at the Visual Studies Workshop. In 1967, she had become interested in Zen Buddhism, an interest that in 1972 took her to a Zen centre in New Mexico and out of photography.

During the 1960s, in addition to exploring their own artistic roots among the giants of photography, Wells and others were discovering in the discards of attics another kind of pictorial heritage – collections by anonymous vernacular and amateur photographers. The direct, unpretentious, and often idiosyncratic vision of such images broadened their under-standing of the medium's potential and stimulated their desire to experiment with modes of seeing that were outside the mainstream. Toward the end of the decade, Wells acquired a large group of glass negatives at a country auction near Rochester.[1] Probably made by an amateur sometime between 1900 and World War I, they show subject matter typical of family snapshots – casual portraits, parties and celebrations, outings at the beach, and sports events. While printing these negatives, she began to experiment with solarizing and chemically staining the prints, in the process becoming aware of the possibilities for inject-ing her own expression into the found photograph. In her mind, this became a true collab-oration between two photographers, creating out of the reality of one person's documen-tary record of family life a disturbing dream world with darker implications than the origi-nal photographer had ever imagined. In *Untitled,* with her darkroom manipulation and its implication of magical wizardry, Wells has emphasized a moment of surreptitious childhood sensuality. At the instant of recapturing time past, time melts away before our eyes.

Yousuf Karsh

Canadian (born Mardin, Armenia-in-Turkey, 23 December 1908)

Duchess of Windsor 8 June 1971

Gelatin silver printed 1988, 35 × 27.4 cm

Gift of Yousuf Karsh, Ottawa, 1989

IT HAS BEEN SAID THAT THE PHOTOGRAPHIC PORTRAIT is incapable of capturing an individual's true personality because photography deals only with the moment. Certainly it is true that the capture of the fleeting is often photography's chief asset. The question we must ask ourselves is whether a passing moment may reflect something significant enough to be seen as characteristic of a sitter. The kind of portraiture western civilization has found most deeply moving and lastingly significant is the psychological portrait. Therefore, as well as being a master of light, the photographer who wishes to make portraits must be part psychologist. Having a poet's sense of metaphor also helps.

Yousuf Karsh has spent a lifetime searching for "the essence of the extraordinary person"[1] through the camera. Arriving alone on 31 December 1924 in Canada at the age of sixteen to live with his uncle, who operated a portrait studio in Sherbrooke, Quebec, he was sent in 1928 to serve an apprenticeship in the studio of John Garo, one of Boston's most fashionable portrait photographers. When Karsh opened his own studio in Ottawa in 1932, pictorialism was still in vogue and the light source in most studios was still the traditional one of daylight. Through watching a theatre group in rehearsals, he discovered that carefully controlled artificial light could be used by the photographer to sculpt forms out of the darkness at will to establish mood, suggest character, create visual drama, and reinforce composition. From that insight came some of the best-known portraits of the twentieth century, including his photograph made in 1941 of Winston Churchill, an image that became the free world's symbol of the fight against Nazi aggression.

Less well-known, but equally effective in its searching penetration of the mask that sitters adopt to protect themselves from public gaze, is Karsh's portrait of the Duchess of Windsor. Here the visual language of the photograph operates powerfully through metaphoric allusions. It is an example of how skilfully Karsh can combine aesthetic form with expressive content. The woman who had the ambition to be Queen of England is seated in a regal pose on a throne-like chair. The formal elements all conspire to create an image of beauty, full of grace and symmetry. The heart-shaped curve of her head is repeated in the curves of the chair that shine with an aura of light. The diaphanous material of her costume reflects a suffused glow, giving it a quality of misty gossamer. Karsh has exploited the subtle greys of the modern gelatin silver paper on which the image has been printed to the fullest to create a shimmer, producing a cloud of dusty silver about the sitter's form – evidence of his sensitive response to the materials of the craft.

But within the elegance and harmony of Karsh's photograph we are also strongly aware of discordant psychological elements. The Duchess of Windsor's face contrasts dramatically with the seductive folds of the drapery. There is a paradox here that speaks of harshness and at the same time of sadness, of power and fragility. She has been pierced with the arrows of a wistful mortality.

LEE FRIEDLANDER

American (born Aberdeen, Washington, 14 July 1934)

Paris 1978

Gelatin silver printed 1990, 26.6 × 39.8 cm
Purchased with funds from the Photography Collectors Group, Ottawa, 1990

IF LEE FRIEDLANDER WERE NOT A PHOTOGRAPHER, he might have been a mathematician – or a musician. The geometry of space he displays in his photographs suggests a mind attuned to the precision of mathematics, or the harmonic order of music, a phenomenon not unknown among painters in the past.

Lee Friedlander began making photographs at age fourteen. After high school, he enrolled in the Los Angeles Art Center School, but left almost immediately because he found the assignments boring. One of his instructors advised him to pursue a career in New York. Arriving in that city in 1956, he launched himself as a freelance photographer. He soon met such members of the local photographic community as Robert Frank, Garry Winogrand, Walker Evans, Diane Arbus, and Helen Levitt. While working on assignments for *Esquire, Sports Illustrated, Holiday, Art in America,* and other magazines, he pursued his personal work, which consisted mainly of photographing in the street but also of photographing friends. Building on the tradition of the snapshot, he explored the theme that, in the 1960s, became known as the social landscape – the impact of people on their environment and of the environment on them. He was given his first solo exhibition in 1963 at the George Eastman House in Rochester. Influenced in the early years by Walker Evans, Eugène Atget, and Robert Frank, he has also used the snapshot aesthetic to question the nature of photographic perception. His images are often humorous and ironic comments on American culture.

How often have we experienced a day when the light was so crystalline, when every object within our vision was etched with such clarity, that we longed for the moment to be preserved forever? The purpose of art since the days of the cave dwellers has been to arrest the passage of time in order that the moment may be contemplated at leisure. With *Paris*, Friedlander has transfixed just such a moment with his camera as the ages have done with petrified creatures preserved in transparent amber. At such moments, we become aware that space is as important as the objects occupied by it, an understanding that has always been of consequence to the visual artist.

Friedlander has given us something not easily detected by the human eye – shadows that are as full of meaning as the objects that cast them, and empty spaces that are as solid as the three-dimensional shapes they define. *Paris* is a construct of small vignettes, both visual and dramatic, within a complex, formal geometry, a collage of positive and negative shapes. In the end, his camera has shown us what marvellously intricate associations of forms are to be found in the urban environment, and at the same time we are made aware that the only relationship between people is a purely spatial one, empty of human contact. We all live in isolation, surrounded by our own cocoons of space.

ROBERT ADAMS

American (born Orange, New Jersey, 8 May 1937)

Eucalyptus, Signal Hill, Long Beach, California 1983

Gelatin silver print, 47 × 38.2 cm

Purchased with funds from the Photography Collectors Group, Ottawa, 1992

"WHAT WE HOPE FOR FROM THE ARTIST," Robert Adams has written, "is help in discovering the significance of a place."[1] In this sense, he went on to say, it is more important for us to spend time looking at a work of art than being at the scene it depicts; from the artist's vision we see more. If what he wishes us to see is the conflict between the natural world and the world made by human beings, then Adams has been successful to a degree that may, however, leave us with ambivalent feelings.

Adams graduated from the University of California at Redlands with a degree in English in 1959. While working on a doctorate, which he received from the University of Southern California in 1965, he taught English at Colorado College, Colorado Springs. From 1967 on, he added freelance work as a photographer and a writer to his university teaching duties. He was given his first solo exhibition in 1971. Two years later, and again in 1980, he received a Guggenheim Foundation grant.

Adams is one of the generation of photographers whose theme, since the early 1970s, has been the new American frontier, where nature and industry are in conflict. The land, encroached upon by sterile housing developments and industrial parks, is often seen by these photographers as both bleak and beautiful at the same time. In Adams's photographs, the monumental western landscapes of Edenic charm made by T. H. O'Sullivan, Eadweard Muybridge, and Ansel Adams have given way to the urban brutality of the manufactured cityscape. If we should be confused in our response to Adams's work, it is certainly because, in the midst of this rape of the land, he has also shown us a sublime and formal harmony. For Adams, the proper goal of art is beauty, a beauty of form that reassures us of "the coherence and structure underlying life."[2]

Eucalyptus, Signal Hill may provide us with alarming evidence of a damaged landscape and vandalized trees, but at the same time it is a terrain with a visual potential to which Adams has fully responded as an artist. The geometric and formal elements of his photograph make us aware of both the vast space and the tenuous but hopeful life of the tree, which he has emphasized by his clever truncation of shapes at the left and right edges of the picture. But the essential quality and meaning of the photograph is deeply imbedded in the medium itself, in the way in which Adams has exploited both the topographical exactitude of the camera's recording power and the ability of the photographic paper to create the shimmering glory of light that overarches the land. "Light still works its alchemy," says Adams.[3]

JOAN LYONS

American (born New York, 6 March 1937)

Happy Birthday August 1986

3 kallitype and cyanotype prints, 56.7 × 151.3 cm (overall)
Purchased 1991

THE TRADITIONAL ONE-EYED VIEW OF THE WORLD the camera lens gives us limits the creative imagination, or so artists who produce handmade pictures often believe. The freedom the painter has in exploring both time and perception in any way he or she sees fit within a single image, it has been argued, results in a more truthful revelation. Joan Lyons came to photography from this background as an experienced painter and printmaker.

After graduation from Alfred University, Alfred, New York, in 1957 with a fine arts degree, she held a graduate assistantship at Mills College, Oakland, California. In 1958, she returned to the east where, in addition to raising a family, she has been both a teacher and an exhibiting artist. In the late 1960s, she began to use family snapshots as source material for her painting and printmaking, and in the following decade turned to making photographs as the end product.

Her personal life has always provided the subject matter for her work – images of family, friends, and self. At the same time, she has continued to explore the relationship between painting, printmaking, and photography. Her use of such obsolete, nineteenth-century processes as the kallitype and the cyanotype, as in *Happy Birthday*, requires her to sensitize her own paper. In so doing, she has been able to introduce and exploit those accidents that occur as the hand coats the paper, thus evoking the spontaneity and the energy involved in carrying out the process, for in a sense *Happy Birthday* represents a dialogue with the medium, both in the manipulation of the materials and in the act of making the exposures. For the painter, the gestural is important in the making of a picture – the movement of the hand in the drawing of a line or in the making of a brush stroke. Such kinetic energy contributes to the expressive content of a painting. Joan Lyons has introduced the gestural into her photograph in several ways – through the blur of her hand as it suggests the controlling factor in making the exposure and through the shifting of space and subject from frame to frame as though time itself were moving.

The year of the artist's fiftieth birthday seemed an appropriate occasion to celebrate time – time manipulated – in the exploration of herself as model, with its ironic reference to the two-dimensionality of the mannequin, in the spontaneity of the process signified by the blue dots of the cyanotype solution spilled in the haste of coating the paper, and finally in the witty conceit of applying a separate self-portrait in the last frame attached to the larger photograph by corner slits as in a family album, the implication being that this last image is an ephemeral snapshot to be replaced and updated in succeeding years. Even the faded colours of the last frame suggest the passage of time. To say, however, that all this passed through her mind in such a precise way while making *Happy Birthday* would be an exaggeration. The artist's purpose is to evoke responses in the viewer. The means are often as intuitive as rational.

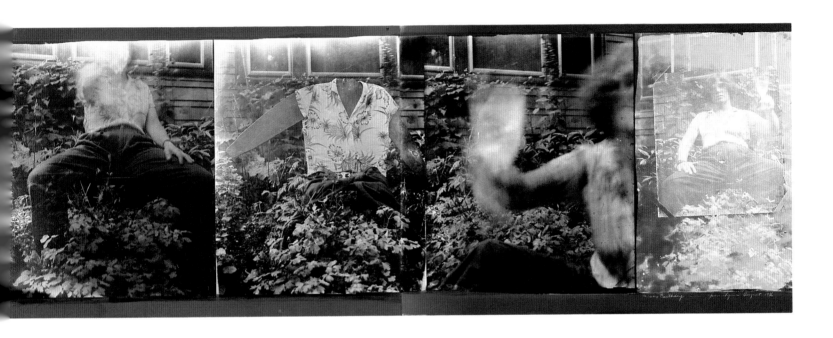

Judith Joy Ross

America (born Hazelton, Pennsylvania, 1946)

Untitled 1988

Gelatin silver printed 1991, gold-toned, 24.6 × 19.5 cm
From *Easton Portraits*
Gift of the artist and the James Danziger Gallery, New York, 1993

While photographers in the twentieth century have striven for a greater understanding of their medium and a more sophisticated awareness of its possibilities, some have also sought the innocence of photography's beginnings, the simple dignity of the portraits of the early daguerreotypists such as A.S. Southworth and Josiah Hawes or Mathew Brady. But there has been another source for innocence – the snapshot. Those naïve little images made by untutored picture-makers since George Eastman gave the Kodak to the world in 1888 have been a persistent and growing influence on photographic vision over the last forty years. Photographers have envied the snapshot's spontaneity, directness, informality, and feeling of authenticity, along with the element of chance that produces visual surprises – accidents that have expanded photography's vocabulary. But what they have marvelled at most in the snapshot is the open rapport it manifests between snapshooter and subject, evidence of "a specific spiritual moment," as Lisette Model called it. She further commented that "of all photographic images it comes closest to the truth."[1] These two paths have been united with a quiet passion in the work of Judith Ross.

A graduate of Moore College of Art, Philadelphia, Ross began to attend the Institute of Design in Chicago in 1968, studying under Aaron Siskind and Arthur Siegel. After graduating from the Institute, she taught college-level photography for fourteen years. Not until the early 1980s did she succeed in breaking away, as she has said, from the Minor White influence, to find a more intuitive approach to the medium. The turning point occurred while photographing children with her 8 × 10 camera in Eurana Park, Easton, Pennsylvania. The openness and vulnerability they displayed in their uncomplicated poses, without glamour or artifice, came close to the human dimension she found in family snapshots and the honesty she admires in daguerreotypes.

Untitled, from the series of Easton portraits, contains that blend of optimism and innocence. Three sisters pose in their bathing suits – twins and a sister older by one year. The essence of nascent femininity, they face the camera with varying degrees of shyness, the eldest showing her slight maturity through a tentative self-confidence, while in the background, appearing by chance, is a male youth checking out the proceedings. With a frontal pose, awkward, open, and vulnerable, it is a classic snapshot situation, reinforced by the intrusion of the accidental in the background – the out-of-focus figure of the boy. It is the latter who reminds us, as is so often the case with the snapshot, of the unruliness of the world. The photograph may be about the tender beauty and vernal hope of the three girls, but it also contains the seeds of other meanings, not the least of which is the reminder of the old myth of Paris's judgment of the three goddesses or, for that matter, the recurring image of the three graces.

The warm and transparent light in Ross's print, together with the contrast between the sharp focus of the foreground and the soft blur of the background, have created a gentle and nostalgic reminder of summertime and youth. But at the same time, as in the work of the early portrait photographers, Ross's camera has discovered an uncompromising truth and a quiet force in the lives of ordinary people.

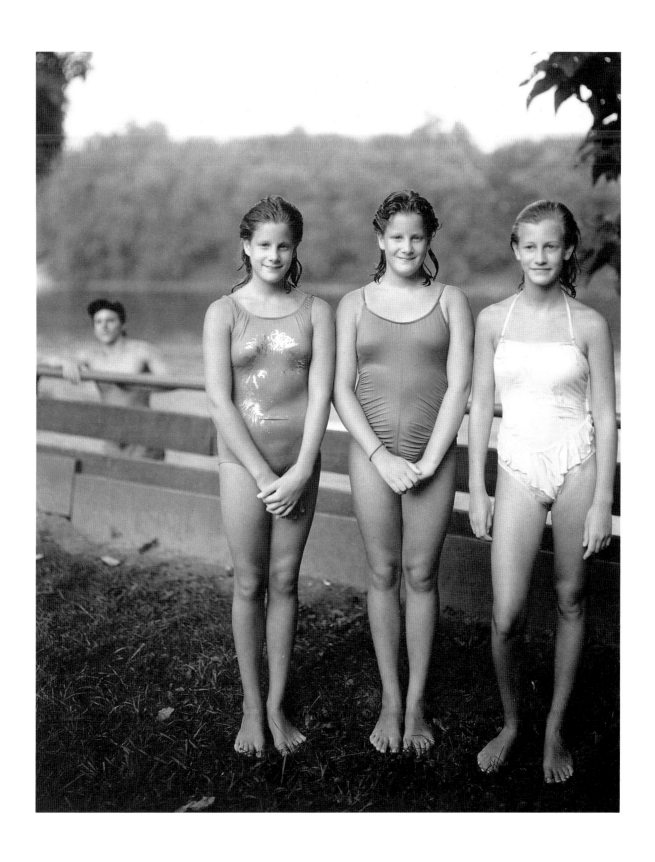

JOEL-PETER WITKIN

American (born Brooklyn, New York, 13 July 1939)

Harvest 1984

Gelatin silver print, toned, 71.9 × 71.4 cm
Purchased 1992

THE STORY JOEL-PETER WITKIN TELLS of himself as a six-year-old seeing a small child's head roll to his feet as the result of a horrendous car accident may have elements of exaggeration.[1] That his brother asked him to make photographs of side-show freaks at Coney Island as a teenager is fact. Which is to say that Witkin comes by his obsession with violence, death, and the grotesque honestly.

He taught himself to photograph around age fifteen, in the mid-1950s, then in 1961 began to work in a colour printing laboratory while attending evening classes at the Cooper Union School of Art in sculpture. Drafted into the army during the Vietnam war, he worked as a photographer, documenting various forms of death. Upon his release, Witkin set as his goal the making of photographs that would help him understand himself. In 1976, he graduated from the University of New Mexico with a master's degree in photography and art history. Witkin had always intended his images to shock and repel, but at the same time he tried to make them emotionally moving and to imbue them with qualities of tenderness. Through advertisements in local newspapers, he sought out damaged people whom he hoped would reveal their pain and suffering to him. His images show physical perversity, often in morbid and misshapen form. The situations depicted are grotesque, often repulsive, and sometimes erotic in an unsettling way. Suggestive of dark visions of hell, the underworld, or the torture chamber, they are apt metaphors for our age of violence.

The formal elements of Witkin's imagery are integral to his message. By abrading and scratching the negatives, printing through crumpled tissue, and staining and toning the paper, he creates a context which refers to the history of art and photography, presenting an oblique approach that tempers his outrageous subject matter by reminding us the arena is art. Like others before him, Witkin reveals for us of the terror of nightmare that lies beneath the veneer of social order and conventional respectability. Hieronymus Bosch, Goya, Henry Fuseli, Guiseppe Arcimboldo, and Max Beckmann are his ancestors.

The reference to the sixteenth century Milanese painter Arcimboldo is especially relevant, for *Harvest* derives specifically from this artist's grotesque paintings of human faces constructed of fruits and vegetables. However, where Arcimboldo combined a bizarre humour with a symbolism that suggests humanity's relationship to the things of the earth, Witkin is concerned with a metaphysical problem. He discovered the head for *Harvest* in a medical museum. Made of wax, it emphasized visceral and skin details as though they were the real thing. "I felt I was on a pilgrimage," he has said, "not to bring death back to life, but to show death's face as a witness to the supernatural."[2] He and his wife spent hours placing the vegetables and roots around the head before making the photograph. As well as death, *Harvest* is about the body's connection with food and, to take it to a religious level, about the Christian theme of transubstantiation, of consumption and regeneration. We may be surprised to find that it is also an object of sensual beauty. Witkin may be asking us to confront the meaning of death, but he is also challenging us to see that art and the human condition are inseparable.

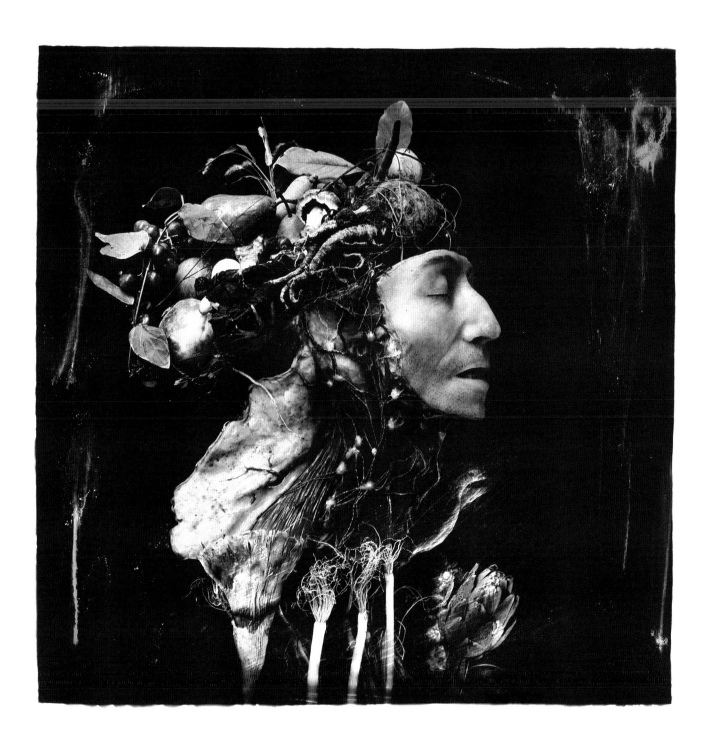

JOHN COPLANS

American (born London, 24 June 1920)

Self-Portrait 1987

Gelatin silver print, 65.7 × 87.1 cm

Purchased 1989

PHOTOGRAPHY'S SPECIFICITY DENIED THE NUDE a serious role in the photographer's canon of subjects in the nineteenth century, except as source material for the painter or as a commodity for the underground market in erotica. Even in painting or sculpture, the nude was acceptable only in idealized form and only as a metaphor or as an illustration of classical mythology. A photograph of a nude offended public morality because, inescapably, it was a portrait of a naked individual. It does not begin to take its rightful place as a photographic subject until the turn of the century, most notably in the work of Heinrich Kühn in Austria, Robert Demachy in France, and, in the United States, Annie Brigman, Alfred Stieglitz, and Clarence White. The photographer's vision of the nude, however, had to conform to public taste by being idealized and romantic, with an emphasis upon the female. Although exceptions may be found, only with the end of the 1960s did photographers begin to have the courage to see specificity in the nude as a virtue and to explore the nude as portrait.

John Coplans arrived in the United States in 1960, first teaching at the University of California, Berkeley. In 1962, he was one of the founders of *Artforum*, an influential magazine of the arts. Five years later, he became curator of the Pasadena Art Museum from 1967 to 1970, then director of the Akron Art Museum from 1978 to 1980. Originally a painter, he then became a teacher, art critic, writer, and editor. Finally, at age sixty, with his retirement from the editorship of *Artforum*, he began to photograph full-time.

Photography had become of serious interest to Coplans during the 1970s, a time when he wrote several perceptive essays on the medium, notably about Carleton Watkins and Weegee. In 1977, he organized an exhibition of the latter's work, and when he began to photograph it was in the Weegee mode, with a large Speed Graphic camera, photographing parades and festivals in the streets of New York. By 1980, he was at work on a series of portraits of friends. Since about 1984, he has concentrated on photographing his own nude body – torso, feet, and hands.

Coplans's photographs constitute some of the most daring nudes in the history of photography. They are an objective and unsentimental examination of an aging body with its sagging flesh and worn skin. We may find a parallel between his self-portraits and the self-examination of Michel de Montaigne's essays written over 400 years ago, in which the author's search for truth through self-knowledge resulted in a lively acceptance of all experience, even the most painful. The honesty of Coplans's vision is coupled with a feeling for sculptural form on a heroic scale. At the same time, the photographer has posed questions about parallels between the body and other worldly matter.

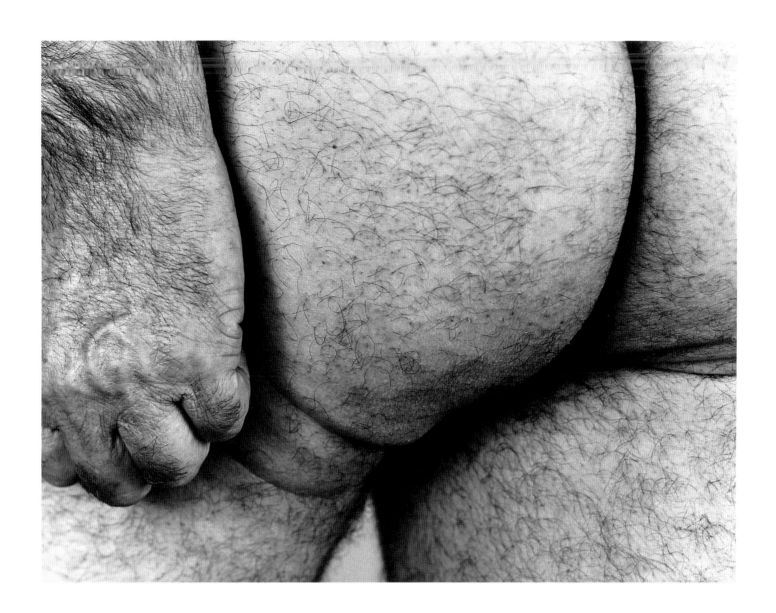

ROGER MERTIN

American (born Bridgeport, Connecticut, 9 December 1942)

Vancouver Public Library, Joe Fortes Westend Branch 1989

Dye coupler print, 69.9 × 55.7 cm
Purchased 1990

COLOUR HAS BECOME A MAJOR ISSUE IN PHOTOGRAPHY since the mid-1970s — largely in revolt against the saturated colour and candy-coated prettiness of advertising and other commercial photography. Photographers such as Roger Mertin are concerned with exploring the particular chromatic qualities and limitations of commercial colour film and print processes, especially colour photography's ability to reveal phenomena usually unseen by the naked eye. Photographers have begun to notice, as did the impressionist painters over a century ago, the role areas of local colour play in animating surfaces and structuring composition. Reflections on the glazed surfaces in *Vancouver Public Library* have allowed Mertin to exploit this phenomenon, bringing luminosity and pictorial richness to his photograph.

Mertin first began to photograph while in high school, then studied photography at the Rochester Institute of Technology, followed by a master's degree from the Visual Studies Workshop in Rochester in 1972. He has been particularly influenced by his mentors, Minor White and Nathan Lyons, and by the works of Eugène Atget and Walker Evans. Mertin has taught at the University of Rochester since 1973.

The photographer places an arbitrary frame around a segment of reality so that whatever falls within it becomes relevant to the image's meaning. The camera's vantage point determines the shape of the pictorial space. That Mertin chose to give us a slightly oblique view of everything and decided to include the clock and the edge of a frame at lower right may at first seem irrelevant, for his subject would appear to be Joe Fortes, a much revered lifeguard at a Vancouver beach. Yet, in such a deceptively simple image, what happens at the edges of a photograph is important — energy is created along the frame line and tension across the surface. In addition, we are reminded that we are looking at only a segment of reality. Through a careful cultivation of the fortuitous, Mertin invites us to discover the incongruities of this world, the subtleties of relationships, the ironies of proximity.

Mertin's photograph has two concerns — the passage of time and photography itself. The framed portrait, a memorial to a smiling Joe Fortes, tells us about photography's power to keep us in contact with the past; its snapshot, slice-of-life spontaneity is of the moment and about the moment, with all its apparent irrelevancies — clues to mysteries that await deciphering. But the clock, if the bathing suit has not already done so, reminds us of time passing, as the movement of its hands records the length of exposure. We are looking at Joe Fortes through a screen of time fixed by the framed portrait itself and traced in minutes on the clock. With this image Mertin takes us on a visual adventure, capitalizing on how the idiosyncrasies of the photographic process reveal the magic of colour and light. So much of what we see in his photograph is a product of chance, or apparent chance — the glowing aura of transparent colour around the clock's dial, the splashes of shimmering colour on the glass covering the portrait (a playful reminder that this is, after all, a colour photograph), the triangle of light pointing like an arrow to Joe's nose as though illustrating a lesson in anatomy. It is the cultivation of such "accidents" that gives Mertin's work its special qualities of surprise, humour, and discovery.

JOE FORTES

LYNNE COHEN

Canadian (born Racine, Wisconsin, 3 July 1944)

Classroom 1991

Gelatin silver print, 72.4 × 91.7 cm
Purchased 1992

THE EVIDENCE IN LYNNE COHEN'S PHOTOGRAPHS is overwhelmingly in favour of human presences. But no one ever appears. What we see in her classrooms, offices, laboratories, community halls, lobbies, and recreation rooms are the bizarre, amusing, and disconcerting environments that humans create for themselves, spaces with the appearance of a theatre set or an installation of sculpture. That they should remind us of sculpture is not altogether surprising, for while studying art between 1962 and 1967, sculpture was Cohen's specialty. She received her bachelor's degree from the University of Wisconsin in 1967, having taken a year off to study at the Slade School of Art in London, followed by a master's degree in 1969, also from Wisconsin. She began to photograph in 1971 because she felt photography brought her closer to life than did the ideas current in other art forms. In 1973, she moved to Ottawa, where she currently teaches photography at the University of Ottawa. She also teaches at the School of the Art Institute of Chicago periodically.

One of the most captivating aspects of a photograph is its ability to present fiction in the guise of truth, to turn the banal into the marvellous and the exceptional, the plain and ordinary into the significant and the beautiful. In walking this fine line, the photograph may have the appearance of being a simple and uncomplicated document. Because of this simplicity and the exactness of the seeing, we are often misled into thinking that the photograph is straightforward. At such moments, we should be most on our guard, for of all the visual arts photography may be the most deceptive. In *Classroom*, as in all her work, Lynne Cohen is confronting reality. These spaces do exist: let there be no mistake about that. They are not constructions fabricated for her camera. They are rooms that people have created to carry on the business of living. At the same time, they are also figments of Cohen's imagination. You and I, walking into the space we see in *Classroom*, constructed to simulate the command station of a ship's bridge in a marine training and research facility, would no doubt have seen something quite ordinary, perhaps even shabbily utilitarian. Cohen's camera, however, has found the enchantment of light, turning the room into a complex structure of crisscrossing shadows. Light glows and takes on a palpable and poetic quality. Each object within the room, because it is seen with such crystalline purity, acquires the heightened presence of a symbol in an arcane ritual. In the end, Cohen's photographs are enigmas. Most enigmatic of all is the race of creatures who have created these haunting spaces. We might imagine the bewilderment of future archaeologists attempting to decipher their meaning.

JOHN WOOD

American (born Delhi, California, 10 July 1922)

Actual ¼ Teaspoon Oil Spill 1990

Gelatin silver print, solarized, with applied lettering, asphaltum, and ink, 38.3 × 50 cm

Purchased 1992

AWARENESS IS THE PRODUCT OF MULTIPLE FORCES acting on our senses. Some artists see their task as directing these forces toward a conclusion. What that conclusion consists of and how it is achieved will evolve from the milieu in which the artist operates – a milieu that determines his or her personal, social, or political convictions on the one hand and, on the other, the nature of the craft with which the artist works. The history of North American photography is deeply rooted in a moral belief in the sanctity of the straight photograph. In the past, any manipulation involving the distortion of photographic realism has always been highly suspect. Attitudes began to change in the 1960s as a few photographers, including John Wood, began to experiment with altering the photographic image for expressive ends, including mixing it with other media. In effect, they treat the camera's product as raw material to be shaped in any way they see fit. Wood's imagery has frequently been motivated by political concerns in the hope that his "small acts," as he has called them, "can bear on our problems."[1]

After studying engineering and architectural drawing, and after service in World War II as a pilot, Wood operated an aerial photography company and portrait studio in Concord, Massachusetts. In 1951, inspired by the writings of László Moholy-Nagy, founder of the New Bauhaus (now the Illinois Institute of Design), he sold his share of the business to become a student there, combining design, typography, and printmaking with photography. From then on, Moholy's principles of exploration and experimentation in art became of paramount importance to Wood. A year after graduation in 1954, he began to teach photography and design at Alfred University, in Alfred, New York, where he remained until retirement.

On 24 March 1989, the Exxon Valdez tanker ran aground in the waters of Prince William Sound, Alaska, spilling millions of gallons of oil. *Actual ¼ Teaspoon Oil Spill* is a response to this ecological disaster. Wood's photograph is purely symbolic, since he was nowhere near the scene. What it presents us with is his emotional response to that situation interacting with the process of the medium he uses. It is an image of foreboding, of tensions between the realistic representation of the stones and the conceptual presentation of taxonomies and geographical locations through applied typography and drawn lines. The squares and rectangles are at odds with each other, the blob of oil is like a black hole, its organic shape an expanding mass threatening to engulf all living creatures it contacts. Wood has mounted a photograph of a carefully arranged square of stones onto another photograph of stones randomly disposed on a beach in such a way as to create tension between the flat light of the inner square and the raking light of the outer. The light of the beach comes from the bottom of the picture, oddly in contrast to that of the rest of the image, an effect exaggerated through Wood's solarization of the print. This has partially reversed the highlights on the stones, increasing their dark and moody character, disorienting the viewer. Given the event out of which the photograph was born, that is appropriate. "In my pictures," Wood has written, "I try to see around the corners of the landscape / feel objects / and touch the / enormity of what we do."[2]

ERIC RENNER

American (born 6 November 1941)

Self portrait diffraction through the pinhole 7 June 1977

Gelatin silver print, 40.4 × 50.4 cm

Purchased 1978

ERIC RENNER IS AGAINST ESTABLISHED SYSTEMS. He prefers to invent his own and to keep them simple. Trained in three-dimensional design, which he taught at Alfred University, Alfred, New York, from 1968 to 1971, he became interested in photography through his association with John Wood, also a member of the teaching staff at Alfred. Out of frustration with the cost of photographic equipment, he decided to design his own cameras from the least costly materials at hand. The results were simple boxes of cardboard, with no shutter and no lens, only an aperture consisting of a pinhole in a sheet of thin alumi-num. In other words, the pinhole camera. Although not a new invention, what Renner brought to this simple device was a spirit of experimentation. Some of his cameras were like large, six-sided hat boxes with a pinhole in each side. A long sheet of film was curved around the inside so that, when exposed, it recorded a 360-degree view of the environ-ment outside the camera. Other boxes had anywhere from seven to nineteen holes on one side. One camera was four feet in diameter with 300 pinholes.

Initially, he exposed film to make a negative from which he could produce any number of positive prints. Since the early 1970s, however, he has also exposed photographic paper directly in the camera, thus producing a negative image on the paper, one that is unique and cannot be duplicated, as in *Self portrait diffraction through the pinhole.*

In addition to allowing him to revolt against the tyranny of established systems, Renner's experiments fascinated him because of their potential for producing the unexpected. "I'm much more excited about things," he has said, "when I don't know what's going to happen and when I can learn from what I don't know."[1]

Perhaps almost more than any other photographer, Renner deals directly with light. Light is his medium and the principal source of his imagery. It is fitting, therefore, that he should portray himself as a magician of light, filtering the sun's dark rays through his hands as he confronts his pinhole. Look, says the photographer, I can trickle light through my fingers, "gilding pale streams with heavenly alchemy."[2] In my role as sorcerer I can spray it around my head like a black halo, the ultimate symbol of the photographic mystery. Talbot and Daguerre would have smiled.

Notes

Introduction Page 15
1. Ann Thomas, "The Tangible Presence of Reality: The Photographs Collection of the National Gallery of Canada," forthcoming in *History of Photography* (fall 1993)

J-G Eynard-Lullin Page 20
1. N-P Lerebours, *Traité de photographie* (Paris: N-P Lerebours, 1843), p. 33, footnote.
2. William Wordsworth, "Vernal Ode," *Wordsworth* (Harmondsworth, Middlesex: Penguin Books, 1950), p. 46.

D. O. Hill, R. Adamson Page 22
1. *The Edinburgh Review*, no. 154 (January 1843), p. 325.
2. Heinrich Schwarz, *David Octavius Hill, Master of Photography*, translated by Helen E. Fraenkel (London: George C. Harrap, 1932), p. 37.

Hugh Owen Page 30
1. *Reports by the Juries: Great Exhibition of the Works of Industry of All Nations, 1851* (London: W. Clowes and Sons, 18[51]–53), p. 275.

Charles Nègre Page 34
1. François Arago, "Chambre des députés, Séance du 3 juillet 1839, Rapport," in *Historique et description des procédés du daguerreotype et du diorama*, by L. J. M. Daguerre (Paris: Alphonse Giroux, 1839), p. 20.
2. Charles Bauchal, "Soirée photographique," *La Lumière*, vol. 2 (28 May 1852), p. 90–91.

Maxime Du Camp Page 36
1. Louis de Cormenin, "Égypte, Nubie, Palestine et Syrie, Dessins photographiques par Maxime Du Camp," *La Lumière* (12 June 1852), p. 99.

Unknown Photographer Page 40
1. John Ruskin, *Modern Painters*, vol. 3 (New York: John Wiley & Sons, 1879), p. 262.
2. Marcus Aurelius Root, *The Camera and the Pencil or the Heliographic Art*, 1864, reprinted with an introduction by Beaumont Newhall (Paulet, Vermont: Helios, 1971), p. 121.
3. William Leible, quoted in *History of German Art*, by Gotfried Lindemann, translated by Tessa Sayle (New York: Paeger, 1971), p. 162.

Félix Teynard Page 46
1. Félix Teynard, *Voyages en Égypte et Nubie: Sites et monuments les plus intéressants pour l'étude de l'art et de l'histoire* (Paris: Goupil, 1858), p. 1.

Édouard Baldus Page 48
1. Malcolm Daniel, "Édouard Baldus, les albums du Chemin de fer du Nord," *La recherche photographique* (February 1990), p. 83–99.

Unknown photographer Page 52
1. C. F. Dendy Marshall, *A History of Railway Locomotives Down to the End of the Year 1831* (London: Locomotive Publishing, 1953).

Platt D. Babbitt Page 54
1. "Mélanges, faits curieux," *Le Voleur* (15 July 1939), p. 45.
2. James Jackson Jarves, *The Art-Idea*, 1864, quoted in *American Painting of the Nineteenth Century*, by Barbara Novak (New York: Harper & Row, 1969), p. 62.

B. B. Turner Page 56
1. William Wordsworth, "The Tables Turned," *Wordsworth* (Harmondsworth, Middlesex: Penguin Books, 1950), p. 49.
2. Geoffrey Crayon, *The Photographic Album for the Year 1855* (London: The Photographic Club, n.d.), opp. pl. 19.

L-E Méhédin Page 58
1. André Jammes and Eugenia Parry Janis, *The Art of the French Calotype* (Princeton, New Jersey: Princeton University Press, 1983), p. 219.

P. H. Delamotte, J. Cundall Page 60
1. Philip H. Delamotte and Joseph Cundall, with descriptive notices by John Richard Walbran, and William Jones, *A Photographic Tour among the Abbeys of Yorkshire* (London: Bell and Daldy, 1856), p. 1.
2. *Ibid.*, p. 41.
3. *Ibid.*

G. N. Barnard Page 62
1. Theodore R. Davis, "Sherman and His Generals," pamphlet accompanying *Photographic Views of Sherman's Campaign*, 1866, reprinted in *Photographic Views of Sherman's Campaign*, by Beaumont Newhall (New York: Dover Publications, 1977), p. xi.

J. B. Greene Page 68
1. Bruno Jammes, "John B. Greene, An American Calotypist," *History of Photography* (October 1981), p. 307.

2. Lady Elizabeth Eastlake, "Photography," *Quarterly Review* (April 1857), reprinted in *Photography: Essays and Images*, edited by Beaumont Newhall (New York: The Museum of Modern Art, 1980), p. 93.

3. André Jammes and Eugenia Parry Janis, *The Art of French Calotype* (Princeton, New Jersey: Princeton University Press, 1983), p. 121.

Gustave Le Gray Page 70

1. André Jammes and Eugenia Parry Janis, *The Art of French Calotype* (Princeton, New Jersey: Princeton University Press, 1983), p. 203.

Francis Frith Page 72

1. Francis Frith, *Upper Egypt and Ethiopia* (Glasgow and Edinburgh: William Mackenzie, 1862?), n. p.

2. Fritz, "The Art of Photography," *The Art-Journal*, vol. 11 (1 March 1859), p. 72.

3. "The Photographic Exhibition," *Journal of the Photographic Society*, vol. 3, no. 50 (21 January 1857), p. 192.

H. L. Hime Page 74

1. Richard Huyda, *H. L. Hime, Photographer — Camera in the Interior: 1858* (Toronto: The Coach House Press, 1975), p. 6–7.

Unknown photographer Page 76

1. Oliver Wendell Holmes, "The Stereoscope and the Stereograph," *The Atlantic Monthly* (June 1859), reprinted in *Photography: Essays and Images*, edited by Beaumont Newhall (New York: The Museum of Modern Art, 1980), p. 60.

2. Ralph Greenhill, *Engineer's Witness* (Toronto: The Coach House Press, 1985), p. 62.

3. Holmes, in Newhall, p. 58.

4. *Ibid.*, p. 59.

William England Page 78

1. Ralph Greenhill, *Engineer's Witness* (Toronto: The Coach House Press, 1985), p. 60.

William Notman Page 80

1. Ralph Greenhill, *Engineer's Witness* (Toronto: The Coach House Press, 1985), p. 64.

2. Stanley G. Triggs, *William Notman, the Stamp of a Studio* (Toronto and Boston: David R. Godine, 1985).

Felice Beato Page 82

1. Michèle and Michel Auer, *Photographers' Encyclopaedia International, 1839 to the Present*, (Geneva: Editions Camera Obscura, 1985), n. p.

G. W. Ellisson Page 86

1. Michel Lessard, *The Livernois Photographers* (Quebec City: Musée du Québec, 1987), p. 58, 67.

Alexander Henderson Page 88

1. *The Photographic News*, vol. 3, no. 53 (9 September 1859), p. 12.

Carlo Ponti Page 92

1. Oliver Wendell Holmes, "The Stereoscope and the Photograph," *The Atlantic Monthly* (June 1859), reprinted in *Photography: Essays and Images*, edited by Beaumont Newhall (New York: The Museum of Modern Art, 1980), p. 58.

Samuel Bourne Page 94

1. Samuel Bourne, "Narrative of a Photographic Trip to Kashmir (Cashmere) and Adjacent Districts," *The British Journal of Photography* (23 November 1866), p. 560.

2. *Ibid.*, 4 January 1867, p. 5.

3. *Ibid.*

David Knox Page 96

1. Alexander Gardner, *Gardner's Photographic Sketch Book of the War* (Washington, D.C.: Philp & Solomons, 1866), opp. pl. 76.

Alexander Gardner Page 98

1. Alexander Gardner, *Gardner's Photographic Sketch Book of the War* (Washington, D.C.: Philp & Solomons, 1866), opp. pl. 36.

2. William A. Frassanto, *Gettysburg, A Journey in Time* (New York: Charles Scribner, 1975), p. 192.

W. L. H. Skeen and Co. Page 100

1. John Falconer, "Nineteenth century photography in Ceylon," *The Photographic Collector*, vol. 2, no. 2 (summer 1981), p. 41–43.

2. W. H. F. Talbot, *The Pencil of Nature* (London: Longman, Brown, Green and Longmans, 1844–46), pl. 10.

Thomas Annan Page 102

1. W. Young, "Introduction," *The Old Closes & Streets of Glasgow* (Glasgow: James Maclehose, 1900).

Jules Andrieu Page 104

1. Nissam Perez, *Focus East: Early Photography in the Near East (1839–1885)* (New York: Harry N. Abrams, 1988), p. 125.

2. C. Fabre, *Aide-mémoire de la photographie* (Toulouse: Édouard Privat, 1876), p. 92–111.

J. M. Cameron Page 106

1. Kenneth Clark, *Landscape into Art* (London: John Murray, 1949), p. 1.

C. L. Weed Page 108

1. Ralph Waldo Emerson, quoted in *American Painting of the Nineteenth Century*, by Barbara Novak (New York: Harper & Row, 1969), p. 110.

Timothy O'Sullivan Page 110
1. James D. Horan, *Timothy O'Sullivan, America's Forgotten Photographer* (New York: Bonanza Books, 1966), p. 295.

John Burke Page 112
1. Henry Hardy Cole, *Illustrations of Ancient Buildings in Kashmir* (London: The India Museum, 1869), caption for pl. 34.

John Thomson Page 118
1. John Thomson and Adolphe Smith, "Preface," *Street Life in London* (London: Sampson, Low, Marston, Searle & Rivington, 1877), n. p.

P. H. Emerson Page 120
1. P. H. Emerson, "Science and Art," read at the Camera Club Conference, Society of Arts, London, 26 March 1889, in *Naturalistic Photography for Students of the Art*, 1899, 3rd ed. rev. (New York: Arno Press, 1973), append. A, p. 72.
2. Emerson, *Naturalistic Photography for Students of the Art* (London: Sampson, Low, Marston, Searle & Rivington, 1889), p. 119.
3. *Ibid*.
4. Emerson, *Life and Landscape on the Norfolk Broads* (London: Sampson, Low, Marston, Searle & Rivington, 1886), p. 9.

Heinrich Kühn Page 122
1. Heinrich Kühn, "How to be sure of making good pictures," *Camera* (June 1977), n. p.

P. B. Haviland Page 126
1. Weston J. Naef, *The Collection of Alfred Stieglitz* (New York: The Metropolitan Museum of Art / Viking Press, 1978), p. 368.

Gertrude Käsebier Page 128
1. Arthur W. Dow, "Mrs Gertrude Käsebier's Portrait Photographs," *Camera Notes*, no. 3 (July 1899), p. 22.
2. Information supplied by Barbara L. Michaels in conversation with the author.
3. Barbara L. Michaels, *Gertrude Käsebier* (New York: Harry N. Abrams, 1992), p. 14.

A. L. Coburn Page 130
1. Alvin Langdon Coburn, "Photographic Adventures," lecture at exhibition opening, University of Reading, 23 January 1962, quoted in *A Portfolio of Sixteen Photographs by Alvin Langdon Coburn*, by Nancy Newhall (Rochester, New York: George Eastman House, 1962), p. 18.

Edward Steichen Page 132
1. Robert Demachy, "On the Straight Print," *Camera Work*, no. 19 (1907), p. 21.

2. Edward Steichen, *A Life in Photography* (Garden City, New York: Doubleday, 1963), [p. 3].
3. *Ibid*.

F. H. Evans Page 136
1. Frederick H. Evans, "Some Notes on Interior Work," *The Amateur Photographer*, vol. 39, no. 1023 (12 May 1904), p. 372.
2. *Photographic Journal* (31 December 1886), p. 22.
3. Evans, p. 372.

Alfred Stieglitz Page 138
1. Émile Zola, *Photo-Miniature*, no. 21 (December 1900), p. 396.
2. Alfred Stieglitz, quoted in *Photo-Secession Photography as a Fine Art*, by Robert Doherty (Rochester, New York: George Eastman House, 1960), p. 28.
3. Stieglitz, quoted in *The History of Photography from 1839 to the Present*, by Beaumont Newhall (New York: The Museum of Modern Art, 1982), p. 168.
4. Stieglitz, letter to John Garo, *Wilson's Photographic Magazine* (October 1911), p. 437.

Paul Strand Page 140
1. Paul Strand, "Photography," *Seven Arts* (August 1917), p. 524–26.
2. Paul Strand, letter to Helmut Gernsheim, 15 December 1960, quoted in *Creative Photography*, by Gernsheim (New York: Bonanza Books, 1962), p. 152.
3. Edward Weston, *The Daybooks* (New York: Horizon Press, 1966), p. 154.

Edward Weston Page 142
1. Edward Weston, "What Is Photographic Beauty?" *Camera Craft* (June 1939), p. 254.

Margaret Watkins Page 144
1. *Photograms of the Year 1911–1912* (London: George Routledge & Sons, [1912]), p. 34.
2. Joseph Mulholland, "A Sad Strange Gleam of Vision," *The Photographic Collector*, vol. 3, no. 1 (spring 1982), p. 54.
3. *Ibid*, p. 58.
4. *Photograms of the Year 1923* (London: George Routledge & Sons, [1923]), p. 8.
5. Edgar Felloes, "The Emporium (second annual) Photographic Exhibition," *Camera Craft* (October 1922), p. 456–57.

Man Ray Page 146
1. John Szarkowski, *Looking at Photographs* (New York: The Museum of Modern Art, 1973), p. 82.

André Kertész Page 154
1. André Kertész, taped interview with the author, 1970, Visual Studies Workshop, Rochester, New York.

2. Pierre Bost, "Spectacles et promenades," *La Revue hebdomadaire*, vol. 6 (June 1928), p. 356–59.

3. Sandra Phillips, David Travis, and Weston Naef, *André Kertész of Paris and New York* (Chicago: Art Institute of Chicago, 1985), p. 266.

Jaromír Funke Page 156

1. Jaromír Funke, "From the Photogram to Emotion," *Fotografický obzor* (1940), as translated in *Jaromír Funke*, by Anna Fárová (Cologne: Rudolf Kicken Galerie, 1984), p. 28.

Alexander Rodchenko Page 162

1. Dziga Vertov, "Kinoks: A Revolution," *LEF* (1923), as translated in *Kino Eye: The Writings of Dziga Vertov*, edited by Annette Michelson (Berkeley: University of California Press, 1984), p. 17–18.

2. Alexander Rodchenko, *Novy LEF* (1928), as translated in *Creative Camera International Yearbook 1978* [1978], p. 227–28.

August Sander Page 164

1. August Sander, "The Nature and Development of Photography," Lecture 3, quoted in *August Sander, Photographs of an Epoch, 1904–1959*, by Robert Kramer (Philadelphia: Philadelphia Museum of Art, 1980), p. 16.

2. Sander, advertising brochure, c. 1910, quoted in Kramer, p. 17.

3. John Szarkowski, *Looking at Photographs* (New York: The Museum of Modern Art, 1973), p. 102.

Albert Renger-Patzsch Page 166

1. *Die Photographische Korrespondenz* (May 1929), quoted in *Creative Photography*, by Helmut Gernsheim (New York: Bonanza Books, 1962), p. 176.

2. *Das Deutsche Lichtbild* (1927), p. xviii.

Herbert Bayer Page 168

1. László Moholy-Nagy, translated by Janet Seligman, *Painting, Photography, Film* (Cambridge, Massachusetts: MIT Press, 1969), p. 28.

L. W. Hine Page 172

1. Lewis Mumford, *The Condition of Man* (New York: Harcourt, Brace, Javanovich, 1944), p. 413.

2. Lewis Hine, letter to Paul Kellogg, 25 November 1930, quoted in *America & Lewis Hine*, by Walter and Naomi Rosenblum (New York: Aperture, 1977), p. 106.

3. "Skyboys Who Rode the Ball," *Literary Digest* (23 May 1931), quoted in Rosenblum, p. 117.

Ralph Steiner Page 174

1. Ralph Steiner, undated letter to Eugene Prakapas, curatorial files, National Gallery of Canada, Ottawa.

2. *Ibid.*

Brassaï Page 178

1. *Minotaure*, 1933.

2. Interview with Brassaï in *Dialogue with Photography*, by Paul Hill and Thomas Cooper (New York: Farrar, Straus, Giroux, 1979), p. 40.

Heinz Hajek-Halke Page 180

1. Franklin Rosemont, ed., *André Breton: What Is Surrealism, Selected Writings* (New York: Monad Press, 1978), book I, p. 131.

Henri Cartier-Bresson Page 182

1. Dan Hofstadter, "Profiles: Henri Cartier-Bresson," part 5, *The New Yorker* (23 October 1989), p. 66–67.

John Heartfield Page 184

1. Shock the middle class.

Berenice Abbott Page 186

1. Berenice Abbott, *A Guide to Better Photography* (New York: Crown Publishers, 1941), p. 54.

2. Abbott, quoted in *Berenice Abbott, Photographer: A Modern Vision*, by Julia Van Haaften (New York: The New York Public Library, 1989), [p. 8].

3. *Ibid.*

4. *Ibid.*, p. 24.

Walker Evans Page 188

1. "The Thing Itself Is Such a Secret and So Unapproachable," interview with Walker Evans, *Image*, vol. 17, no. 4 (December 1974), p. 18.

2. *Ibid.*

3. Jerry L. Thompson, *Walker Evans at Work* (New York: Harper & Row, 1982), p. 151.

4. Walker Evans, "Photography," *Current Perspectives* (Rochester, New York: Light Impressions, 1978), p. 17.

Morris Engel Page 190

1. "For a League of American Photography," *Photo Notes* (August 1938), p. 1.

Frederick Sommer Page 192

1. *Aperture*, vol. 10, no. 4 (1962), [p. 16].

Ansel Adams Page 194

1. Ansel Adams, *An Autobiography* (Boston: Little, Brown, 1985), p. 200.

Lisette Model Page 200

1. Ann Thomas, *Lisette Model* (Ottawa: National Gallery of Canada, 1990), p. 29.

Minor White Page 206

1. Minor White, *Aperture*, vol. 7, no. 2 (1959), p. 73.

2. "Equivalence: The Perennial Trend," *PSA Journal*, vol. 29, no. 7, reprinted in *Photographers on Photography*, edited by Nathan Lyons (Englewood Cliffs, New Jersey: Prentice Hall, 1966), p. 169.

3. *Ibid.*, p. 170.

4. White, *Song Without Words*, 1947, in *Minor White: Rites and Passages*, by James Baker Hall (Millerton, New York: Aperture, 1978), p. 72.

Leon Levinstein Page 210

1. Helen Gee, "Where Life Is," *Camera Arts*, vol. 2, no. 2 (March/April 1982), p. 50.

Dave Heath Page 212

1. Dave Heath, "Dave Heath," *The Liberal Context*, no. 14 (spring 1965), p. 22.

2. *Ibid.*

3. Heath, taped interview with the author, 1979, Photographs Collection Archives, National Gallery of Canada, Ottawa.

Robert Frank Page 214

1. Jack Kerouac, "Introduction," in *The Americans*, by Robert Frank (New York: Aperture, 1969), 2nd edition, p. vi.

2. Robert Frank, "A Statement," *U.S. Camera Annual* (1958), reprinted in *Photographers on Photography*, edited by Nathan Lyons (Englewood Cliffs, New Jersey: Prentice-Hall, 1966), p. 67.

Harry Callahan Page 216

1. Harry Callahan, "Statement," reprinted in *Photography in Print*, edited by Vicki Goldberg (New York: Simon & Schuster, 1981), p. 241.

Aaron Siskind Page 218

1. Edward Weston, *The Daybooks of Edward Weston* (Rochester, New York: George Eastman House, 1966), vol. 2, p. 154.

2. Aaron Siskind, "Credo," *Spectrum* (1956), reprinted in *Photographers on Photography*, edited by Nathan Lyons (Englewood Cliffs, New Jersey: Prentice-Hall, 1966), p. 98.

3. Siskind, quoted in *Aaron Siskind Photographer*, by Nathan Lyons (Rochester, New York: George Eastman House, 1965), p. 5.

4. Siskind, "The Drama of Objects," *Minicam Photography* (1945), reprinted in *Photographers on Photography*, p. 96.

Eikoh Hosoe Page 220

1. Alfred Stieglitz, quoted in "Alfred Stieglitz: Introduction to an American Seer," by Dorothy Norman, *Aperture*, vol. 8, no. 1 (1960), p. 35.

2. Eikoh Hosoe, "Photographer's Note," *Ordeal by Roses* (New York: Aperture, 1985), n. p.

J. N. Uelsmann Page 224

1. H. P. Robinson, *Pictorial Effect in Photography* (London: Piper and Carter, 1869), p. 11.

2. Robinson, "Paradoxes of Art, Science, and Photography," *Wilson's Photographic Magazine* (1892), reprinted in *Photographers on Photography*, edited by Nathan Lyons (Englewood Cliffs, New Jersey: Prentice-Hall, 1966), p. 83.

3. James Borcoman, "Notes on the Early Use of Combination Printing," in *One Hundred Years of Photographic History, Essays in Honor of Beaumont Newhall*, edited by Van Deren Coke, (Albuquerque: University of New Mexico, 1975), p. 16–18.

4. Jerry N. Uelsmann, quoted in *Jerry N. Uelsmann, Twenty-five Years: A Retrospective*, by James L. Enyeart (Boston: Little, Brown, 1982), p. 13.

Nathan Lyons Page 226

1. Nathan Lyons, *Toward a Social Landscape* (New York: Horizon Press, 1966), [p. 3].

2. *Ibid.*, [p. 1–2].

Alice Wells Page 228

1. Susan C. Cohen, *Time after Time, the Photographs of Alice Wells* (Rochester: Visual Studies Workshop, 1990), [p. 49].

Yousuf Karsh Page 230

1. Yousuf Karsh, *In Search of Greatness: Reflections of Yousuf Karsh* (Toronto: University of Toronto Press, 1962), p. 41.

Robert Adams Page 234

1. Robert Adams, *Beauty in Photography, Essays in Defense of Traditional Values* (New York: Aperture, 1981), p. 16.

2. *Ibid.*, p. 24.

3. Adams, quoted in *A Critical History of American Photography*, by Jonathan Green (New York: Harry N. Abrams, 1984), p. 170.

J. J. Ross Page 238

1. Lisette Model, in *The Snapshot*, edited by Jonathan Green (New York: Aperture, 1974), p. 6.

J-P Witkin Page 240

1. Joel-Peter Witkin, "Revolt against the Mystical," master's thesis, 1976, quoted in *Joel-Peter Witkin, Forty Photographs*, by Van Deren Coke (San Francisco: San Francisco Museum of Modern Art, 1985), p. 7.

2. Coke, p. 16–17.

John Wood Page 248

1. John Wood, "Quiet Protest: Recent Work by John Wood," *The Consort* (September 1992), p. 1.

2. *Ibid.*

Eric Renner Page 250

1. Charles Hagen and Charles Kelly, "Eric Renner: 'I really feel I should be interviewing you'," *Afterimage* (December 1974), p. 8.

2. William Shakespeare, *Sonnet xxxiii*.

GLOSSARY

John P. McElhone

Albumen silver print

Positive image composed of silver particles held in a binder layer of albumen on paper. Used to make contact prints from negatives from 1850 to the end of the nineteenth century. Instances of continued use into the 1920s.

Invented by Louis-Désiré Blanquart-Évrard, this was the most common photographic print process from the mid-1850s to the turn of the century. Thin paper, coated with a layer of salted albumen (egg-white protein), is made light-sensitive by application of a solution of silver nitrate. The paper is exposed to daylight through a negative placed in close contact with the sensitized surface until the silver image appears, or "prints out." Albumen prints are characterized by a smooth surface with a fine network of tiny cracks; they may have a low sheen, typical of early papers, or the high gloss of the thicker albumen layer that was considered desirable in the late nineteenth century. The image tone may range from chocolate-brown to purple-brown, depending on the toning treatment. Over time, highlight areas often become yellowed but may also show evidence of pink or mauve tinting in the paper base. The sensitivity and tonal range of albumen paper made it the ideal material for printing images from collodion wet-plate negatives. With the advent of gelatin dry-plate negatives in the 1870s, gelatin silver prints began to displace albumen prints. There is at least one commercial firm currently manufacturing and printing on albumen paper.

Ambrotype

Image composed of silver particles held in a binder layer of collodion coated on glass. The image appears as a positive when the plate is positioned against a dark-coloured backing. Used to make unique images directly in the camera from 1852. Rarely used after 1880.

This process, in which a collodion wet-plate negative is turned into a positive image, was suggested in England by Frederick Scott Archer and, independently, by Gustave Le Gray in France. In the 1850s a number of variations on this idea were put forward, including one patented by James Ambrose Cutting of Boston in 1854; the American name – ambrotype – was first applied to this variant. A glass plate, coated with a light-sensitive collodion solution, is slightly under-exposed in a camera. The resulting negative is processed in such a way that the silver image areas – representing the highlights of the original scene – are made to appear white in reflected light. The conversion of the negative to a positive is completed by backing the glass with black cloth or paper or by applying black paint behind the image. Elaborate hand-colouring is sometimes present. Ambrotypes were considered as inexpensive substitutes for daguerreotypes and, like them, were largely used for portraiture. Also like the daguerreotype, the assembled package of plate, decorative mat, backing, etc., was typically housed in a hinged case or a frame. Ambrotypes were largely superseded in commercial photography by ferrotypes and albumen prints, but they remained available into the 1890s. The replacement of the collodion wet-plate by the gelatin dry-plate made the ambrotype obsolete.

Blueprint (see *Cyanotype*)

Bromoil print

Positive image composed of printing ink on paper or on gelatin print paper. Used to make enlarged prints from negatives from 1907 through the 1930s.

In the 1890s E. Howard Farmer had observed that the silver present in a gelatin silver print could produce a local hardening of the emulsion when treated with a dichromate solution. In 1907, Edward John Wall suggested that this phenomenon could be used to make a variant of the oil process, then popular among pictorialist photographers. C. Welborne Piper immediately took up the suggestion and published details of the bromoil process, "a remarkable method of turning bromide prints and enlargements into oil-pigment prints." A normally processed bromide print is bleached in a dichromate solution. After clearing the bleach residue in a water bath and fixing to remove all the silver compounds, the print holds a relief image of gelatin, more or less hardened in proportion to the amount of silver originally in place. Soaking in warm water swells the unhardened areas of the gelatin film and, as with the collotype process, applied lithographic ink is retained by the hardened shadow areas and rejected by the water-swollen highlight areas. In this case, printing ink is applied directly to the image with brushes. An optional transfer step may be carried out to a plain paper support. The bromoil process allowed the printer an even greater latitude of control than was possible with the gum bichromate process and did not restrict the image to contact size; the print could be as large as could be practically enlarged onto gelatin silver (bromide) paper. Bromoil, like other hand-manipulated processes favoured by the pictorialists, eventually fell into disuse but has experienced a limited revival among some artists in recent times.

Calotype

Negative image composed of silver particles on plain (un-coated) paper. Used to make camera images from 1841 until the mid-1850s.

William Henry Fox Talbot's work through the late 1830s resulted in this paper negative process announced in 1841. Talbot used the Greek root, *kalos* (beautiful), to name the invention, in which an invisible "latent" image is produced during a short camera exposure. This is subsequently made visible, or developed, in a solution of gallic acid, silver nitrate, and acetic acid. Treatment with melted wax renders the paper negative translucent; this can then be used to produce multiple prints on salted paper. Talbot's 1843 modification introduced a solution of sodium thiosulphate ("hypo") as a fixing agent, capable of removing the undeveloped silver compounds. In 1851 Gustave Le Gray introduced a variation in which the paper was waxed prior to sensitization; this allowed the sensitized material to be prepared well in advance of exposure and sharpened the detail of the image. Calotype negative images show a variety of colours depending on the sensitizers and fixing agents used. They are characterized by soft focus and low resolution of detail; however, their higher density and contrast made them superior to plain salted paper for use as a camera material. By the early 1860s the collodion wet-plate process had superseded both the calotype and waxed negative processes.

Carbon print

Positive image composed of pigment in a binder layer of gelatin on paper. Used to make large editions of contact prints from negatives from the late 1860s. Use decreased after 1900 until disappearance in 1940s.

Mungo Ponton suggested using the light-sensitive dichromate ion to produce photographic prints as early as 1839. A workable process was first proposed by Alphonse Louis Poitevin in 1855 and several variants which made the process commercially practical were introduced in France and England in the following years. In this process, a pigment-charged film of gelatin, supported on thin paper – the "tissue" – is treated with a sensitizing dichromate solution. The tissue is then exposed in contact with a negative. Parts of the image representing the shadows of the original scene harden, while the highlights, protected from exposure by the negative, remain unhardened and soluble in water. The tissue is placed face-down on a new sheet of paper and hot water is used to wash off the original paper support and the soluble portions of the gelatin film. A pigment image of varying thickness in a hardened gelatin binder is left on the new paper support. The image is laterally reversed; this can be corrected by a second transfer step. The process takes its name from the carbon lamp-black pigment frequently used as a colorant but tissues with a variety of different pigments were available. Multiple printing can produce true colour images. Carbon prints show fine tonal gradation and a distinct relief between shadow and highlight areas. They were often used for book illustrations and commercial editions of photographic images. Offset lithographic printing technology has progressively replaced all other large-scale reproductive printing processes but a few establishments currently maintain high quality printing processes based on the carbon print.

Collotype

Photomechanical print composed of printing ink on paper. Used to make large editions of prints from the 1870s up until recent years.

First patented by Alphonse Louis Poitevin in 1855 and modified and improved in the ensuing years, the collotype was frequently used in book illustration in the latter part of the nineteenth century, often described by a variety of proprietary process names. All of these variant processes produce a fine-grained half-tone image. The process is based on the fact that gelatin, sensitized with a dichromate solution, becomes water-repellent when exposed to light; the lithographic principle that water and grease repel one another completes the printing system. A dichromated gelatin layer held on a glass plate is reticulated by heating to provide a grain network. When exposed to light in contact with a negative, the gelatin becomes water-repellent in proportion to the amount of light it receives. The plate is washed so that the unexposed areas absorb water while the exposed areas remain dry. When a greasy lithographic ink is applied the image is revealed according to the amount of ink accepted or rejected by the gelatin surface. These ink images can then be transferred to paper using a conventional printing press. The characteristic grain pattern of the collotype, derived from the reticulated gelatin surface, can usually be seen upon close inspection. The finished prints can range from matte to glossy depending on the surface of the paper used, and can be printed in any colour of ink. Collotype printing is limited to relatively short runs and the process is slow compared to modern offset lithographic printing but some establishments still maintain facilities for producing collotypes.

Cyanotype

Image composed of particles of iron compounds on plain (un-coated) paper. Used to make contact prints in the 1840s; reintroduced to make contact prints and line reproductions in the 1870s. Not used after 1960 except, occasionally, as an artist's material.

The cyanotype was invented in 1842 by John Herschel, but did not come into widespread use until the end of the nineteenth century. In this process paper is coated with a solution of ferric ammonium citrate and potassium ferricyanide and then printed by exposure to light through a negative, a translucent drawing, or a thin natural specimen, as in the photograms of Anna Atkins. The deep olive-grey image which prints out is converted to a brilliant

blue colour in a water bath; this also acts to remove the unexposed iron compounds. Like other plain paper photographic prints, cyanotypes do not have a binder layer; the image is held in the upper surface fibres of the paper support and the print has a matte surface. The prints show a compressed tonal scale and are capable of reproducing fine detail. The low cost and simplicity of the process appealed to amateurs, who used it as a means of making proof prints from negatives. Known in its commercial form as the "blueprint," it had widespread use for reproduction of maps and architectural or engineering plans. Both these applications had been taken over by other processes by 1960. Some artists have returned to the process in the intervening years.

Daguerreotype

Image composed of silver particles on a polished silver surface supported on a copper plate. May appear as positive or negative depending on the viewing environment and the angle of illumination. Used to make unique images directly in the camera from 1839. Rarely used after 1860.

The daguerreotype process was invented by the French painter Louis-Jacques-Mandé Daguerre, and announced in 1839. It was the first commercially available photographic process. The carefully polished silver surface of the plate is sensitized by exposure to the fumes of iodine and bromine, producing a thin light-sensitive layer of silver salts on the surface. A brief camera exposure produces an invisible, or latent, image which is made visible, or developed, by exposure to the fumes of heated mercury. Fixation in thiosulphate solution ("hypo") removes the undeveloped silver salts and leaves silver particles in the highlight areas of the image. Shadow areas show only the polished silver metal surface. Gold toning was invariably used after 1841 to reinforce the image and to reduce the fragility of the silver particles. Held under the correct illumination and at the correct angle, a positive image is seen, which is characterized by minute detail, sharp definition, delicacy of tone, and a mirror-like surface. Some plates are finely hand-coloured using dry pigments. The finished plates are usually sealed into glass and paper packages – often with hinged cases – that protect them from environmental pollutants and cover the fragile image surface. This early process was enormously successful and remained the dominant commercial photographic medium until the end of the 1850s, when it was superseded by ambrotypes and albumen prints made from collodion negatives.

Dye coupler print

Positive colour image composed of organic dyes held in binder layers on paper. Used for making contact prints and enlargements from colour negatives and transparencies from the late 1940s. In current use.

This is the positive reflection print version of a technology first applied to making camera transparencies by Leopold Mannes and Leopold Godowsky at the Kodak Research Laboratory in the 1930s. Their success followed on decades of industrial research by many workers. The images are produced by "chromogenic" technology in which organic dyes of the three subtractive primary colours (cyan, magenta, and yellow) are formed in separate gelatin silver emulsion layers by the chemical reaction of dye precursors, colour couplers, and oxidized silver developer. Modern dye coupler prints are held on a support of plastic-coated paper. Usually the prints show soft to moderate contrasts in their colours, and have a medium surface gloss and a slightly grainy surface texture. The dye coupler print is by far the most common type of photographic print and the one which will be familiar to all photographers who request prints from their negatives at a commercial photographic processing outlet.

Dye transfer print

Positive colour image composed of organic dyes held in a binder layer of gelatin on paper. Used for making prints from colour separation negatives. First commercialized in 1906. In current use.

Ernest Edwards observed in 1871 that the unhardened and water-swollen portions of an exposed dichromate-treated gelatin film would selectively absorb (or "imbibe") water-based dyes. This was the critical observation that led to the so-called dye imbibition processes, including the famous Technicolor motion picture film process. Dye transfer prints are built up from three layers of hardened gelatin matrix, each exposed through one of a set of monochrome separation negatives and stained with a dye solution of the corresponding subtractive primary colour (cyan, magenta, or yellow). Each dye-impregnated gelatin layer is subsequently transferred to a single sheet of specially prepared gelatin-coated paper, to build up the full colour image. The prints are characterized by rich colour and tonal values, stemming from the extensive manipulation of both colour saturation and contrast that is possible during the printing steps.

Gelatin silver print

Positive image composed of silver particles held in a binder layer of gelatin on paper. Used to make contact prints and enlargements from negatives from late 1870s. In current use.

This process includes a series of materials that began to appear in the 1870s as a result of industrial research efforts based on the gelatin emulsions used in dry-plate negatives. These new printing materials were particularly well suited for reproducing dry-plate images. A critical factor in the invention of these new processes was the sensitizing effect which gelatin exerts on the silver halide salts formed in the emulsion during manufacture. Highly sensitive gelatin emulsions prepared in this way are laid onto papers coated with a barium sulphate filler – the baryta layer – which gives these prints a smooth, reflective surface and bright, luminous highlights. The precise

control of manufacturing variables required for making materials of this kind irrevocably moved the preparation of photographic printing papers into the industrial realm and away from the hand of the printer-photographer. Gelatin papers have been designed in several versions; some are "printed out," or fully developed during light exposure without the aid of a chemical developer – these are called "P.O.P.," for "printing-out paper"; others are exposed to light only briefly and then developed with an alkaline reducing agent – a "developer" – that produces an image of filamentary silver particles. Some papers are meant for contact printing (requiring lower light sensitivity), while others are used for making enlarged prints from smaller negatives. Image tone in gelatin prints varies widely, depending on the type of silver halide employed, its development, and the choice of toning treatment. Gelatin silver enlarging papers continue to be widely used for black-and-white photography.

Gum bichromate print

Positive image composed of pigment in a binder layer of gum arabic on paper. Used to make contact prints from negatives from 1894 through the 1920s. Currently used by a number of artists to make both monochrome and colour prints.

The suggestion of using a binder of gum arabic – a resin from the acacia tree – with the light-sensitizing dichromate ion to form a pigment image originated with Alphonse Louis Poitevin and was made workable by John Pouncy in 1858. The process involves the brush application of a pigmented solution of gum arabic and dichromate onto a paper support. When dry, this is exposed to light through a negative, causing hardening of the gum in the shadow areas. Subsequent water washing removes the unhardened coating in the highlight areas and leaves the hardened pigmented gum in the shadows. Brushing, the use of water jets and the control of water temperature allows the printer to selectively work local areas of the print. Multiple printing and combining with other techniques, such as platinum printing, allows for further selective manipulation of the image. True colour images can be produced by multiple printing. The choice of image colour for monochrome prints is unlimited; the colorants are usually tube watercolours. The choice of paper surface texture also provides an opportunity for controlling the print quality. Gum bichromate prints (named with the nineteenth century appellation for the dichromate ion) did not find much application until the 1890s when the technique was rediscovered by pictorialist photographers, who appreciated the opportunities for hand manipulation of rather grainy, "impressionistic" images. Out of general use by 1930, gum printing has undergone a limited revival among artists in the last twenty-five years.

Kallitype

Positive image composed of silver particles on plain (un-coated) paper. Used to make contact prints from negatives from 1889. Still in limited use.

Patented by William Walter James Nicol in 1889, and named using the same Greek root as Talbot's calotype (*kalos*, or beautiful), this process derives directly from John Herschel's iron-based processes of 1842. Many variations on the original procedure have been developed by photographers over the years. Like the cyanotype and platinum processes, it uses the light sensitivity of oxidized iron salts to produce a metallic image, but in this case a silver image is formed rather than one of iron compounds or platinum. The prints are reminiscent of salted paper prints but show higher contrast in their shadow areas. The process is capable of reproducing the long tonal range characteristic of platinum printing. The image colour can be varied from black to brown or sepia by adjusting the proportions of the developer constituents and by applying toning treatments to the silver image.

Palladium print (see *Platinum print*)

Platinum print

Positive image composed of platinum (or palladium) particles on plain (un-coated) paper. Used to make contact prints from negatives from the early 1880s. Use declined from the time of World War I; manufacture discontinued in the late 1930s.

In this process, patented by William Willis in 1873 and available in Britain by 1880, light-sensitive iron salts are combined with a platinum compound. Through processing, platinum metal replaces the weak iron image produced during exposure. Giuseppe Pizzighelli and Arthur von Hübl provided substantial improvements to the system in the 1880s, which made the process more generally used. As with other processes that have no binder layer, the platinum print has a matte surface and the image appears to be embedded in the paper. Platinum prints were considered pleasing for their rich blacks and delicate silvery-grey mid-tones. Although they exhibit rather low overall contrast, the prints show tremendous resolution of tone and detail. The colour of the image may be changed by modifying the sensitizing components, by varying the temperature of the developing solution, or by using chemical toners. Palladium papers and combined platinum-silver papers were introduced at the time of World War I as less expensive substitutes; these variant processes produce prints which closely resemble those made using the original platinum process. In the last twenty-five years there has been a substantial revival in the use of the process among contemporary artists.

Salted paper print

Positive image composed of silver particles on plain (un-coated) paper. Used to make contact prints from negatives from 1839. Rarely used after 1860, although there was a limited revival at the turn of the century.

This material was first used in 1834 by William Henry Fox Talbot to make "photogenic drawings." These were photograms of objects such as leaves, flowers, or lace printed in contact with sensitized paper by exposure to sunlight. Later, camera negatives were used to produce photographic prints. The paper is prepared by first floating it on a solution of sodium chloride (common table salt), and then brushing it with a solution of silver nitrate. The resulting silver chloride will darken when exposed to light; this is therefore known as a printing-out process. Areas of the print protected from light exposure by the denser parts of the negative will remain un-darkened. This chemical combination was the basis for the negative/positive photographic system announced by Talbot in 1839, with improvements published in 1841 (see *Calotype*). A variant process employing a chemical development step, therefore known as a developing-out process, was introduced by Louis-Désiré Blanquart-Évrard in the late 1840s, which allowed efficient production of large numbers of prints for publication. Salted paper prints range in colour from warm chocolate-brown to slate-grey and have a matte surface; the image appears to be embedded in the paper. They were superseded by albumen prints in the 1850s.

Woodburytype

Photomechanical print composed of pigment in a binder layer of gelatin on paper. Used to make large editions of prints from the 1870s until the end of the nineteenth century.

This photomechanical version of the carbon print process was patented in the years 1864 to 1866 by Walter Bentley Woodbury, and was used extensively for book and magazine illustration. The image is a pigmented gelatin relief – like that of the carbon print – but in this case produced from a lead mould. To make the mould, an un-pigmented gelatin relief image is produced using an approach similar to that used for carbon prints. This relief image is hardened, dried, and pressed into a sheet of soft lead. To print the image, pigmented gelatin is poured into the mould, plain paper laid on top, and pressure applied. The monochrome prints produced in this way are subtle in tone and show a glossy surface relief. The process is unique among photomechanical techniques in that it produces continuous tone images, like a true photograph, rather than images composed of half-tone dots. The colour of the print depends on the pigments used; frequently this was a rich brown colour which recalls the tones of a pristine albumen print. The prints usually bear a process credit, "Woodburytype" or "Photoglyptie." Woodburytypes were gradually displaced in high-quality reproductive printing by collotypes and photogravures.

SYNOPTIC CATALOGUE

Following is a summary of the items held in the permanent collection and the study collection of the Photographs Collection of the National Gallery of Canada. Unless otherwise indicated, numbers refer to photographs held in the permanent collection. Where a number does not appear, holdings are listed in the cross-reference. (Entries are cross-referenced only in the case of additional holdings or information.) The catalogue does not include the work of unknown photographers, or related publications, prints, drawings, etc., although objects such as cameras are listed in the section entitled "Apparatus" on page 291.

A. & J. Bool
British
active 1870–1878
9

A. G. B.
[possibly Alexandre Bellio or Bellu]
Italian?
active 1850s
17

A. N.
French?
active 1850s
1

Abbott, Berenice
American
1898–1991
20

Abbott, C. Yarnall
American
1870–1938
5

Abdullah Frères
Turkish
active 1858–1899
12, and 2 attributions

Ackermann Bros
American
active 1880s – 1890s
1

Adam-Salomon, Antoine-Samuel
French
1818–1881
10

Adams, Ansel
American
1902–1984
27

Adams, Robert
American
1937–
2

Adamson, Prescott
American
active 1890s – 1900s
1

Adamson, Robert
(see also D. O. Hill)
British, born Scotland
1821–1848

Aerokartographisches Institut
Polish
active 1930s
4

Agius, Horatius
Maltese
active 1870s – 1920s
2

Aguado, Count Olympe-Clémente
French
1827–1894
2

Alban, Georges
French
active 1920s – 1930s
1

Albin-Guillot, Laure
French
? 1962
20

Alexander, Kenneth
American
active 1880s – 1890s
15

Alinari & Cook
Italian
active 1870s – 1900s
50

Alinari, Giuseppe
(see also Alinari Brothers)
Italian
1836–1890

Alinari, Leopoldo
(see also Alinari Brothers)
Italian
1832–1865

Alinari, Romualdi
(see also next entry)
Italian
1830–1891

Alinari Brothers
Italian
active from 1852
76, and 1 attribution

Alinder, Jim
American
1941–
4

Alman, Louis
American
active 1870s – 1900s
2

Altobelli, Gioacchino
(see also next entry)
Italian
1814 – after 1878
1 attribution

Altobelli [Gioacchino] & Molins [Pompeo]
Italian
active c. 1858 – 1865
5

Alvarez Bravo, Manuel
Mexican
1902–
1

Amateur Photographic Association
British
active from 1861
3 in study collection

American Stereoscopic Co.
American
active 1896–1906
1

Amson, Marcel
French
1905–
2

Ancelle, Charles
French
active 1850s
1

Anderson, James (Isaac Atkinson)
British
1813–1877
16, and 1 attribution

Anderson, Robert W.
Canadian
1831 – after 1897
1, and 1 attribution

Andrieu, Jules
French
active 1860s – 1870s
8

Annan, James Craig
British, born Scotland
1864–1946
32, and 1 attribution

Annan, Thomas
British, born Scotland
1829–1887
58

Anriot, Emilio
Italian
active c. 1860s
1

Anson, [Rufus?]
American
active 1851–1867
1

Anthony, Edward
(see also E. &
H. T. Anthony)
American
1818–1888
8

Anthony, John
British
active 1850s – 1880s
1

Appert, Eugène
French
1814–1867
1

Applebaum, Isaac
Canadian, born Germany
1946–
1

Arbus, Diane
American
1923–1971
35

Arlaud, G. L.
Swiss
active 1890s – 1930s?
20

Arless, George C.
Canadian
1841–1903
2, and 1 in study collection

Arnold, Bill
American
1941–
10, and 1 in study
collection

Arnold, Grant
Canadian
1955–
2

Arnold, Mary
Canadian
1953–
2

Arnoux, Hippolyte
French
active 1860s – 1880s
2, and 10 attributions

**Ashford Brothers
& Co.**
British
active 1860s
3 in study collection

Ashley & Crippen
Canadian
active from 1915
1

**Ashton, Frederick
George**
Canadian
1888–1967
70

Atget, Eugène
French
1857–1927
164

Atkins, Anna
British
1799–1871
1 attribution

Avrutis, Newton
American
1906–
1

B. Borri & Son
Italian
active 1870s – 1900
7

Babbitt, Platt D.
American
?–1879
3, and 1 attribution

Baird & Twiford
American
active 1860s?
1

Balbec
French
active 1850s
1

Baldus, Édouard
French, born Saxony
1813 – c. 1890
18, and 2 attributions

Baltn, Lewis
American
1945–
44

Baltzly, Benjamin F.
American
1835–1883
2

Bane, E. M.
American
active c. 1905
2

Bankart, George
British
1829–1916
25

Barker, George
Canadian
1844–1894
33, and 2 attributions

Barnard & Gibson
(see also next entry, and
James F. Gibson)
American
active 1860s
9

Barnard, George N.
American
1819–1902
61

Barnum, [Delos?]
American
active 1850s – 1870s
1

Baron, Paul
American
1946–
20

Barraud Studio
Canadian
active late 19th c.
1

Barraud, Herbert R.
British
1845–1896
146

Barraud, Philip George
British
1859–1929
3

Barró, P.
French
active 1860s – 1870s
1

Barron, John
Canadian
active 1877–1906
1

Barrow, Thomas F.
American
1938–
19

Batson, Alfred
British
active 1850s
1

Bayard & Bertall
(see also next entries,
and Bertall)
French
active c. 1852 – 1866
2

Bayard, Hippolyte
(see also next entry)
French
1801–1887
25

**Bayard, Hippolyte;
Renard, François-
Auguste**
French
active 1853–1854
1

Bayer, Herbert
American, born Austria
1900–1985
2

Baz, Douglas
American
1943–
4

Beal's Art Gallery
American
active 1860s – 1870s
1 in study collection

Beato, Antonio
British, born Italy
1825?–1903
14, and 7 attributions

Beato, Felice
(see also Robertson,
Beato & Co.)
British, born Italy
c. 1830 – after 1904
65

Beaton, Cecil
British
1904–1980
6

Beaver, Bert
Canadian
1920s –
2

Béchard, Émile
French
active 1869 – 1890s
100

Béchard, Henri
French
active 1869 – late 1880s
13

Becher, Arthur E.
American?
active 1903
1

Becotte, Michael
American
1945–
34

Bedford, Francis
British
1816–1894
327, and 63 attributions

Bell, William
American, born Britain
1830–1910
18, and 2 attributions

Bellocq, Ernest James
American
1873–1940
10

Benque, M. M.
(see also next entry)
French
active late 19th c.
5

**Benque, M. M;
Klary, C.**
(see also C. Klary)
French
active late 19th c.
1

Benson, John
American
1927–
9, and 1 in study collection

Benson, T. W.
British?
active 1850s – 1860s
1

Bentam
American
active 1860s
1

Beny, Roloff
Canadian
1924–1984
2

Berg
German
active late 19th c.
1

Bergerson, Philip
Canadian
1947–
6

Berggren, G.
Swedish
1835–1920
18

Bernoud, Alphonse
French
1820–1875
1

**Berry, Kelley &
Chadwick**
American
active 1900 – 1910s
2

**Bertall (Charles-Albert
d'Arnoux)**
(see also next entry, and
Bayard & Bertall)
French
1820–1882
9

Bertall & Cie
French
active 1866–1882
1

Berthaud, M.
French
active 1860s – 1890s
1

Bertillon, Alphonse
French
1853–1914
34

Bierstadt, Charles
American, born Germany
1819–1903
14

**Biewend, Hermann
Carl Eduard**
German
1814–1888
23

Bing, Ilse
German
1899–
2

Bingham, Robert J.
British
c. 1800 – 1870
4

Biow, Hermann
(see also C. F. Stelzner)
German, born Prussia
1810?–1850
1, and 1 attribution

Bird, Walter
British
?–1969
1

Bishop, Michael
American
1946–
3

Bisson Frères
French
active 1840–1864
14

Blanc, Numa
French
active 1860s – 1870s
1

Blanc, Numa, fils
French
active 1860s – 1870s
1

Blanchard, Valentine
British
1831–1901
1

**Blanquart-Evrard,
Louis-Désiré**
French
1802–1872
5 attributions

Block, Adolphe
French?
1829 – c. 1900
5

Blondeau, Barbara
American
1938–1974
2

Blumberg, Donald
American
1935–
33

Blumenfeld, Erwin
American, born Germany
1897–1969
4

Boisgontier, Gilbert
French?
active 1930s
1

Boissonas & Neumayer
(see also next entry)
Swiss
active 1900s
1

Boissonas, Fred
Swiss
1858–1946
78

Bonfils, Félix
French
1831–1885
134, and 7 attributions

Boorne & May
Canadian
active 1887–1893
1 in study collection

Borcoman, James W.
Canadian
1926–
1

Doughton, Alice M.
American
1866–1943
11

Bourdeau, Robert
Canadian
1931–
59

**Bourke-White,
Margaret**
American
1904–1971
12

Bourne, Samuel
(see also next entry)
British
1834–1912
75, and 77 attributions

Bourne & Shepherd
British, in India
active from 1862
7 attributions

Bradbeer & Vanalstine
Canadian
active late 19th c.
1

Bradley, Jessica
Canadian
1948–
1

Bradley, Randy H.
Canadian
1948–
2

Bradshaw, ?
American
active late 19th c.
1 in study collection

Brady, Mathew B.
American
1823–1896
11, and 2 attributions

Brandt, Bill
British
1904–1983
2

Braquehais, Bruno
French
1823–1876
1

Brassaï (Gyula Halász)
French, born Hungary
1899–1984
12, and 1 attribution

Brassey, Annie A.
British
1839–1887
20

Braun & Cie
(see also next entry)
French
active 1865–1895
1

Braun, Aldolphe
French
1812–1877
6, 1 in study collection,
and 1 attribution

Brébisson, Alphonse de
French
1798–1872
1

Brechtel & Urmetzer
German
active 1846
1

Brennan's Studio
Jamaican
active early 20th c.
2

Breuning, Wilhelm
German
1816–1872
1

Breuninger, Mugg
German
active 1930s
1

Bridges, Marilyn
American
1948–
2

**Bridges, Rev. George
Wilson**
British
1788–1863
1

Briggs & Son
British
active 1880s
4

Brigman, Annie W
American
1869–1950
11

Brill, Julius
American
active 1850s – 1870s
4

Broadbent & Co.
(see also next entry)
American
active 1860–1865
1

Broadbent, Samuel
American
1810–1880
1

Broadbridge, Richard
Canadian
active 1909–1915
31

Brogi, Giacomo
Italian
1822–1881
60, and 31 attributions

Brooke, R. S.
Canadian
active 1860s – 1870s
1

Brooks, Ellen
American
1946–
9

Brown, ?
American
active 1880s – 1890s?
1

Bruehl, Anton
American, born Australia
1900–1982
1

Bruguière, Francis J.
American
1879–1945
2

Bryant's Studio
Canadian
active 1900s
1

Bryce, J. Fraser
Canadian
active late 19th c.
1 in study collection

Bubley, Esther
American
1921–
1

Bucher, Herman
American
active 1890s
1

Bucovich, Marius Von
American, born Germany
1894–
1

Bullock, John G.
American
1854–1939
1

Bullock, Wynn
American
1902–1975
3

Bureau, S.
French
active 1860s – 1880s
1

Burke, Bill
American
1943–
2

Burke, John
British
active c. 1860 – 1907
43

Burley, Robert A.
Canadian
1957–
2

Burns, Archibald
British
active c. 1858 – 1880
46, 3 in study collection,
and 24 attributions

Burtynsky, Edward
Canadian
1955–
14

C. R. Chisholm & Bros
Canadian
active 1860s – 1870s
1

Cadby, William A.
British
active 1891 – 1930s
2

Cadwallader Bros
American
active 1860s – 1880s
1

Callahan, Harry
American
1912–
91

Cameron, Julia Margaret
British, born India
1815–1879
11

Campbell, Alfred S.
American
active c. 1893 – 1904
2

Campbell, David
American
active 1960s
1

Campeau, Michel
Canadian
1948–
3

Canada View Company
Canadian
active 1880s
11

Caneva, Giacomo
Italian
1810 1890
2

Capa, Robert
American, born Hungary
1913–1954
1

Caponigro, Paul
American
1932–
16

Caret
French
active 1877–1884
1

Carjat, Étienne
French
1828–1906
65

Carpenter & Westley
British
active 1850s
1

Carson [Bros ?]
American
active in Canada
1857–1865
4

Cartier-Bresson, Henri
French
1908–
27, and 3 in study collection

Casasola, Augustin Victor
Mexican
1874–1938
1

Caswell, Philip Hines
American
1854–1939
3

Centennial Photographic Co.
Canadian
active in United States
1876
1

Chace & Hawes
American
active 1860s
1

Chambey
French
1827–1892
1

Chamorro, Koldo
Spanish
1949–
1 in study collection

Chamouin, Alphonse
French
1800–?
27

Charles Goodal & Son
British
active 20th c.
1

Charlet & Jacotin
French
active 1860s – 1870s
1, and 1 in study collection

Charnay, Claude-Joseph-Désiré
French
1828–1915
1

Chase, Lorenzo G.
American
active 1844–1856
2

Cheney, Robert Henry
British
c. 1800 – 1866
64

Chicago Transparency Co.
American
active 1920s?
2

Childs, B. F.
American
active 1860s – 1892
1

Ciappei, Francesco
Italian
active 1857–?
1

Citroen, Paul
Dutch, born Germany
1896–1983
2

Claflin, Charles R. B.
American
1817–1897
1

Clark, Larry
American
1943–
50

Claudet, Antoine François Jean
British, born France
1797–1867
11

Clergue, Lucien
French
1934–
249

Clifford, Charles
British
1821–1863
5 attributions

Clift, William
American
1944–
7

Climo, John S.
Canadian
1833–?
1

Coburn, Alvin Langdon
British, born United States
1882–1966
136, and 1 in study collection

Coghill, Sir John Joscelyn
British, born Ireland
1826–1905
1

Cohen, Lynne
Canadian, born United States
1944–
65

Cohen, Mark
American
1943–
3

Coke, Van Deren
American
1921–
8

Cole, Bernard
American, born Britain
1911–1982
1

Collie, William
British
1810–1896
1

Collier, Joseph
American, born Scotland
1836–1910
1

Colwell, Larry
American
1911–
2

Connor, Linda
American
1944–
5

Constant, Eugène
French
active 1840s – 1870s
2

Continent Stereroscopic Co.
American
active 1870s – 1890s
1

Conway, Charles
British
active 1850s
1

Cooper, Frank
Canadian
1845–?
1

Cooper, Thomas Joshua
American
1946–
1, and 1 in study collection

Coplans, John
American, born Britain
1920–
12

Coral, Guy de
Dutch
active early 20th c.
1

Corot, Camille
French
1796–1875
2

Coshdas, Marie
American
1925–
2

Cotton, Bill
American
1916–
1

Courtin, Émile
French
active 1870s – 1880s
2

Cousineau, Penny
Canadian
1947–
1

Cousineau, Sylvain P.
Canadian
1949–
38

Coutellier, Francis
Belgian
1945–
2

Cowin, Eileen
American
1947–
2

Cox, E. J.
American
active 1870s
1

Cramer, Konrad
American, born Germany
1888–1963
4

Crémière, Léon
French
1831–?
1

Crespon, A.
French
active 1850s – 1860s
1

Cruikshank, George
British
1796–1878
2

Crum, R. D.
American
active 1870s
1

Cuccioni, Tommaso
Italian
?–1864
1, and 1 attribution

Culpet, ?
French
active c. 1860
1

Cumming, Donigan
American
1947–
1

Cundall, Joseph
(see also next entry, and
P. H. Delamotte)
British
1818–1895
1

Cundall, Joseph; Fleming, ?
British
active before 1866 – 1872
15

Cunningham, Imogen
American
1883–1976
2

Curran, Darryl J.
American
1935–
1

Currey, Francis Edmond
British, born Ireland
1814–1896
1

Curtis, Edward Sherriff
American
1868–1952
28, and 2 in study
collection

Curtis, George E.
American
1830–1910
1

D'Alessandri, Antonio
(see also D'Alessandri
Brothers)
Italian
1818–1893

D'Alessandri, Paolo Francesco
(see also D'Alessandri
Brothers)
Italian
?–?

D'Alessandri Brothers
Italian
active 1855–1880
2

D'Alessandro, Robert
American
1942–
2

D. Appleton & Co.
American
active 1850s – 1860s
1

Dagenais, Joseph-Alfred
Canadian
active 1873–1907
1 in study collection

Dagg, S. H.
British
active 1860s
3

Dagron, Prudent René-Patrice
French
1819–1900
2

Dahl-Wolfe, Louise
American
1895–1989
1

Dakin, Clarence L.
American
1848–?
1

Dally, Frederick
British
1838–1914
1

Dame, William H.
Canadian?
active 1890s
5

Dancer, John Benjamin
British
1812–1887
3

Dane, Bill Z.
American
1938–
218

Dardoize, Louis-Émile
French
1826–?
1

Dater, Judy
American
1941–
3

Daubigny, Charles-François
French
1817–1878
1

Daumier, Honoré
French
1808–1879
1

Dauthendey, Carl
German
1819–1896
1

Davanne, Louis-Alphonse
French
1824–1912
3

Davenport, Alma
American
1949–
3

David, Jules
French
active 1880s – 1890s
1

Davidson, David
American
active 1900s – 1920s
1

Davis's Gallery
Canadian
active 1860s – 1890s
1

Davis, Saul
Canadian
active c. 1850 – 1865
1 attribution

Davison, George
British
1854–1930
8

De Lory, Peter
American
1948–
2

De Meyer, Adolf
British, born Germany
1868–1946
27

De Suze, ?
French?
active 1870s
1

Defraoui, Silvie
Swiss
1935–
1 book

Del Tredici, Robert
American
1938–
3 in study collection

Delamotte, Philip Henry
(see also next entry)
British
1820–1889
39

Delamotte, Philip Henry; Cundall, Joseph
(see also Joseph Cundall)
British
active 1853–1856?
21, and 4 in study collection

Delbet, Jules
French
active 1861
1

Delessert, Benjamin
French
1817–1868
8

Demachy, Robert
French
1859–1936
18

Demarchi, Arturo
Italian
active 1890s
42

Depaulis, Alexis-Joseph
French
1790–1867
1

Derderian, Dicran
American
1938–
1

Derker, E.
American?
active 1860s – 1880s
1

Deroche & Heyland
Italian
active 1865–1871
1

Desplanques, E.
France
active 1850s
1

Després, Denise
Canadian
active 1975
9

Detroit Photographic Co.
American
active from 1898
3 in study collection

Deutch, Stephen
American
1908–
1

Devens, Mary
American?
active 1898–1905
1

Di Biase, Michael
American
1925–
1

Diamond, Hugh W.
British
1809–1886
1

Diamond, Paul
American
1942–
14

Diènes, André
French
1913–
1

Dietz, ?
German?
active 1930s
6

Dieulafoy, Jane
French
active 1880s
2

Dieulafoy, Marcel-Auguste
French
1844–1920
1

Dillon, Luke C.
American
1844–?
2

Dino, André
French
active 20th c.
1

Disdéri, André-Adolphe-Eugène
French
1819–1889
7

Dittrich, P.
German?
active 1880s – 1890s
1

Dixon, Henry
British
1857–1943
10

Dixon, Thomas J.
British
1857–1943
1

Doherty, William
American
1940–1972
3

Doisneau, Robert
French
1912–
1

Dost, Friedrich
Wilhelm
German
1816–1853
2

Douglas, Fred
Canadian
1935–
1

Dovizielli, Pietro
Italian
1804–1885
4

Dow, Jim
American
1942–
37

Downes, George
(see also Robert Howlett)
British
?–1874

Drier, ?
French
active 1850s – 1860s
1

Drisch, Russell
American
1943–
2

Drtikol, Frantisek
Czechoslovakian
1883–1961
2 in study collection

Du Camp, Maxime
French
1822–1894
127

Duchenne, Guillaume-
Benjamin-Armand
(see also O. G. Rejlander)
French
1806–1875
10

Dugmore, A. Radclyffe
American
1870–?
2

Dujardin, P.
French
active 1870s – 1890s
4

Dumas, Tancrède R.
Italian?
?–1905
2

Dunshee, Cornelius E.
(see also Dunshee Bros)
American
c. 1829 – 1880

Dunshee, Horace S.
(see also next entry)
American
?–1883

Dunshee Bros
American
active c. 1865 – 1883
2

Dupee, Isaac H.?
American
active 1855–1875
1

Durand, Henri
Canadian
active from 1970s
1

Durandelle, Louis-
Émile
French
1839–1917
38

Durst, André
French
1907–1949
1

Dwiggins, Eugene
American
1944–
2

Dyer, William B.
American
1860–1931
2

E. & H. T. Anthony
& Co.
(see also Edward Anthony)
American
active 1852–1901
8

E. H.
French?
active 1870s – 1900s
1

Eastman, George
American
active from 1960s
1

Eckerson & Bell-Smith
Canadian
active 1870
1

Edgerton, Harold E.
(see also next entry)
American
1903–1990
11

Edgerton, Harold E.;
Vandiver, Kim
(see also Kim Vandiver)
American
active 1973
1

Edler, Anton
German
active 1840s
1

Edwards, Ernest
British
1837–1903
1, and 3 in study collection

Eichmann, David;
Riel, L.
German
active 1854
1

Eickemeyer, Rudolf, Jr
American
1862–1932
1

Eidlitz, Dorothy Meigs
American
c. 1895 – 1975
7

Eisen, F. C., fils
German
active 1860s
1

Eisenmann, Charles
American, born Germany
1850–?
1, and 2 attributions

Elliott, James J.
British
1835–1903
10

Ellis, Alfred
British
?–1930
6

Ellisson, George
William
Canadian, born Ireland?
c. 1818 – c. 1879
10

Emerson, Peter Henry
British, born Cuba
1856–1936
129

Emonds, P.
French
active before 1870s – after
1900s
3, and 16 attributions

Engel, Morris
American
1918–
4

England, William
British
1816–1896
6

Esposito, ?
Italian?
active 1870s – 1890s?
1

Esson, James
Canadian
1854–1933
59, and 1 in study
collection

Estabrook, Reed
American
1944–
1

Eugene, Frank
American
1865–1936
30

Evans, David
Canadian
1948–
1

Evans, Frederick H.
British
1853–1943
25

Evans, Walker
American
1903–1975
403

Evergon (Alfred H. Lunt)
Canadian
1946–
5

Ewing, Robert D.
Canadian
1828–1893
9

Eynard-Lullin, Jean-Gabriel
Swiss
1775–1863
4

Falk, Benjamin Joseph
American
1853–1925
1

Falkner, F. B. W.?
Canadian
active 1900s
1

Fantin-Latour, Henri
French
1836–1904
3

Faris, Thomas
American
active 1841 – after 1877
1

Farquharson, Robin
American
active from 1960s
1

Fehr, Gertrude
Swiss, born Germany
1895–
2

Feininger, T. Lux
American, born Germany
1910–
1

Fenton, Roger
British
1819–1869
118

Ferrier père & fils; Soulier, Charles
(see also next entries)
French
active 1859–1867
3

Ferrier, Jacques-Alexandre
French
?–1912
2

Ferrier, C. M.
French
1811–1889
2

Fichter, Robert W.
American
1939–
18

Fitz, Grancel
American
1894–1963
2

Fitz-George, Capt. G.
British
active 1870
9

Fitzgerald, Otho Augustus
British
1827–1882
1

Fizeau, Armand-Hippolyte-Louis
French
1819–1896
1

Flagg, J. Montgomery
American
1877–1960
2

Flaherty, Robert J.
American
1884–1951
10

Fleischmann, Trude
American, born Austria
1895–1990
1

Flick, Robbert
Canadian, born Holland
1939–
3

Fontaine, G.
French
active 1855–1888
2

Forrest [Lorenzo] & Lozo [Alexander]
Canadian
active 1867–1871
1

Forrester, Joseph James
British
1809–1861
1

Fortier, Fr. Alphonse
French
?–1882
1

Foster, C. H.
Canadian?
active late 19th c.
1

Foster, L. D.
American
active from 1960s
1

Foster, Steven D.
American
1945–
3

Fowx, Egbert Guy
American
1821–?
1

Fox Photos
British
active 1930s
1

Fraget & Viret
French
active 1860s – 1870s?
1, and 1 attribution

Franck (François-Marie-Louis-Alexandre Gobinet de Villecholle)
French
1816–1906
8

Frank, Robert
Swiss
1924–
52

Fraser, John
(see also Gagen & Fraser)
Canadian
1838–1898

French & Co.
American
active 1860s
1

French, Herbert G.
American
1872–1942
5

Friedlaender & Horwitz
American
active 1860s – 1870s
1

Friedlander, Lee
American
1934–
35

Frith, Francis
British
1822–1898
351, and 9 attributions

Fuhr, Charles-Jérémie
French
1832–?
3

Fukasawa, T.
Japanese
active c. 1890s
2, and 3 attributions

Funke, Jaromír
Czechoslovakian
1896–1945
1

Furne & Tournier
French
active 1850s
1

Furst, ?
British?
active 1930s
1

Furst, E.
French
active mid-19th c.
1

G. West & Son
British
active 1890s
1

G. R. Lambert & Co.
British
active 1860s – c. 1890
8

Gagen, Robert Ford
(see also next entry)
Canadian
1847–1926

Gagen & Fraser
(see also John Fraser)
Canadian
active 1873?–1883?
3

Gagnon, Charles
Canadian
1934–
27

Gagnon, Raymond
Canadian
1933–
1

Garcin, A.
Swiss
active 1860s – 1870s
1

Gard, Emery R.
American
active 1856–1866
1

Gardner, Alexander
American, born Scotland
1821–1882
35, and 1 attribution

Gardner, James Anthony
American, born Scotland
1832–?
10, and 1 attribution

Garzón, ?
Spanish
active 1870s – c. 1900
1

Gasoi, Marvin
Canadian
1949–
2

Gassan, Arnold
American
1930–
8

Gaudard, Pierre
Canadian, born France
1927–
4

Genova, G.
Italian
active mid 19th c.
3

Genthe, Arnold
American, born Germany
1869–1942
1

Geodatisches Institut
Danish?
?–?
1

Gérard, Charles
French
active 1860s – 1870s
2

Germon, Washington L.
American
1823–1877
1

Gersh, Stephen
American
1942–
4

Gerstein, Rosalyn
American
1947–
1

Gething, G. B.
British
active 1850s
1

Giacomelli, Mario
Italian
1925–
4

Giannini, Egidio
Italian
active 1880s
1

Gibson, James F.
(see also Barnard & Gibson, and Wood & Gibson)
American, born Scotland
1828 or 1829 – ?
1

Gibson, Ralph
American
1939–
8

Gibson, Tom
Canadian, born Scotland
1930–
31, and 13 in study collection

Gilbert, Douglas R.
American
1942–
1

Gilchrist, George C.
American
active 1849–1860
1 attribution

Gill, Leslie
American
1908–1958
1

Gilpin, Laura
American
1891–1979
6

Glass, Douglas
British
1901–1978
1

Gloeden, Wilhelm von
German
1856–1931
6

Godet, Jules-Michel
French
active 1860s – 1870s
8

Godfrey, George W.
American
1818–1888
2

Gohlke, Frank W.
American
1942–
4

Goldbeck, Eugene Omar
American
1892–1986
3

Good, Frank Mason
British
1839–1928
51, and 8 in study collection

Gordon, Bonnie
American
1941–
1

Gorny, Hein
German
1904–1967
1

Gove & North
Mexican
active 1880s
1

Gowin, Emmet
American
1941–
15

Graff, Philipp
German
1814–1851
3

Graves, Carlton H.
American
?–1943
2

Gravning, Wayne
American
1935–
3

Gray Brothers
South African
active 1870s – 1880s
2 attributions

Gray, Todd
American
1954–
1

Grazda, Edward
American
1947–
2

Green, ?
American
active late 19th c.
1 in study collection

Greene, John Beasly
American, born France
1832–1856
36

Grégoire, Normand
Canadian
1944–
1

Grillet, [J.?]
French
active 1850s – 1860s
1

Groll, A.
Austrian
active 1850s – 1860s
4

Grossman, Sid
American
1913–1955
31

Grotz, Paul
American, born Germany
1902–1990
1

Gunther, Hermann
German
active 1860s?
1 in study collection

Gurney, Jeremiah
American
1812–1886
2

Gutch, John Wheeley Gough
British
1809–1862
1

Gutekunst, Frederick
American
1831–1917
1

Gutmann, John
American, born Germany
1905–
1

Gutsche, Clara
American
1949–
7

Guzelimian, Vahé
Canadian, born Egypt
1949–
1

H. B. & S.
British
active 1930s
19

H. C. Tait & Co.
Canadian
active 1870s?
1

H. C. White Co.
American
active 1899 – 1910s
3

Hahn, Betty
American
1940
37

Haiko, Robert F.
American
1942–
1

Hajek-Halke, Heinz
German
1898–1983
1

Hale, Benjamin F.
American
1831–1900
1

Hall, Marshall
American
1865–1925
4

Hall, W.
British
active 1860s?
1

Hallman, Gary
American
1940–
4

Halsman, Philippe
American, born Latvia
1906–1979
1

Hammerschmidt, W.
German
? – after 1869
7

Hanfstaengl, Franz
German
1804–1877
1

Harbutt, Noel C.
British?
?–1949
1

Hardie, ?
American?
active c. 1900
1, and 2 attributions

Harrison, Jim
American
active from 1960s
1

Hart, Charles S.
American
1836–1915
1

Hatch, ?
American
active 1870s
1

Hautecoeur, Édouard
French
1847–1889
5, and 1 attribution

Hautecoeur, Jules
French
active 1877 – 1890s
50, and 1 attribution

Haviland, Paul B.
French
1880–1950
14

Hawes, Josiah Johnson
(see also A. S. Southworth)
American
1808–1901

Hawkins, Ezekiel C.
American
active 1806–1860?
1

Haynes, J. E.
American
1884–1962
5

Hazelton, Benson C.
American
active 1855–1864
1

Heartfield, John
German
1891–1968
6

Heath, Dave
American
1931–
83, and 1 in study
collection

Heath, W.
British
active 1860s? – 1880s?
1

Heidersberger, Heinrich
German
1906–
1

Heilmann, Jean-Jacques
French
active 1852–1859
1

Heinecken, Robert F.
American
1931–
13

Helders, Johan Anton Joseph
Canadian, born Holland
1888–1956
1

Hemphill, William Despard
British
active 1861–1871
5

Henderson, Alexander
Canadian, born Scotland
1831–1913
100, and 9 attributions

Henderson, Henry
Canadian, born Britain
1836–1898
21, and 1 attribution

Hennah, Thomas H.
British
active 1850s – 1880s
1

Henneberg, Hugo
Austrian
1863–1918
3

Henneman, Nicolaas
Dutch
1813–1898
1

Hermann & Cie
French
active from 1870s?
1

Heron, Reginald
American, born Britain
1932–
3

Herzog, F. Benedict
American
?–1921
8

Hetherington, ?
Canadian?
active late 19th c.
1

Hevy, ?
American
active late 19th c.
1

Hill, David Octavius
(see also next entry)
British, born Scotland
1802–1870

Hill, David Octavius; Adamson, Robert
(see also Robert Adamson)
British
active 1843–1847
176

Hill, Ira Lawrence
American
active c. 1900 – 1920s
1 in study collection

Hillers, John K.
American, born Germany
1843–1925
1

Hime, Humphrey Lloyd
Canadian, born Ireland
1833–1903
2

Hine, Lewis Wickes
American
1874–1940
106

Hinton, Alfred Horsley
British
1863–1908
4

Hofmeister, Oskar
(see also Hofmeister & Hofmeister)
German
1869–1937

Hofmeister, Theodor
(see also next entry)
German
1865–1943

Hofmeister, Theodor; Hofmeister, Oskar
German
active 1895 – 1900s
6

Hogg, Jabez
British
1817–1899
1

Holbrook, William
Canadian
active 1890s – 1910s
1

Holden, Richard
Canadian, born Britain
1946–
3

Holmes, Silas A.
American
1820–1886
1, and 3 attributions

Holownia, Thaddeus
Canadian, born Britain
1949–
3, and 1 in study collection

Holpern, J.
Austrian?
active 1930s
1

Hopkins, William P.
American?
active 1860s?
1 attribution

Hoppé, E. O.
British, born Germany
1878–1972
15

Horetzky, Charles George
Canadian, born Scotland
1838–1900
1

Horne, Fallon
British
?–1858
1

Horst, P.
American, born Germany
1906–
12

Hosoe, Eikoh
Japanese
1933–
40

Howlett, Robert
(see also next entry)
British
1831–1858
1

Howlett, Robert; Downes, George
(see also George Downes)
British
active 1850s
1

Hoyningen-Huene, George
American, born Russia
1900–1968
1

Hubbard, William A.
American?
active 1890s
1

Huberland, Morris
American, born Poland
1909–
2

Hudson, John
British
active 1860s – 1870s
12

Huet, Paul
French
1803–1869
1

Huguet & Van Lint
(see also Enrico Van Lint)
Italian
active 1860s – 1880s
3, and 1 attribution

Hyde, Scott
American
1926–
6

Ignatovich, Boris
Russian
1899–1976
1

Incorpora, Guiseppe
Italian
active 1860 – 1870s
12

Inglis, Alexander
British
active 1860s – 1870s
17, and 15 attributions

Inglis, James
Canadian, born Britain
1835–1904
1

International Stereoscopic View Co.
American
active 1880s? – 1900s?
2

Isenring, Johann Baptist
Swiss
1796–1860
1

Izis (Israël Bidermanas)
French, born Lithuania
1911–1980
2

J. W. D.
French?
active 1850s
2

Jackson, William Henry
American
1843–1942
8

Jacquier, V.
Italian?
?–?
6

Jaecklé, A.
Canadian?
active 1860s
1

James Valentine & Sons
(see also James Valentine)
British
active 1880–?
522, and 3 attributions

James, Geoffrey
British
1942–
3

Janiak, Lawrence
American
1938–
1

Janney, W. C.
American
active 1890s
1

Jarvis, John F.
American
1850–?
21

Jaynes, E. L.
American
active 1870s – 1880s
1

Jenks, ?
American
active 1890s – 1910s
1

Jennings, John Payne
British
?–1926
13

Jensen, N. P.
American
active 1880s
1

John & Charles Watkins
British
active 1860s – 1870s
2 in study collection

Johnston & Hoffman
British
active late 19th c.
4

Jonaty, ?
French?
active 1880s
1

Jones, Harold
American
1940–
17

Jones, John L.
Canadian
active 1869–1903
3

Jones, Rev. Calvert Richard
British
1804–1877
4

Jory, Samuel C.
Canadian?
c. 1831 – ?
1

Josephson, Ken
American
1932–
1

Junkers-Luftbild
German
active 20th c.?
2

Kalland, A.
Norwegian?
active 20th c.
1

Karsh, Yousuf
Canadian, born Armenia
1908–
89

Käsebier, Gertrude
American
1852–1934
26

Kato, Taizo
American, born Japan
active 1910s – 1920s
2

Kattelson, Sy
American
1923–
1

Keely, Robert Neff
American
active 1840s – 1860s
1

Keiley, Joseph T.
American
1869–1914
8

Kelham, Augustus
British
active 1860s – 1880s
2

Kelley, E. W.
American
active 1868?–1908?
1

Kelley, William
Canadian?
active 1890s
4

Kells, Harold F.
Canadian
1904–1986
10

Ken, Alexandre
French
active 1860s – 1870s
2

Kent, William Hardy
British
1819–1907
2

Kerner, Sidney
American
1920–
2

Kernochan, Marshall R.
American
active 1900s
1

Kerr, Arthur
British
active 1854
1

Kertész, André
American, born Hungary
1894–1985
13

Kesting, Edmund
German
1892–1970
1

Ketchum, Cavalliere
American
1937–
3

Keystone (Paris)
French
active from 1920
1

Keystone View Co.
American
active 1892 – 1940s
5

Kilburn Brothers
American
active 1855–1877?
10

Kilburn, Benjamin W.
American
1827–1909
102

Kilburn, M. D.
Canadian
active 1890s – 1900s
1

Kilburn, William Edward
British
active 1846?–1862?
3

Kimbei, Kusakabe
Japanese
active 1880s – 1912
1

King, Horatio B.
American
active 1849–1859
1

Kinsey, Darius
American
1869–1945
151

Klary, C.
(see also M. M. Benque)
French
1837–?

Klein, William
American
1928–
2

Klutsis, Gustav
Russian, born Latvia
1895–1944
1

Knight, James
British
active 1850s
1

Knottenbelt, Marianna
Canadian, born Holland
1949–
4

Knox, David
American
active 1860s
4

Knudsen, Knud
Norwegian
1832–1915
2

Koster, Peter
American
active from 1970s
1

Kowal, Cal
American
1944–
1

Kowall, Earl
Canadian
1948–
2

Krastof, Mark
American
1942–
1

Krims, Les
American
1943–
26

Krone, Hermann
German
1827–1916
2

Krot, Paul
American
1939–1992
1

Krueger & Co.
American
active 1870s? – 1890s?
1

Krupsaw, Warren
American
1942–
1

Kühn, Heinrich
Austrian, born Germany
1866–1944
27

Kuhn, Konrad
(see also Kuhn & Kuhn)
German
1811–1878

Kuhn, Leonhard
(see also next entry)
German
1809 – c. 1866

Kuhn, Konrad; Kuhn, Leonhard
German
active 1840s
1

L. P.
French
active 1890s
1

Labrot, Syl
American
1929–1977
11

Lacas, Émile
Canadian
1866–?
54

Ladrey, Ernest
French
active 1860s – 1870s
1

Lafayette, J.
French
active c. 1865 – c. 1880
1

Lagarde, François
French
active 1970s
10, and 1 portfolio

Lamaille, Adolphe
French?
active 1840s
1 attribution

Lamb, Frank
American?
active from 1960s
1

Lamy, Eugène
French
active 1860s – 1870s
2, and 24 attributions

Land Weber, Ellen
American
1943–
7

Lange, Dorothea
American
1895–1965
1

Langerock, ?
French?
active 1860s – 1870s
3

Langlois, Col. Jean-Charles
(see also L-E Méhédin)
1789–1870

Larson, William G.
American
1942–
2

Laubier, ?
German?
active c. 1850
1

Laurent, Juan
Spanish, born France
1816–1892?
7

Lawes, ?
Canadian
?–?
1 album

Lawrence, William M.
British
1840–1931
8

Lazorik, Wayne R.
American
1939–
2

Le Bègue, René
French
1857–1914
3

Le Blondel, A.
French
active c. 1842 – c. 1870
2

Le Deley, E.
French
active 1900
103

Le Gray, Gustave
French
1820–1882
7, and 1 attribution

Le Secq, Henri
French
1818–1882
7

Lebowitz, Richard
American
1937–
2

Lecadre, ?
French
active 1870s – 1880s
8

Lee, Russell
American
1903–1986
3

Legrady, George
Canadian
1950–
1

Lehman, Dale
American
1946–
1

Leipzig, Arthur
American
1918–
1

Lejeune
French
active 1860s – 1870s
1

Lékégian, G.
Armenian
active 1860s – 1890s
2

Lenthall, Henry
British
active 1860s – 1880s
1

Lepkoff, Rebecca
American
1918–
3

Levenson, Randal
American
1946–
1

Levinstein, Leon
American
1908–1988
16

Levitsky, Sergei L.
Russian
1819–1898
1

Levitt, Helen
American
1918–
2

Lewis, Arthur Allen
American
1873–1957
2

Libsohn, Sol
American
1914–
2

Liébert, Alphonse J.
French
1827–1913
50

Lieblein, Muni
American
1913–
1

Liebling, Jerome
American
1924–
1

Liebman, Steven
American
1942–
1

Linde, E.
German
active 1860s – 1880s
1

Linn, J. Birney
American
active 1863–1886
1

Littleton View Co.
American
active 1883 – 1890s
16

Livernois, Jules Ernest
Canadian
1858–1933
3 attributions

Livick, Stephen
Canadian
1945–
24

Llewelyn, John Dillwyn
British
1810–1882
2

Lochart, ?
French?
active 1880s
1

Lock & Whitfield
British
active 1857–1895
1

Loescher & Petsch
German
active 1867–1873
1

Lombardi, Paolo
Italian
1827–1890
2

London Stereoscopic & Photographic Co.
British
active 1854? – c. 1908
13, 1 in study collection, and 1 attribution

Long, Chin-San
Chinese
1890–?
1

Lotze, Maurizio
German
1809–1890
4

Loubère, P.
French?
active 1870s
21 attributions

Loydreau, Édouard
French
1820–1905
1

Lutwidge, R. W. S.
British
1802–1873
1

Lynes, George Platt
American
1907–1955
18

Lynn, Mary E.
British
1813–?
1

Lyons, Joan
American
1937–
13

Lyons, Martin
Canadian, born Ireland
1939–
1 in study collection

Lyons, Nathan
American
1930–
55

Lyte, F. Maxwell
British
1828–1906
1

M
French?
active 1860s – c. 1900
1

M. D.
French?
active 1850s
1

MacAskill, Wallace R.
Canadian
1890–1956
2

Macdonald, Marcia Lee
American
1944–
2

Mackinlay, Thomas G.
British
1809–1865
1

Macleod, J. R.
Canadian
active 1870s
1

Macpherson, Robert
British, born Scotland
1811–1872
19, and 1 attribution

Maggs, Arnaud
Canadian
1926–
1

Magniant, Adrien
French?
active 19th c.
1

Maguire, Bill
American
1943–
1

Maheux, L. E.
Canadian?
active late 19th c.?
1, and 1 attribution

Mahl, Sam
American
1920–
1

Mairet, H.
French
active mid-19th c.
11

Maison de la Bonne Presse
French
active c. 1900
3

Maitland, George F.
Canadian
active 1880s – 1900s
2, and 1 attribution

Maldre, Mati
American, born Germany
1947–
1

Malègue, Hippolyte
French
1825–?
1

Man Ray (Emmanuel Rudnitsky)
American
1890–1976
27

Mandello, ?
French?
active 1930s
1

Manning, Jack
American
1920–
3

Mansell, Thomas L.
British
1809–1879
1

Marey, Étienne-Jules
French
1830–1904
1, and 1 attribution

Mariën, Marcel
Belgian
1920–
1

Marshall, F. A. S.
British
active 1850s
1

Marsters, [Joseph D.?]
American
active c. 1850
1

Martin, W.
Canadian
active 1870s
1

Marville, Charles
French
1816–1879?
25, and 1 attribution

Mason & Co.
British
active 1860s
1 in study collection

Mather, Margrethe
American
1885–1952
1

Mathers, Charles W.
Canadian
1868–1950
3 in study collection

Maull & Polyblank
British
active 1854–1865
2 in study collection

Mauri, Achille
Italian
active 1860s – 1880s
1, and 34 attributions

Maurice, A.
French
active late 19th c. – early 20th c.
1

Maurisset, Théodore
French
1803–1860
2

Max, John
Canadian
1936–
16

Mayall, John E.
American
1810–1901
8, and 3 in study collection

Maynard, Hannah
Canadian, born Britain
1834–1918
1

Mayne, Roger
British
1929–
2

Maywald, Wilhelm
German
1907–1985
2

McBriggs, David B.; McBriggs, John
American
active 1850s
1

McClees, James E.
American
1821–1887
1

McClure, James
Canadian
active c. 1869 – 1884
20

McCosker, Duncan
American
1944–
2

McDonald, A. J.
American
active 1870s – 1880s
1

McIntyre, Alex Carson
Canadian?
active 1857–1885
1

McLain, B. W.
American
active 1880s
2

McLaughlin, Samuel
Canadian, born Ireland
1826–1914
2 attributions

McLean & Melhuish
British
active 1860s
2

McMillan, David
American, born Britain
1945–
2

Meatyard, Ralph Eugene
American
1929–1972
19

Meerson, Harry O.
Polish
1910–
2

Méhédin, Léon-Eugène
(see also next entry)
French
1828–1905
1

Méhédin, Léon-
Eugène; Langlois,
Col. Jean-Charles
(see also J-C Langlois)
French
active 1856
1

Mélandri
French
active 1860s – 1883
1

Merkel, Bernadette
American
active 1970s
2

Merrick, ?
British
active 1860
1

Mertin, Roger
American
1942–
460

Metz, Gary
American
1941–
45

Metzker, Ray K.
American
1931–
11

Michalik, Chester J.
American
1935–
2

Michals, Duane
American
1932–
16

Michelez, Charles
French
1817 – c. 1883
33

Militar-
Geographisches
Institut
German
active in Brazil 1930s
1

Militar-
Geographisches
Institut
German
active in Chili 1930s
1

Militar-
Geographisches
Institut
German
active in Spain 1930s
1

Miller, David
American
1949–
3

Miller, Milton M.
American
active 1850–1875
1

Miller, Mr and Mrs
Canadian
active 1860s?
1

Milne, Robert
Canadian
active 1851 – after 1875
1

Mitchell, Thomas
(see also next entry)
British
?–1924

Mitchell, Thomas;
White, George
British
active 1875–1876
6

Model, Lisette
American, born Austria
1901–1983
293, and archives

Modotti, Tina
American, born Italy
1896–1942
1

Moholy, Lucia
British, born
Czechoslovakia
1899–1989
2

Moholy-Nagy, László
American, born Hungary
1895–1946
2

Mollino, Carlo
Italian
active 1935–1949
1 book

Montabone, Luigi
Italian
?–1877
1

Montizon, Count de
British?
active 1850s
1

Morgan, Barbara
American
1900–1992
5

Morris, Wright
American
1910–
1

Mortensen, William
American
1897–1965
25

Mortimer-Lamb,
Harold
Canadian, born Britain
1872–1970
6

Mosher, Robert E.
American
1939–
1

Moss, Joan
Canadian
1931–
1

Moulin, Félix
Jacques A.
French
c. 1800 – after 1875
2

Mountford, [John?]
American
active 1861–1879
2

Mudd, James
British
1821–1906?
1

Muir, Ward
British
1878–1927
4

Mullen, James
American
active 1860s – 1870s
1

Mulnier, Ferdinand
French
1825–?
61

Munro, [William M.?]
Canadian
c. 1861 – 1947
1

Munshaw, J. W.
Canadian?
active 1860s? – 1890s?
1

Muntz, Charles F.
American
active 1860s? – 1890s?
1

Muybridge, Eadweard
British
1830–1904
528, 1 in study collection,
and 4 attributions

N. Caple & Co.
Canadian
active 1866–1911
1

Nadar (Gaspard Félix
Tournachon)
French
1820–1910
50, and 1 in study
collection

Nadar, Paul
French
1856–1939
5

Namuth, Hans
American, born Germany
1915–
1

Narmand [Normand?]
French?
active late 19th c. – early
20th c.
1

Nasmyth, James Hall
British
1808–1890
20

Naya, Carlo
Italian
1816–1882
37, and 5 attributions

Neelands Brothers
Canadian
active 1891–1897
4

Neelley, Julius
American
1946–
2

Nègre, Charles
French
1820–1880
198

Negretti & Zambra
Italian
active 1818–1879
1

Nesbit, William A.
American?
active 1860s
1

Nettles, Bea
American
1946–
5, and 8 books

Neurdein, E.
French
c. 1845 – c. 1913
29, and 1 attribution

Newman, Arnold
American
1918–
2

Newton, Neil
Canadian
1933–
2

Nicholl, W. H.
British
active 1850s
1

Nicholson, W
British
active 1870s
16

Nicolas, E.
French
active 1850s
4

Nixon, Nicholas
American
1947–
7

Noack, Alfred
Italian, born Prussia
1833–1896
35

Noggle, Anne
American
1922–
2

Noskowiak, Sonya
American, born Germany
1900–1975
4

Notman & Fraser
(see also following entries,
excluding Notman
Photographic; and see
W. J. Topley)
Canadian
active 1868–1880?
5

**Notman Photographic
Co. Ltd**
American
active 1872 – 1880s
3

Notman Studio
Canadian
active 1856–1935?
1

Notman, James
(see also Notman &
Notman)
Canadian
1849–1932
5

Notman, William
(see also next entries, and
William Notman & Son)
Canadian, born Scotland
1826–1891
280, 3 in study collection,
and 7 attributions

**Notman, James;
Notman, William**
(see also next entries)
Canadian
active 1877–1884
1

**Notman, William;
L'Africain, Eugène
[painter]**
Canadian
active 1878–1889
1

**Notman, William;
Sandham, J. Henry
[painter]**
Canadian
active 1877–1882
2

**Notman, William
McFarlane**
Canadian
1857–1913
11

Nott, J. Fortuné
Canadian
active 1880s – 1890s
26

Noverre & Company
Canadian
active 1867
1

Nutting, Wallace
American
1861–1941
2, and 1 in study collection

Oehme, Carl Gustav
German
1817–1881
1

Oehme, F.
German
active 1840s
1

Ogawa, Takayuki
Japanese
1936–
1

Ogle & Edge
(see also next entry)
British
active 1857–1866
1

Ogle, Thomas
British
active 1850s – 1860s
15

O'Leary, Thomas
Canadian?
active 1860s?
1

Ongania, Ferdinando
Italian
1842–1911
100

O'Reilly, L.
American?
active 1890s?
1

Ostheim, O. von
Austrian
active 1850s – 1860s
2

O'Sullivan, Timothy H.
American, born Ireland?
1840–1882
104, and 9 attributions

Outerbridge, Paul
American
1896–1958
1

Owen, Hugh
British
1804–1881
2

Palfi, Marion
American, born Germany
1907–1978
1

Palmer, Eli J.
Canadian
c. 1821 – c. 1886
1

Panoramic Camera Co.
Canadian
active 1908
1 in study collection

Papageorge, Tod
American
1940–
3

Parcell, H. G.
American
active 1860s
1

Pare, Richard
British
1948–
1

Park, O. H.
American
active 1880s
1

Parker, Bart
American
1934–
3

Parks, J. G.
Canadian
?–1895
38

Parks, Julie
American
1942–
1

Parsons, O. S.
American?
active 1890s
1

Partridge, A. C.
American
active 1860s – 1880s
1

Peary, Robert
American
1856–1920
1

Pégard, ?
French
active 1840
1 in study collection

Pegot-Ogier, E.
French?
active 1860s
62

Pelletier, Brian C.
American
1941–
2

Penn, Irving
American
1917–
2

Penrose, James
Canadian
1846–?
1

Percy, John
British
1817–1889
1

Périer, Paul
French
1812–?
5

Perini, Antonio
Italian
1830–1879
3

Petit, Pierre
French
1831–1909
10

Petley, Lieut.
British
active 1850s
1

Pfahl, John
American
1939–
60

Phiz (Hablot Knight Browne)
British
1815–1882
2

Photographic Portrait Gallery
British?
active c. 1850
1

Piot, Eugène
French
1812–1891
1

Pirou, Eugène
French
active c. 1860 – 1890
2

Plaut, Henri
French
1819–?
1

Plumbe, John, Jr
American, born Britain
1809–1857
1

Plunket, W. C.
British
active 1850s
1

Pollard, Harry
Canadian
1880–1968
6 in study collection

Pollock, Arthur Julius
British
1835–1890
1

Pollock, Henry
British
1826–1889
1

Ponti, Carlo
Italian, born Switzerland
1822?–1893
9, and 38 attributions

Post, William B.
American
1857–1925
1

Pottier, Philippe
French
active from 1930s
3

Poulton, S. E.
British
active 1850s – 1880s
3, and 1 in study collection

Pouzon, Paul
Swiss?
?–1967
1

Powell, James William
Canadian
1842–1894
2

Pozzi, Pompeo
Italian
1817–?
5

Pratt, Frederick H.
American
active c. 1900s
1

Pratt, William A.
American, born Britain
1818–?
1

Praun, E.
Italian?
active 1850s
1

Price, William Lake
British
1810–1895
1

Prince, Doug
American
1943–
2

Prince, W. B.
British
active 1860s?
2 in study collection

Proctor & O'Shaughnessy
American
active 1860s
1

Pumphrey, William
British
1817–1905
15

Pywell, William Redish
American
1843–1886
3

Quick, Herb
American
1925–
3

R. & H. O'Hara
Canadian
active 1871
3

Rabetz, Walter
American, born Poland
1940–
2

Radiguet & Fils
French
active 1860s?
2

Radowski, F. H.
American
active 1930s
2

Raginsky, Nina
Canadian
1941–
2

Rat, Émile
French
active 1880s
1

Rau, William H.
American
1855–1920
30

Redmond, Joan
American
1946–
1

Reekie, John
American
active 1860s
7

Reeves & Welch
American
active 1870s
1

Regnault, Henri-Victor
French
1810–1878
3, and 2 attributions

Reid, D. Smith
Canadian
active c. 1905 – after 1941
1

Reid, John
American, born Britain
1835–1911
2

Reilly, John James
American, born Britain
1838–1894
4

Rejlander, Oscar G.
(see also next entries)
British, born Sweden
1813–1875
5, and 1 book

Rejlander, Oscar G.;
Duchenne, Guillaume-
Benjamin-Armand
(see also G-B-A Duchenne)
French
active 1870s
2

Rejlander, Oscar G.;
Duchenne, Guillaume-
Benjamin-Armand;
Wallich, R.
(see also G-B-A Duchenne)
French
active 1870s
1

Rejlander, Oscar G.;
Kindermann, ?
French
active 1870s
1

René-Jacques
French
1908–
1

Renger-Patzsch, Albert
German
1897–1966
8

Renner, Eric
American
1941–
38, and 2 in study
collection

Renwick, William W.
American
active 1907
1

Reutlinger, Charles
French, born Germany
1816 – c. 1898
1

Rey, Guido
Italian
c. 1870 – c. 1920
2

Rice, Leland D.
American
1940–
4

Richardson, Frederick
Samuel
Canadian
1858–1925
1

Richardson, T. G.
American
active 1860s – 1870s
1

Richfield, Robert
American
1947–
2

Rigge, Henry
British
active 1860s
1 in study collection

Ripp
French
active late 19th c. – early
20th c.
1

Riss, Murray
American, born Poland
1940–
4

Rive, Robert
Italian
active 1860s – 1870s
4

Robert, Louis-Rémy
French
1811–1882
6

Robertson, Beato
& Co.
(see also next entries,
and Felice Beato)
British
active 1850s
2

Robertson, James
(see also next entry)
British
1813?–1888
6, and 3 attributions

Robertson, James;
Beato, Felice
(see also Felice Beato)
British
active 1850s
10

Robinson, Henry
Peach
(see also next entry)
British
1830–1901
4

Robinson, Henry
Peach; Cherrill,
Nelson K.
British
active 1868–1875
1

Robuchon, Jules César
French
active 1865–1895
155

Rochas, Aimé
French
active c. 1850
3

Roche, Thomas C.
American
?–1895
1

Rockwood, George
Gardner
American
1832–1900
1

Rodchenko, Alexander
Russian
1891–1956
2, and 1 book

Ronay, Denes
Hungarian
active 1920s – 1940s
4

Root's Gallery
(see also next entry)
American
active 1846–1855
3

Root, Marcus Aurelius
American
1808–1888
1

Root, Samuel
American
1819–1889
1

Rose & Sands
American
active 1900
1

Rose, Ben
American
1916–1980
2

Rosenblum, Walter
American
1919–
5

Rosling, Alfred
British
1802 – c. 1882
1

Ross, Judith Joy
American
1946–
2

Rossler, Jaroslav
Czechoslovakian
1902–1990
1

Rothe, Frau W.
German
active 1890s
1

Rothman, Henry
American
1910–
4

Rousse, E.
Canadian?
active 1900s
1 in study collection

Rousseau & Joron
Canadian
active late 19th c.
1 in study collection

Rousset, Ildefonse
French
active 1850s – 1860s
25

Rowantree, Karen
(see Karen Smiley)

Rozzo, Edward
American
1947–
1

Rubin, Eugène
French?
active 1940s – 1950s?
3

Rubincam, Harry C.
American
1871–1940
1

Rudomine, Albert
French, born Russia
1892–1975
1

Russell & Sons
British
active 1852–1870s
3

Russell, Andrew Joseph
American
1829–1902
2, and 1 attribution

Ryan, Cyril
Canadian, born Aruba
1946–
1

Ryder, James F.
American
1826–1904
1

Sacchi, Luigi
Italian
1805–1861
1

Saché, John
British
active 1860–1880
4

Saint-Jean, Michel
Canadian
1937–
2

Saladin, F.
French
active 1855
1

Salmo, Frank
American
1942–
1

Salviati, Paolo
Italian
active 1870s – 1890s
10

Salzmann, Auguste
French
1824–1872
149

Sander, August
German
1876–1964
53

Sandhage, Douglas E.
American
1947–
1

Sandrof, Mark
American
1947–
2

Sarony, Napoleon
Canadian
1821–1896
8, and 1 book

Savage, Charles R.
American, born Britain
1832–1909
7

Schaaf, Albert E.
American, born Canada
1866–1950
3

Schad, Christian
German
1894–1982
1

Schaeffer, Richard W.
American
1949–
5

Schall, Johann Carl
German
1805–1885
1

Schiff, Darryll N.
American
1948–
1

Schmidt, G.
German
active c. 1845
1

Schneider, Gary
American, born South
Africa
1954–
6

Scholz, Richard
German
active 1843–1856
1

Schreier, Michael
Canadian, born Austria
1949–
36

Schroeder & Co.
Swiss
active late 19th c.
5

Schuh, Gotthard
Swiss
1897–1969
1

Schwartz, Joseph
American
1913–
1

Schwarzschild & Co.
British
active 1860s
1, and 1 attribution

Scowen & Co.
British?
active 1876 – 1890s
1

Sears, Sarah C.
American
1858–1935
2

Sébah & Joaillier
(see also next entry)
Turkish
active 1857–?
12

Sébah, J. Pascal
Turkish
?–1890
29, and 4 attributions

Sedgfield, W. Russell
British
1826–1902
17

Seeley, George H.
American
1880–1955
19

Segun, ?
French?
active 19th c. – early
20th c.
1

Seltzer, Leo
Canadian
1916–?
1

Semak, Michael
Canadian
1934–
7, and 1 in study collection

Semchishen, Orest
Canadian
1932–
1

Sesto, Carl
American
1945–
16

Seymour, David (Chim)
American, born Poland
1911–1956
1

Shadbolt, George
British
1819–1901
1

Shahn, Ben
American
1898–1969
1

Shannon & Nicholson
Canadian?
active 1900s
1

Shaw, George Bernard
British
1856–1950
1

Sheeler, Charles
American
1883–1965
2

Sheeler, Musya
American
active from 1960s
1

Sheldon & Davis
Canadian
active 1863 – c. 1904
11

Sheldon, Henry K.
Canadian, born United
States
1820–1877
1

Shepherd, C. F.
American
active 1870s – 1880s
1

Sherborn, H. R.
American?
active late 19th c.
1

Sheridan, Sonia
American
1925–
2

**Shindler, Antonio
Zeno**
American, born Bulgaria
1823–1899
29

Shore, Stephen
American
1947–
7

Siegel, Adrian
American
1898–1978
1

Siegel, Arthur Sidney
American
1913–1978
1

Sievers, Edwin
American
1932–
1

Silverthorne, Jeffrey
American
1946–
3

Silvester, Alfred
British
active 1850s – 1860s
1

Silvy, Camille de
French
1835–1910
1

Singley, Benjamin L.
American
1864–?
35

Siskind, Aaron
American
1903–1991
78

Sissons, J. W.
British
active 1850s
1

Sloan, Lynn
American
1945–
1

**Smiley, Karen
(Karen Rowantree
[from 1992])**
Canadian
1947–
14

Smith, Henry Holmes
American
1909–1986
10

Smith, Keith
American
1938–
7

Smith, Michael A.
American
1942–
2

Smith, W. Eugene
American
1918–1978
1

Smith, W. Morris
American
active 1860s – 1870s
1

Smyth, Charles Piazzi
British
1819–1900
20

Snow, Michael
Canadian
1929–
1 book

Sommer, Frederick
American, born Italy
1905–
1

Sommer, Giorgio
Italian, born Germany
1834–1914
78, 1 in study collection,
and 13 attributions

Sourkes, Cheryl
Canadian
1945–
3

Southwell Brothers
British
active 1860s
1 in study collection

**Southworth, Albert
Sands**
(see also next entry)
American
1811–1894

**Southworth, Albert
Sands; Hawes, Josiah
Johnson**
(see also J. J. Hawes)
American
active 1843 – c. 1862
2

Spencer, Elihu B.
Canadian
1818–1898
1

Spencer, Ema
American
1857–1941
1

Spencer, Michael J.
American
1948–
31

Spuris, Egons
Latvian
1912–
1

Spurling, Stephen
Australian
active 1870s – 1890s
3, and 1 attribution

Stanhope, Clarence
American
1851–1924
2 attributions

Starbuck, Fletcher
Canadian
active 1970s
6 in study collection

Stark, Larry
American
1940–
10

Stebbing, E.
French
active 1880s
1

Steichen, Edward
American, born
Luxembourg
1879–1973
183

Steiner, Eedie
Canadian
active 1972
1

Steiner, Ralph
American
1899–1986
23, and 1 in study
collection

Steinhauser, Judith
American
1940–
5

**Stelzner, Carl
Ferdinand**
(see also next entry)
German
1805–1894
5, and 4 attributions

**Stelzner, Carl
Ferdinand; Biow,
Hermann**
(see also Hermann Biow)
German
active 1842–1843
1

Sternfeld, Joel
American
1944–
1

Stettner, Louis
American
1924–
1

Stevens, Roy
American
active 1940s
1

Stewart, John
British
1800–1887
1

**Stiegler, Robert
William**
American
1938–
1

Stieglitz, Alfred
(see also C. H. White)
American
1864–1946
71

Stoddard, Seneca Ray
American
1843 or 1844 – 1917
2

Stokes, George B.
British
?–1903
1

Stone, Benjamin
British
1838–1914
49

Stone, Erika
American, born Germany
1924–
1

Stoumen, Lou
American
1917–
3

Straiton, Ken
Canadian
1949–
3

Strand, Paul
American
1890–1976
60

Strauss, John Francis
American
active 1900s
2

Strohmeyer & Wyman
American
active 1890s – 1900s
63

Stroud, William
American
1812–1889
1

Struss, Karl F.
American
1886–1981
8

Stuler, Jack
American
1932–
1

Sturr, Edward R.
American
1937–
1

Styrsky, Jindrich
Czechoslovakian
1899–1942
1

Sudek, Josef
Czechoslovakian
1896–1976
3

**Sutcliffe, Frank
Meadow**
British
1853–1941
4

Swain, Llewellyn G.
Canadian
active 1860s – 1890s
1

Swedlund, Charles A.
American
1935–
8, and 1 in study collection

Sweet Studios
American
active 1890s – 1940s
1, and 3 attributions

Szilasi, Gabor
Canadian, born Hungary
1928–
7

T. Eaton Co. Ltd
Canadian
active c. 1906 – 1910
26

Tabard, Maurice
French
1897–1984
2

Taber, Isaiah West
American
1830–1912
8

**Taft's Gem Picture
Gallery**
American
active 1860s? – 1870s?
2

Tairraz Frères
French
active 1850s – 1860s
1

Tait & Arthur
Canadian
active 1860s
1

Talbot & Co.
Canadian
active 1860s – 1870s
2

**Talbot, William Henry
Fox**
British
1800–1877
135

Tata, Sam
Canadian, born Shanghai
1911–
10

Taunt, Henry William
British
1842–1922
36

Taylor, Henry
British
1800–1886
1

Taylor, Jeremy
Canadian
1938–
12

Tessler, Ted
American
1919–
2

Teynard, Félix
French
1817–1892
2

Thall, Bob
American
1948–
9

Thiébault, E.
French
active 1850s – 1870s
1

Thompson & Co.
British?
active 1860s
1

Thompson, Jerry
American
1945–
1

Thompson, S.
British
active 1860s
12

Thompson, Stephen Joseph
Canadian
1864–1929
2

Thoms, William John
British
1803–1885
1

Thomson, John
British, born Scotland
1837–1921
36, and 2 attributions

Topley, William James
(see also Notman Studio)
Canadian
1845–1930
21, 4 in study collection,
4 under Notman Studio
management, and
3 attributions

Tourtin, [Émile or J.?]
French
active 1870s
2

Traub, Charles H.
American
1945–
1

Traube, Alex
American
1946–
7

Trémaux, Pierre
French
1818–1895
74

Trim, J.
South African
active 1870s – 1880s
2

Tripe, Linnaeus
British
1822–1902
1

Tromholt, Sophus
Norwegian?
active 1880s
1

Trueman & Caple
Canadian
active c. 1888 – 1894
8

Trutat, Eugène
French
1840–1910
6

Tucker, Carlyn Ann
American
1956–
1

Turner & Cohen
American
active 1866
1

Turner, Benjamin Brecknell
British
1815–1894
6

Turner, Edwin R.
Canadian
active 1866–1871
2

Turner, Jack
Canadian
1889–?
2 in study collection

U. S. Geological Survey
American
active 1930s?
1

Uelsmann, Jerry N.
American
1934–
23

Ulmann, Doris
American
1882–1934
1

Ulrich, L. E.
German
active after 1849 – ?
1

Underwood & Underwood
American
active 1880–1921
137

Underwood, Bert
American
1862–1943
11, and 7 attributions

Unna, M.
Danish
active 1860s
1 in study collection

Vachon, John
American
1914–1975
3

Valentine, James
(see also James Valentine
& Sons)
British
1818–1880

Valéry, ?
French
active 1870s
1

Vallée, Louis-Prudent
(see also next entry)
Canadian
1837–1905
19

Vallée, Louis-Prudent; Labelle, Francois-Xavier
Canadian
active 1867–1868
1

Vandiver, Kim
(see also H. E. Edgerton)
American?
active 1973

Van der Poel, ?
Dutch?
active 1950s
1

Van Dusen, Ray
Canadian
1949–
1

Van Lint, J. Enrico
(see also Huguet & Van
Lint)
Italian?
active 1850s – 1880s
1

Van Loan, Samuel
American, born Britain
active 1844 – 1850s
1

Vanderpant, John
Canadian, born Holland
1884–1939
3

Vestal, David
American
1924–
2

Vigier, Viscount Joseph
French
1821–1862
?

Vivian, W. Graham
British
1827–1912
1

Vivot
French
active 1860s
1

W. & D. Downey
British
active 1860s – 1914
2, and 1 in study collection

W. L. H. Skeen & Co.
British, in Ceylon
active 1862 or 1863 – 1903
20, and 6 attributions

W. R. & S.
British
active 1890s?
2

Waldeck
French?
active 1860s?
1

Waldeck fils
French?
active 1860s
1

Walker, Samuel A.
British
active 1860s – 1890s
3

Walker, Todd
American
1917
2

Walker, W. C.
American?
active 1890s
1

Wallis, James Dodridge
Canadian
1838–?
17, and 1 attribution

Wallowitch, Edward
American?
active 1950s – 1960s
2

Walter [or Walther], Jean
French
1806–1866
1

Warrington, E. F.
American
?–1870
1

Washburn, William Watson
(see also next entry)
American
c. 1827 – 1903

Washburn & Co.
American
active 1849–1869?
1

Watkins & Hill
British
active 1840s
1

Watkins, Carleton E.
American
1829–1916
2

Watkins, Margaret
Canadian
1884–1969
7

Watson-Schutze, Eva
American
1867–1935
8

Watzek, Hans
Austrian
1848–1903
5

Webb, William
Canadian?
active 1863 – after 1867
1

Weber, Erik
American
1940–
4

Weber, H. W.
Canadian
active 1860s?
1

Webster & Albee
American
active 1886–1910
3

Weed, Charles Leander
American
1824–1903
1

Weegee (Arthur H. Fellig)
American, born Austro-Hungary
1899–1968
14

Wehnert, Bertha
German
active c. 1843 – c. 1900
1

Wehrli Brothers
Swiss?
active 1900s – 1910s
2

Weiner, Dan
American
1919–1959
1

Weiss, G.
German?
active 1850s
1

Weiss, Sabine (Sabine Weber)
Swiss
1924–
1

Weissmann, Lawrence
Canadian, born United States
1943–
8

Weller, F. G.
American
1833–1877
4

Wells, Alice
American
1927–1987
30

Wessel, Henry
American
1942–
30

Wesselink, Michael
Canadian
active from 1970s
2

Westman, Tony
Canadian, born United States
1946–
3

Westmount Studio
Canadian
active late 19th c. – early 20th c.
1

Weston, Brett
American
1911–1993
9

Weston, Chandler
American
1910–
1

Weston, Edward
American
1886–1958
110

Weyler, ?
French
active 1860s
1

Wheeler, Warren
American
1944–
1

Whipple, John Adams
American
1822–1891
1 attribution

White, Clarence H.
(see also next entry)
American
1871–1925
53

**White, Clarence H.;
Stieglitz, Alfred**
(see also Alfred Stieglitz)
American
active 1909
4

White, Henry
British
1819–1903
1

White, Minor
American
1908–1976
24

White, T. E. M.
American
1834–1909
1

Whitehurst, Jesse H.
American
c. 1820 – 1875
1 attribution

Whiten, G. E.
Canadian
active 1870? – 1890s?
1

Wiklunds, A.
Swedish
active 1890s
1

Wilcox, Walter Dwight
American?
1869–?
12

Willard, Oliver H.
American
?–1876
1

William Notman & Son
(see also William Notman)
Canadian
active 1882–1891
7, and 1 in study collection

William & Co.
British?
active 1860s
1

Williams, T. R.
British
1825–1871
2

Williamson, Andrew
British
active 1858 – 1870s
18

Williamson, W.
Canadian
active 1876
1

Wilmerding, William E.
American
1858–1932
1

**Wilson, George
Washington**
British
1823–1893
68, and 1 attribution

Wilt, Peter J.
American?
active 1950s
2

Wing, Simon
American
1826–1916
1

Wingrave, T.
British
active 1860s
1

Winkle, Lisel
German
active 1930s
1

Winkler, Karl
Austrian?
active 1920s
1

Winningham, Geoff
American
1943–
1

Winogrand, Garry
American
1928–1984
1

Witkin, Joel-Peter
American
1939–
2

Wojnarowicz, David
American
1954–1992
1

Wolcott, Marion Post
American
1910–
2

Wood & Gibson
(see also James F. Gibson)
American
active 1862–1865
6

Wood, Brian
Canadian
1948–
1

Wood, Horatio Bertini
American
1858–1940
1

Wood, John
American
1922–
22

Woodbury, David B.
American
?–1866
1

Woodruff, John
Canadian, born Britain
1859–1914
1

Woodson, James
American
1950–
1

X
French?
active 1850s
21

Yavno, Max
American
1921–1985
4

York, Frederick
British
1823–1903
1

Young, Andrew
British
active 1870s
29

Young, E. J.
American
active 1868–1885
1

Young, R. Y.
American
active c. 1895 – 1905
1

Zahner, M. H.
American
active 1880s – c. 1900
2

Zangaki Brothers
Greek
active 1860s – 1880s
8

Zeiss, Carl
German
1816–1888
8

Zeiss-Aerotopograph
German
active 1920s
37

Zucca, André
French
active 1930s – 1940s
1

Zwart, Piet
Dutch
1885–1977
1

Zybach, John
Canadian
active 1850s – 1860s?
4

Apparatus

Beckers, Alexander
American, born Germany
active 1843–1855
1 stereoscope

Chevalier, Charles Louis
French
1804–1859
1 camera obscura

Eastman Dry Plate & Film Co.
American
active from 1881
1 camera

Eastman Kodak Co.
American
active 1881–1884
1 camera

Ernemann-Werke
German
active 1889–1926
2 cameras

Ernst Leitz
German
1871–1956
1 camera

Gilles & Faller
French
active from 1860s
1 camera

Gundlach-Manhattan Optical Co.
American
1896–1928
1 camera

Hermagis appareils photographiques
French
active from c. 1860 – 1890s
1 camera

Holmes, Oliver Wendell
American
1809–1894
2 stereoscopes

Horne & Thornthwaite
British
active c. 1858 – 1886, 1894–1913
2 cameras

Houghton's Ltd
British
active 1904–1926
1 camera

J. Lancaster & Son
British
active 1880s – 1900s
1 camera

London Stereoscopic Co.
British
active 1840s – c. 1908
1 stereoscope

Negretti & Zambra
Italian
active 1850 – 1870s
1 camera

Queslin, Amédée
French
active 1840s
1 daguerreotype camera

Rochester Optical Co.
American
active 1883–1903
1 camera

Rowsell, Charles
British
active 1860s
1 graphoscope

Soho Ltd
British
active from 1880s
1 camera

Unis Stéréoscopes
French
active late 19th c.
1 stereoscope

Unknown
American
active 1840s
1 daguerreotype camera

Unknown
American
active c. 1860 – 1880s
1 carte-de-visite camera

Unknown
French
active c. 1800 – 1820s
1 camera obscura

Unknown
French
active 1850s
1 Brewster stereoscope

Unknown
French
active 1850s
1 stereoscopic camera

Unknown
French
active c. 1860 – c. 1900
1 graphoscope

Unknown
French
active early 20th c.
1 stereoscope

W. & W. H. Lewis
American
active c. 1843 – 1852
1 daguerreotype camera

W. W. Rouch & Co.
British
active from 1880s?
1 camera

Zeiss Ikon
German
active from 1926
1 camera

Zeiss-Aerotopograph
German
active from mid-19th c.
1 stereoscope

INDEX OF NAMES AND TITLES